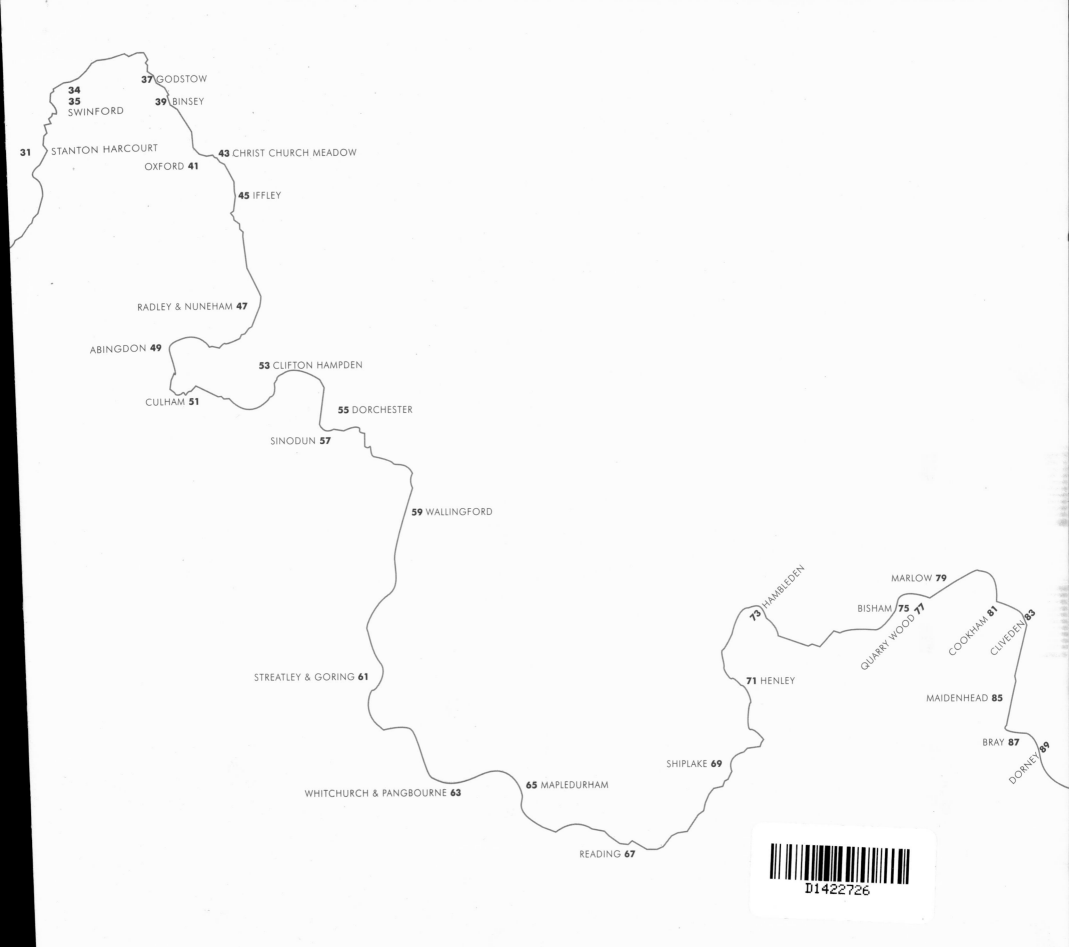

34
35
SWINFORD

37 GODSTOW

39 BINSEY

31 STANTON HARCOURT

43 CHRIST CHURCH MEADOW

OXFORD **41**

45 IFFLEY

RADLEY & NUNEHAM **47**

ABINGDON **49**

53 CLIFTON HAMPDEN

CULHAM **51**

55 DORCHESTER

SINODUN **57**

59 WALLINGFORD

HAMBLEDEN

MARLOW **79**

73 BISHAM **75** **77**

QUARRY WOOD

COOKHAM **81**

CLIVEDEN **83**

STREATLEY & GORING **61**

71 HENLEY

MAIDENHEAD **85**

BRAY **87**

DORNEY **89**

SHIPLAKE **69**

WHITCHURCH & PANGBOURNE **63**

65 MAPLEDURHAM

READING **67**

continued on back endpaper

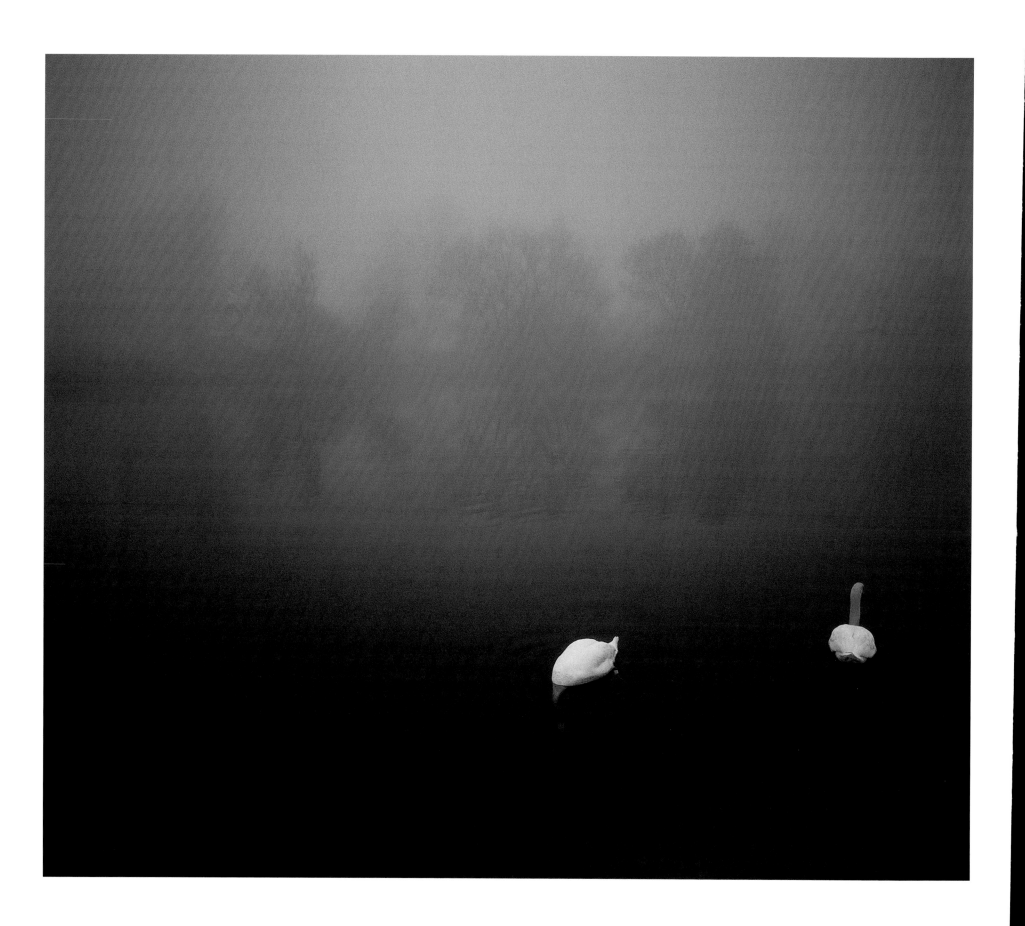

SEARCHING THE THAMES

a journey from the source to the sea

PHOTOGRAPHS BY DENIS WAUGH | TEXT BY PRISCILLA WAUGH

AURUM PRESS

First published in 1999 by Aurum Press Limited,
25 Bedford Avenue, London WC1B 3AT

A catalogue record for this book is available from the British Library

ISBN 1 85410 620 1

Designed by Derek Birdsall
Typeset in Monotype Walbaum by Shirley Thompson/Omnific
Printed in Singapore by CS Graphics

Frontispiece
Swans at Mapledurham through January fog

CONTENTS

INTRODUCTION

The strange thing about writing an Introduction to a book of this kind is that you have to do it last, when you have found out what it was for which you were searching, which is almost certainly not what you thought it was when you set out. And as the journey proceeds, it becomes apparent that it is not just your search, any more than it was your idea. It is as if all the ideas are out there somewhere and you have been allotted this particular one.

So, when you become bogged down with expectations and concerns and crises of faith, it is good to be reminded that this is not just your personal ego trip: that in fact when ego enters into it you have diverged from the path, and when you return to the point at which you were misled by that red herring, the path reappears so clearly that you wonder how you could have got so lost. Yet even the getting lost, you now see, was part of the journey.

How many times in the course of the past five years have I been asked: 'The Thames? What is your angle?' A photographer never gets asked this question, perhaps because his angle appears obvious. (Though it is not.) And at first I thought, 'Oh, bother this "angle," How can I say "Love and enthusiasm" without sounding at best unprofessional and at worst a complete prat?' This was a search undertaken with joy and the haziest of preconceptions and any perceived angles have simply smoothed themselves out. As if, again, this was not our idea in the first place but simply a path presenting itself to us to be followed, posing questions along the way: questions that would always answer themselves if only one learned how to listen.

> *And I would do it again, but set down*
> *This set down*
> *This: were we led all that way for*
> *Birth or Death?*
>
> T.S. Eliot: *Journey of the Magi*

From the burst of the first bubble at Trewsbury Meadow where I splashed in brand-new wellies five years ago down to the day this week when I stood alone on the whispering mud of the estuary (because even in that apparent silence a million life forms are teeming about their daily lives and there is no such thing as silence any more than there is any such thing as alone-ness) my question has been formulating itself, and it is this: Were we the searchers or part of the search? And all the time the answer has been travelling alongside: we were – and are – both.

Our thanks are due to many: first of all to Bruce Bernard who believed in the search and set it on the way; to Derek Birdsall who gave freely of his invaluable time and incomparable talent to give it form when the dark forces of The Market were seemingly conspiring against it; to Mike Shaw who kept faith over the years; and to Piers Burnett who believed him and wielded the editorial pencil with consummate skill.

Despite all the help received, there will inevitably be errors and omissions, and for these I must accept full responsibility; but meanwhile I would like to place on record our gratitude to the following: the Adelphi, Cantillon Demolition, Christ Church Oxford, Cliveden, the Docklands Museum, Dorney Court, Hampton Court, Kelmscott Manor, Kew Gardens, Kodak, the National Maritime Museum, Reading Prison, the Savoy, Shakespeare's Globe, Syon House and the Tower of London; to the Anchor Inn at Blackfriars, the Plough at Clifton Hampden, Robin Hergist, Don Marshall, and the librarians of Wallingford, Oxford, Southwark and Gravesend.

Thanks are due to Bronwyn Fecteau for her invaluable help with the photographs; to Jan and Barbara Darowski, Noel McKenzie and Paul Kirwan for sharing information and enthusiasm; to Carol, Gerda, Geertje, Jessica, Lydia, Stephanie and Sue for in various ways sharing parts of the journey; to John and David for their friendship and advice; to Greg and Rosemary for technical help; to Ron, Leslie, Fred and Chas for the lift on their narrow boat, and to Marian who fortuitously hung on the strap next to mine on the Bakerloo Line from Lambeth North twenty years ago.

Our grateful thanks also go to all those tireless and anonymous compilers of information who write descriptions and histories of their parish churches; to Ben for his miraculous sense of humour, to Miranda for bringing sunshine into the darkest corner and, above all, to you, our fellow searchers, to whom this book is dedicated.

Priscilla Waugh
Dulwich, September 1998

About a quarter of a mile across the fields from the King's Head pub on the A433 outside Kemble, a simple monument beneath an ash tree bears the inscription:

THE CONSERVATION OF THE RIVER THAMES

1857–1974

THIS STONE WAS PLACED HERE TO MARK THE

SOURCE OF THE RIVER THAMES

Ten feet in front, a small basin of stones in the ground may, if you are very lucky, be submerged in clear water. If you look closer you will see sporadic bursts of tiny bubbles making their way to the surface; gently, so that, if you did not know, you might think they were raindrops. This is, indeed, the source of the river up which the Romans sailed at about the time Christ was born, on which, in 1536, Anne Boleyn took her final tragic journey and for which Handel in 1717 composed the sublime *Water Music* for a homesick German king. The river on which, during Victoria's reign, three men in a boat undertook an hilariously memorable holiday and on which Ratty and Mole will adventure forever, just messing about in boats.

From here until it reaches Oxford, the Thames is called the Isis, after the Egyptian fertility goddess, sister and consort of Osiris, god of the underworld and judge of the dead. Jung saw Isis as *anima*, the feminine principle present in the male unconscious: guide and mediator to the inner world.

Here is quiet. From the thicket of blackberries and briar beyond you may hear the bubbling of wood pigeons, or a lone song thrush may burst the silence. If you have made your way here from the Pool of London or from the Thames Barrier it could seem that it would take but a small leap of faith to follow Isis into a higher, more spiritual world.

Again, if the season has been abundant in rain, you may look south-eastwards from the tablet and see a series of shallow pools receding into the distance. Follow them, and stop occasionally to look closely. Here and there the tell-tale bubbles will surface and at some point you will notice that the shallow water is moving; flowing forward with a sense of purpose, and you can almost begin to

believe that you are at the beginning of a secret that will in time become apparent as the most historic river in the world.

In winter, after snow, to believe that this is the source of a great river requires a larger leap. Crows cronk and caw derisively from the frost-laden thicket behind. Huge bulls lounge in the snow disregarding one perhaps just a little too carefully, and the apparently seamless fields stretch far and white down to the Fosse Way, or the A433 as it is more likely to be known today.

The Fosse Way is the road the Romans built between Lincoln (*Lindum*) and Bath (*Aquae Sulis*), just part of the 6,000 or more miles they built: straight, no-nonsense highways, many still serving today. A fosse is a ditch, and the Fosse Way was so named because of the deep trench either side which it has still. Along to the left, before the road to Ewen, you will have to clamber over it to read a plaque in a little stone bridge almost obscured in autumn by probably the best blackberries in the world. This is the old Thames Head Bridge of 1789, which realignment of the road in 1962 rendered redundant. Below ran the visionary Thames and Severn Canal, which effectively converted mainland Britain into two islands, long disused and now dry.

The Thames, however, as land form dictates, soon contracts itself into a deeper, swifter channel where river crowfoot spreads out its mermaid tresses. Its artless white flowers will caress the surface of the water in spring as its less aquatically inclined cousin, the tiny, yellow-flowered, celery-leafed crowfoot, shyly hugs the bank of what is clearly a river with ambition.

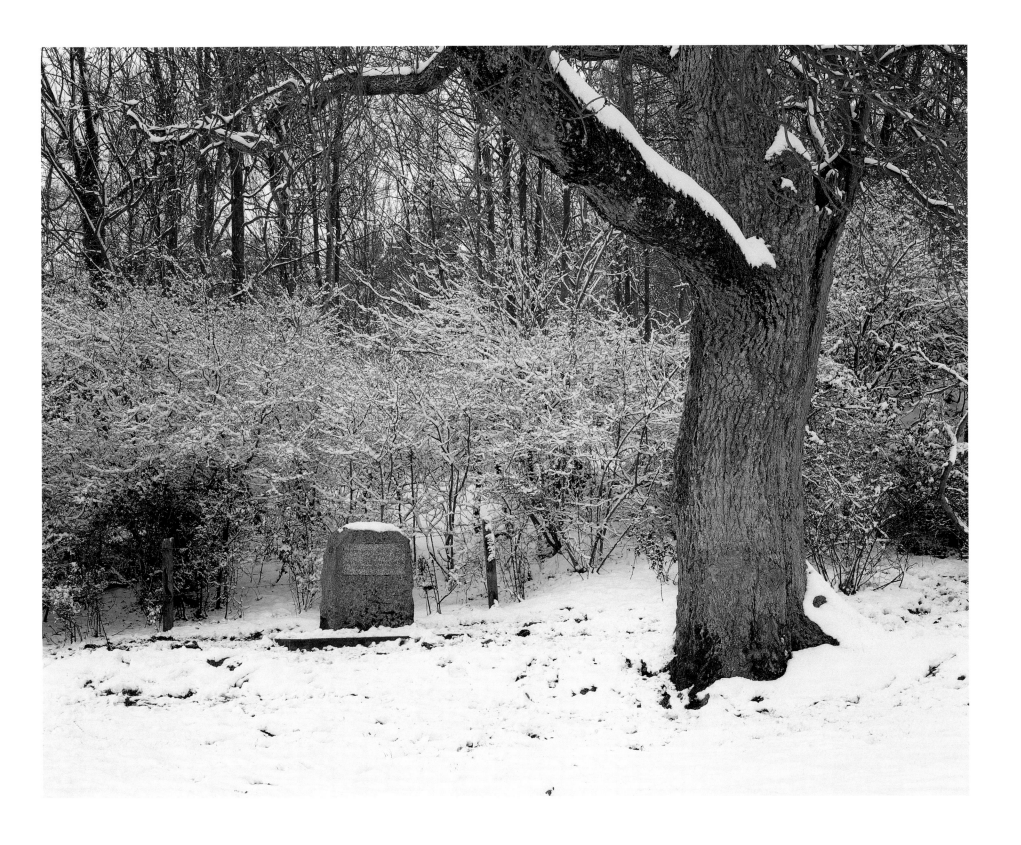

A stone plinth marks where the first slow trickle of the infant
Thames *sometimes* emerges in a field near Cricklade, a few miles
south of Cirencester.

The little Catholic church of St Mary in Cricklade looks more Saxon than Norman. Saxon with all sorts of additions, which may or may not be evident depending from which angle you approach. From the eaves of the larger Church of St Sampson, dejected gargoyles gaze sorrowfully down on what was once a pretty important town and is now just pretty.

The flood plain of the Thames hereabouts left one area standing high and dry: the shingle mound called in the Domesday Book *Crichelade*, the crossing on the hill. When the Romans built Ermin Street, linking *Londinium* with *Corinium* (or London with Cirencester), Cricklade was the obvious place to cross the river, and probably the primary function of the settlement which grew here was the maintenance and protection of the highway.

Alfred the Great, some centuries later, having seen off the Danes at the Battle of Ashdown in 870, enclosed Cricklade, as he did other towns strategically placed on the Wessex border, in a fortified wall, the better to repel further invasions from the north, and it thus became a borough. The wall is still commemorated in the street names, although little physical trace of it remains.

Ermin Street is still used by an army twice a day. Try cycling from Swindon along the enticingly straight and flat A419 and you take your life in your hands as juggernauts pound past and captains of local commerce and industry speed by one-handed as they discuss strategy and sales projections. One wonders how Alfred achieved anything without access to a mobile phone.

The Roman Ermin Street/A419 now bypasses the little town, leaving it refreshingly unconcerned with the demands of tourism. There is one tea shop and the tiny museum (built in 1852 as the chapel for the Particular Baptists) opens for two hours on Wednesday afternoon and two hours on Saturday morning.

Cricklade gained a certain notoriety during the eighteenth century as a rotten borough when, with a population of a mere 1,400, it returned two Members of Parliament. Not very useful ones as far as the poor voters were concerned. William Cobbett hated the place. In his *Rural Rides* of 1821 he rails:

A more rascally looking place I never set eyes on… The labourers seem miserably poor. Their dwellings are little better than pig-beds, and their looks indicate that their food is not nearly equal to that of a pig… In my whole life I never saw human wretchedness equal to this… These, O Pitt! are the fruits of thy hellish system!

Cobbett was not one to pull any punches. In his publications and his brief parliamentary career he spoke straight to the people in an age when elegant prose was the accepted language of government. By the time he published *Rural Rides* Pitt was dead, but his perceived legacy of a crippling national debt was still growing. Cobbett saw England as a one-time agrarian paradise now hag-ridden by commerce and corruption, and his anti-intellectual approach did much to persuade the labouring classes that improvement of their lot depended on parliamentary reform.

Cricklade was never much of a place to toe the line. There was a wooden castle here, illegally built by one William Peverel of Dover, a friend of Edward the Confessor, of which no trace remains. Peverel was a supporter of the Empress Matilda in her struggle against King Stephen, so it may have been misguided enthusiasm which in 1147 prompted the fourteen-year-old Henry Fitz Empress (it means son of the Empress) to leave his home in France and raise an army of mercenaries for the conquest of Cricklade. Young Henry's expedition came to nothing and, broke and homesick, he applied to his mother to bail him out. Matilda refused, so her son turned to his uncle, King Stephen: rather cheekily when you consider that his intention had been to claim Stephen's crown. Charmingly, Stephen paid off Henry's army and sent him home with a flea in his ear, which is probably the most avuncular behaviour ever.

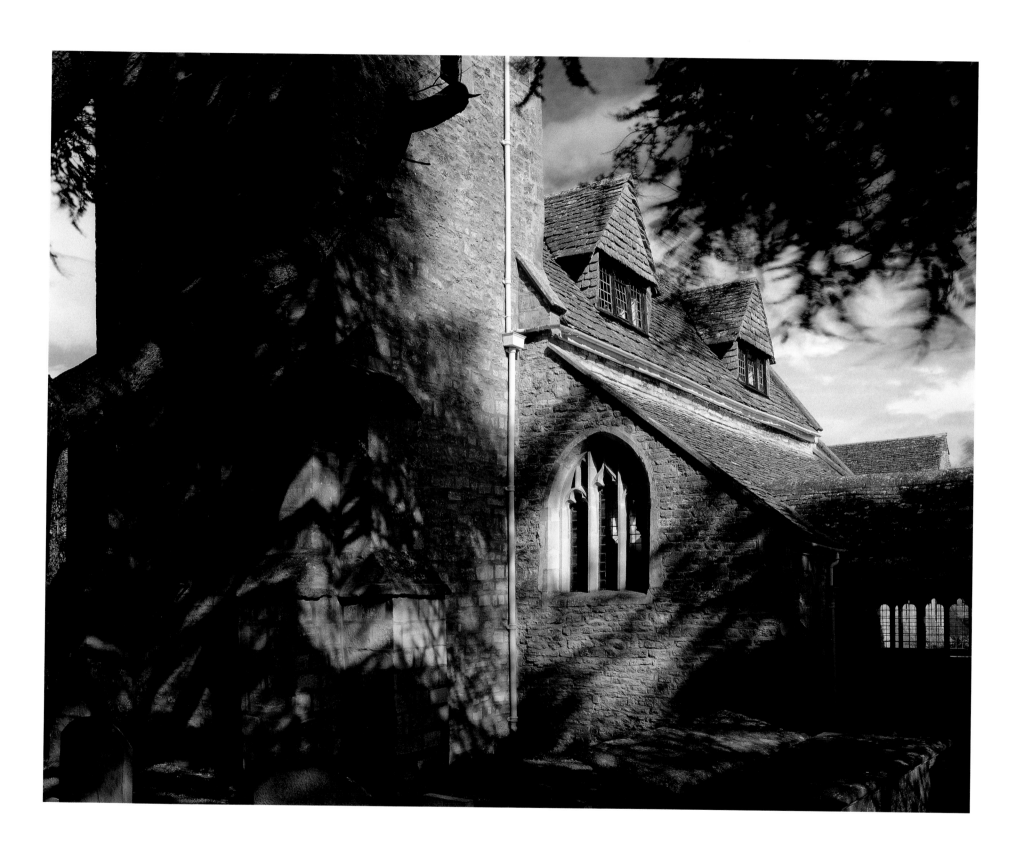

The church of St Mary in Cricklade: people have worshipped here
from the time of Alfred the Great.

The *Anglo-Saxon Chronicle* describes this place in the year 800:

> *Here the moon grew dark at the second hour of the night on 16 January. And King Beorhtric and Ealdorman Worr passed away. And Egbert succeeded to the kingdom of Wessex: and the same day Ealdorman Ethelmund rode from the Hwicce across at Kempsford; then Eldorman Weohstan met him with the Wiltshire men; and there was a big battle, and both ealdormen were killed there and the Wiltshire men took the victory.*

The information comes to us indirectly by courtesy of King Alfred the Great, King of Wessex between 971 and 999, and generally considered the first King of England. He gathered together the numerous kingdoms and tribes to confront their common foe: the Danes. Alfred is also credited with the spread of literacy, he himself learning to read only as an adult. But as king he personally translated numerous Latin texts into the vernacular English for general use and he was responsible for the compilation – also in English – of the *Anglo-Saxon Chronicle*: a kind of national propaganda exercise which was kept faithfully by monks in abbeys scattered about England.

The first part of the *Chronicle* is retrospective, and therefore it depended on human memory. In fact, at this point the narrative is two years out (the year was 802) but the small matter of an inaccurate date cannot dim the voice of an anonymous monk speaking to us across twelve hundred years.

The Hwicce, a substantial people whose territory in the seventh century embraced Gloucestershire, Worcestershire and western Warwickshire have disappeared long since, but not entirely without trace, because the name remains in Wychwood Forest, one of the few remaining woodland tracts of the huge medieval Forest of Arden.

Even earlier, there was a considerable Roman presence in the area. The major town of *Corinium* (Cirencester) was a thriving centre of Roman civilization and numerous remains of the period are to be found hereabouts. At the shallows by the Hannington bridge, for instance, there was once a Roman crossing, whilst east of the bridge and south of Sterts Farm four huge earthworks denote the site of early British settlements or forts from Roman times. At dusk on a January evening, walking across the site of the skirmish reported in the *Chronicle*, a 100-acre meadow outside Castle Eaton still called Battlefield, you may find your pace quickening involuntarily – this battlefield and the village of Kempsford have long been associated with a variety of ghosts.

The tower of Kempsford's Church of St Mary the Virgin across the river, so idyllically completing the ideal English landscape was, local tradition has it, built by John of Gaunt, who married Blanche, daughter and heiress of the Duke of Lancaster. But as John of Gaunt died in 1399 and the tower probably dates from the mid-fifteenth century, this is probably a case of mistaken identity.

The same goes for the horseshoe nailed to the church door, which is said to be that of the first Duke of Lancaster, whose only son drowned in the river here. According to tradition, the distraught duke mounted his horse and galloped away, never to be seen again, his horse dropping a shoe as it went. I hate to put a damper on things, but the first duke was Blanche's father who is recorded as dying of plague. (The 'Plague Cottages' that you pass on the way in to Castle Eaton from Cricklade, though, refer neither to the fourteenth-century outbreak of the Black Death nor the Great Plague of the seventeenth century. This no-nonsense pair are dedicated to giving thanks for deliverance from the Great Cattle Plague of 1806.) Nevertheless, Kempsford is quite rightly proud of its Plantagenet connections and the most famous of its ghosts are Lancastrian spirits.

The great Thames and Severn Canal passed through Kempsford on its 30-mile route from Lechlade to Stroud. Its purpose was to open up trade between Bristol and London, which it did for over a hundred years until the new and exciting Great Western Railway put paid to such a leisurely mode of commerce.

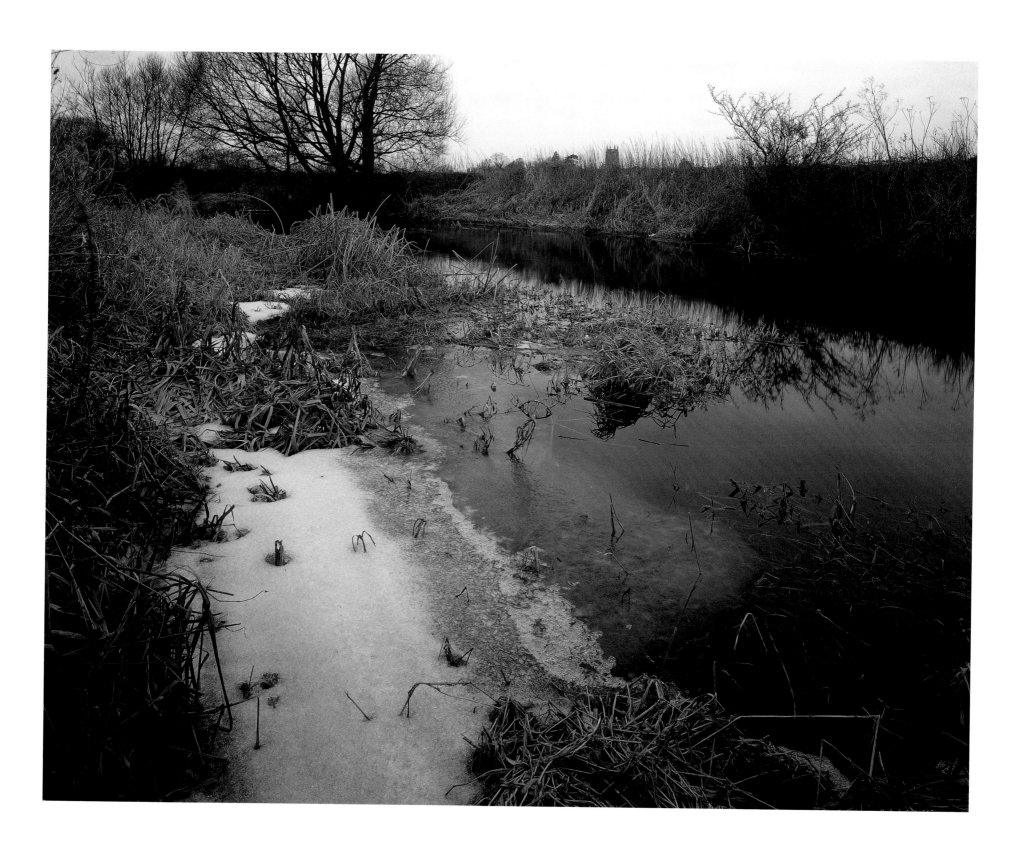

The tower of the church of St Mary the Virgin is seen across
the frozen fields of Battlefield, Castle Eaton.

A flurry of tiny snowflakes wisped along the ice leaves a delicate fan on the frozen lock water *en route* to Inglesham. Unreal, monotone countryside, straight from a Rackham illustration, with sepia-toned fields of dead corn, remote brown-brick story-book houses and scribbled trees over ice-white fields. Until the Church of St John the Baptist rises solidly from the riverside mist.

Thank God and William Morris for this beautiful church, saved by the Society for the Protection of Ancient Buildings from renovation in the approved Victorian manner. The powerful nineteenth century Cambridge Camden Society of 'Ecclesiologists' saw it as their function to ensure that 'the science of worship' was carried out appropriately in a building of the type pleasing to God, a category strictly limited, apparently, to the Gothic style of the fourteenth century, the Age of Faith. Which is why in the booklet guides to local churches the words 'restored in the 1880s' can strike a chill into the heart.

In 1888 Morris and his Society took the Church of St John the Baptist under their wing and insisted that its layers of history be preserved. Thus survives this beautiful and silent testimony to the lives of centuries of English people of divers descents. The church was given by King John to the monks of Beaulieu in 1205, but even then it was over two hundred years old. In the chancel, a stone carving of the madonna and infant revealed by the hand of God could be from the time of Edward the Confessor and the ancient Saxon preaching cross in the churchyard was surely the place from where itinerant priests from a central mother church spoke to the local populace before St John the Baptist of Inglesham was built – certainly well before the Norman Conquest.

Wandering across these frozen fields, with traces of medieval farming visible in the furrowed landscape – it must look wonderful from the air – you can see the appeal the Christian message must have had to these people, beset by poverty, hard grind and, when the local lord so decided, the call to war. Love, forgiveness and eternal rest would have been welcome news indeed.

The interior, with its Jacobean boxed pews, remains much as it was in the time of Cromwell's Commonwealth, but throughout are traces of continual use – from the early thirteenth century the nave, arcades and ochre-coloured wall paintings, still clear despite much over-painting in following ages; from the fourteenth century the north door with its foliate hinges; from the fifteenth the font; from the sixteenth the wooden pews and screens; from the seventeenth the pulpit; from the eighteenth the communion rails; and the Hanoverian Arms of the nineteenth century. The twentieth century's contribution is no less important. It comes from the Churches Conservation Trust who now care for this atmospheric and still consecrated ancient building.

Inglesham was a flourishing village in the heyday of the medieval Cotswold wool industry. In more recent times it was well placed for trading with both London and Bristol during the brief flurry of activity on the Thames and Severn Canal, so soon to be eclipsed by rail transport. The canal joined the Thames at Inglesham Lock, which now comprises the garden of the picturesque Round House on the north bank, the home of the last Inglesham lock keeper.

The village is first mentioned in the year 950, and it probably means '*the enclosure or river-meadow of a man called Ingen or Ingin*' but it may have been named for King Ine, the 'Law Giver' who, according to the *Anglo-Saxon Chronicle*, built the Minster at Glastonbury and, having succeeded to the Kingdom of Wessex in 688, held it for 37 years, despite engagement in numerous local battles. Or perhaps it was for Ingeld, his brother. The brothers, according to the *Chronicle* in 855, could trace their ancestry back through '*Noah, Lamech, Methuselah, Enoch, Jared, Mahaleel, Cainan, Enos, Seth, Adam the first man who is Christ. Amen.*'

Old? Well, you can't argue with that.

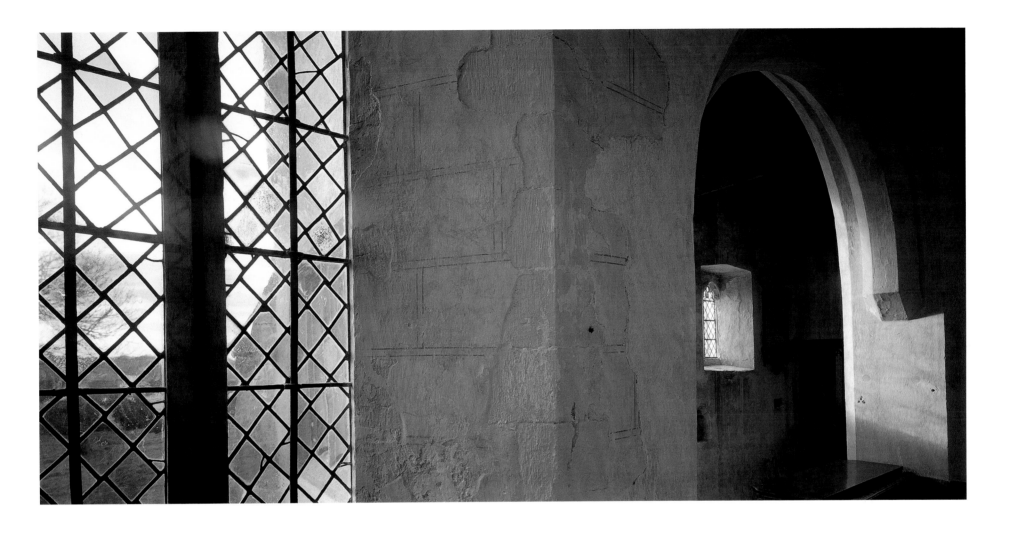

Thanks largely to William Morris, the layers of history are preserved
intact in the church of St John the Baptist in Inglesham.

In early September, 1815, the foundations of perhaps three literary works were laid on a river journey terminating at Lechlade.

Rowing up from Windsor were the poet Shelley, his mistress Mary Godwin, her stepbrother Charles Clairmont and the novelist Thomas Love Peacock. The purpose of the ten-day expedition was to discover the source of the Thames, but somewhere around this point the ever mercurial Shelley conceived the notion of diverting to the Severn Canal and thence on a 2,000-mile return voyage which would encompass Wales, Durham and the Lakes, the Tweed and the Forth. But the epic journey was not to be, the four between them being unable to muster the Severn Canal sailing fee of twenty pounds.

Neither was Plan A realizable. The journey to the source had to be curtailed shortly after Inglesham, when the river became so clogged with weeds that the local cattle grazed across the river bed. So Plan C was adopted, and they returned downstream to Lechlade.

The Swan, the oldest pub in the town, still has friendly staff and fine home-made food at sensible pub prices, despite today's sign proclaiming it to be the Oldest Public House in Lechlade, which proclamation is usually enough to make any sensible person scarper. Our travellers spent a leisurely few days here and the path between the river and the church (pure fifteenth-century Perpendicular) is called 'Shelley's Walk'. It was long enough for Shelley to write the surprisingly non-polemical 'A Summer Evening Churchyard':

> *The wind has swept from the wide atmosphere*
> *Each vapour that obscured the sunset's ray;*
> *And pallid Evening twines its beaming hair*
> *In duskier braids about the languid eyes of Day:*
> *Silence and Twilight, unbeloved of men,*
> *Creep hand in hand from yon obscurest glen.*

And the following summer, during a sojourn with Byron in Switzerland, Mary was to write: *'I saw the pale student of unhallowed arts kneeling beside the thing he had put together…'*. Was the student Frankenstein based on the student Shelley? On the way upstream, the party had stopped off at Oxford to be shown around his old college by the poet. Shelley, obsessed always by the weird and the macabre, regaled them with tales of his nefarious scientific experiments there. His friend Thomas Jefferson Hogg (expelled along with Shelley) was to describe Shelley as *'the chemist in his laboratory, the alchemist in his study, the wizard in his cave'* and his interests as *'horror books, alchemy, ghost-raising, chemical and electrical experiments…'*.

But to my mind the best outcome of the journey was Peacock's hilarious novel *Crotchet Castle*. Crotchet Junior determines to fit out a

> *flotilla of pleasure boats, with spacious cabins and a good cellar to carry a choice philosophical party up the Thames and Severn, into the Ellesmere Canal, where we shall be among the mountains of North Wales; which we may climb or not, as we think proper; but we will, at any rate, keep our floating hotel well provisioned and we will try to settle all the questions over which a shadow of doubt yet hangs in the world of philosophy.*

And so they do, in a fashion:

> *In this manner they glided over the face of the waters, discussing every thing and settling nothing. Mr Mac Quedy and the Reverend Doctor Folliott had many digladiations on political economy: wherein each in his own view, Doctor Folliott demolished Mr Mac Quedy's science, and Mr Mac Quedy demolished Doctor Folliott's objections…*

Afloat with his best friends in the world, discoursing dreamily on the waterways of the world and far from critic and creditor, this was probably the happiest journey of Shelley's life.

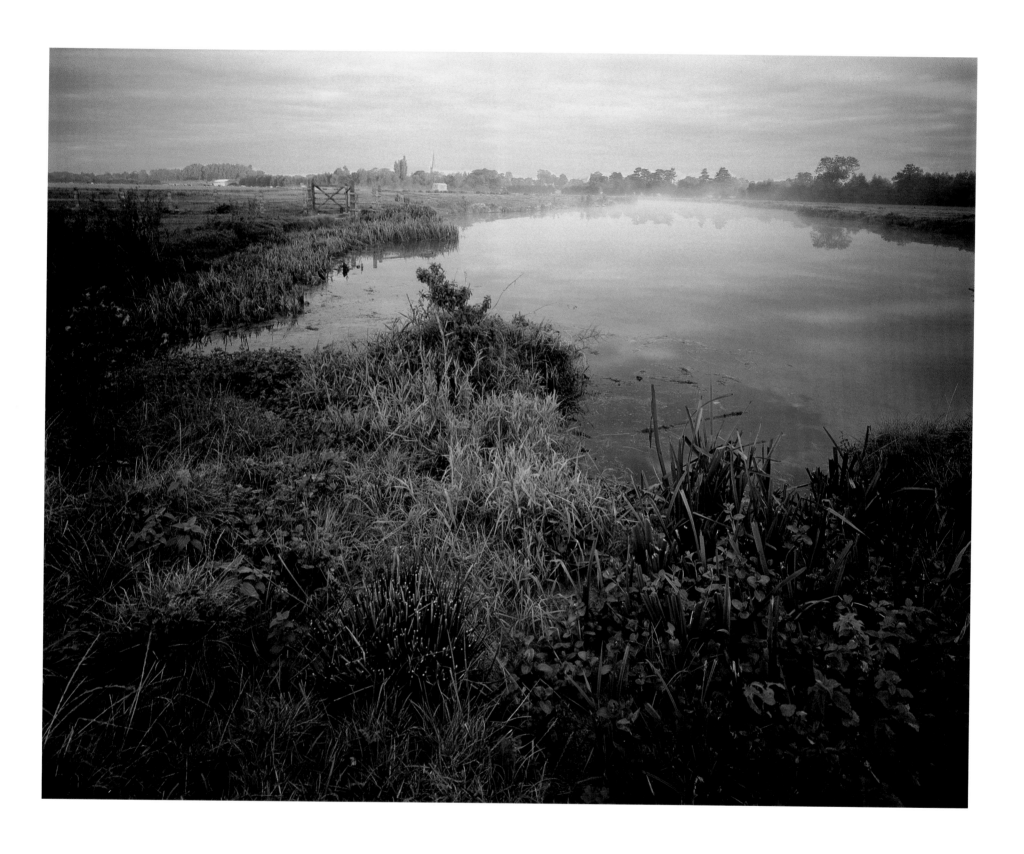

Looking upriver towards St John's Bridge, early morning mist slowly rises
to reveal the spire of Lechlade's fifteenth-century Perpendicular church.

The Trout Inn at St John's Bridge has been dispensing fine hospitality for about seven hundred years now, since about 1220 when the old wooden bridge was replaced by a stone one and the workmen were granted accommodation in the almshouse in the local priory, built by a certain Peter Fitzherbert and dedicated to St John the Baptist.

In 1471 Edward IV, *en route* to Tewkesbury, crossed the bridge here with his army, ready for battle with Margaret of Anjou, queen of Henry VI, and their son Edward, Prince of Wales. Strictly speaking, Edward was not king at this juncture, because his cousin Henry was imprisoned in the tower. Pope Pius II pronounced Henry *'a man more timorous than a woman utterly devoid of wit or spirit, who left everything in his wife's hands'.*

But what hands! The powerful Margaret, married to Henry at fifteen, kept the kingdom going through several insurrections by Richard of York, Edward's father, throughout her husband's reign. In fact, Richard may have had a stronger claim, but he had little support and was never to see his son crowned Edward IV. Henry VI was, after all, the son of the great Henry V and as such, inheriting the throne as a baby, was widely loved by the people.

Henry VI grew up pious, gentle, and possibly a little feeble-minded. He dressed unfashionably, in rough robes and clumsy shoes and never pursued the claim to France so hard pressed by his father. 'Peace at any price' could have been his motto and on his capture by his cousin Edward he was paraded through the streets to the Tower, his feet tied to the stirrups, a straw hat on his head like a rustic fool.

Bookish, sickly and shabby, Henry may have inherited a mental instability from his mother, Catharine. She was the daughter of Charles VI of France, and the Dauphin's sister. The Dauphin, as portrayed by Shakespeare, was the one who sent the tennis balls to Henry V and Catharine was the maiden so touchingly wooed by England's Henry after the victory at Agincourt.

But clearly, the saintly presence of Henry VI was something of an embarrassment after Tewkesbury and although it *may* have been shock that killed him it would have been quite extraordinarily convenient if it were so.

After her defeat in 1471, Margaret had the misfortune to see her son Edward – the rightful heir, if you discount the Yorkists – murdered and she was imprisoned, first in the Tower, then at Windsor and finally at Wallingford. After five years' confinement she was ransomed by her father (the beloved *Le bon roi Rene*) for 50,000 golden crowns, to raise which he sold *'the kingdomes of Naples and both the Sicils withe the Countie of Provence'* to Louis XI. She died in France in 1482.

In fact, the Battle of Tewkesbury and the subsequent murder conveniently rid Edward of no fewer than four men who claimed to be Henry's heir – and it would seem that all four of them were right. The Duke of Gloucester certainly believed so, and he it was who pronounced the death sentence on the Duke of Somerset after the battle. It was also rumoured that he personally despatched the rightful king, Henry, in the Tower. But then, the good duke has always had a bad press – especially since he reputedly later despatched his two nephews, Edward's sons. We remember him, for better or worse, as Richard III. The terribly sad thing about these so-called Wars of the Roses is that it was all between cousins. Power corrupts indeed.

In 1472, the foundation was dissolved by Edward, and the 'priory' which may be still marked on your map is now a caravan park. But the almshouse continued as the inn 'Ye Sygne of St John Baptist Head' and the ancient fishery rights granted to the brethren were still held there. They are still, although since 1704 'Ye Sygne of St John Baptist Head' has, very sensibly, been the Trout Inn.

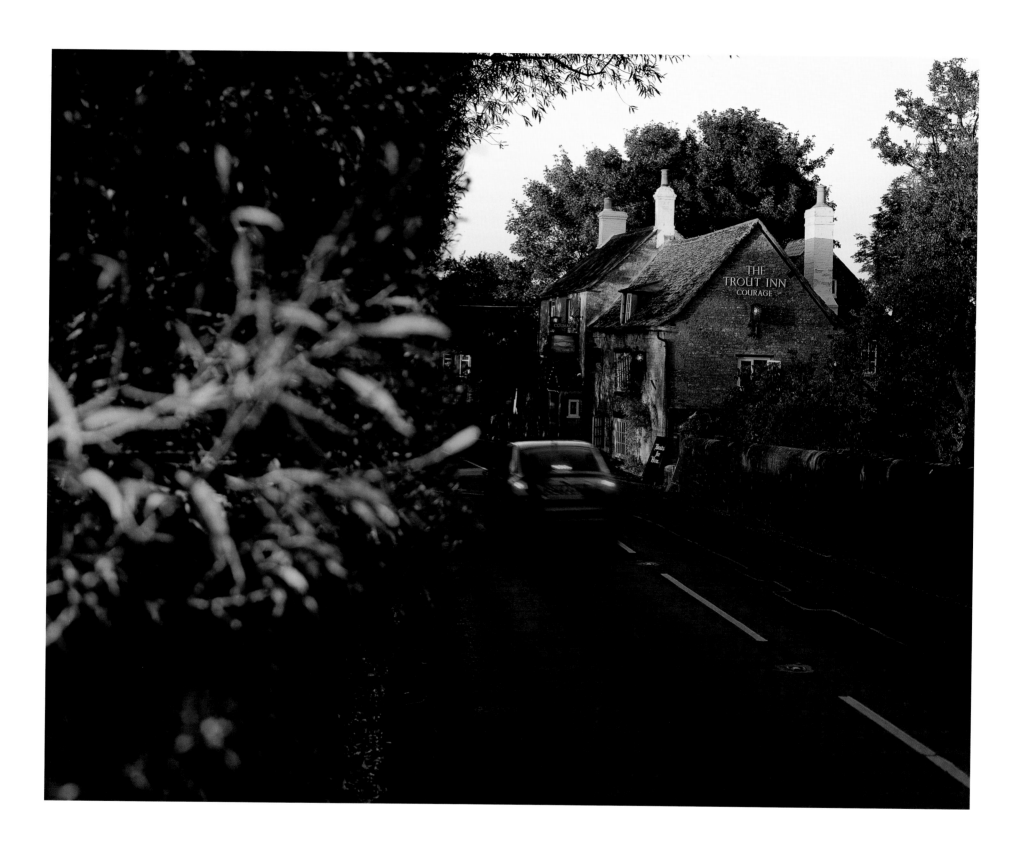

After 700 years, The Trout Inn at St John's Bridge, Lechlade,
is still dispensing real ale, fine food and good music.

The National Trust notice at the delightful Thames-side picnic and fishing spot proclaims it to be Cheese Wharf. 'Cheese?' you may ask, 'Wharf?' Well, yes. From the end of the seventeenth to the beginning of the nineteenth century the cargo shipped annually from this spot and from Buscot Wharf, just 250 yards inland from here, included 2,000–3,000 tons of cheese.

The name itself is a useful reminder of the fact that the Thames has a long history as a working river. For centuries barges plied between here and London, picking up and unloading cargo all along the way: stone, bricks, timber, lead, cheese, flour, meat, wool and hides. And, intermittently, finished clothing. The English cloth trade goes back at least as far as 796 when the first trade treaty in English history was signed between Charlemagne and the great King Offa. Letters from Offa to Charlemagne request that 'black stones' be cut to a specified length and letters from Charlemagne to Offa pass on complaints regarding English-made cloaks and request that in future they should likewise be of a more appropriate length. Kingship was a very hands-on affair in those days.

But fashion is by its very nature the most capricious of industries. English clothing fell out of fashion and for a period up until the fourteenth century the export of fleeces to manufacturers in the Low Countries prevailed until Queen Philippa of Hainault, wife of Edward III, brought clothworkers from her native low countries to train the English clothmakers in current trends. From 1334 to 1515 village clothmaking brought growing prosperity to the Cotswolds .

The journey to London was never easy, with continuous animosity between navigators, millers and fish traders regarding use of the water. While weirs made the catching of fish easier and the drawing off of water was essential for the working of the numerous watermills along the river, they made navigation extremely hazardous.

At one point Richard II decreed that all fish weirs should be removed from the river, designated as it was the 'King's Highway' but Richard was never able to command the respect his grandparents Edward and Philippa had done, and the law proved unenforceable. Some sort of compromise was reached with the introduction of flash locks, a part of which could be lifted to enable boats to pass through in the ensuing rush of water. But then, of course, the local miller might have to wait several days until sufficient head had built up again to drive his mill wheel. And this would only work going downstream: coming upstream the craft would have to be manhandled up against the current.

It was Leonardo da Vinci (1452–1519) who designed the first pound (as in enclosure) lock, although the system did not gain wide acceptance in England until the eighteenth century, the age of canals. And here I pause for reflection, as I tend to do when the subject of canals is raised. The reason is this: at the beginning of the twentieth century, Great Britain had a system of internal transport which was the envy of the world. It was based on an unsurpassed network of railways and canals. And if only the catchword of the century had been cooperation rather than competition, then there would perhaps have been no question of rail superseding water and being, in turn, superseded by road.

From here to London the journey by barge would probably take five days and, depending on the cargo, could require anything between one and fourteen horses. Cargo coming upstream from London, largely waste products such as ashes, rags and horse manure, would probably take eight days. Costs would include lock tolls, wages for bargemen and haulage fees. Sometimes, too, a towpath toll was demanded by riparian landowners.

No, it wasn't all beer and skittles, but cycling – or motoring – along Britain's highways, you have to admit that the system has a certain appeal.

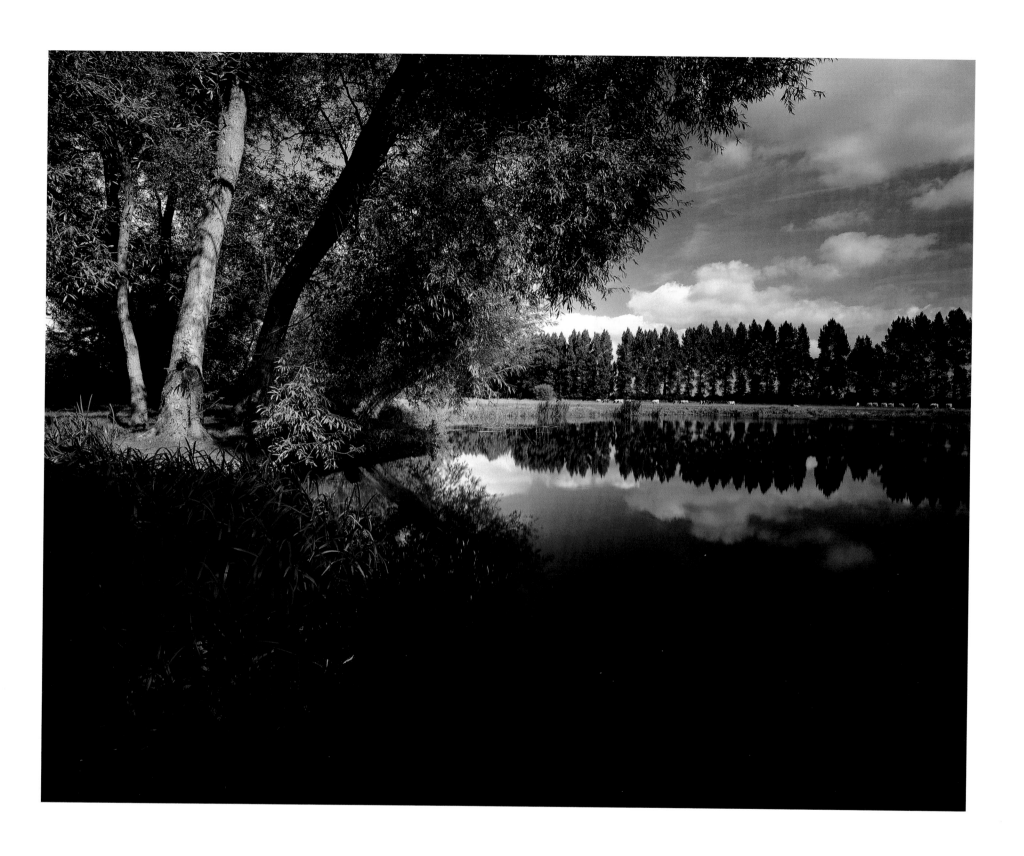

The Thames makes its most spectacular meander near Buscot where
Cheese Wharf was built to cater for a thriving river trade.

During the period 13 February to 13 April 1306, in the reign of the formidable Edward I ('Longshanks' or 'Hammer of the Scots' depending on your view of him), the fields hereabouts were frozen into just such a state of immobility as today by continuous frost. For two solid months it might have looked much like this, with a pale sun glinting on a frosted horizon, branches from the black stick-trees beached randomly on the ice of the river and, underfoot, earth of such unforgiving rigidity that you might wonder if ever green shoots would venture forth again.

Life is easier today. You, too, could wake on a New Year's Day in Lock Cottage at Buscot and wonder if you have died of cold in the night and then look out from the window of the tiny dwelling at the gulls wheeling hopefully over the weir and think well, yes, maybe I have and this is heaven.

The National Trust owns several properties on the Thames for holiday lets, and the old lock keeper's cottage at Buscot is the farthest upriver. Which means that you, too, in venturing outside to take stock of your temporary home could be accosted by a trio of ducks: a pair of mallards with their white hybrid companion, whose needs are simple – just a spare crust of bread. Each, please. And perhaps a bit earlier tomorrow *if* it's not too much to ask.

Squire Loveden, the lord of the manor at the time Lock Cottage was built in the eighteenth century, was a man with his eye on the main chance. Apart from making sure the lock keeper was kept busy collecting tolls both up and down the river (accepted practice was one way only) the lock keeper at Buscot had, in his spare time, to tend the squire's fish business. For his dwelling doubled as a 'fish stew' i.e. there were fish ponds under the house, fed by the river which surrounded it on three sides.

The lock keeper is on duty this New Year's Day but there are no customers. Water is frozen below the lock – some petrified into streamers, some into decorative clusters of tiny balls like fish eggs. Walking across frozen fields, you are startled by the odd pistol shot of ice cracking under the pressure from the still flowing water and delighted by the electric-blue flash of a kingfisher, the unexpected encounter with a grey wagtail (which is predominantly yellow) and its companion the white-bibbed dipper.

The area hereabouts has long been rich in those visionary eccentrics that make life worth living. Buscot Village was built by one such: Squire Campbell from Australia who in 1879 also built the waterwheel which was situated in the millstream near Lock Cottage. The wheel supplied water to the village tenants as well as irrigating the squire's land and in his determination to introduce modern farming methods in order to produce sugar beet for alcohol Campbell virtually bankrupted himself. He also decided with incredible audacity to produce brandy for export to France and used Buscot Wharf for the purpose. Perhaps he was just trying to cash in on the local market – one lock keeper at Eaton Weir in the 1830s was well known (in a hush-hush sort of way) for smuggling spirits which came up-stream by water and were stored in barrels secured by long chains at the bottom of the river. Buscot 'Wharf' is now well inland from the river, but it is easy to imagine from the numbers of 'leats' or ditches hereabouts that the area was once criss-crossed with natural and man-made waterways.

Eventually Campbell sold out to Lord Faringdon, an art connoisseur. Rather than the production of brandy, Faringdon House is known today for the Faringdon Collection (Rembrandt, Murillo, Reynolds and the 'Briar Rose' series by Burne Jones). Approached by path from the riverside, the house, with grounds complete with three lakes landscaped by Peto, is open on summer afternoons only. Rats.

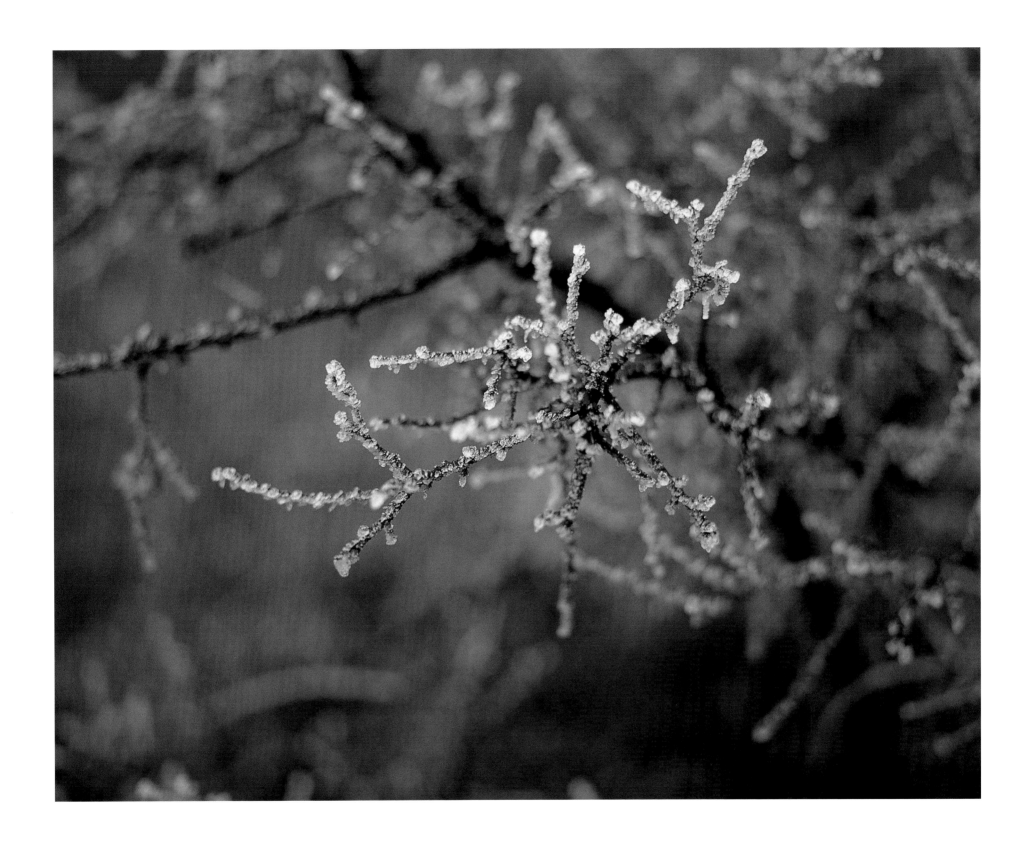

The rare and beautiful sight of hoar frost at Buscot: frozen water
vapour from the air is deposited on vegetation to spectacular effect.

The Plough Inn at Kelmscott dates from 1690 and the Church of St George from the eleventh century, but Kelmscott today, of course, is chiefly associated with William Morris who, as soon as he saw the 'manor' house of Kelmscott (manor is a courtesy title only – Kelmscott actually belongs to the manor of Broadwell) had a sense of immense strength and of coming home.

What a man he was: craftsman, writer, social reformer and printer. A lover of the Middle Ages, at Oxford Morris came into contact with the Pre-Raphaelite Brotherhood. From Oxford, he started out as writer of poetry and a painter, but became absorbed in 'art for use' – domestic architecture and decoration. He despised the shoddy products of the modern age, believing the soulless machine could never emulate craftsmanship. In the belief that man's work has an inherent sanctity, in 1861 he founded Morris and Co. which revived the handicrafts of a pre-industrial age, whose products were simple and fit for the purpose: *'made by the people and for the people, as a happiness to the maker and the user'.*

The company produced carvings, wallpapers, carpets and furniture which confirmed Morris as the tastemaker of his era and which are still admired today as incomparable in their field. Morris and Co. also produced some of the most stunning stained glass of the Victorian era – some fine examples of which (by Burne-Jones) are to be found in the church of Eaton Hastings, across the river from Kelmscott. In the early Kelmscott days, Rossetti shared the lease with Morris, and it was Rossetti who persuaded Burne-Jones to abandon the idea of entering the church and instead to devote his life to art. He agreed, perhaps because art is like God: a deep human need, and sometimes the longing for one becomes confused with the other.

In 1877 Morris founded the Society for the Protection of Ancient Buildings as a counter to the enthusiasm for 'restoration' of historic churches. In his manifesto he explains:

The civilized world of the nineteenth century has no style of its own amidst its wide knowledge of the styles of other centuries. From this lack and this gain arose in men's minds the strange idea of the restoration of ancient buildings; and a strange and most fatal idea, which by its very name implies that it is possible to strip from a building this, that and the other part of its history, of its life that is, and then to stay the hand at some arbitrary point and leave it still historical, still living and even as it once was.

Morris's belief in beauty and excellence encompassed not only artefacts but also society. As an early Fabian socialist, he wrote *The Dream of John Ball* (1886–87) and *News from Nowhere* (1890), in which he argued for the replacement of machines by skilled labour. *News from Nowhere* was about Kelmscott, and while he wrote he repaired his house according to his precepts: every nail was made by the local smith, local quarries provided stone for the window frames and local elms the timber for roof and dado. And meanwhile he and his friends painted, carved, sculpted and discussed socialism – the socialism where the best was for everybody rather than the socialism which involves bringing everybody down to the lowest common denominator. But I'll get off my soapbox now.

It could be argued, of course, that Morris's emphasis on the small and hand-made may have led into a bit of a backwater, as it was Art Nouveau (which was itself much influenced by him) that emerged as the main gift of the late nineteenth century. If machine cannot emulate the work of man, and machines are what the modern world is all about, then why not see what a machine can do and cut our coat according to our cloth? But Morris understood what a lot of our century does not – the relationship of man with the earth and his responsibilities toward the planet and his fellow man. The essence of living simply, in tune with nature. To the student of design Morris is surely what Bach is to the student of music.

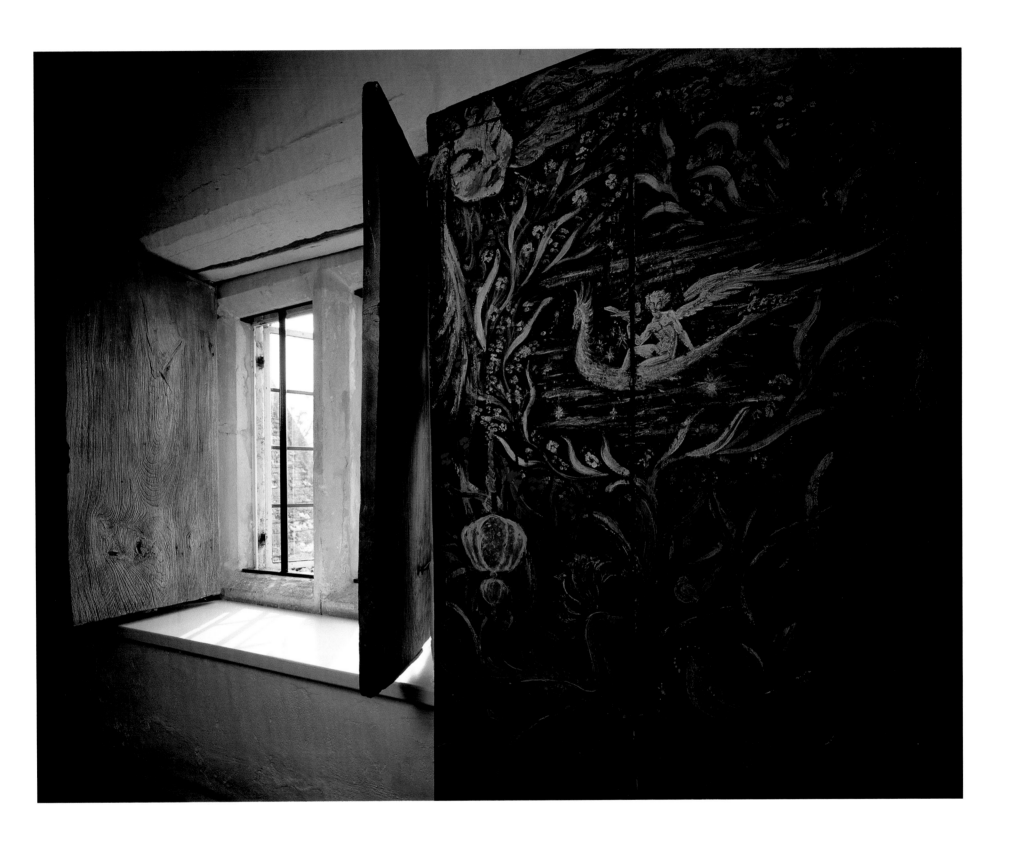

Dante Gabriel Rossetti painted this fairy-tale design hanging in Kelmscott
Manor on the door to the sick-room of William Morris's daughter.

Despite the fact that one third or more of the population of fourteenth century England was annihilated by plague, there was a tremendous flurry of building royal and ecclesiastical establishments along the river, and Edward III in 1362 commissioned William Coke of Wheatley to provide stone for Windsor Castle from the Oxfordshire quarries of Wheatley and Taynton 'by both land and water'. The stone was brought overland by carts to Radcot and despatched thence by barge down the river.

The three-arched bridge at Radcot is thought to be the oldest on the Thames, probably dating from 1280 in the reign of Edward I, although on a second look it becomes apparent that the middle arch of the row of little pointed arches is not pointed. Nor has it been for some 600 years. In 1387, in a semi-treasonable action, the Lords Appellant blocked the crossing of the Thames at Radcot to Richard II's favourite, Robert de Vere. Richard's cousin Henry Bolingbroke, later Henry IV, had the bridge blown up. De Vere jumped from the bridge into the river, and despite being clad in full armour, managed to escape to his estates in Ireland.

It is likely that the Appellants meant to depose Richard, but the attempt at insurrection was pretty half-hearted. There might have been more commitment had they been in agreement as to a successor but there were too many counter-claimants, none of whom wanted to look too pushy. And none of whom, in fact, had any right to the throne. Richard, son of Edward III's eldest son, the Black Prince, and his wife Joan, the Fair Maid of Kent, came to the throne at the age of ten. His natural successor, in the event of his dying without issue, should have been Roger Mortimer, descended through Edward III's second son, Lionel Duke of Clarence.

It is small wonder that Richard loved Robert de Vere. He had little enough affection in his life, being taken from his mother on the death of his grandfather and emotionally torn between the two uncles appointed his guardians, who both eventually adjudged him unfit material for kingship. Richard himself had no such doubts, having, while still a boy, twice seen off insurgent peasants in London.

But the 'Merciless Parliament' of 1388 despatched all of Richard II's friends, after which the frustrated Richard employed his devious nature to advantage. The Lords Appellant were tricked into attending a banquet, from whence Warwick was despatched to the Tower. Gloucester, declining the invitation, was fetched by Richard himself, then shipped off to Calais and 'secretly despatched'. Bolingbroke and Mowbray were exiled. On John of Gaunt's death, Richard confiscated his property, leading to the return of his son, the ireful Henry Bolingbroke, and the inevitable insurrection.

As Henry IV, Bolingbroke confined Richard to Pontefract where he was probably starved to death aged 33:

> *I live with bread, like you; feel want*
> *Take grief, need friends. Subjected thus,*
> *How can you say to me I am a king?*

But Henry required that his body could be shown to the people, intact and unmutilated, thus proving he died a 'natural' death.

He never had much joy from Richard's throne. He was continually harried by the Scots under the Earl of Douglas, the Percys ('Hotspur' and his father the Earl of Northumberland) and the Welsh under Owen Glendower, bent on restoring the descendants of Richard's designated heir. The last years of his reign were spent suffering from an illness long believed to be leprosy, which he saw as divine retribution for Richard's death. On his deathbed, Shakespeare's Henry passes the crown to his son:

> *How I came by the crown O God forgive*
> *And grant it may with thee in true peace live.*

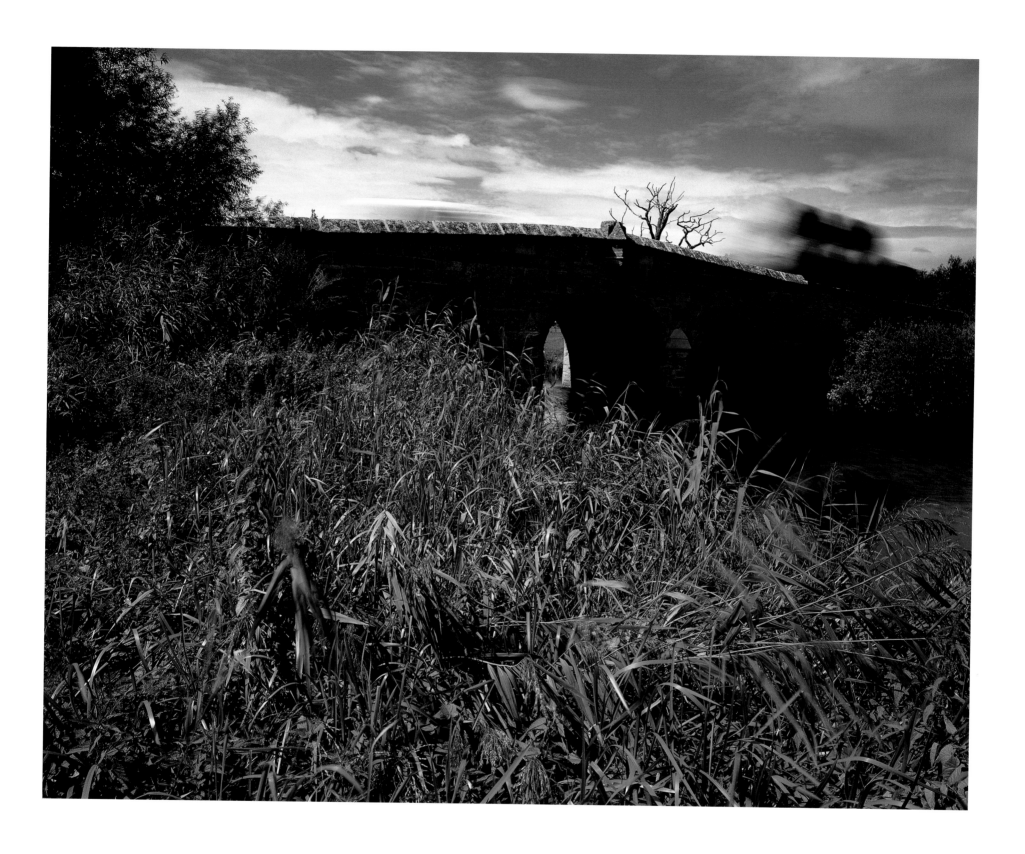

Probably the oldest bridge on the Thames, in 1387 Radcot was the scene of bitter fighting between the followers of Richard II and Henry IV.

William Morris and I disagree on few points, but one of them is the railway. Despite his conviction that trains were a harbinger of disaster, the fact that much of the upper Thames is not approachable by rail means that occasionally I have to swallow my principles and hire a car. I think he might have changed his mind given today's choices.

My friendly local car hire company doesn't have a cycle rack, but they do, as it happens, have a folding bike available which has never yet been used. It won't get punctures, either, because the tyres are foam-filled. Trustingly, I take it; but once off the surfaced track, this so-called 'mountain' bike shows its true worth. About a hundred gears and none of them the right one. Walking would be faster and easier. The solid tyres render the steering incredibly difficult and before I have crossed one field I am longing for my sturdy Hercules. Take it from me, there is nothing to compare with a solid bike with three-speed Sturmey Archer gears.

Tadpole Bridge was built in tandem with the Thames and Severn Canal, when the water depth had to be increased to the 3 feet, 6 inches required by the barges. Not a lot, but enough to render the existing Tadpole Ford unuseable.

You forget, don't you, the human pace of life? Approaching Tadpole I see a young couple with a dog and two piebald horses. One of the horses is pulling a cart, with the young woman aboard. The man walks beside the other horse which pulls a caravan: round, the shape and style of a prairie wagon. They make a timelessly handsome couple. She with her old green sweater and short dark hair, he with long golden hair, dreadlocked, and dungarees. The girl smiles but then the traffic light on the bridge changes to green and suddenly the man cries 'Gyp! Get up boy!' and the dog races ahead, up and over the hump of the bridge, the horses break from their leisurely amble into a clattering canter, up and over. And they have gone. I gaze after them, dazed. This is how Toad felt before he decided to go for the motor car. And then I retreat into the Trout Inn to take stock.

Late October and it is still warm enough to eat outside, where rosehips twine through late creamy blooms and snowy pampas grass waves gently against a sky the blue of Australian opal. The landlord looks genuinely pleased to see me, which is the first sign of a good pub, and there is a fine selection of real ales, which is the second.

Rushey Weir is an old fashioned sort of weir, with a huge number of great wooden paddles standing by ready to regulate the flow as required. The water sprays out in a great fan and then falls in lacy patterns like Cinderella's ballgown. The lock keeper is having trouble with his chainsaw and I pass by discreetly with what I judge to be just the right amount of sympathy. It has never been my habit to mess with a fellow having trouble with a chainsaw.

The rushes seen in abundance in this part of the Thames have had a multitude of uses for many generations, including the weaving of mats, chair seats and baskets and the making of fine paper. And wouldn't it be wonderful to find a country pub that still spread its floors with rushes? They used to be strewn in great halls and in churches, over earthen or stone flagging, and must have been warm and fragrant, mixed with meadowsweet and sweet-flag. A bit like herbal teabags, perhaps. Having seen service as a floor covering, they could be chopped up for garden mulch.

Rush lights were vastly preferred by William Cobbett to candles. Rush lighting is apparently brilliant and clean, especially with the addition of beeswax. It was for many years the basic source of illumination in the country cottages hereabouts. The lights were made by stripping the outside skin of the stem until just one long rib was left to keep the pith together. Then, having being left outside to dry for some days, they were dipped in scalding mutton or bacon grease. I'm not entirely sure about the smell of mutton or bacon grease, but Cobbett's word is good enough for me.

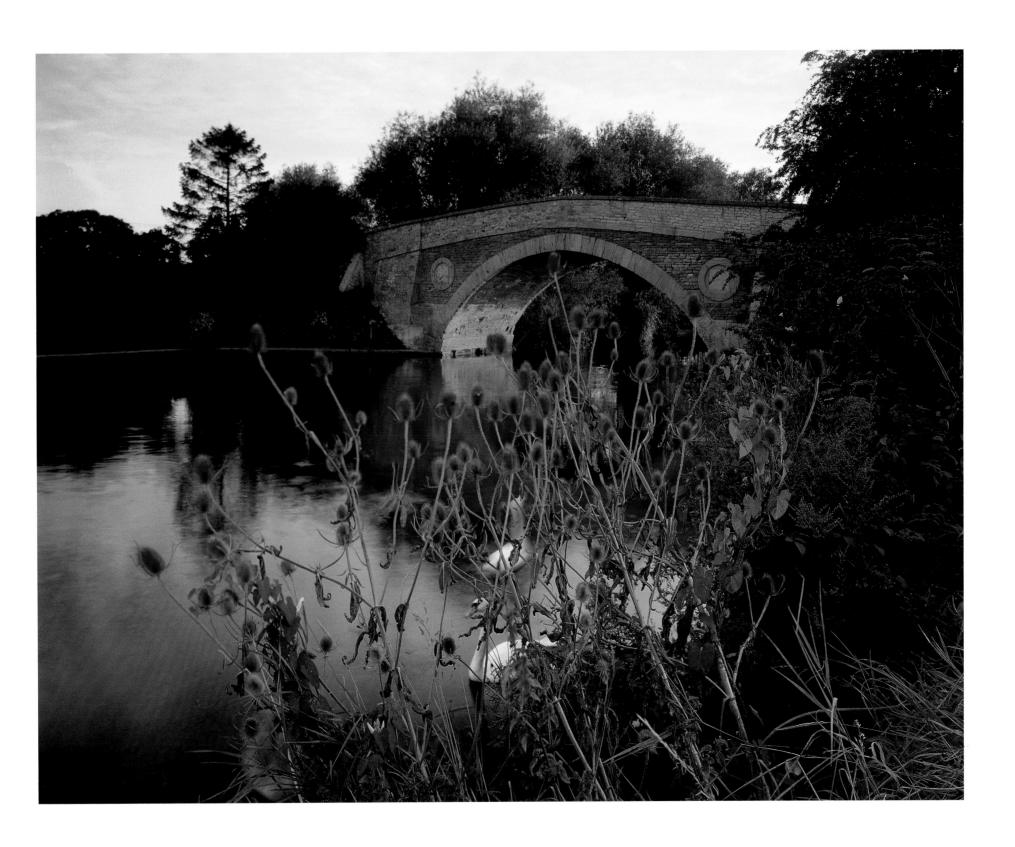

Late afternoon sun highlights detail on the eighteenth-century stone bridge
at Tadpole, which spans what is now the most remote stretch of the river.

Unless you are walking the length of the Thames Path or making a special journey by car, Stanton Harcourt is not easy to reach. But it is worth the effort. From the river, the bridle path to the village is about halfway between Bablock Hythe (famous for Matthew Arnold's 'Scholar Gypsy' but now largely a caravan site) and Newbridge, arguably the oldest bridge on the river. The argument is with Radcot.

Along the riverside kingfishers and dragonflies skim the river surface, and the declining reed bunting is, I hope, still nesting as is the yellow hammer in the open country beyond. Little brown heads poke up from the long wet grass on our approach and as we near they take to the water. Pink-footed geese, I say with authority, but my rather more expert daughter disagrees. Greylag, she says and it seems churlish to insist. Pink-footed geese are winter visitors, she tells me, and the heads were not as dark brown as I thought. But I know what I saw. I think.

Beside the bridle path is a summer froth of creamy elderflower interspersed with sprays of palest-pink dog rose, deep-pink sweet briar and the occasional pure white rosette of guelder. This is a truly beautiful walk and one probably frequently undertaken by Alexander Pope. Pope's friend Sir Simon Harcourt invited him to use the family property at Stanton Harcourt whilst working on his translation of Homer's *Iliad*, which was published in 1715. Pope spent several summers here: working first on the *Iliad* and five years later on the *Odyssey*. He wrote: '*Indeed I owe this old house the same sort of gratitude we do an old friend, that harbours us in his declining condition, nay even in his last extremities…*'

Even when Pope stayed here the old manor house was in ruins. The Harcourts had built the manor in the fifteenth century, but when Pope lived here the Harcourts were no longer in residence, having moved the family seat to Nuneham Courtenay, where they had their grounds landscaped by Capability Brown. Pope found its solitude an ideal place for retirement and study but the Harcourts were teased by Oliver Goldsmith in his *Deserted Village* for the wholescale removal of the local populace who spoiled the view at their new seat:

> *Vain transitory splendours! Could not all*
> *Reprieve the tottering mansion from its fall!*
> *Obscure it sinks, nor shall it more impart*
> *An hour's importance to the poor man's heart*

Still surviving is the church, containing some beautiful family monuments and the oldest (thirteenth-century) rood screen in the country. From the manor house survives the medieval kitchen with its conical roof, designed to let the smoke escape, and what is now called Pope's tower, where the poet lived and worked. Writing to his friend Lady Mary Wortley Montague in 1718 Pope mused on decay:

> *And yet, must one not sigh to reflect, that the most authentic record of so ancient a family should lye at the mercy of ev'ry boy that throws a stone? In this Hall, in former days have dined Garterd Knights and Courtly Dames, with Ushers, Sewers, and Seneschalls; and yet it was but tother night that an Owl flew in hither, and mistook it for a Barn… All this upper story has for many years had no other Inhabitants than certain rats, whose very Age renders them worthy of this venerable mansion, for the very Rats of this ancient Seat are gray. Since these have not yet quitted it, we hope at least this House may stand during the small remainder of days these poor animals have to live, who are now too infirm to move to another. They have still a small Subsistence left them, in the few remaining Books of the Library.*

To précis Pope's prose is a thankless task. Even there, he writes as a poet, with no word superfluous. The master of the heroic couplet, wherever you look you see something memorable – and something it is possible to remember. Or, as Johnson said: '*If Pope be not a poet, where is poetry to be found?*'

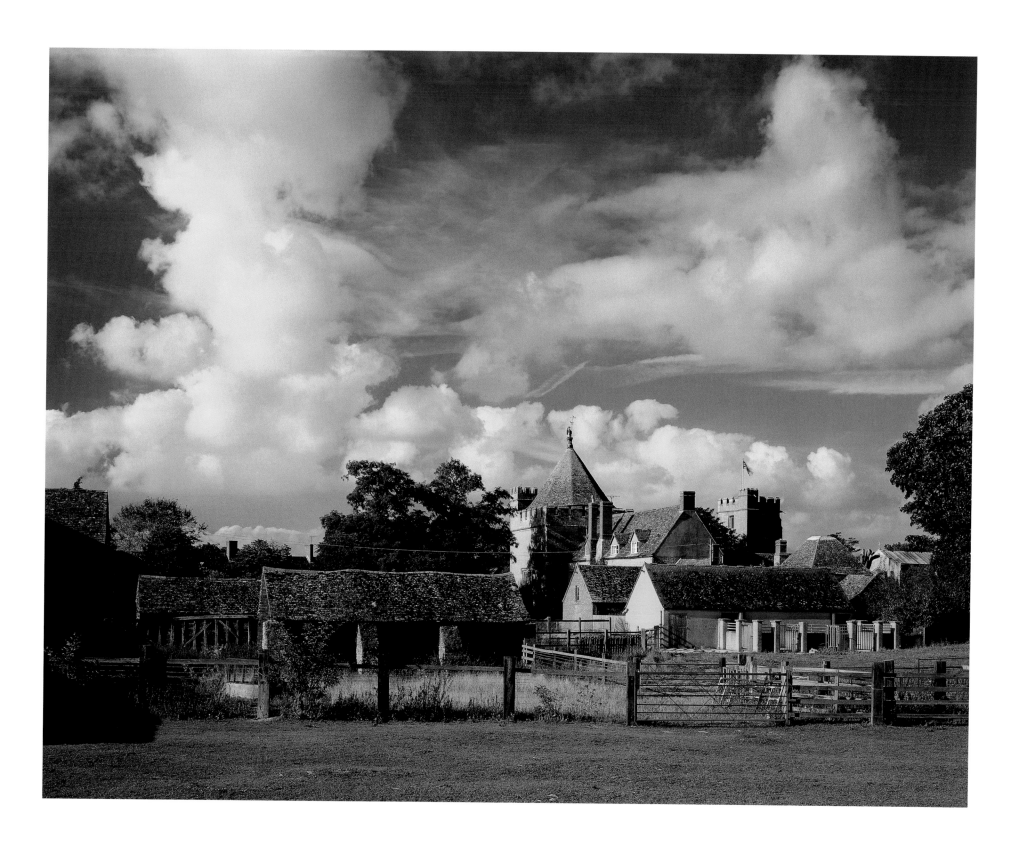

Pope's Tower at Stanton Harcourt is named after Alexander Pope,
who stayed here while working on his translation of Homer's *Iliad*.

The bridge at Swinford on the A4040 is currently owned by Mr Michael Hawley, and you will be required by him to pay the small matter of 5p in order to cross one of the few remaining toll bridges in England. Not by Mr Hawley personally, but by the bridge managers, David and Sue Jackson, who have been here since David was made redundant from Fareham Council years ago, and who have never been happier.

There has been a toll crossing at Swinford for close on a thousand years. Originally, as the name suggests, there was just a ford. For pigs, presumably, so the toll of a mere 2p in order to cross in style would have been a small price for the more elegant traveller to pay. The present delightfully balustraded bridge was built in 1767, by the Earl of Abingdon, and even then, apparently, only because King George III travelling at a time when the river was in flood, almost came to grief here. The fourth Earl was reluctant, pleading poverty.

'Nonsense!' cried good Farmer George, 'Charge tuppence a vehicle to cross and it will pay for itself!'

And 2p remained the price until 1994. Even then, the increase to 5p was granted only after lengthy debate and a special Act of Parliament, and is strictly to pay for necessary repairs over the next twelve years. After which the price will supposedly revert to 2p. Or so I am told.

The first vehicle over the new bridge in 1767 was a water wagon, bringing fresh drinking water to the residents of Eynsham. Why, you may ask? An outbreak of plague, perhaps? The official records do not talk about reasons, only numbers. In 1785 there were about five stage coaches a week crossing the river here and the present traffic is something like 3 million vehicles a year.

Conducting a formal interview with David is fraught with interruption. It is rush hour, and as I perch on my bike at the roadside wall firing questions, David collects tolls from intervening motorists. Archers devotees have latterly been making pilgrimages to Eynsham, as the village where the late and much loved Mollie Harris ('Martha') lived most of her life. Her last book *The Stripling*

Thames, with watercolour and line illustrations by local artist Gary Woodley, is a personal record of her journeying in all weathers along the upper reaches of the river.

The remains of a thirteenth-century abbey and a twenty-foot-high medieval cross testify to Eynsham's significance in the past, but it is now chiefly important as an up-market commuter town for those involved in keeping the twenty-two historic colleges of Oxford flourishing.

I think David and Sue Jackson must have one of the most enviable jobs on the Thames in their eighteenth-century cottage with walls four feet thick. Until I meet Adrian, the duty lock keeper, mowing the grass and oiling the gates at Eynsham Lock.

Adrian used to be a bank manager until 1988 when he finally admitted to himself that banking had changed. He did not want to be a salesman and could no longer face the stress of setting and achieving targets and trying to sell pensions and financial packages to customers who just wanted a bank.

He is not too concerned about the harmful effects of tourism. 'I see my job as helping people to have a nice time,' he says. 'I don't want to make them feel silly because they can't handle the steering gear very well. And I don't want to come down heavy on them about what they can and can't do. They've paid a lot of money for their holiday. I want to help them make the most of it.'

So do I. So I thumb a lift with Ron, Leslie, Fred and Chas who are taking their annual holiday together. They are experienced lock-users, having been taking boating holidays for the past twenty years. They have hired a ten-berth narrow boat.

'Because we all snore,' says Ron with an honesty disarming enough for me to admit that I do too. 'Anyway,' he says, 'you have to have enough room to spread out during the day.'

How right he is. Narrow boat hire companies, like any concern, are naturally intent on maximizing profits, and anyone considering a canal or river holiday would be well advised to take with a pinch of salt claims about how many a vessel 'sleeps'. There is more to life afloat then sleeping.

I am treated to a cup of tea up for'ard where Leslie wants to know what my angle on the river is. Bother this angle. 'Probably historical.' I say tentatively. Leslie mentions his interest in Lawrence of Arabia and then he, Chas and I have to spend some time working out which war it was in which the great man featured. 'I wish I hadn't mentioned it now,' says Leslie sadly.

The threat of rain is still in the air, and the river this evening is teal coloured. Beside Wytham (pronounced white ham) Great Wood the may trees and the abundant riverside Queen Anne's lace (cow parsley sounds less romantic) fill the bank with a froth of white.

A heron stands motionless, intent on supper, a grebe poses thoughtfully, and swallows and martins dart ceaselessly hither, thither and yon, and you can't help hoping that they find somewhere to nest soon and have some babies just so they can let up for a bit. Living on the wing must be absolutely exhausting.

There is a field station here for Oxford University, and researchers keep an eye out for creatures such as the red blooded *Planorbis acronicus*, a rare species of ram's horn or trumpet snail.

Our huge craft is expertly steered into Godstow Lock by Fred and I jump ship, having exchanged names and addresses and promised to meet up at the book launch. 'If we find a publisher,' I hedge.

'You will,' says Chas. 'It's going to be great.'

I lift my bike over a stile and loiter over supper at the Perch, a seventeenth-century thatched inn, for so long that I have to make indecent haste along the tow path, over two hump backed bridges and past two startled students to make it to the station. I hoist my Hercules over my shoulder, hurtle up the stairs and along the platform to the guard's van and just make the last London train.

By Eynsham the river passes under Swinford Bridge, one of the few
remaining toll bridges (5p a car!) before passing through Eynsham Lock.

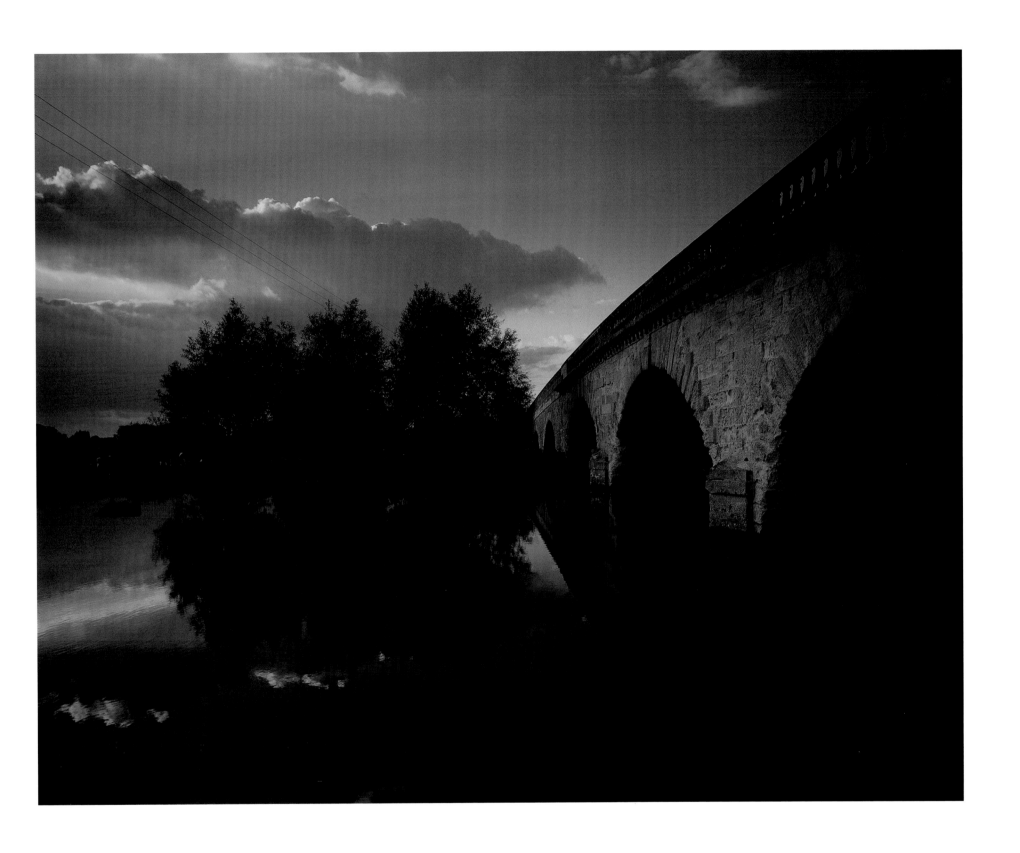

Between Godstow Lock and King's Weir lie the neat remains of what is variously described on walking maps as 'nunnery' or 'priory'.

Godstow Nunnery was built in 1138, during the troubled reign of King Stephen, and its nuns entrusted with the upbringing and education of numerous girls. Among them was little Rosamund Clifford, who would have been living here when Henry Fitz Empress, passed by aged just fourteen, intent on the capture of first Cricklade Castle, and then England.

Young Henry was not to gain the kingdom until seven years later, and then only by means of a treaty between Stephen and Matilda, rather than war. It is unlikely that little Rosamund even noticed his passing in 1147, and even if she had she would almost certainly have been too young to know what was happening.

Henry was to marry the glamorous Eleanor of Aquitaine, twelve years his senior, in 1153, the year before he ascended the English throne. No doubt for some time Henry, a down-to-earth, stocky young man of uncertain temper but with a good head for business (like his great-grandfather William the Conqueror), was beguiled by the chivalric court presided over by the worldly Eleanor. She was to bear Henry nine children, among whom were Kings Richard I and John of Magna Carta fame. But none of this will have concerned Rosamund until the King fell in love with her in 1168.

Courtly love was all very well, and Henry had long been known for his wandering eye, but this was something else. Henry built Rosamund a palace at Woodstock: a bower of love which gave the troubadours a field day but has since disappeared without trace. The fifty-year-old Eleanor, despatched to Poitiers, determined to sever her links with Henry and set up an independent court in the more attractive climate of her beloved France.

From Poitiers she was to aid and abet her three sons Richard, Geoffrey and John wherever she could in their increasingly bitter dealings with their father.

The age of chivalry and romance was not all sweetness and light in England, either. The fair Rosamund was variously and snidely described in ballads of the day as *Rosa-Mundi* (Rose of the World) and *Rosa-Immundi* (Rose of doubtful virtue). But there can be little doubt that Rosamund loved the king as deeply as he did her and she was to bear him two sons, William, who was to become Earl of Salisbury, and Geoffrey, in time Archbishop of York.

Then Rosamund returned to Godstow Nunnery, where she took holy orders and spent the remaining years of her short life as a penitent. She was to die in 1176, and of course rumours abounded that she had been poisoned by Queen Eleanor. But however much Eleanor may have been tempted, the rumours were just that. Fed up with her interference in affairs of state, Henry had had his wife imprisoned in 1173 and she was not to be released until the accession of her son Richard the Lionheart in 1189.

Dependent on royal patronage for the existence of their order, the nuns enshrined Rosamund's body until 1191, when the Bishop of Lincoln, enraged at the honour being done *'that harlot'*, had her body removed to the cemetery. And there it no doubt remains, but exactly where among these ruins it is impossible to say. The nunnery was demolished by Fairfax under orders from Cromwell during the English Civil War in 1646, and when the lock was built at Godstow the stone slabs from the coffins of the nuns were used to make a footpath across the fields to Wytham. One of them, no doubt, from the grave of the lovely Rosamund.

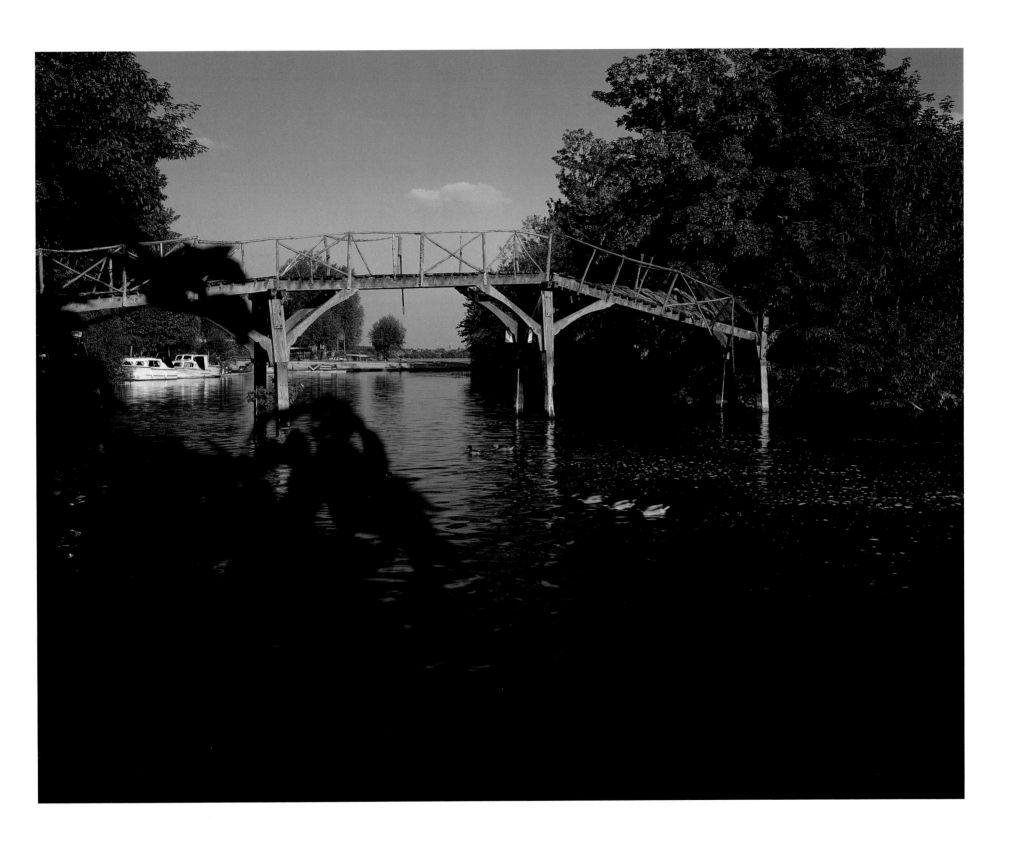

From Godstow Nunnery, destroyed by Fairfax in 1646, one can see Oxford's
'dreaming spires' through the stanchions of a decaying footbridge.

My old friend and tutor Gerda, despite having taught me all I know about writing, seems to have little faith in me.

'It's about fifteen miles,' she insists of the route to Swinford. I have worked it out painstakingly. Five miles, maximum. But I am a great believer in fence sitting.

'Hmm,' I say, agreeably, 'I would have thought about ten.'

'You won't be able to cycle much of the way,' she says. 'It's not a proper track. And its very narrow.'

To which I point out that I have cycled everywhere up until now, getting off to wait for pedestrians, and I can't see the Oxford riverside meadow beating me. Anyway, I take up much less room on my bike than beside it.

'There are hundreds of books on the Thames,' she says gloomily. 'I hope you've got a good angle.'

I sometimes wonder why I bother. But not for long. Gerda, bless her, takes me on a detour to the tiny hamlet of Binsey. This was the home of Miss Prickett (the Red Queen), governess to Alice Liddell, or Alice in Wonderland. The churchyard is well peopled with Pricketts, resting in such peace as is possible next door to the A34.

Binsey Church must be one of the few remaining unspoiled churches in the country. The electric age has not touched it, as the simple hanging oil lamps testify. It is part of the ancient priory of St Frideswide, a Mercian princess (died 735) who founded a nunnery in Oxford. Regardless of her decision to live a cloistered life, she was forced to flee the attentions of the persistent King Algar. Whilst Frideswide lived secretly and simply beside the Thames with a swineherd and his wife, Algar marched on Oxford with his army and the town was saved from devastation only by providence: Algar was suddenly struck blind, presumably as punishment.

The good Frideswide, though, felt sorry for Algar and prayed that his sight should be restored. In answer to her supplications a holy well sprang up (*can* a well spring up?) and Algar was healed by its magical water. St Frideswide built a church beside the well, which she dedicated to St Margaret of Antioch.

She probably felt some affinity with Margaret, the daughter of a pagan priest during the time of the Roman emperor Diocletian (245–313) who ordered the last great persecution of the Christians. Margaret also had to flee from the advances of an unwelcome suitor, the prefect Olybrius, who then denounced her as a Christian. She went through various tortures such as being swallowed by Satan in the guise of a dragon, and was finally beheaded.

This is the original treacle well. Remember? In *Alice in Wonderland* at the Mad Hatter's tea party the Dormouse (a.k.a. Charles Dodgson, a.k.a. Lewis Carroll) tells the story of the three little girls who lived at the bottom of the treacle well. In fact, this is truly a treacle well. In ancient times treacle was the term for an antidote to poison and a treacle well is thus a healing well.

When the Reverend Prout, one of Dodgson's friends, became the incumbent of St Margaret's Church and lovingly restored it (which is why it looks so perfect) he asked the author what he should do with the well. Dodgson replied that, in his opinion, his friend should 'Leave well alone'. A man after my own heart. Consequently, St Margaret's well is as it should be – uncovered with mesh and unlittered with explanatory signs. Conservation at its best.

At the famous Trout Inn the barman insists that there is no local ale. I hope none of the Morrell family hear him. We sit outside with a raucous peacock for company, listening to the rushing weir and sheltered from the rain by an overhanging ivy.

'Good luck with the book,' says Gerda as we part. 'I'm sure it's going to be really good.' She might have said so earlier.

Binsey Church, isolated even from the village,
provides a haven of quiet from the passing traffic.

In about 1224 in Oxford, a Franciscan monk, Salimbene, noticed that it was the Englishman's habit always to drain off a beaker of wine saying *'ge bi a vu'* ('I drink to you'), thus implying that it would be churlish for his friend not to drink as much as he. Very convivial, but if, like me, you are sitting here thoughtfully regarding Messrs Salters' boats just below the pub garden, and have any idea of acquitting yourselves with any style, think very carefully. I am.

By the end of of the eleventh century the Franciscan Theobald of Etampes, formerly Master at Caen, was giving instruction to between sixty and a hundred students here, subscribing himself in letters *Magister Oxenfordiae*. Oxford University was on its way. Then, in 1167, in the heat of the dispute between Henry II and Thomas à Becket, English scholars were recalled from Paris to arbitrate. They congregated at Oxford and its future as a seat of learning was assured. The nucleus of the university centred on St Mary's Church and Catte Street and around them sprouted up a supporting community of bookbinders, illuminators and parchment-makers.

A university was originally a guild – a union formed by masters and scholars to protect themselves from profiteering townspeople and thus was the line drawn between town and gown. In 1209, after an affray in which a townswoman was killed (accidentally, the students insisted, aggrieved by the fuss), citizens apprehended what students they could and hanged two, at which point the rest – perhaps 3,000 'gowns' – scattered to Reading, Paris and Cambridge, where Oxford's sister university was to grow. It is possible that Oxford and Cambridge became great universities because in neither place was there a bishop – hence there was freedom from ecclesiastical supervision and a certain independence of thought was possible.

Or sometimes it was. John Wyclif (1330–84) became the first Englishman to lecture on the Bible in about two hundred years. In his ire (some fifty years later in 1428), Richard Fleming, Bishop of Lincoln, had Wyclif's bones dug up and burned, the ashes being cast into the river. And just to make sure, the next year he founded Lincoln College for students preparing to equip themselves for the fight against unorthodoxy.

'It is a noble flourishing city, so possessed of all that can contribute to make the residence of the scholars easy and comfortable, that no spot of ground in England goes beyond it' wrote Defoe in *A Tour Through the Whole Island of Great Britain*, but there are those who would disagree. Sir Thomas More remembered his days at Oxford as days of cold and hunger, and later Dr Johnson was to remember the *'sting of humiliation'* that his poverty entailed.

And earlier, there was the thirteenth-century St Richard of Wych, a poor vegetarian who, because he shared a gown with a friend, could only attend alternate lectures.

Walter Map thought that it was the *'rustics… who vie with each other in bringing up their ignoble and degenerate offspring to the liberal arts,'* the aristocracy being *'too proud or too lazy to put their children to learning'* and it was perhaps in response to his jibes that in 1474 Magdalen College was founded by William of Waynflete. Its aristocratic cloister between chapel and river was expressly designed to make the sons of fee-paying nobility feel comfortably at home.

But the sentiments of an early thirteenth-century letter home could be those of any student in any age.

This is to inform you that I am studying at Oxford with the greatest diligence, but the matter of money stands greatly in the way of my promotion as it is now two months since I spent the last of what you sent me. The city is expensive and makes many demands; I have to rent lodgings, buy necessaries, and provide for many other things which I cannot now specify. Wherefore I respectfully beg your paternity that by the promptings of divine pity you may assist me, so that I may be able to complete what I have well begun…

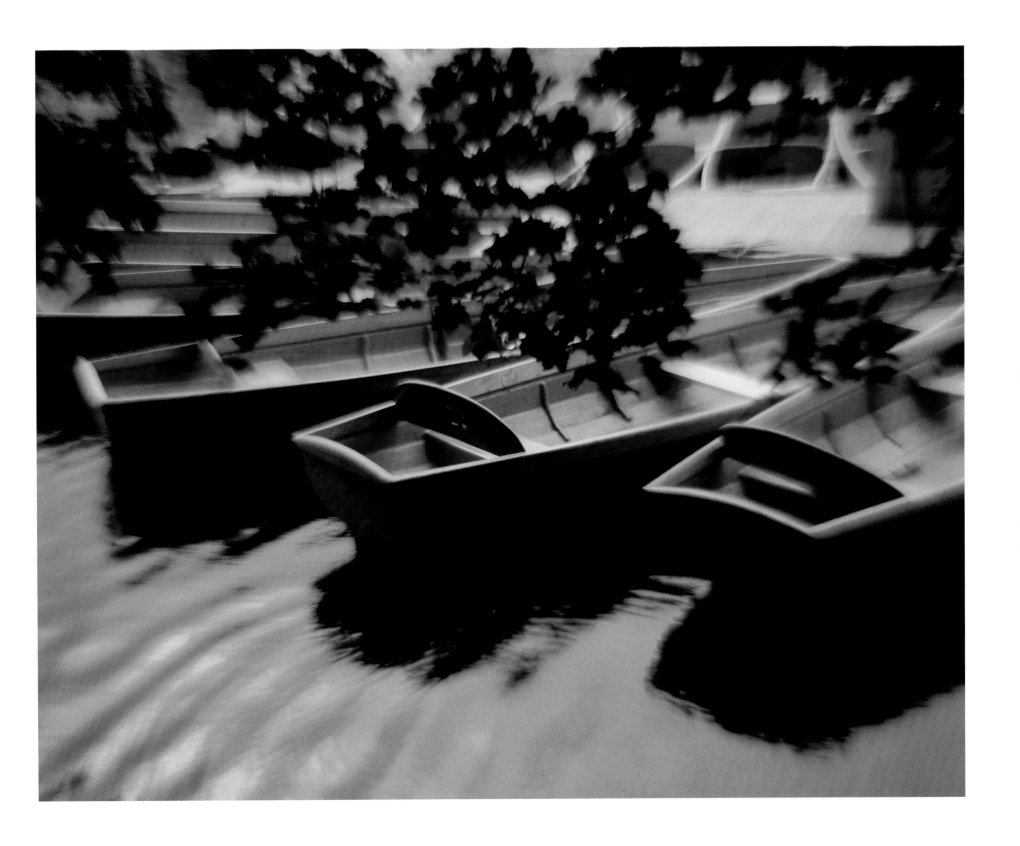

Boats from Salters Yard, below Oxford's
Folly Bridge Inn, await the day's trade.

Having dealt with Algar, Frideswide returned to Oxford and across this fine English meadow she founded a priory on the site of today's Christ Church College. But the spire we can see to the left of the square tower of Oriel College is not actually that of Frideswide's original church. In 1002, King Ethelred, plagued as he was ever to be by unruly Vikings, ordered a pogrom of Scandinavians and Oxford's Danes were burnt in St Frideswide's Church where they had taken refuge. The current building was constructed in the twelfth century.

Four hundred years later, in 1525, a butcher's son, Thomas Wolsey, who had risen through society by the unbeatable combination of intelligence and determination to become a cardinal of the Church of Rome and a personal friend of the King of England, founded an Oxford college: Cardinal College, which, after his death, was renamed Christ's College by his erstwhile friend, Henry VIII.

Wolsey was determined that his college would eclipse all others in its glory, and in order to finance it he organized the dissolution of some thirty small and decayed religious houses including that founded by St Frideswide. To staff it, he sought out the brightest teachers of the day, including John Taverner, appointed Master of the Children of Cardinal College and overseer of music.

Taverner, though, did not come up to Wolsey's expectations – not because of his music, surely, which is sublime, but because of his beliefs. He was thrown, together with other so-called heretics into a cellar *'with a deep cave under the ground of the same colledge, where their salt fyshe was layde, so that through the fylthe stincke therof, they were all infected.'* Wolsey eventually pardoned Taverner on the grounds that he was, after all, *'but a Musitian'*.

The college was to train two hundred men at a time to be priests, with the emphasis upon their education in law rather than in theology. 'Tom Quad' still preserves the founder's name but 'Tom's Tower' was built by Wren in 1681 and is named for 'Great Tom', the bell housed within it. Great Tom was rescued from the dissolved Osney Abbey and it still strikes 101 times (once for each of the original members of the college) at 9.05 p.m. every evening: 9 o'clock Oxford time, which is five minutes west of Greenwich.

'No Peel!' states a glaring piece of graffiti on a door at the bottom of the stairs to the hall. This is not a protest about the quality of student dinners. It dates from 1829 and an undergraduate protest against Sir Robert Peel's plans for Catholic emancipation. Old habits die hard, and one wonders what Wolsey would have made of it.

The kitchens are not open to the public, but within the college the smell of student meals – with or without peel – pervades the ancient stone. Apparently in the days of turtle soup the children of the college used to ride the turtles around the kitchens before their final despatch. Whether or not they ate the soup is debatable. There are still reputedly turtle shells on the kitchen walls.

Open to public view is the famous picture gallery of Christ Church, with a breathtaking collection of Renaissance paintings and drawings. You are also welcome to visit the thirteenth century chapterhouse, now doubling as museum and souvenir shop, which still has traces of fine medieval ceiling paintings.

When Henry VIII created Christ Church he uniquely (and economically) combined the college with the Cathedral of the Diocese of Oxford, which means that the cathedral today doubles as the chapel for Christ Church. Within its cloister a tiny courtyard has been recreated as a medieval garden with a lawn studded with forget-me-nots and cowslips. It is quite lovely, as is the face of St Catherine in Burne-Jones's stained-glass window inside the cathedral. Edith Liddell, Alice's little sister, was Burne-Jones's model for Catherine.

Dodgson had hoped he might learn enough about illustration to do his own for *Alice in Wonderland*, but Ruskin dissuaded him. His talent was insufficient, he said, to justify the amount of time he would have to spend on it. Which sounds a bit harsh, but Ruskin has surely been proved right. Without Tenniel, I doubt if the book would have been the outstanding success it was. So there.

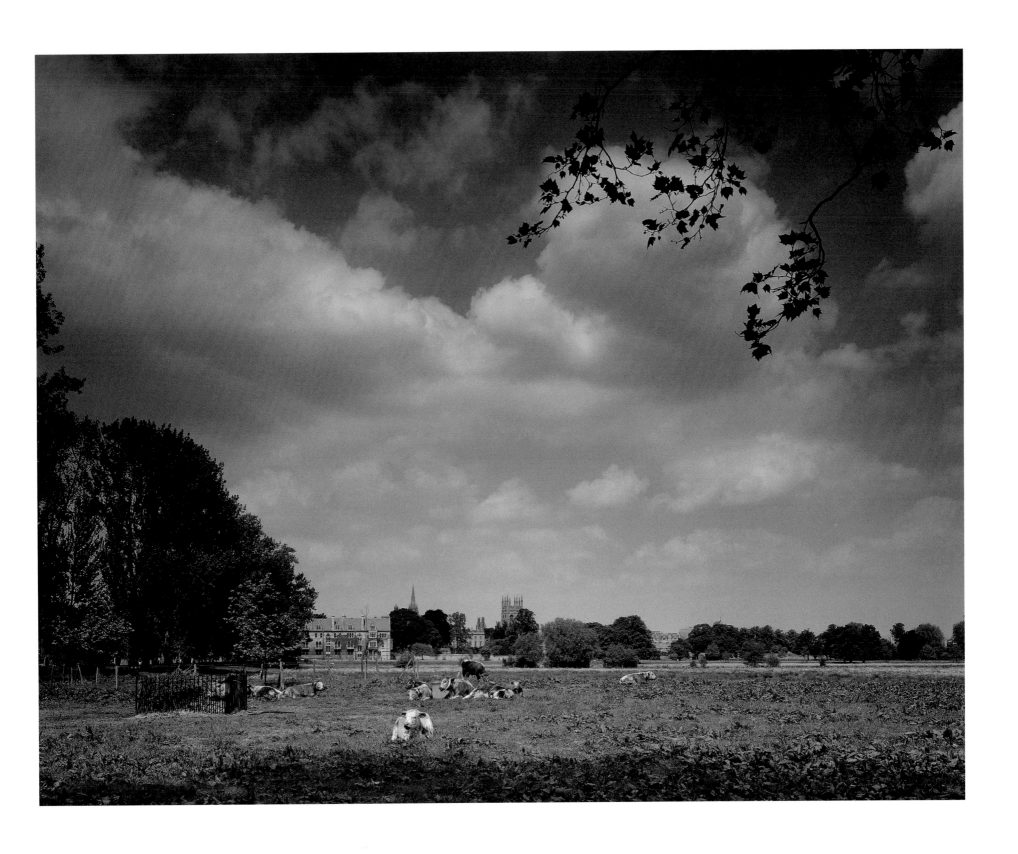

Charles Dodgson would have walked across Christ Church Meadow with
the Liddell sisters and their governess *en route* to their picnic at Godstow.

At Osney Lock in high summer the scene is of jigsaw-box perfection, with limpid green water and prematurely grey baby coots shrilly demanding food indiscriminately from parents and siblings. Here the freshwater Olympics are in full swing. A minnow leaps five times from the water in a straight line, like a skipping stone. The fishermen, though, on this warm August afternoon, are despondent. 'Not a bite all day,' complains a hefty bronzed yoof, tattooed chest bursting from black singlet, blue-emblazoned with the inspiring legend 'Fuck off'. A coarse fisherman, no doubt. As he packs up, a nonchalant tern dives, brings up a five-inch shimmer of silver and proceeds to parade it up and down the river. It's easy, really.

The chunky little Church of St Mary the Virgin at Iffley is pure Norman – quite possibly the finest remaining example of a Norman church in England. The six-foot groove for the massive wooden bar used to secure the church against attackers seems something of an anomaly in this most gentle of Oxford suburbs, a favourite Sunday lunchtime stroll or punt for undergraduates. In 1940 one of them wrote:

What sudden fearful fate
can deter my shade wandering next year
from a return? Whistle and I will hear
and come another evening, when this boat
travels with you alone towards Iffley
as you lie looking up for thunder again
this cool touch does not betoken rain
it is my spirit that kisses your mouth lightly.

In March, 1944 he wrote:

Everyone, I suppose, will use these minutes
to look back, to hear music and recall
what we were doing and saying that year
during our last few months as people, near
the sucking mouth of the day that swallowed us all
into the stomach of a war…

Which was, of course, the answer. And Keith Douglas, knowing it and having thus arranged his life's work ready for publication, died that year in Normandy aged twenty-four.

Some historians say the church was built in the time of Henry II, others during the reign of one of his recalcitrant sons, Richard or John. The appearance of Henry, supposedly the instigator of Becket's murder, amongst the monsters on the south doorway is quoted as evidence. Possibly. What is certain is that the chevron patterns and the hundred-odd beak-heads on the door arches, the likenesses of the evangelists, and the numerous stone carvings of animals and birds both within and without this glorious building cannot fail to move the heart of even the most churlish of visitors.

In 1207 King John, not the most equable of men, quarrelled with one of his staunchest supporters, William de Braose. He outlawed William and imprisoned his wife and their eldest son in Windsor Castle, where they were left to starve to death. A daughter, Annora, later became an anchoress here at Iffley, living in a cell attached to the church. The blocked up arch in the east end of the south wall may signify the presence of a window through which she could see the altar. Henry III, John's son, and noted for piety rather than wise government, was clearly ashamed of his father's cruelty and made gifts to Annora of grain and clothing as well as firewood and building timber from his forests.

A couple in the churchyard have arrived just too late to gain admittance. 'I was baptized here in 1929,' says the wife. 'Then we moved. I would have liked to see it.'

'You must see it,' I insist. I cannot bear that someone with a piece of personal history invested in this remarkable building should give up because I, too, have found a link with this church. The father of a New Zealand soldier killed in the Great War funded a plaque here for his son. My cousin was to marry his granddaughter. When so unexpectedly reminded that we are not just bystanders but a part of it all, we can perhaps be forgiven for assuming such a proprietorial air.

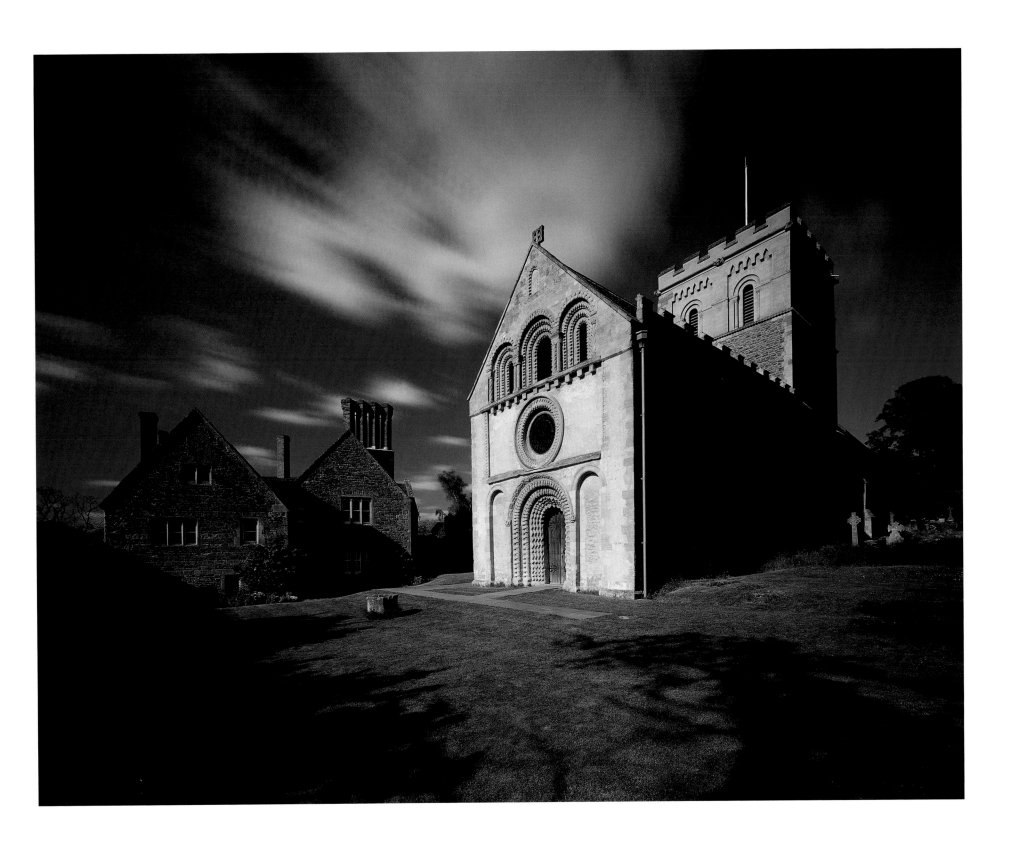

The little church of St Mary the Virgin at Iffley is quite possibly the
finest remaining example of a Norman church in England.

'You have a lot of work to do,' smiles the plump, elderly lady sitting beside the slipway at Radley. I'm never all that gracious when people throw this line at me, in total ignorance as to how much work I have done. 'We may not be able to buy your book if it's too expensive,' she simpers. 'But we'll order it from the library.'

I'm no more gracious to people whose support is carefully cool and whose inevitable criticisms come from a depth of self seldom fathomed in kindness. 'Why don't you go jump in the river,' I say sweetly and shove her in. Oh, the power of the imagination.

From Iffley to Abingdon is not a long distance, but it is a hard one along a track too bumpy to cycle comfortably. Across the river is the stately bulk of Nuneham Park, manor house of Nuneham Courtenay. The Nuneham means 'new village' and the Courtenay comes from the Curtenay Family, who lived here in the thirteenth century. It has been new any number of times. In the *Domesday Book* it is listed as 'Newham' and as recently as 1760 the whole village was rebuilt in nice modern semi-detached cottages because the existing houses spoiled the view from the First Earl of Harcourt's new house.

But, a very fine house it is, with landscaping by Capability Brown. Queen Victoria and Prince Albert spent their honeymoon here, according to the couple taking the balmy evening air outside Radley College's impressive modern boathouse. They remember the late Earl cycling down the hill to Radley railway station every morning, on his way into London to work in the City.

The estate now belongs to Oxford University and on the skyline is visible an elaborate monument dating from 1616. The Carfax Conduit was the cistern in the middle of Oxford from which the city's water was drawn: a primary cistern for university folk and a secondary one for the townspeople. A monument to the past indeed.

Why do we grow so much oilseed rape? With a such a wealth of sweetness, brilliance and delicacy to choose from – here in the bright red mini-globes of wild arum, the palest-pink florets of yarrow, the exquisite coral-and-lime sprays of water dock, the regal purples of thistles and knapweeds and the tiny yellow snapdragons of toadflax; with the plethora of blue speedwell, white archangel, wild marjoram, water mint, comfrey, forget-me-not, pimpernels, poppies, balsams and loosestrife; with rosebay willowherb, enchanter's nightshade, musk mallow and sun spurge, dovesfoot cranesbill, strawberry clover and meadowsweet; all with their specific hue or scent or form, not to mention the beauty of the names – why, oh why do we suddenly have all these fields of the unspeakable rape? The overwhelming smell in spring of the garish yellow flowers, then the reek of the seed pods… Yet even as I write synchronicity is at work. Rape is out and linseed in, for commercial rather than aesthetic reasons, but one day soon, perhaps, this sea of acid yellow will be a haze of subtlest blue.

The hour is late when we reach Abingdon. Back to Oxford by road, we decide. The A4183 looks suitably cycle-friendly, and so it proves until we have to cross the A34 and temporarily lose our bearings. A couple with a tandem wait to cross from the Oxford side and rather than meet halfway across the slipway, up which the cars speed ceaselessly, we wait on the comparative haven of the traffic island to ask directions. The woman is delighted to help. Her voice, though, is barely intelligible to us. Haltingly, using a minimum of words but a maximum of smiles, it is left to her gentle, kindly and cultured white-haired companion to interpret while she nods emphatically. A companionship of mutual respect and affection.

'A battleground,' he says, gesturing to the traffic beating up from the trunk road. We all four stand and look for a minute at the combat zone and beyond, to where the great orb of the setting sun spins, huge and silent and ruby red. Along the A34 and past us up the slip road the mechanized army hurtles headlong into endless battle, heedless.

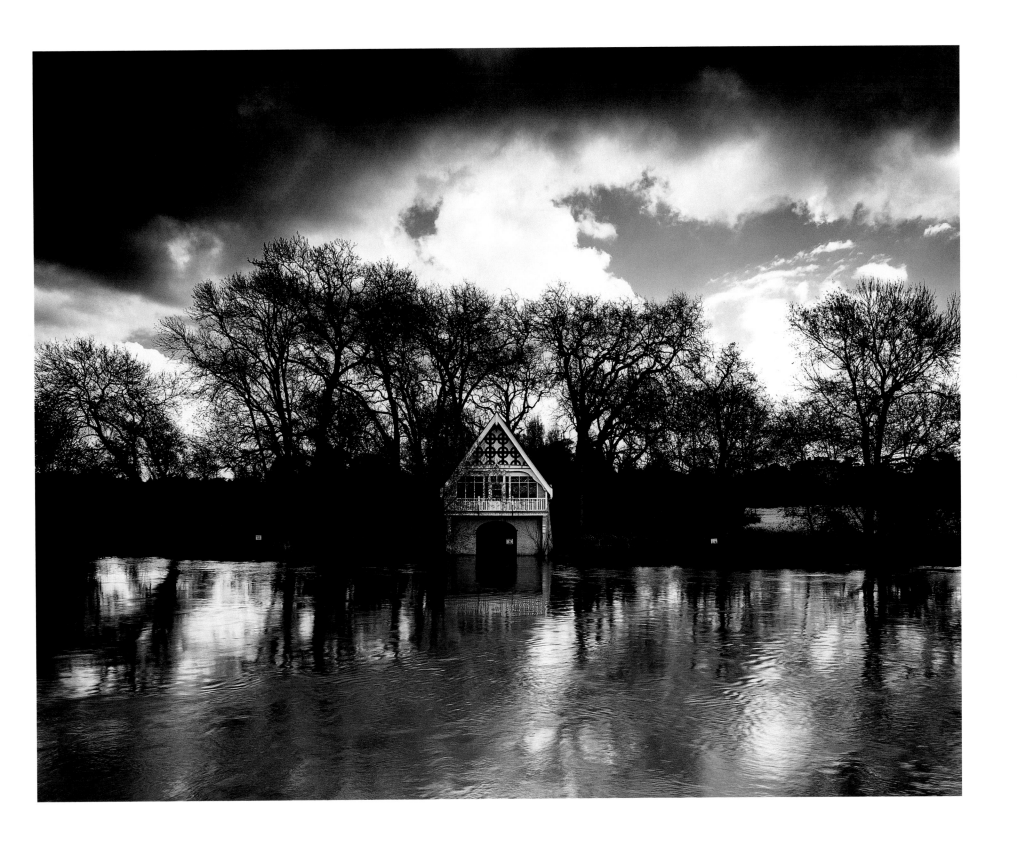

'The man of wealth and pride / Takes up a space that many poor supplied'
wrote Oliver Goldsmith of Nuneham Courtenay's garden, landscaped
by Capability Brown.

There is something I can't quite put my finger on about Abingdon. Fifteen fluffy, cheeping mallard ducklings happily follow their mother in and out of reeds, learning life skills. Apparently such a number is not uncommon with this species. Five minutes later the mother is the victim of a ferocious attack. While two males are darting at her with furiously beating wings and jabbing bills, a third is holding her head under water. Such gang rapes are not uncommon among mallards either. Handsome is as handsome does, as the proverb goes.

Abingdon, dating from before 500 BC, is probably the oldest town in England. In the middle ages, when the Abingdon manuscript of the *Anglo-Saxon Chronicle* was being written, its abbey was on a similar scale to that of Westminster, but little remains of it today.

Twelfth-century chroniclers record that Danes destroyed the monastery in the time of King Alfred (of whose efforts on their behalf they are extremely scathing), leaving only ruined walls. The earliest remains date from the Norman period, some three hundred years later. There is Norman vaulting in the crypt where you buy your ticket, there is a fifteenth-century ceiling in the hall, now the Unicorn Theatre. And there is the sixteenth-century Long Gallery, where a male blackbird dances up and down on squeaky little feet trying to tell me that There Is Nothing Interesting at All in the Chimney. I hope he decides on a better place to build before the tourist season starts in earnest.

Caxton writes of twelve-year-old St Edmund of Abingdon going into a meadow and having a vision of Christ as a child: *'And sodenlye there apperyed tofore him a fayr chylde in white clothynge which sayd; "Hayle, felowe that goest allone!"'* which is, I reflect, probably one of the most beautiful things I have ever read. But I also remember that the American academic Richard Cassady awards him his personal accolade as the most priggish saint on record for taking his university teachers along to an assignation with a local girl who fancied him to *'beat the offending Eve'* out of her.

The monks of Abingdon had their own mill, for which they diverted the main flow of the Thames past the abbey here (the original course is now a quiet backwater), and inside the dining room of the Upper Reaches Hotel you may still see the mill wheel turning. You may, but I don't, because the day I visit it is awaiting the attentions of one of the only two millwrights in the country.

The old town hall, built in 1678–82, is recognized as one of the finest in England. It has a museum upstairs and it straddles the centre of the marketplace like a kind of genial overseer. And utterly charming are the Long Alley Almshouses, built by the Fraternity of the Holy Cross around St Helen's Church in 1447.

The Fraternity was a hugely fashionable lay society and there was considerable tension between it and the abbey. The monks were irritated by the mourners visiting the cemetery (inside the abbey grounds) and invading their devotions, so they closed it to the town. Whereupon, quite sensibly, you would think, the townspeople opened their own cemetery adjacent to their parish church, St Helen's. But, whether invited or not, the monks believed they should still have the right to charge for officiating at burials. When an order from Rome finally closed the town cemetery, the parishioners were obliged to rebury their dead within the abbey grounds, paying the cost of disinterment and reburial. A pretty unedifying episode.

As was an excursion with feasting, games and ribbons in 1555 organized by local worthies William and Elizabeth Bates: a pleasure cruise to Oxford. The occasion? To see the burning of Protestant Bishops Hugh Latimer and Nicholas Ridley.

Modern Abingdon is somewhat dominated by the old gaol – a massive stone bastille dating from the early nineteenth century. It is now given over to a sports and leisure centre, but one wonders just how many wrongdoers this little town could have had less than two hundred years ago to warrant such an extraordinary structure. Unless you count the ducks.

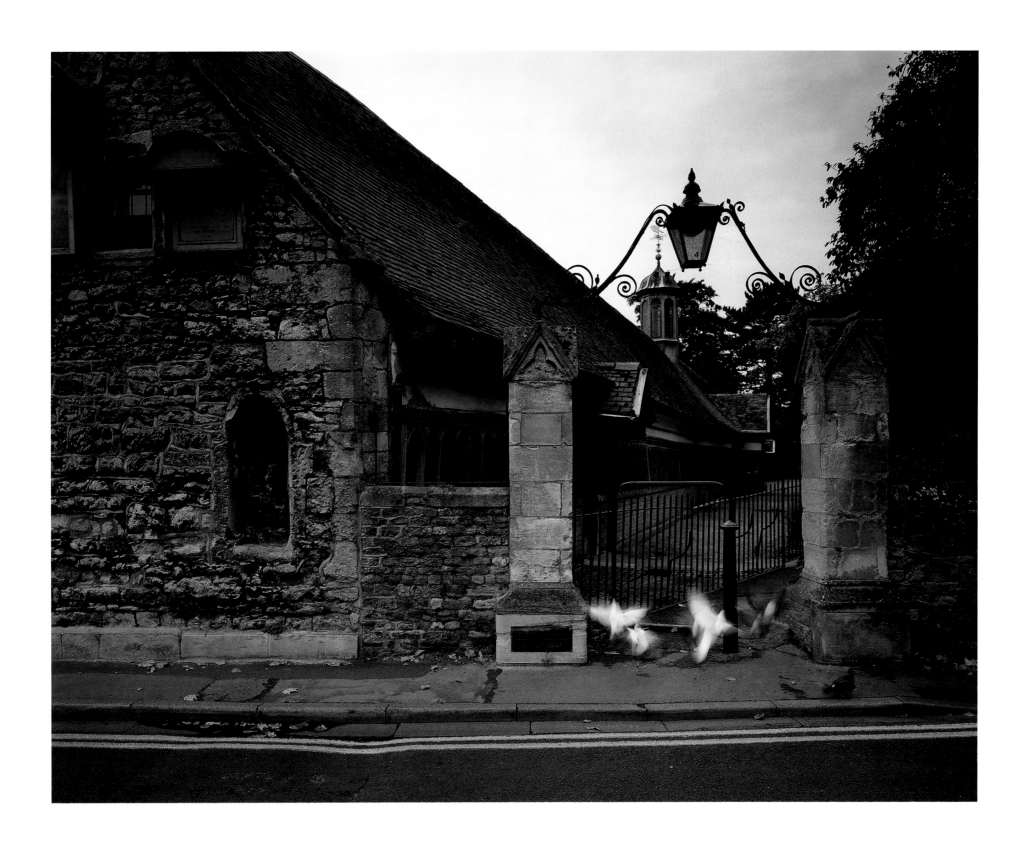

Abingdon's fifteenth-century almshouses were built by the lay Fraternity
of the Holy Cross, to which the town's élite belonged.

We once knew a marvellous elderly couple who had an endless collection of ancient Ordnance Survey maps. They could produce one for any projected outing and were genuinely puzzled when we came back having got completely and utterly lost. It's hard to accept that your OS maps are OD, but I think it's about time I did.

The fields (according to my map) outside Didcot are now commuter country and it is easy to lose one's bearings on a bike. No one can tell me the way to Appleford and to the young man tending the garden of one of these nice new houses it is irrelevant. He drives a van in from Swindon to do a number of gardens and it's not on his route. So I look at the trees to find which is the mossy side and, having ascertained which direction is north, I set off down a brand-new cycle track through a froth of blackthorn attended by numerous parties of finches, both green- and chaff-, and a skylark. It takes a Londoner to master these new-fangled country skills.

There is still a Ladygrove Farm, despite my fears that the name exists now just as this satellite town. The farm still has a traditional and delightfully ramshackle pigsty in the field where Gypsy, a gazelle-like lurcher, takes the air and nearby is a neat field with lots of charming porkers in their own brand new little bungalows. Somehow, there is something much less dispiriting about the new Pig City than the new Ladygrove.

Appleford is still there: a lovely old village with a twelfth-century church and hundreds of rabbits who will pop out and blithely carry on with the day's business if you linger over your picnic lunch, and Culham Village still has its old stocks and village pond. Culham House is a gaunt brick pile and Culham Manor overlooking the river to the west of the lock is a cosy Jacobean house, beautifully restored with topiary gardens. The 1416 bridge here, quietly overgrown with brambles and ivy, was the scene of a Civil War skirmish in 1645.

Today's traffic, though, uses a bridge built in 1928 a little higher up, thence to traverse the monks' causeway over Andersey Island. The Saxon Abbots of Abingdon diverted as much water as they could to the side streams which ran past their abbey, and the present river is apparently the result of their dredging.

The old brick bridge at Culham, like the one at the Abingdon end of the causeway, was part of an ambitious engineering project by the merchants of Abingdon in the fifteenth century. Troubled by the fact that the rival town of Wallingford was thriving on the commerce that passed over its Thames bridge — especially the pack-trains of mules carrying Cotswold wool to London — they decided to build their own. To which end they purchased Andersey Island from the Abbot, obtained a charter from Henry V and in June 1416 they laid the first stone of their two bridges.

It proves difficult to get a view of Culham Manor from across the river, but I do come across Sutton Pools and a cluster of weirs through which huge volumes of water are crashing at high speed and and where totally superfluous signs urge me to desist from bathing. No problem.

Sutton Courtenay Abbey was the grange of Abingdon Abbey, and a community lives here offering hospitality in the old Benedictine tradition. The community is Christian but anybody is welcome. The Dalai Lama received his exiled countrymen here in the 1970s. Whole-food vegetarian cookbooks stand on shelves and dried herbs are scattered about a lovely big kitchen. It is beautifully silent.

From Didcot my carriage is reserved for people who like to travel in quiet and a notice asks passengers to switch off their mobile phones. A passenger from Reading dials his first number before I twig. 'Business never stops,' he says, throwing back a pill for his blood pressure. It does for me, I say, pointing to the notice and we part amicably. At Paddington I glimpse him in the aisle of the next carriage, feverishly dialling just one last number.

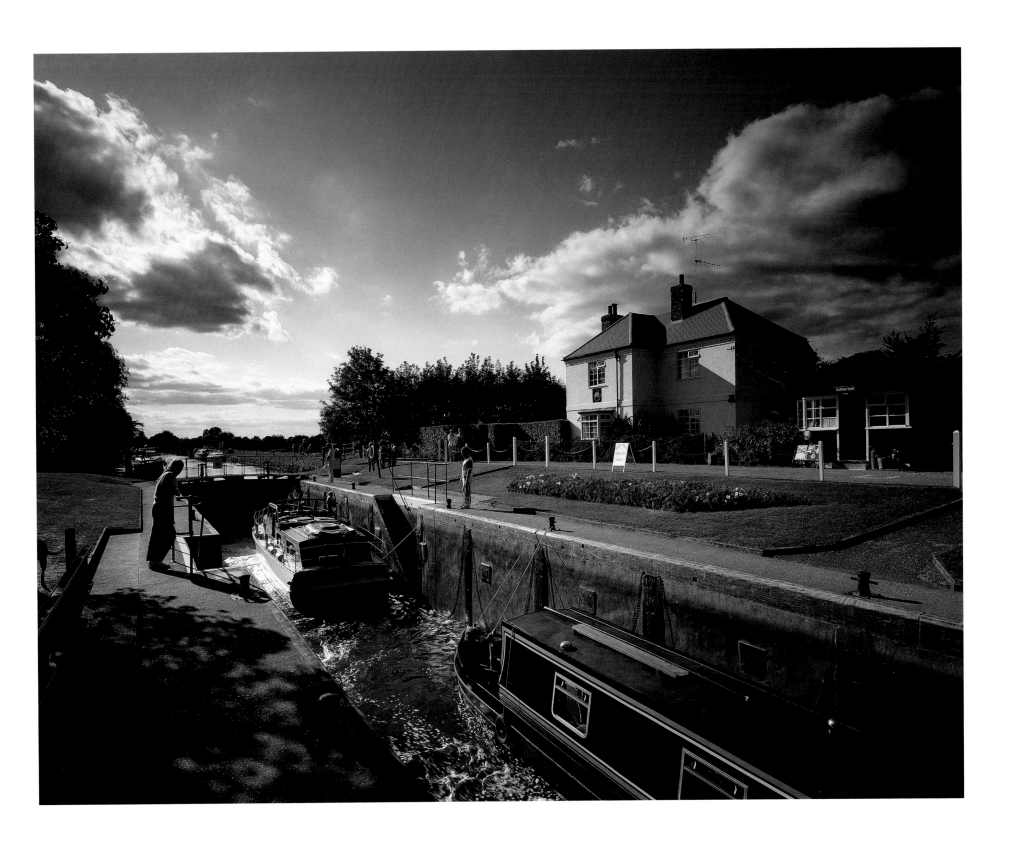

River travellers can negotiate Culham Lock in relative peace
at the end of the holiday season .

The brick bridge of Clifton Hampden looms silently and unexpectedly through dense early morning fog and seems to present the opportunity for morning coffee at the Barley Mow opposite, much admired by three men in a boat. But this thatched pub, from 1350, is now owned by one of the huge chains that are gobbling up England's hospitable little hostelries, euphemistically naming them 'Family Restaurants' and incorporating them into the charmless Heritage Industry.

For morning coffee and friendly service of the traditional English country type, we return to the village side of the river where it is dispensed by the landlord of the Plough, who is Turkish. The Plough also serves afternoon tea (not easy to find in these parts) and home-grown vegetables with its meals. It has a rabbit warren of four-poster bedrooms which offer accommodation such as Jerome and his mates would have killed for. Landlord Yuksel Bektas pauses in our tour of the garden and dives into an old-fashioned hen run from which he emerges with a gift: four brown and beautiful home-laid, free-range eggs. Forget Heritage and go for the real thing.

The pre-eminent Victorian architect George Gilbert Scott built Clifton Hampden's charming single lane bridge in 1864 in the popular pointed Gothic style beloved of the time. Twenty years earlier he had built the school house (now translated into a modern primary school) and the manor house overlooking the river (it was to be the vicarage for a time) in similar style. Work on the church, he explained, was *doctoring up rather than restoring… we had very little left to restore'*.

So the stone church of St Michael and All Angels standing on the rocky outcrop above the Thames owes more than a little of its sturdy prominence to the good Sir George. The little leaded windows in the roof, for instance, and the small bell tower, stone-studded with angels. But some of the original church survives. Passing up the steps through the bluebells the main doorway on the south side is flanked by the stone heads of the genial King Stephen (1133–54) and his queen, the lovely Matilda (that is, Queen Matilda as opposed to Stephen's cousin, the formidable Empress) and the two heads on the outside wall are thought to be those of St Birinus and King Cynegils of Dorchester fame.

Clifton Hampden was part of the estate of John Hampden, a prominent member of both the Long and Short parliaments preceding the Civil War. Hampden was a cousin of Oliver Cromwell, so it is unsurprising that he fought on the side of the parliamentarians. Although it was not as cut-and-dried as one might think. The war was to divide many families and it was probably less Hampden's kinship with Cromwell that decided him than his long-standing disagreement with King Charles over the revival of the Elizabethan tax of Ship-Money, a contribution made by seaports and coastal regions for the express purpose of building up and maintaining the navy, then engaged in endless skirmishing with Barbary and Dunkirk pirates.

The tax met with little opposition until the king decided to extend it to include inland landowners. Then some, including Hampden, demurred. Rex *v.* Hampden became a long running *cause célebre* and the king was soon came to wonder at his naïvety in describing himself in 1637 as *'the happiest king in Christendom'*. Hampden was a bit like the king: handsome, intelligent, charming and a persuasive speaker. But he was also a shareholder in two off-shore companies: the Providence (in the Caribbean) and the New England. Their business was – well – piracy. Hampden was wealthy enough to fight to the end and eventually he won. Or maybe he didn't, because early on in the Civil War he was killed at nearby Thame by the infantry of schoolgirl heart-throb Prince Rupert of the Rhine, King Charles's cousin. His ghost is said to haunt a room in the Plough.

Truth, like bridges, is easily obscured by fog, and it may be that justice, like clarity, just depends on where you are standing.

A watery sun reflects off the river in early morning fog
at Clifton Hampden.

In late October, at Chesters Coffee Shop in Dorchester, wedding guests are all of a hoo-hah over their lunch. Probably too excited even to appreciate what extremely fine home cooking they are being offered. If you were ever to be suddenly overcome with longing for a slice of mince pie with apricot with lashings of clotted cream I would recommend a trip to Dorchester-on-Thames.

What a wonderful place to get married! This village is pure picture-book, or you would think so if it were not for its extraordinary history. Each of the old pubs is picturesque and friendly. The bridesmaids waiting, chilled, in the churchyard, are dressed in mulberry and cream, almost too perfectly synchronizing with the autumnal leaves on the shrubs and the rosehips amongst the ancient yews and tumbling gravestones. The glorious abbey building (mainly fourteenth century – from the time of Edward II) sports a chequer-board pattern of flint and stone on octagonal pillars at the corners of the massive turreted tower.

Late at night, the door to the abbey is mysteriously left unlocked. Inside, a single light in the chancel burns, barely enough to illuminate the beautiful stone tracery of the famous Jesse window, doubling as the branches of the genealogical tree which details the descent of Jesus from Jesse, father of David.

Here is also an unusual memorial to a crusader: the curved effigy of Sir John Holcombe, knighted on the field of battle, who died of wounds received in the Holy Land. This may explain the curious position of the effigy – the body twisted around as if he wanted to reach something just… over… there.

The monks of Dorchester were famous for their beer. I try to explain the quality of the silence to a local in the pub over a pint of today's brew. He says: 'I have felt that – and the deathly cold. The time I saw the monk disappear behind the pulpit, where the tunnel begins.'

I am not fortunate enough to see the ghost of the monk, nor indeed unfortunate enough to feel the deathly cold. Instead, there is a silence so beautiful and so profound that I am loath to leave. Emanating from the bouquets of lilies left from the wedding earlier in the day a faint scent of spice – like nutmeg? – permeates the stone.

Dorchester is perhaps most famous for a baptism. St Birinus was a missionary bishop, probably of Germanic birth, sent from Rome to preach in the 'inner parts' of England, but when he found that the people of Wessex were still heathen he decided to stay and work there. He baptized King Cynegils in the river here at Dorchester in 635 and here, too, is where he set up his see.

The year after the baptism of Cynegils Birinus also baptized the king's son, Cwichelm. Cynegils and Cwichelm seem to have been a formidable combination. They fought the great Mercian king Penda (575–655) at Cirencester in 628 and, as the *Anglo-Saxon Chronicle* reports, *'then came to an agreement'*. Anyone who came to an agreement with the warlike Penda is worthy of respect, but as far as Penda was concerned, they chose their friends badly.

For their respective baptisms both Cynegils and Cwichelm had as sponsor the Northumbrian king Oswald, whose daughter Cynegils married, and no friend of Oswald was a friend of Penda. Penda spent a large part of his time fighting Northumbrians and, it must have seemed, an increasingly large part fighting newly converted Christians. He never converted himself, but his son, Peada, was baptized when he married the daughter of the Northumbrian king Oswiu, and even before his father's death he had begun arranging for the conversion of the Midlands.

In 636, the year after his baptism, Cwichelm died and perhaps it is he who is remembered on the Sinodun Hills on the 'Poem Tree'.

That ancient earthwork form'd old Murcias bounds
In misty distance see the barrow heave
There lies forgotten lonely Culchelm's grave.

A late afternoon shadow on the wall of the People's Chapel of Dorchester Abbey:
a haunting, perhaps, of the now-extinct East window?

At Dorchester the River Thames meets, confusingly, the River Thame. Just as the Thames itself forms a right angle near Little Wittenham and the lock, so is a right angle formed by the junction of the Thame with the Thames. The Roman town of Dorchester is therefore surrounded on three sides by water, and if you were to dig channels between the flooded gravel pits to the north of the town you would make Dorchester-on-Thames into an island. Take a walk up to the Wittenham Clumps – the clusters of trees on the Sinodun Hills to the south of Dorchester and look back to see what I mean.

You feel a slight discomfort, as if you may be intruding, as the little path from the town leads you past the parlour windows of residents and through the allotments to Days Lock on the Thames, but probably nothing to compare with that felt by the Iron Age inhabitants of the fort on the Sinodun Hills when the Romans decided to settle at Dorchester. The double row of earthworks you walk alongside and then cross *en route* to the lock are the Dyke Hills, enclosing an area of about 112 acres. They were constructed by Iron Age chiefs long before the Romans came as a means of securing the safety of the tribe and its livestock in times of danger. But no previous tribal warfare could have prepared the local tribes, the *Atrebati* and the *Catuvellauni* for the coming of the Romans. Nothing could have.

The fort remains. Rather than take it over for their own use, the Romans preferred to build their town, Dorchester, where their highway linking Alchester and Silchester met the Thames. Now there's confidence for you.

Across the footbridge is the strung-out village of Little Wittenham, and hidden in the woods the church of St Peter – mainly Victorian but with a surviving fifteenth-century tower. There is a marble effigy here of William Dunch, auditor for Henry VIII, Edward VI and Elizabeth I. There is also one of his grandson, another William Dunch whose wife, Mary, was the aunt of Oliver Cromwell.

In the Sinodun Hills, as in perhaps no other place, I have felt the layering of history – that inevitable and universal matter of each era leading on seamlessly to the next. Although the earthworks we walk around on this hill date from the Iron Age, archaeological finds made here date from the Neolithic, over a thousand years earlier. Who knows what feats of heroism were performed here by Britons unremembered?

Here have been found traces of Anglo-Saxon burials, including a complete skeleton of the early Saxon period. After the Roman occupation ended Alfred the Great founded a base here as part of his tireless campaign against the encroaching Danes.

On a wet, windy October morning standing amongst the ancient beeches you can almost feel his presence. Alfred's inspiration in kingship came largely from the writings of Gregory the Great (Pope Gregory I, 590–604) who urged rulers to conclude peace with evil men in the hope that the *'love and society of their neighbours may humanise and reform them'*. On the other hand, Gregory suggested, very sensibly, rulers should be careful not to encourage peace between their enemies, thus consolidating their power. Sound advice when dealing with the Vikings, who were formidable enough as independent bands of marauding thugs.

The trunk of one of the beeches, now felled, remains upstanding overlooking the surrounding plain. This is the 'Poem Tree', the words in its bark carved just over a century ago. Because the tree was still growing – expanding unevenly in sinewy strands – some of the letters and words have become strangely distorted, but it is still almost possible to read it. There is something powerfully moving about standing on a spot where people have stood over the centuries, thinking the same thoughts about the same people, wondering who they were. And who, come to think of it, are we?

From the Wittenham Clumps, high on the Hills of Sinodun, Iron Age
tribes would have watched the building of Dorchester by the Romans.

The ancient Ridgeway path passes between Goring and Wallingford, and despite the reservations of those traditionally testy riparian landlords, you should feel very welcome to traverse it, disregarding ploughed-up footpaths and heaps of tangled roots across gateways to your side, and six-foot-high fences denying any view of the river.

In 1066–7 William the Conqueror was intent on crushing London where Edgar Atheling, the legitimate heir to the Anglo Saxon kingdom of Edward the Confessor, was ensconced. Having been thwarted at Southwark he took a wide loop westward and finally crossed the river at Wallingford, held by the Saxon chief Wigod, a champion of William's claim. It was a long journey, but the Normans made the most of it, ravaging, burning and slaughtering along the way, because their duke had a point as well as a crossing to make.

Wallingford's many-arched bridge does not go back quite this far, but dates certainly from the twelfth century and has been mended by recycled stone from various buildings of various ages from then until the present. Also by bricks, cement, iron, chewing gum… Crossing it as you approach the town you are greeted by the graceful spire of the church of St Peter and something niggles at me as I look around it – something to do with one of Wallingford's sons, Jethro Tull, who invented the seed drill. Is it not extraordinary that Jethro Tull and Sir Christopher Wren were contemporaries? That man was perfecting his most civilized architecture before he had actually mastered the art of drilling seed in rows?

Until 1652 the town was entirely dominated by Wallingford Castle. During the twelfth-century civil war between King Stephen and Matilda the Empress, this castle was held by Brien Fitzcount, a singularly unpleasant man much given to torturing and pillage. He was personally devoted to Matilda – in fact he was the only friend she had hereabouts – and it was here, to his protection, that Matilda made a romantic escape by night from imprisonment in Oxford Castle in 1141, walking across the frozen Thames and snowy fields for six miles, dressed in white and accompanied by three white-clad knights.

On the whole, Matilda's men were second-rate barons, united only by personal grievances against Stephen. And even they were continually changing sides, depending on who seemed to be offering the best prospect of success. The war dragged on for sixteen years: two lone kings endlessly chasing each other around an empty chess board. Stephen, who usually had the advantage in men and money, quite simply lacked the martial expertise to bring the skirmishing to an end. That it did eventually end, just as Matilda's son Henry, Duke of Normandy, arrived to join the fight, was due in no small part to a fine piece of oratory by the Earl of Arundel.

In what manner had Matilda governed when she was in control? he asked. In what manner Stephen? Was not her pride more intolerable still than his levity, her rapine than his profuseness? Yet when she was driven out, did Stephen regret his bad conduct? Did he discharge his lawless foreign hirelings? And now, he pointed out, yet more foreigners – Angevins, Gascons, Poitevins and *'he knows not what'* – had come over for yet more of the same pointless conflict. He pleaded for agreement rather than victory, whereby Stephen should enjoy the royal dignity for his lifetime, and be succeeded by the duke as Henry II. So the Treaty of Wallingford was signed in 1153, in which it was agreed that castles should be razed, Crown lands resumed, foreign mercenaries banished from the country and Stephen remain king with Henry as his heir.

Stephen's son, Eustace, took himself off in fury to plunder East Anglia and die of a *'fever of the brain'* and Stephen, who had invested all of his hopes in the unpleasant Eustace, had little heart to transfer them to his second son, William, waiting in the wings.

Brien Fitzcount, knowing that Stephen had little reason to love him, took the cross and went to Jerusalem and will not have been greatly missed by the good people of Wallingford.

The thirteenth-century bridge of Wallingford was of strategic importance during the years of *'strife and evil and robbery'* of King Stephen's reign.

At Goring the Ridgeway (the ancient trackway along the crest of the chalk downs) crosses the Icknield Way (the prehistoric route joining Norfolk with Dorset) and meets with the Thames Path; but even on this perfect late summer day there is little likelihood of congestion. This morning, on a round cycle trip from Pangbourne via Whitchurch and Streatley, only two walkers have been encountered, and each of those so absorbed in their own thoughts as to be surprised and not a little put out at the intrusion of a friendly greeting.

The village of Goring is seemingly unspoiled, but all is not quite what it seems. The 'old' mill, now housing a small art gallery, dates in fact only from 1923, being built as a replica of the original.

The bell now inside the Parish Church of St Thomas of Canterbury, though, was cast in 1290, and is one of the oldest in the country. Although the church is dedicated to Henry II's ill-fated chancellor, Thomas à Becket, the solid, square tower, complete with the unusual stair turret, confirms the building as early Norman, some centuries before Henry. It was probably built by Robert d'Oilly, one of William I's barons, who was awarded Goring (or *Garinges*), along with another fifty-nine manors after the conquest. The Saxon lord Wigod, Thane of Wallingford, and William's supposed friend, seems to have been dispossessed in the process.

Don't be too hard on the more recent restorers of this fine old church when you consider the pebble-dash exterior. During the time of Henry I, the church was surrounded on three sides by a priory, at that time the only Augustinian nunnery in Oxfordshire. Some remains of the outer walls are still visible from the churchyard.

As a religious community for the purposes of contemplation the priory of St Mary's was less than ideal. In 1300 a bitter dispute arose between two rival groups of nuns who were each determined to see their candidate elected prioress. The two would-be prioresses were escorted to the altar as their respective supporters sang the *Te Deum* at full volume, each group trying to drown out the voices of the other.

Never well endowed financially, the nuns took in boarders to help make ends meet, and, being an Augustinian order, rather less strict than the Benedictine or Cistercian, they were also permitted to make recreational visits home and to receive visits from relatives – who *may* have been relatives, but were not carefully monitored.

The consequent abuses can be well imagined by those of an even moderately prurient turn of mind, and in 1445 the visiting bishop found it necessary to censure the nuns for wearing their veils in a manner unsuitable to women of a religious order.

Through the lych gate of the churchyard are attractive almshouses built in 1714 by Richard Lybbes for *'Four poor old men to dwell in'*. These are now converted to two, but as with the rest of Goring's charming architecture of flint, brick and Virginia creeper, the transformation has been apparently seamless. You might be hard put to find suitable poor old men nowadays in Goring. The houses in this 'Chilterns Area of Outstanding Natural Beauty' tend to be owned by celebrities like Danny la Rue and Elton John, but you never know.

At the lock a young shipmate is giving orders to his mother and her friend as they negotiate their way into the lock: 'Why don't you… why can't you… haven't you heard of…?'

'Why don't you put her in neutral?' he asks, eyes rolling in exasperation.

The forbearing women achieve their object perfectly adequately without heeding his advice. (I have heard lock keeper Don Marshall tell a previous skipper it is best to remain in gear, retaining control of the steering.) As they leave, the youth, balanced precariously on the transom, heaves small pebbles of bread at the swans.

'Don't fall in,' I call solicitously.

'Course I won't!' he replies, pityingly.

Oh, yes he will.

On the chalk hills at Goring the ancient Ridgeway meets with
the Icknield Way and the Thames Path.

The first toll bridge at Whitchurch was built in 1793, putting the nose of the local vicar somewhat out of joint, as it was he, needing a second string to his ecclesiastical bow, who held the ferry rights.

The current Rector of Whitchurch, the Rev. Richard Hughes, does no mean line in b&b. With the two local pubs no longer offering accommodation and a rambling rectory going to waste, it is a pretty obvious solution. Richard Hughes has been here for seventeen years, but not yet long enough to inscribe the death date of the first (fifteenth-century) Rector who had his brass ready made with the date for his death left blank. A handsome chap, judging from the brass, with a down-to-earth attitude towards his own mortality.

The flint-clad brick church of St Mary is a glorious mixture of Saxon, Norman, medieval and Victorian. The Victorians cheerfully redeployed stones, monuments, etc. at will, so it is hard to know where anything was originally. A fine but restless-feeling church. It might be worth having that date inscribed.

This is *Wind in the Willows* country. Across the river from Whitchurch, at Pangbourne, Kenneth Grahame lived at Church House, which he bought with his wife, Elspeth, in 1924. You might be surprised, on viewing Church House, at its lack of seclusion. But the marriage was not a happy one and seclusion was not something ever sought by Kenneth or Elspeth Grahame, neither of whom seems to have wanted time or space for introspection.

They had no telephone and Elspeth haggled over prices in the village shop, becoming more and more eccentric as she grew older. On summer days they took lunch on their front steps and after the years they had spent living in Rome the meal would usually consist of bread and sausage and wine in the manner of the Italians. But without the style of Italians, because they would inevitably be eating out of paper bags. Elspeth had a gift for squalor.

Arthur Ransome made a memorable comment on *The Wind in the Willows*. He said: '*If we judge the book by its aim, it is a failure, like a speech to Hottentots made in Chinese.*'

So have we been enjoying *The Wind in the Willows* all these years by mistake? What was Grahame's aim? Well, I doubt if he had one. Mole and Ratty invented themselves as bedtime stories and the seafaring Rat would, I think, be Grahame himself, longing for boyish adventures without the millstone of his marriage around his neck.

And Toad? Toad was undoubtedly the Grahame's son, Alastair, nicknamed Mouse, born in 1900. Here is Grahame on animals: '*Every animal is honest. Every animal is true – and is, therefore, according to his nature, both beautiful and good…*' But Mouse was not really very good. In fact, he was appallingly spoiled. And he suffered from very poor eyesight, which his parents, sadly, never acknowledged. Because, according to Elspeth (and Grahame seems to have colluded in the fantasy), Mouse was perfect. And not only physically perfect. He was also the most amazingly clever child who had ever lived and he was destined for the highest academic honours.

Kenneth Grahame had longed to go to Oxford, but he was orphaned as a child and his uncle curtailed the financial handouts unexpectedly early. Kenneth, bitterly disappointed, had gone into the Bank of England where he did well enough to become its Secretary – although it is unlikely that his lacklustre performance would pass muster in today's banking world – and he remained there until he finally took early retirement on health grounds in 1908.

So Kenneth Grahame, having never achieved his dream of an Oxford place, inflicted it on his son. Alastair was sent to Rugby, where he nearly had a breakdown and then to Eton, where he did. And on his twentieth birthday, despairing of ever passing his Oxford exams, he died on the railway line at Port Meadow.

A Victorian iron bridge, one of the two remaining toll bridges on the river,
joins the peaceful town of Whitchurch-on-Thames with busy Pangbourne.

The Thames Path skirts Farmer Worlidge's field across the river from Mapledurham House just as it has done since 1777 when the worthy yeoman refused to sell land in Purley Meadow for a towpath. The detour occasioned an extra journey of half an hour for the bargemen, plus the hassle of unharnessing and re-harnessing the horses and poling the barge along to meet them. Think of them as you leave the riverside after a tantalizing glimpse of Mapledurham House.

Mapledurham has looked much like this since it was rebuilt by Sir Michael Blount, who entertained Queen Elizabeth I here. Mapledurham House is noted as a perfect Tudor mansion which you are welcome to visit on weekend and bank holiday afternoons in summer. You take a boat from Caversham Pier for the landing stage on the Mill Island where you must purchase an entrance ticket. Similarly if you land from a private boat, and you can moor only on open days. The mill is still in working order.

The lock at Mapledurham was the first on the river to be mechanized, in 1777. But then, Mapledurham and the Blounts, its owners, have ever been at the forefront of modern technology. Pepys's friend Colonel Blount was a keen follower of the latest trends although Pepys himself was singularly unimpressed by *'Col. Blunt's whicker chariot with springs'.*

The place also has associations with literature. Mapledurham was the home of Soames Forsyte of the *Forsyte Saga* as well as Toad of Toad Hall. Who was also, come to think of it, rather keen on state-of-the-art transport.

Sir Thomas Blount was Steward of Royal Household under Edward II. On Edward's deposition, Blount broke the rod which was the symbol of his office, declaring himself to be released from the service of the royal house and you have to admire his loyalty. The Blounts were back in business before too long, though, because in 1390, 63 years after Edward's death, under Richard II, they were able to buy Mapledurham Manor. Before long, they had demolished the existing building and built a splendid house. The fourteenth-century chapel still exists, containing the Blount family monuments.

During the eighteenth century Martha and Teresa Blount lived here with their mother until, on the death of their father, they were unceremoniously despatched by their brother, who inherited the house. Alexander Pope loved Martha ('Patty') Blount. He wrote to her: *'I have little to say to you when we meet; but I love you upon unalterable principles; which makes me feel my heart the same to you as if I saw you every hour.'* To her he dedicated his 'Epistle on Women' and perhaps she loved him, as he left her most of his estate on his death. But Pope had no illusions, presenting himself always as the fool, the lapdog, rather than the man he longed to be.

Most souls, 'tis true, but peep out once an age,
Dull sullen pris'ners in the body's cage

is from his 'Elegy to the memory of an unfortunate Lady' but it surely comes straight from the heart. Crippled from early childhood by tuberculosis, Pope's physical disability meant he was always going to be a pariah. And to make matters worse, he was a Catholic. Patty enjoyed the compliments he paid her – it was nice to be admired by the greatest wit of the age – and she found him good for conversation, but not, probably, to take to bed.

Gossip surrounded them though, and cruel caricatures were circulated of 'Dirty Patty' and her crippled admirer. But Swift, one of the age's greatest satirists, wrote of her:

I deny she was dirty, but a little careless, and sometimes wore a ragged gown… She saved her money in summer only to be able to keep a chair at London in winter. This is the worst you can say.

And if that was truly the worst you could say it is hard to forgive the malevolence of eighteenth-century society.

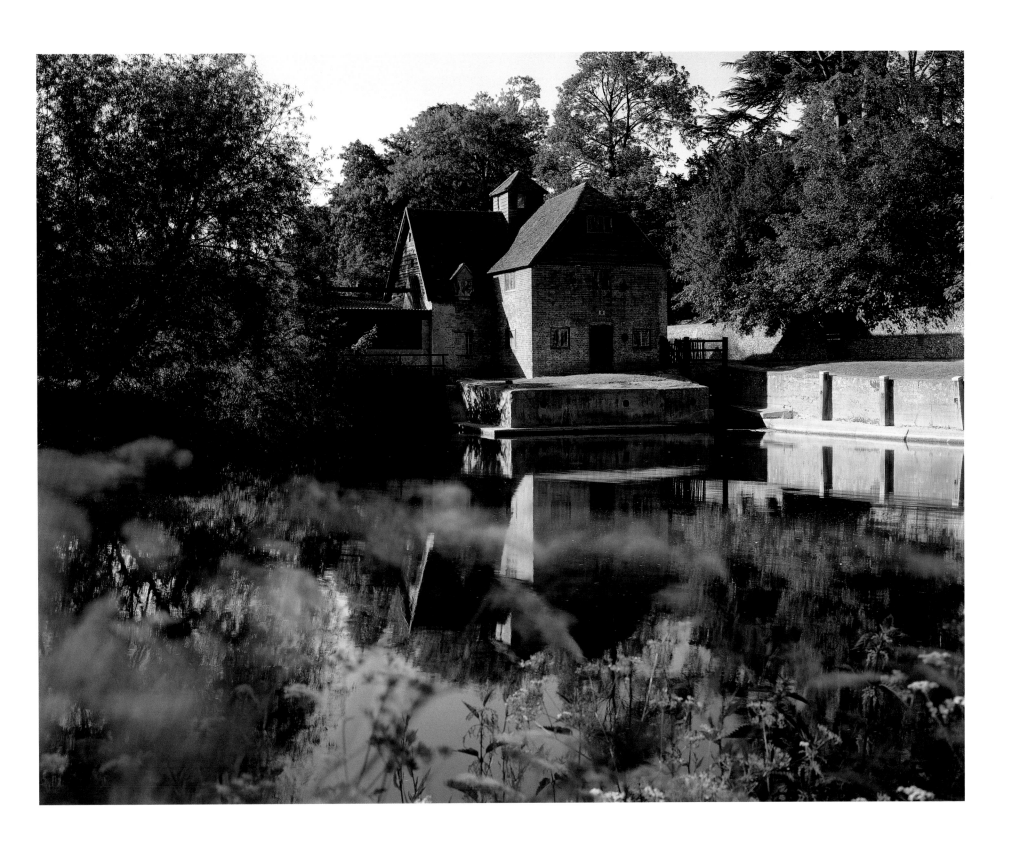

Out of the fog: Mapledurham's restored water mill in summer.
The house is probably Toad Hall from *The Wind in the Willows*.

Shrieks of delight emanate from the children in the nursery school adjacent to the ruins of Reading Abbey. Two hundred years ago one of them could have been Jane Austen, who was a pupil at the school in the old abbey gatehouse. Although the teaching left a lot to be desired (as an adult she was very scathing about the talents of schoolmistresses), the setting was pleasant and the girls were able to play in the abbey ruins.

The abbey was founded by Henry I ('Beauclerc'), in 1121, the year following the tragic death of his son William Atheling in the White Ship. Caen stone was transported up the river to be used for the building and some was carved into the beautiful birds, animals and fabulous beasts which are preserved in Reading's museum. You will also find inside the museum the nineteenth-century copy of the Bayeux Tapestry lovingly worked by Victorian ladies. It is faithful in every detail except for the shorts embroidered on to the squatting male figure whose generously proportioned genitalia were offensive to their delicate sensibilities. The restoration and display of the tapestry (actually more of an embroidery) was imaginatively sponsored by Bayers of Asprin fame and the Norman Insurance Company. Neat!

Henry built a royal mausoleum in the abbey and somewhere in these ruins are his remains. When he died in France in 1136, his body was transported back here, sewn inside the hide of a bull.

A tramp has entered into the spirit of the place where I stop for lunch. The ashes of this unknown fellow traveller's fire are in the middle of the once great hall and the atmosphere is still somehow welcoming despite its ruinous state. St Hugh of Cluny believed that a very large church encourages a very large piety. Or perhaps a very large party, because life in Reading followed the great Cluniac tradition of fine music and hospitality and the days appear to have been a constant round of beautiful services and fabulous music. The ancient part-song 'Sumer is icumen in' was probably first written down here by the monk John of Fornsete in the thirteenth century.

Here, in 1185, Beauclerc's grandson Henry II received the Patriarch of Jerusalem, and, in 1359, John of Gaunt married Blanche of Lancaster. It was here, too, in 1464 that the secret marriage of Edward IV and Elizabeth, one of of the widely distrusted Woodvilles, was made known at a royal council. It was probably witnessed by Edward's younger brothers, the ill-fated George, Duke of Clarence, who was to die in a butt of malmsey and Richard, Duke of Gloucester, soon to be Richard III. The partying ended only when the last abbot, refusing to acknowledge Henry VIII as the Supreme Head of the Church in England, was hanged at the abbey gates.

Behind the abbey is a vast expanse of brick wall. Reading was famous for its bricks and the standard of its product can be seen today in the town's huge Victorian municipal buildings, particularly the council chambers, the fine Reading Museum in grey and red, and, more sombrely, in Reading Gaol.

Here, in 1897, Oscar Wilde was imprisoned. He had been charged with gross indecency – an offence on the statute books only for two years – and sentenced to two years' hard labour, which in 1895 was as good as a death sentence. Accusing him of *'sapping the strength of English youth'*, the governor determined to *'knock the nonsense out of him'* and set him to the treadmill. Meanwhile, in the outside world, his name was removed from all posters and his plays were taken off at the theatres.

In prison the inmate of Cell no. C.3.3. wrote 'De Profundis', a letter to Lord Alfred Douglas, who was quite simply not worthy of it, and he wept at the same time every day for a year. On his release, commuters spat in his face and he left for Paris, where, his health in ruins, he unsurprisingly lasted only eighteen months. He wrote *The Ballad of Reading Gaol* in the Paris hotel room where he died in 1900. *'Prison doesn't break your heart,'* he wrote, *'it turns it to stone.'*

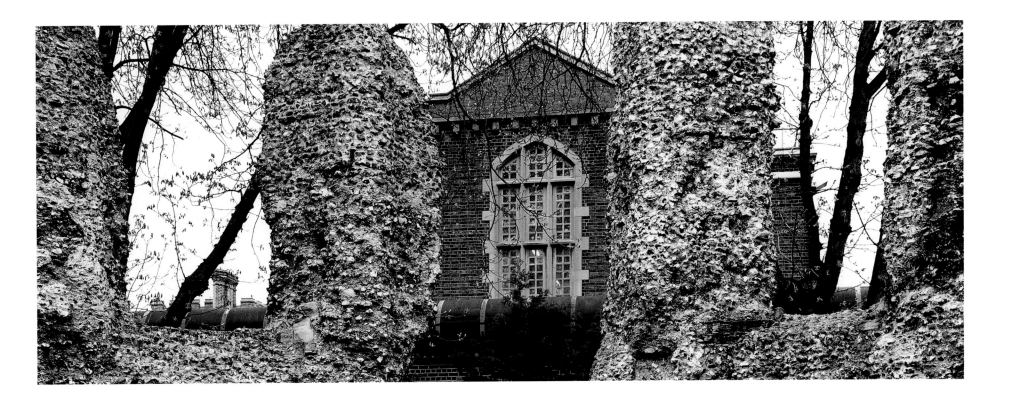

The major town of modern Reading has a surprisingly ancient history:
here the prison which held Oscar Wilde is viewed through the ruins of
Henry I's abbey.

In Henley an elderly lady is weeding around her neighbour: a nameless bishop who has lain peacefully for some hundreds of years beneath a stone slab at the front door of her almshouse. She is telling me about her friend who has been consigned to a Home.

'He was always so immaculate in his dress,' she says, 'And now he never even has his own clothes on. I've bought him lots of new underwear, but it's all disappeared.' I wish our market-obsessed society hadn't turned old people into a commodity.

I am wishing a lot of things as I leave: that I had listened to my mother's concern when her attractive and lively retirement village was purchased by a modern, profit-driven conglomerate. I wish that, instead of hurrying by earlier today, I had stopped to investigate the old people's home I passed that smelled of urine-soaked sheets. And I wish that wishes were not so often tinged with regret — to be about what we *could* have done, and did not.

There are two gents atop the twelfth-century tower of Shiplake church, which promises a stunning view of the surrounding countryside and I rather hope I will be invited up. Then one starts talking the other down: 'Now your next step will be on to the ladder, just a litle bit more to your right… Oh, dear, no, a little bit less…' and suddenly the bird's-eye view seems less attractive.

Inside, on a tour of inspection, a grizzled old alsatian-cum-labrador pads companionably around after me and one of three ladies arranging flowers for a wedding, and apparently concerned that I may have my eye on the church plate, periodically admonishes her very clearly: 'Now, Jess… lie down Jess… It's OK! Behave, Jess.' Then, to me: 'She's quite friendly really.' I had rather gathered that.

Shiplake Church has carvings surviving from the thirteenth century that are believed to be of Henry III and of his brother, Richard, Earl of Cornwall, who built the nave. Perhaps its greatest glory, though, is the medieval stained glass which came, thanks to an enterprising nineteenth-century vicar, from the ruined Abbey of St Bertin in St Omer. Not as inappropriate as one might think,

because it was to the Abbey of St Bertin that Thomas à Becket fled the fury of Henry II. The glass had survived because the monks of the abbey sensibly took out the windows and buried them during the French Revolution.

The riverside meadowland below Shiplake has probably changed very little since Alfred, Lord Tennyson walked here.

The seasons bring the flower again,
And bring the firstling to the flock;
And in the dusk of thee, the clock
Beats out the little lives of men.

Could he, writing *In Memoriam* to his dead friend Hallam, have been listening to the clock on the tower of Shiplake College? From this fine conglomeration of old red-brick and flint buildings the drone of a history master emanates very much as is the wont of history masters, while down at river level the college sports its own boatsheds where boating skills are practised by pupils of a variety of ages and aptitudes and a uniform courtesy.

In 1850 Tennyson was married in Shiplake Church to Emily Sellwood after a fifteen-year courtship. Emily had been engaged to marry Hallam and it is believed that she finally succumbed, despite her reservations, after reading *In Memoriam*:

Old Yew, which graspest at the stones
That name the under-lying dead,
Thy fibres net the dreamless head;
Thy roots are wrapt about the bones.

He wrote it quite possibly in the very spot I am having lunch in the company of John Culley (d. 1901). *'Watch, therefore, for ye know not what hour your Lord doth come'* admonishes his tombstone, and I only hope that when the time is ripe I can forego the smelly sheets and the community-chest underwear and that He will come and topple me gently off my bike into the Thames.

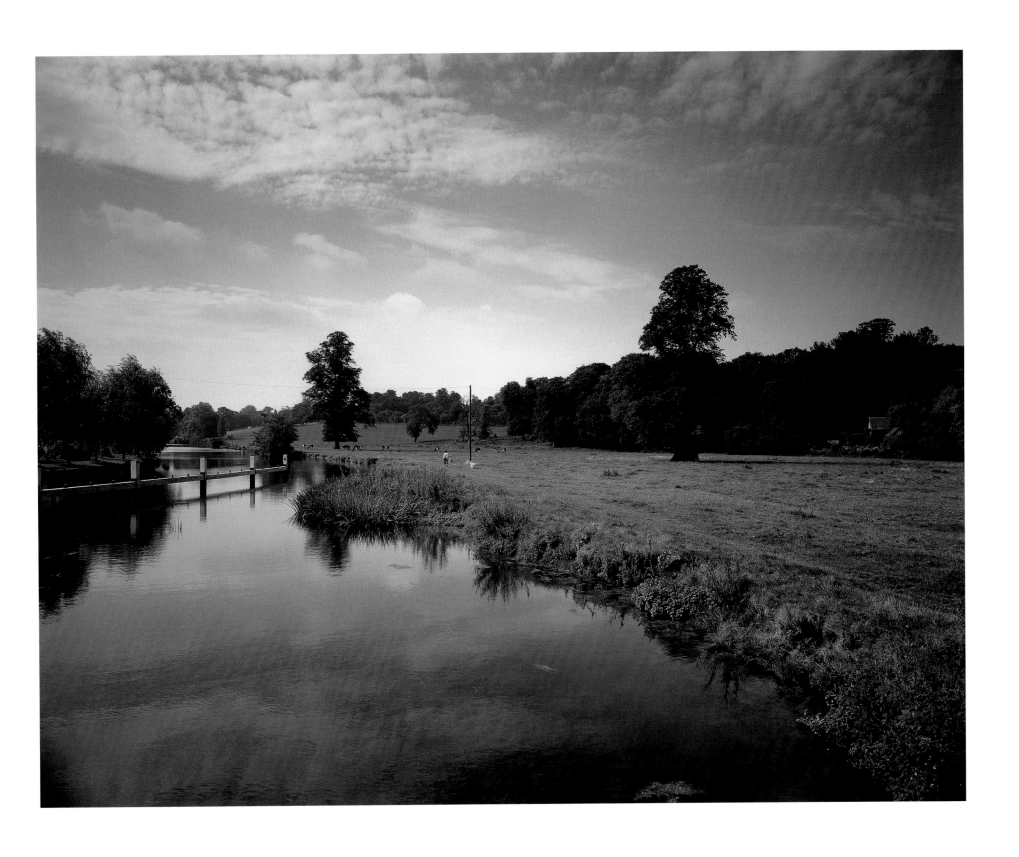

The poet Alfred, Lord Tennyson often walked this stretch of the river
during his fifteen-year courtship of Emily Sellwood.

The lady in the Henley Tourist Information Centre has never heard of him – I suppose because people nowadays are more interested in the famous Henley Regatta – but just for the record, I think we should remember the thirteenth-century agricultural writer Walter of Henley.

Walter advised farmers to bring seed from the manors at Michaelmas because *'Seed grown on other ground will bring more profit than that which is grown on your own.'*

He offered proof, too: *'Plough two selions at the same time and sow one with seed which is bought and the other with corn which you have grown; in August you will see that I speak truly.'*

Now I don't know how large an area a selion is – and I don't know anyone who knows it either, and I would hate to be accused of nagging, but I do find it extraordinary that a person can have been so perspicacious regarding seed in the thirteenth century, and yet it was to be five hundred years before Jethro Tull perfected the seed drill.

But back to modern day Henley, noted for sartorial elegance and rowing: in that order. Charles Dickens would have been fifteen years old when the first Oxford and Cambridge Boat Race was rowed between Hambleden and Henley in 1829. He called Henley *'the Mecca of the rowing man'* and might have added *'and the fashionable woman'* because the outfits on display during regatta week are rather more beautiful than sporting, with picture hats, white gloves, pretty frocks and parasols, like participants in a Monet painting. There is always – and doubtless there will always be – controversy between fashion victims and the press because it's all good fun and cheap copy. The first Henley Regatta proper was held in 1839 and it became Royal in 1851 with Prince Albert as patron.

From the regatta starting point, downriver by Temple Island, you can see the sixteenth-century tower of St Mary's Church with its four pinnacles pointing skyward. The rest of the church dates from earlier and its outbuildings include the lovely little timbered fourteenth-century chantry house. This is the oldest building in Henley in daily use, a parish lady tells me proudly. Today the Mothers' Union are doing parish lady things with teapots and potted plants but an invitation is issued to me to look upstairs and I accept with alacrity.

With its old timbered roof and its herring-bone brick-and-timber walls it seems that this must be one of the oldest buildings in the whole country in daily use. The information on the noticeboard would seem to indicate that it has been so for about six hundred years: sometimes as a school, sometimes a chapel and sometimes an annexe to the Red Lion Hotel which has at various times entertained Charles I, the Duke of Marlborough and Johnson and Boswell.

There is a monument to Chancellor Bacon's sister, Lady Elizabeth Periam, in the church, commemorating her three marriages: to Robert D'Oyley, Henry Nevill and finally William Periam. One wonders how much choice she had in her marriages, as rich widows seem to have been bought and sold as commodities by monarchs, but I hope her influential brother saw to her well-being. At any rate, she was able to do useful things with her money, as in 1609 she founded a dame school in the lower room of the chantry house. She also founded a school for the education of twenty poor boys of the town and is thus accounted the chief benefactress of the Grammar School (now King James's College of Henley) and a yearly sermon, attended by the pupils, is still preached in her honour. Elizabeth also founded a fellowship and two scholarships at Balliol and past generations of Oxford academics might be deeply ashamed to think that women were admitted to Balliol as students only in 1979.

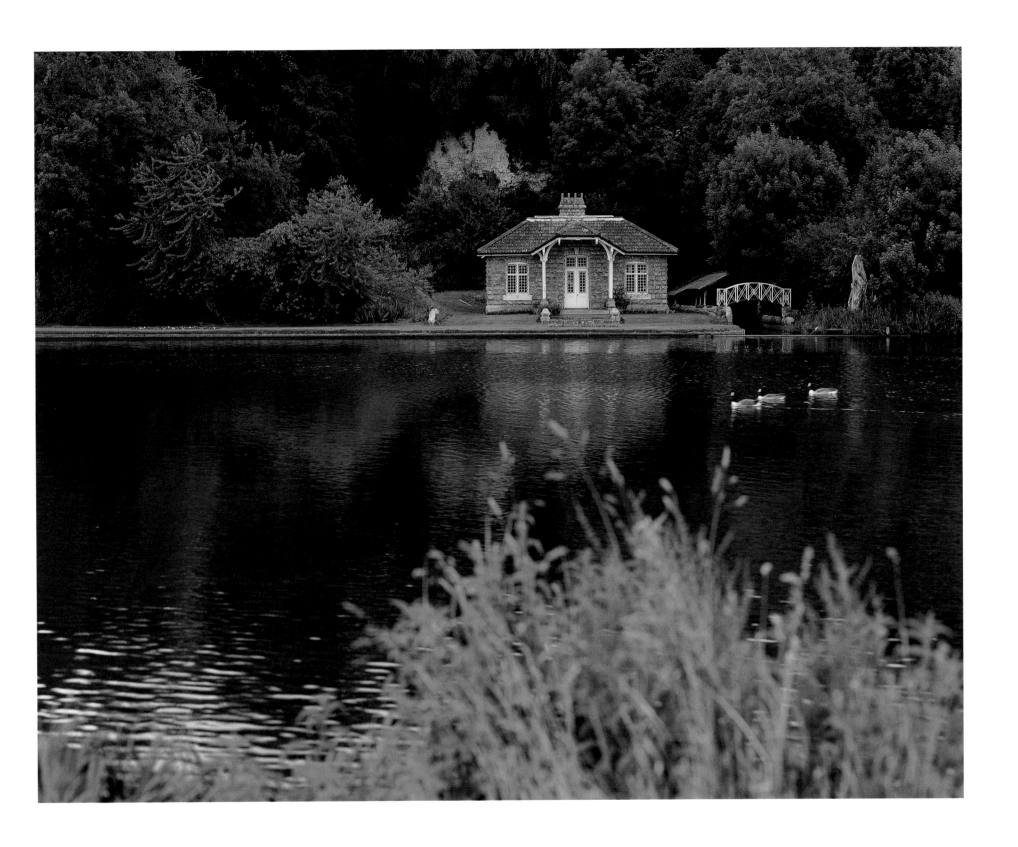

There is more to Henley than the famous regatta: calm prevails just a little
distance upriver in a stone cottage complete with its own boathouse.

When Charles II crossed the river at Medmenham in 1678 it will have been by means of ferry, this being the site of one of two such that plied the river hereabouts until relatively recently. A monument here was erected by the First Viscount Devonport in 1899 to commemorate his success in proving in court that the Medmenham Ferry was a public amenity. It was probably a relief both to the public, who could feel very free to drop their lolly wrappers and to his Lordship, who presumably no longer had to fund its upkeep.

If only there were a ferry still, but for a view of the building on your left with the ancient-looking stone arches you must cross the river by going east on the inland path to Hurley or west along the river bank to Hambleden. We choose Hambleden, where the sound of meadow pipits larking it up in the fields is soon drowned by the tons of water cascading deafeningly down a welter of terraces and a long string of walkways conducts one through that intoxicating smell of water crashing through air.

Medmenham was the site of St Mary's Abbey, founded by the Cistercian order in 1200. The Cistercians ('White Monks') stemmed from the Benedictines ('Black Monks') but whereas the Benedictines were known for their hospitality, their teaching and their charitable works, the Cistercians were more concerned with personal salvation and their order was strict and severe. The motto for both could still perhaps be the words of St Benedict: 'Laborare est orare' or 'To work is to pray', but unlike St Benedict the Cistercians seem to have taken little joy in their work. They had no servants, tending to their own agricultural labour and raising their own sheep. They eschewed participation in parish affairs and refused to get involved in estate ownership, which would bring with it the responsibility of providing knights to fight for the king. The life of a Cistercian on the banks of the Thames here would have been hard in the winter months: living in an unheated cell, eating a minimum of meat and not a lot else. Of course, leading the simple life in summer months could have been idyllic, but this was not the idea of joining a Cistercian order.

By the time of the Dissolution of the Monasteries under Henry VIII there were only the abbot and one monk left at Medmenham, and the abbey passed into the hands of the Duffield family.

It is tempting to imagine these arches as remaining from the Cistercian's cloister but all of this is illusion, a scene set in eighteenth-century Gothic style by Sir Francis Dashwood, at various times Chancellor of the Exchequer and Postmaster General. Dashwood's home was at High Wycombe, but he was granted the lease of Medmenham by Francis Duffield and proceeded to turn it into a high-class brothel where he and his wealthy, aristocratic and totally reprehensible cronies of the infamous 'Hell Fire Club' could dress up as the 'Medmenham Monks' and whoop it up in their inimitable way.

Philip Heseltine, otherwise known as the composer Peter Warlock, was one of their number, as were several self-righteous public figures like John Wilkes. Wilkes is credited with being a major force for parliamentary reform and so he was – whatever his motives. In 1776 he pleaded for the political rights of *'the meanest mechanic, the poorest peasant and day labourer'*, pleading that some share in the law-making process should be allowed *'even to this inferior but most useful set of men'*. But his real interest was in furthering the influence in the City of wealthy merchants and tradesmen. *'Do you suppose,'* he purportedly asked his opponent on the hustings as the throng cheered him on to electoral victory, *'that there are more fools or rogues in that assembly?'* But actions have longer-lasting consequences than motives and the group of men who are popularly remembered as evil reprobates were really just rather silly. The decor during Dashwood's days defied the imagination, but we are reliably informed that the place has been redecorated now and judging from these decorously manicured lawns, it seems very likely that it has.

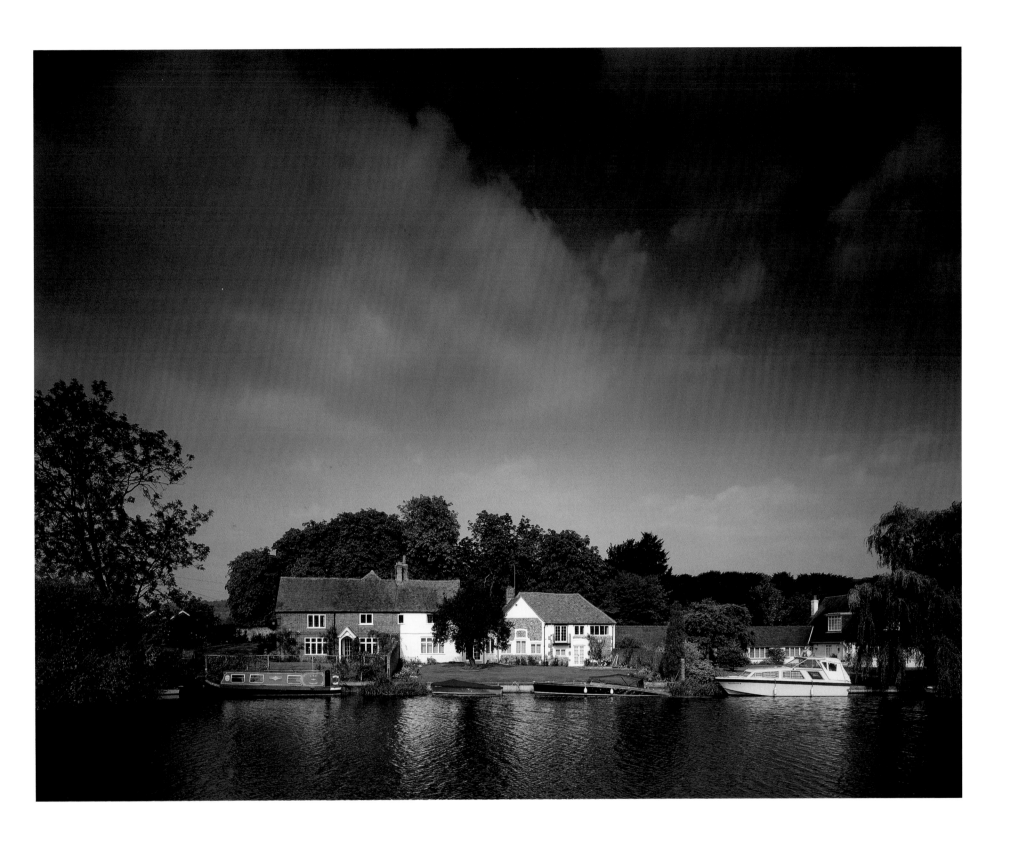

The hamlet at Hambleden Lock offers a peaceful contrast
to the crashing waters of the nearby weir.

Bisham Abbey now houses the Central Council of Physical Education and is a centre of excellence for just about every sport you can think of, from archery to weight lifting. It was built, though, in the twelfth century as a preceptory, which is a subordinate community of the Knights Templar. On dissolution of the Order by Philip IV (the Fair) of France on pretty spurious charges of heresy, blasphemy, etc. it became an Augustinian priory and then a Benedictine abbey. It is also the burial place of the illustrious Nevilles.

In 1463 Richard Neville, Earl of Warwick (a.k.a. Warwick the Kingmaker) staged a showpiece service here for the reburial of his father and his brother, killed at Pontefract. It was designed, perhaps, as a challenge to Edward IV, who had recently held a memorial service for *his* father and brother, killed at Rutland.

Warwick's problem was perhaps basically jealousy. He found it difficult to come to terms with the increasing popularity of his tall and handsome cousin Edward when the hero's role had for so long been his. The term 'kingmaker' was applied to him because the fortunes of his two kingly cousins, Henry VI of Lancaster and Edward IV of York, waxed and waned according to his support. His last change of side was to Henry in 1471, when he was killed during the Battle of Barnet. His body was exposed for three days on the pavement of St Paul's so there could be no doubt about his death. Then he was buried in the Abbey of Bisham. After his death the Nevilles lost some of their aura, because no one wants to be associated with a loser.

Strangely, his two daughters were married into both the Lancastrian and Yorkist families. Isabel married the Duke of Clarence who, in Shakespeare's *Richard III* was drowned in the butt of malmsey and Anne married Prince Edward, son of Henry VI. She is Shakespeare's 'Lady Anne'.

Bisham Abbey became a country house for Anne of Cleves on her divorce from Henry VIII, six months after her wedding at age 23. Holbein, having been despatched to paint her, had done neither Anne nor the king any favours with his depiction of an attractive and graceful girl.

'I like her not,' Henry announced on finally meeting her. Anne had a *'gravity of face'* that displeased him. We never hear what she thought when confronted with this grossly fat man, old before his time. Henry (although of course it was Anne's fault) was unable to consummate the marriage. He insisted that he doubted her virginity and was thus disinclined to perform his marital duty. Anne took Henry's decision that their marriage was 'invalid' with equanimity and wrote to her brother the Duke of Cleves begging him not to rock the boat – lest her fate be rather worse than retirement to the state of 'the king's well loved sister'.

Anne was always good to Elizabeth, who spent a lot of time here as a child, and whom most people seem to have treated in a rather off-hand manner – certainly when compared with her siblings Mary and Edward – and she developed a taste for fleshly compensations. Supplies for her London dwelling in 1556 are recorded as *'two hogsheads of beer of a ton each, three hogsheads of Gascon wine, ten gallons of Malmsey wine, ten gallons of sack…'*

Elizabeth I had other friends here besides her stepmother Anne. Bisham Church contains fine monuments to the Hoby family, who cared for the king's sadly neglected second daughter. Sir Philip Hoby was Henry's special envoy, despatched with Holbein on his next trip to ensure he didn't exaggerate the attributes of the future marriage candidates. Especially the tall and lovely Christina of Denmark, aged 16, recently widowed by the Duke of Milan. Her portrait now hangs in the National Portrait Gallery. On being assured that the king was *'the gentlest of gentlemen'* it is reported that Christina hid her face behind her fan, which shook uncontrollably. Emerging with a very nearly straight face, she replied demurely that if she had two necks the king should have one of them.

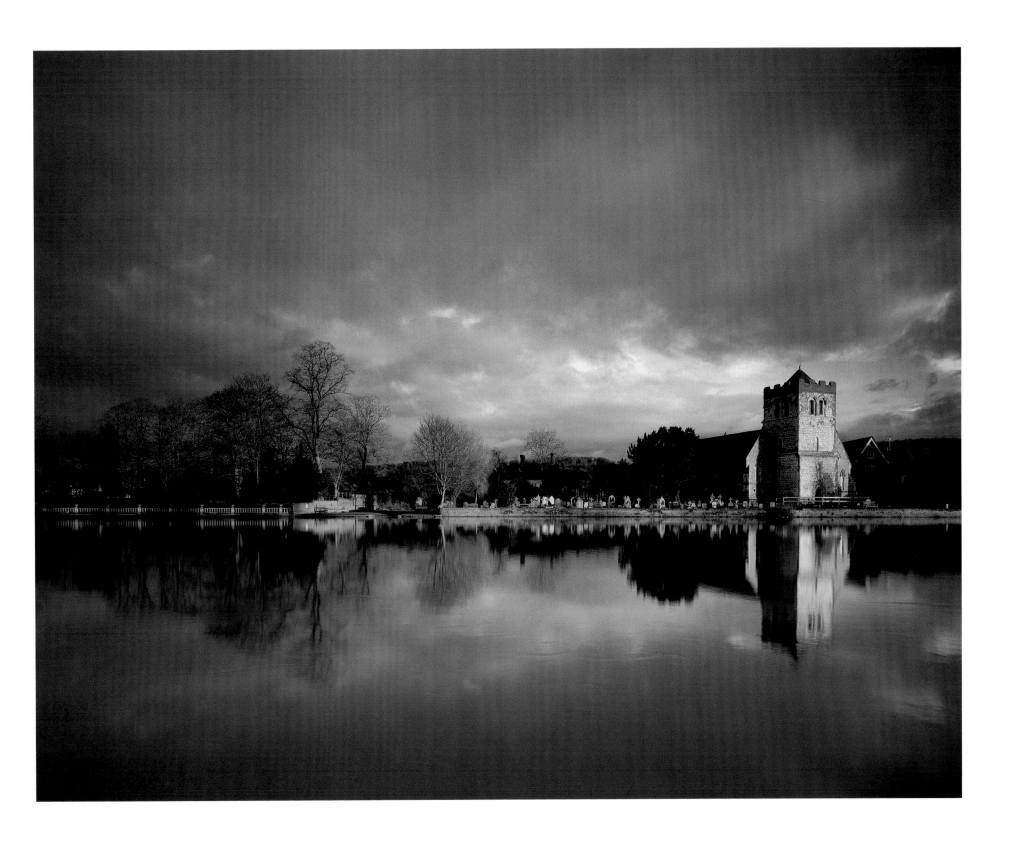

Bisham Church is superbly set, right on the water's edge. Elizabeth I spent
a lot of time here as a child with her stepmother, Anne of Cleves.

At Bourne End a cup of UHTea dribbles down my white shirt, which is unlikely to recover. It is probably a sign that I should have crossed the river at Bourne End railway bridge which has a footpath attached. But instead I take the path at the foot of Winter Hill past Quarry Wood.

> *'very long ago, on the spot where the Wild Wood waves now, before ever it had planted itself and grown up into what it now is, there was a city – a city of people, you know. Here, where we are standing, they lived and walked, and talked, and slept, and carried on their business. Here they stabled their horses and feasted, from here they rode out to fight or drove out to trade. They were a powerful people, and rich, and great builders. They built to last, for their city would last for ever.'*
>
> *'And when they went at last, those people?' said the Mole.*
>
> *'When they went,' continued the Badger, 'the strong winds and persistent rains took the matter in hand, patiently, ceaselessly, year after year. Perhaps we badgers, too, in our small way, helped a little – who knows? It was all down, down, down, gradually – ruin and levelling and disappearance. Then it was all up, up, up, gradually, as seeds grew to saplings, and saplings to forest trees, and bramble and fern came creeping in to help…'*

Quarry Wood was probably Kenneth Grahame's inspiration for the Wild Wood in *The Wind in the Willows*. It *is* like a wild wood, with hawthorn, oak, holly, hazel, hornbeam and elder all of a tangle and, struggling upwards through it now and then to catch some air, the odd tall ash.

In Bisham Woods is the old icehouse for Bisham Abbey, built in 1760 and beautifully restored. But I am getting ahead of myself. That is at the far end of the woodland. For the most part, throughout Bisham Woods is an undercarpet of ivy and dog's mercury which is apparently a sign of undisturbed ancient woodland. It depends what you mean by undisturbed. Here is the din of non-stop traffic. Every now and then a path leads off to the side and I think maybe there is a way underneath, but no. The marked paths lead you straight to the roadside and crossing the A404 is just not on. So I take an unmarked path and, where a great beech has slid from its chalk bed and toppled over the way, negotiate the root bundle and press on.

These woods have the most evocative names: The Hockett and Bisham-under-the-Hill; Fultness Wood and Inkydown Wood. And they are famous for bluebells in spring, but their more obscure plants also include members of the orchid family like the birds nest orchid and violet and green-flowered helleborines; as well as yellow bird's-nest, tutsan, thin-spiked wood sedge and yellow archangel. I am approaching the task of identification with a kind of frenzied purposefulness which must be due to the non-stop traffic. How can I loiter in woods to so little purpose when the rest of the world seems so preoccupied? Through the spaces in the traffic, even a woodpecker is practising typing. And doing rather better at its task than I am.

Shelley walked here with Peacock, at a time when he felt over-whelmed with remorse about his first wife, Harriet. He told Peacock that he intended to *'take a great glass of ale every night to deaden my feelings'*. Shelley had eloped with Harriet when she was just sixteen and repeated the escapade in 1815 with Mary Godwin when she was also aged sixteen; the year after Harriet had committed suicide by drowning herself in the Serpentine. Harriet believed it was the idea of Mary Wollstonecraft's daughter that attracted Shelley.

> *Most wretched men*
> *Are cradled into poetry by wrong,*
> *They learn in suffering what they teach in song.*

Bluebells abound in Quarry Wood. In Kenneth Grahame's
The Wind in the Willows the Badger lived here.

Plans in 1966 to demolish Marlow's elegant suspension bridge, completed in 1836, were fortunately defeated and it was renovated instead. But one suspects the impatient rush-hour traffic gives not a jot for Tierney Clarke's masterpiece. The bridge allows for single lane crossing only, so when they get the go-ahead the drivers follow too close to each other. A Volvo has hit a Rover in the back, crumpling it severely, but the Volvo has suffered no more than some scratched paint, and the Volvo driver, getting out his business card, looks positively smug.

Percy Bysshe and Mary Shelley lived in Albion House, West Street, now named Shelley Cottages, between 1816 and 1817. Shelley Cottages is an attractive little whitewashed rough-cast terrace with scalloped windows which do credit to some extraordinary craftsman. In 1867 Sir William Robert Clayton, Bart, placed a tablet on the parapet inscribed:

> *He is gone where all things wise and fair…*
> *Death feeds on his mute voice and laughs at our despair*

When the Shelleys lived here, the lace-making trade, for which the town was famous, was in the doldrums and Marlow was hit by severe poverty. Although never destitute – 'Bysshe' expected to inherit a substantial family estate – the Shelleys were always short of money and Albion House suffered from damp, so they felt they had some idea of poverty. Shelley provided blankets, food and other necessities for the poor and the rich thought he was mad.

The lace-makers were not alone in their difficulties. When the weavers' demand for a minimum wage led to the use of troops by employers and property owners to 'keep the peace', Shelley was incensed. His revolutionary instincts were aroused and he wrote *The Revolt of Islam*, a symbolic tale which illustrates, as Shelley says *'the growth and progress of individual mind aspiring after excellence and devoted to the love of mankind… and its impatience at all the oppressions that are done under the sun.'*

Shelley longed for the ideal society. His wife Mary, the daughter of William Godwin and the feminist Mary Wollstonecraft, was a grafter. She wrote *Frankenstein* while they lived in Marlow and she worked hard at her novels and stories after his death. Shelley saw the reconstruction of society as his work. While living here, writing as 'The Hermit of Marlow' he published 'A proposal for Putting reform to the Vote', and when Princess Charlotte, the popular daughter of George IV and his despised wife Caroline of Brunswick, died in childbirth in November 1817 he wrote 'An Address to the People on the Death of Princess Charlotte'.

The Shelleys had been encouraged to Marlow by one of the more down to earth of Shelley's friends, Thomas Love Peacock, who also lived in West Street in a house which is now a motoring superstore. Although he supported a good many of Shelley's beliefs, Peacock was perhaps a little more worldly and cynical in his espousal of the means for social betterment. Also, whereas Shelley, despite his frequent lack of money, never actually considered that he might get a job, Peacock was very much of the establishment, holding an important post with the East India Company.

Shelley's hypochondria must have driven Mary to despair as he variously supposed himself to have elephantiasis and consumption. But it was not illness that finally despatched him; he drowned in 1822, sailing in the Mediterranean.

At Oxford his father had introduced Percy Bysshe to the local booksellers and printers Slatter and Munday: *'My son here has a literary turn… do pray indulge him in his printing freaks.'*

Yet Timothy Shelley, so keen to further his son's literary interests at University College, forbade the publication of any of his works after his death on pain of ending his allowance to Mary and Percy Florence, their only surviving child.

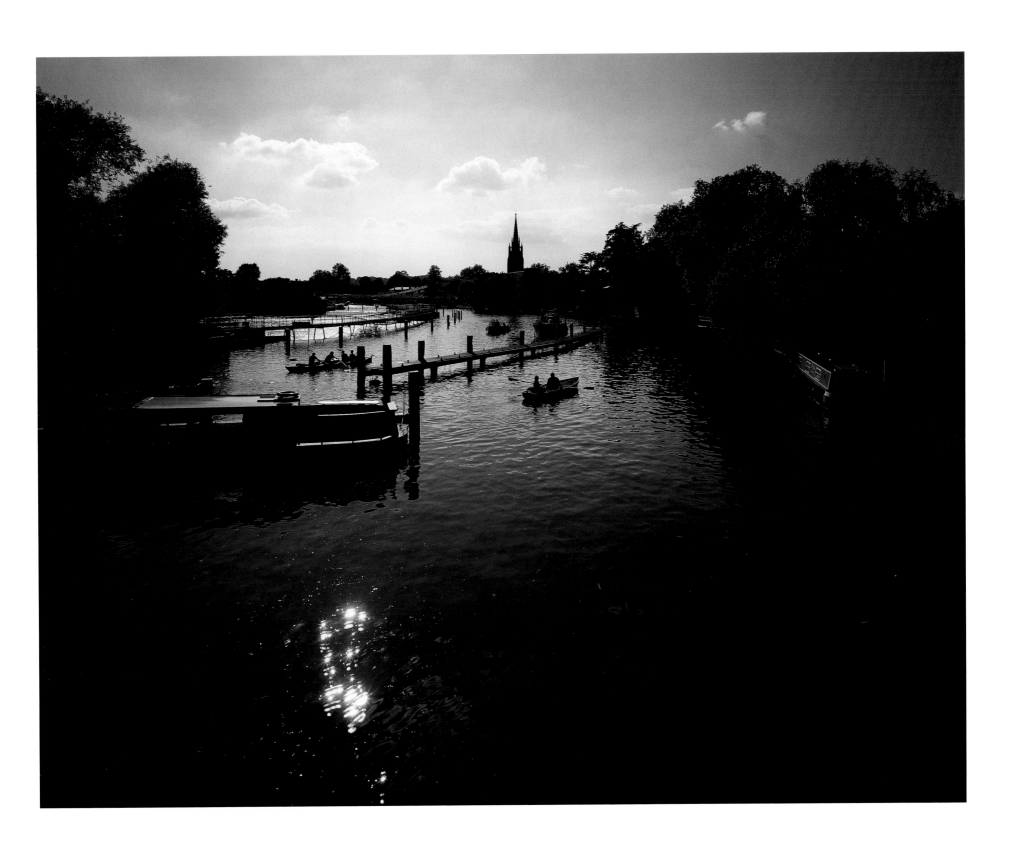

The fine riverside town of Marlow offers rewarding walks, including
views of the suspension bridge by Tierney Clarke and the church by
Sir George Gilbert Scott.

'*Art is 90% living*' wrote Stanley Spencer to his brother Gilbert in 1952, and Stanley lived to the full, despite limiting himself almost entirely to the Thames-side village of Cookham.

'Cookham' was the name he was given by his contemporaries at the Slade School of Fine Art when he took up his place there in 1908, and it was to tea in Cookham at the family home, Fernley, that he returned every evening after his day at art school.

Fernley stands in the High Street, semi-detached from its partner, Belmont. The pair were built for Stanley's father, William and his brother, Julius, on their respective marriages by their father. In fact, much of Victorian Cookham was built by Julius Spencer Snr, the local master builder at the time. In his book *Stanley Spencer by his brother Gilbert*, Gilbert Spencer decries his grandfather's houses as ugly, but perhaps tastes have mellowed since then. Fernley and Belmont are not seriously ugly – simply solid, uncompromising villas in the Victorian manner, intended to house large Victorian families.

William Spencer's family was large. Stanley was one of ten surviving children, and the grave of three who died in infancy is in the local churchyard, alongside a simple memorial to Stanley and his first wife, Hilda. Probably in about the spot from which Stanley envisaged the monumental *Resurrection, Cookham* now in the Tate Gallery. Did the young Stan picture the resurrection here as a child, visiting the grave of his deceased siblings? Certainly, for him, the world and the hereafter were encompassed in Cookham; Gilbert remembers that Stanley had an idea that Heaven was sideways – just out of the corner of his eye, on Widbrook Common.

Stanley Spencer never rated his landscapes highly. He was always disappointed that the public preferred them to what he considered his real work of the religious pictures, in the realm of which he numbered his later 'sex' pictures, including the naked double portraits of himself with his second wife, Patricia Preece.

Hilda and Stanley divorced in 1937, Stanley having met and fallen in love with Patricia who had also studied at the Slade. He married her the same year but the marriage remained unconsummated. Although there is no doubt that Stanley loved Patricia, neither is there doubt that he loved Hilda until her death in 1950, writing letters to her regularly to which she, unable to share in his vision of a love which could encompass everyone, never responded. He continued to write to her even after her death.

There is a directness, a certainty about Spencer's work. Just along from Fernley is the Stanley Spencer Gallery where one entire wall is taken up with the uncompleted work *Christ Preaching at Cookham Regatta*. The central section is almost finished, with Christ leaning forward from his cane chair wearing a black straw boater, a censorious figurehead leaning to the crowd ashore and local figures including the publican and 'the Turk' who hired out boats from the boatyard, shouldering a conglomeration of oars, paddles and cleaning equipment. The rest of the canvas is squared out with figures drawn in ready to be painted, but what clarity in this drawing! Stanley Spencer was uncompromising in his life and in his art. He knew exactly what he had to do. One thinks of him in the closing stages of the First World War, obsessed with *Swan Upping at Cookham*, still waiting, unfinished, in his bedroom at Fernley. He wrote of that time:

> *I was being detailed off for worse and worse dangers. As an infantry man what would have been the use of this insignificant fragment of gun fodder that I was if I had said to the sergeants 'I have a picture at home and I just want to finish it before going into this attack…'*

Spencer did get home to finish his picture, and even if the unimpressive Cookham bridge which features in the picture were to be demolished tomorrow, *Swan Upping at Cookham* would remain safely at the Tate Gallery. Which is enough for me.

Cookham churchyard seems to be full of Spencers:
the artist Stanley Spencer's *Resurrection* was viewed from here.

When, in 1938, Mr Chamberlain returned from his meeting with Herr Hitler waving his worthless piece of paper to an ecstatic electorate proclaiming *'Peace in our time'*, Lady Astor and her cronies from Cliveden believed their policy of appeasement had been vindicated.

The 'Cliveden Set' was not, as was rumoured, pro-Nazi, yet neither was the MP in Hyde Park entirely wrong in complaining that foreign policy was decided not in Cabinet any more but at Lady Astor's country home. Waldorf and Nancy Astor and their friends (including the editors of both the *The Times* and the *Observer*) were idealists, believing that once the more reasonable of Hitler's grievances had been sorted the unreasonable could be despatched more forcefully – if they still remained.

But Winston Churchill was unimpressed. He could see, from the way the *Führer* was swallowing up the small states surrounding the Fatherland that there would be no appeasing Hitler, and once the popular press realized the same they turned on Cliveden with the self-righteous fury peculiar to those who feel they have been conned.

Churchill and Lady Astor were never to be close. Churchill was invited to Cliveden along with the rest of the famous and influential people of his day, but Lady Astor's glamorous lifestyle and her amateurish approach to politics (her husband, Waldorf, wrote her speeches, but in the House Lady Astor was likely to sidetrack into anecdotes more suited to a dinner party) irritated him intensely.

'Winston,' said Lady Astor to Churchill at a Cliveden breakfast, 'if I were married to you I'd put poison in your coffee.'

'Nancy,' replied Churchill gloomily but with feeling, 'if I were married to you, I'd drink it.'

The great stately pile of Cliveden, designed for the Duke of Sutherland by architect Charles Barry in 1850, had been a wedding present to Waldorf and Nancy from William Waldorf senior, Waldorf's fabulously rich and reclusive father, 'Walled-off' Astor as he was nicknamed in the press. Not *his* press of course: he bought the *Observer* in 1911, later giving it to Waldorf Jnr, and by the time of the Second World War *The Times* was owned by his son John.

When petite American society belle and divorcée Nancy (née Langhorne) moved into her father-in-law's gift she set about furnishing it to her taste (retaining the panelling from Madame de Pompadour's eighteenth-century Château d'Asnières) and entertaining the élite. Her guests included Edward VII and Mrs Keppel, Kipling, Belloc, Henry James, Sargent (he painted the portrait of Nancy hanging in Cliveden), George Bernard Shaw and T.E. Lawrence, to name a few.

Her husband Waldorf became MP for Plymouth, doing a useful job in Lloyd George's government setting up the new Ministry of Health. It was always his intention to head the ministry, but then his father died and Waldorf was despatched unhappily to the Lords. Which is when Nancy stepped in to his shoes to become the first woman MP. It is ironic that in 1918, when women's suffrage had finally achieved its aim and women were given (nearly) full political rights, that the first woman elected to Parliament should be not impassioned suffragette Christabel Pankhurst but society hostess Lady Astor.

Nancy's political career was successful enough and her Christian Science faith – or her personal version of it – kept her in good health and spirits. She campaigned on social issues, particularly Prohibition which proved a great election liability, and she enjoyed it immensely, but one can't help feeling that it was an absorbing hobby for her. Her great friend and Cliveden habitué George Bernard Shaw described her approach: *'She has no political philosophy and dashes at any piece of kindly social work that presents itself, whether it is an instalment of socialism or a relic of feudalism…'*

But it is probably Harold Nicolson who described doing battle with Nancy in the House best of all. *'It was,'* he said, *'like playing squash with a dish of scrambled eggs.'*

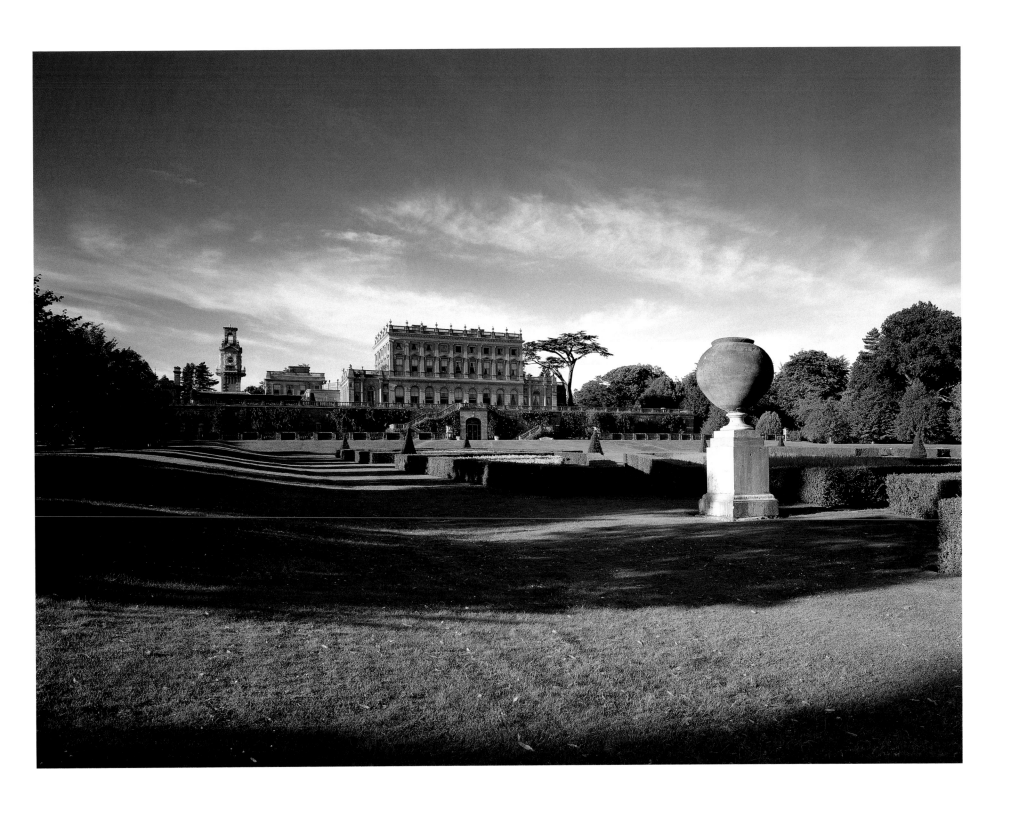

Cliveden, built in a dominant position above the Thames at Taplow,
has been the scene of much political and social intrigue.

Trying to cross the dual carriageway *en route* from Maidenhead's railway station to the river I am hailed by the youthful driver of a pulsating red sports car travelling at speed.

'Plucky idiot!' He yells admiringly. I think that's what he says. It sounds a bit like that.

I am not sure why engineers talk of bridges being 'thrown' across rivers, unless it is a kind of macho bravado, trying to persuade us that this most extraordinary feat of their skill is a mere bagatelle. Maidenhead Bridge was clearly not thrown. It was designed by Robert Taylor and constructed in 1777. It is made of Portland stone, is beautifully balustraded and can be viewed to advantage through the spans of Brunel's railway bridge of 1839. Perhaps Brunel's bridge was shied. It crosses the Thames in two elegant bounds like a skipping stone, the central pier pausing momentarily on an island. Brunel's bridge is of brick and has probably the widest span as well as the shallowest rise ever achieved in pure brick construction. The painter Turner greatly admired it and used it as the setting for his painting *Rain, Steam and Speed*.

The great BBC broadcaster Richard Dimbleby lived in a rather lovely house on Ray Mill Island in the middle of the Thames a little to the north, to which you can cross to see Boulter's Weir, at present undergoing major renovation. 'If travelling alone,' reads a notice, 'park and walk to the site office where you will be given a banksman.' It might be rather nice to have a banksman, but I don't know if I've brought enough lunch, so I carry on.

The steep chalk scarp of the Chilterns forces the Thames into a north-south stretch between Maidenhead and Cookham and the great stately pile of Cliveden rises four-square above the beech woods opposite. It looks – well, frankly, it looks scary. Down at the water's edge, though, is Spring Cottage and a couple of nights there could be yours for about £2,000. Fully serviced, of course.

This picture-book cottage with its sculptured chimneys was built in 1813 and enlarged in the 1870s for the Duchess of Sutherland, lady-in-waiting and confidante of Queen Victoria. It was the place they chose when they wanted somewhere private to talk.

In the swinging 60s Spring Cottage was rented from Viscount 'Bill' Astor by Dr Stephen Ward, a man gifted with healing hands (he practised osteopathy) as well as immense charm and artistic ability. He was less gifted when it came to choosing friends. Celebrities of the time were happy to spend days or weekends as his guests here but nearly all of them abandoned him when he needed their support. He committed suicide in 1963, just as he was about to be pronounced guilty of the dubious charge of living on the immoral earnings of Christine Keeler and Mandy Rice-Davies.

Stephen Ward's downfall was an extraordinary bit of luck for the erstwhile Minister for War John Profumo, though. Focusing attention, as it did, on the sordid details of the lives of two pretty but extraordinarily silly girls, Ward's trial displaced from public awareness the fact that Profumo had lied to Parliament about his private life. He had been carrying on an affair with Miss Keeler at the same time as had Yevgeny Ivanov, a Soviet Naval Attaché. In the great scheme of things it all mattered not a jot – Profumo was hardly likely to have entrusted state secrets to the vacuous Miss Keeler, although it was helpful for the sales of her memoirs that he *could* have done.

Perhaps it was just inconvenient that the Cold War was in progress just as England was swinging. Or perhaps it served to bring everyone down to earth again when they were getting carried away by the apparent glamour of it all. Or perhaps I'm just a bit of a cynic.

Anyway, Profumo's career in politics was over but he was awarded the CBE in 1975. Following Ward's trial and death he devoted his time to charitable works. Well, he would, wouldn't he?

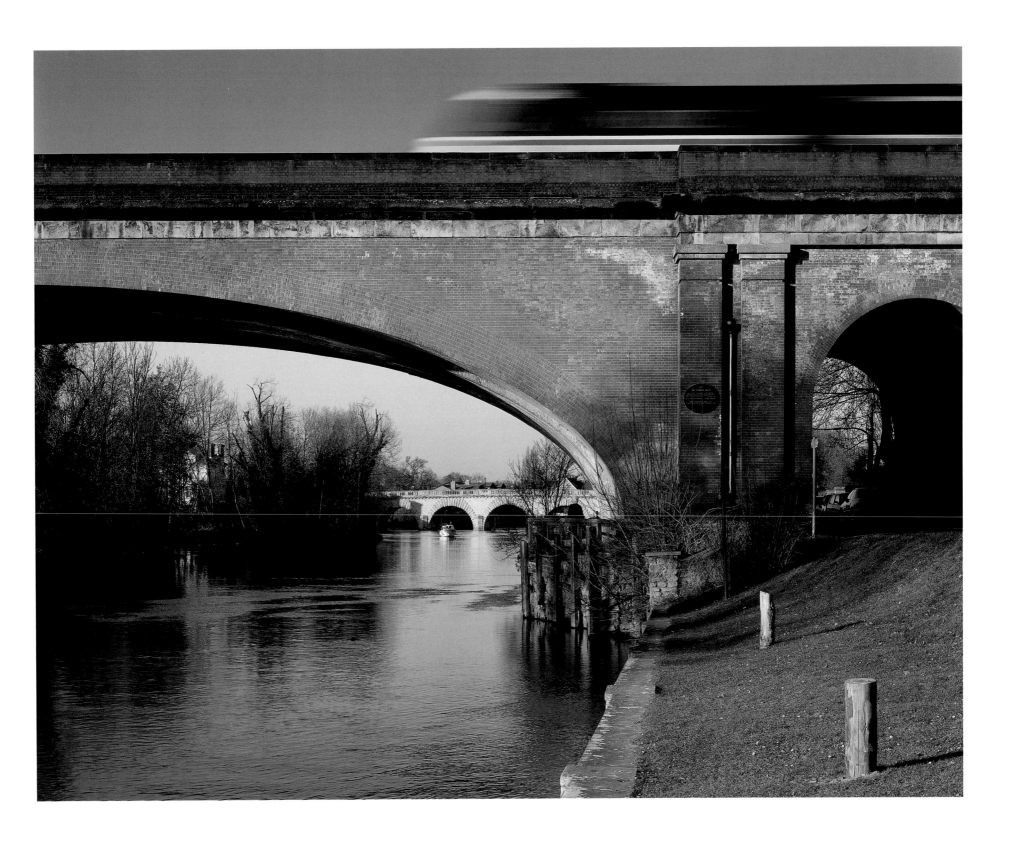

Maidenhead's stone bridge of 1777 is viewed through
the spans of Brunel's railway bridge of 1839.

Bray has been civilized for a very long time. Neolithic pottery and flint tools have been found in the river here, which means that urban life has been in progress for more than 5,000 years. People grew crops, reared stock, lived in wickerwork huts (which they later set on piles) in stockaded villages, they made dug-out canoes and they traded and fought with each other. And, no doubt, they fought with the Bronze Age people who swept up from the coast in a series of sorties from about 2,000 BC. The Bronze Age people, too, left evidence of their culture in the river: swords, axes, spears, bows and flint-tipped arrows, of both local and European origin, which suggests that having set up house here they remained extensive travellers and traders

It also suggests that the Thames has always been a trading route: a natural means of transporting people and goods from place to place. So one can understand the ire of the river traders of the City of London in 1253 when they refused to pay tolls to Godfrey de Lyston, Constable of Windsor Castle and Bailiff of the Royal Manors of Cookham and Bray, who had 'arrested' their boats and goods. Because although, as the 'King's Highway', the river was free, boatmen were charged for tying up to the bank or for wharfage tolls.

Godfrey had arrested the ships of the citizens, exacting from each the sum of sixpence *contrary to their liberties* whilst working for Henry III, who was obviously doing a bit of fundraising for his ecclesiastical projects.

To reach the village of Bray from the Thames Path today you have to hoist your bike up the steps of the bridge and join the traffic from the M4. But its attributes are many: the ancient almshouses, the rural setting, exclusive restaurants by the river, Monkey (i.e. 'Monks') Island with its smart hotel incorporating parts of the Duke of Marlborough's fishing lodge; and the sixteenth-century church of St Michael with its charming 'lich' gate beneath an attractive Tudor brick-and-timber house.

Not forgetting, of course, that this was the patch of the overly accommodating vicar of the anonymous eighteenth-century song, who lived through the reigns of Charles II, James II, William III, Anne and George I, adapting his religion to suit the current sovereign.

In fact, there have been at least two clergymen to fit the description of the famous song. The sixteenth-century vicar Simon Aleyn, who lived through the reigns of Henry VIII, Edward VI, Mary and Elizabeth, was also amiable enough to embrace the religion of each of his monarchs, thus being twice a Catholic and twice a Protestant. But although he may have changed his religion, he, too, could have assured his critics that he remained true to his principle, *'which is to live and die the Vicar of Bray'*. Of course, as the story was told by Disraeli, it could be taken with a pinch of salt.

Which is more than I am offered, inadvertently wandering on to the river terrace of one of the afforesaid exclusive restaurants, being intent on a leisurely pint of ale by the river. 'This is not a *bar*, Madam,' says a smartly uniformed lackey eyeing my trusty Hercules with what I feel is an unnecessary disdain. Bray is noted for being accommodating *up to a point*.

The church is closed today – surely it is not so many years ago that churches were always open – but I wander around the churchyard while I recover from the M4 experience. A blackbird sings to me from the top of a yew about George Watson of Maidenhead who 'passed away' in 1887 at the age of thirty-one. Just a minute! Where is the anger of this young widow, the venting of the spleen, the fury? You can't just 'pass away' at thirty-one! How prissy, how middle class, how profoundly irritating! Don't they have any basic human instincts here? I am still pondering the question when I arrive back at the river. A decidedly elderly and dissolute-looking heron is hunched on a buoy. What does he think of it all – life, the universe, Bray, everything? His back is extremely expressive. 'Search me,' it says.

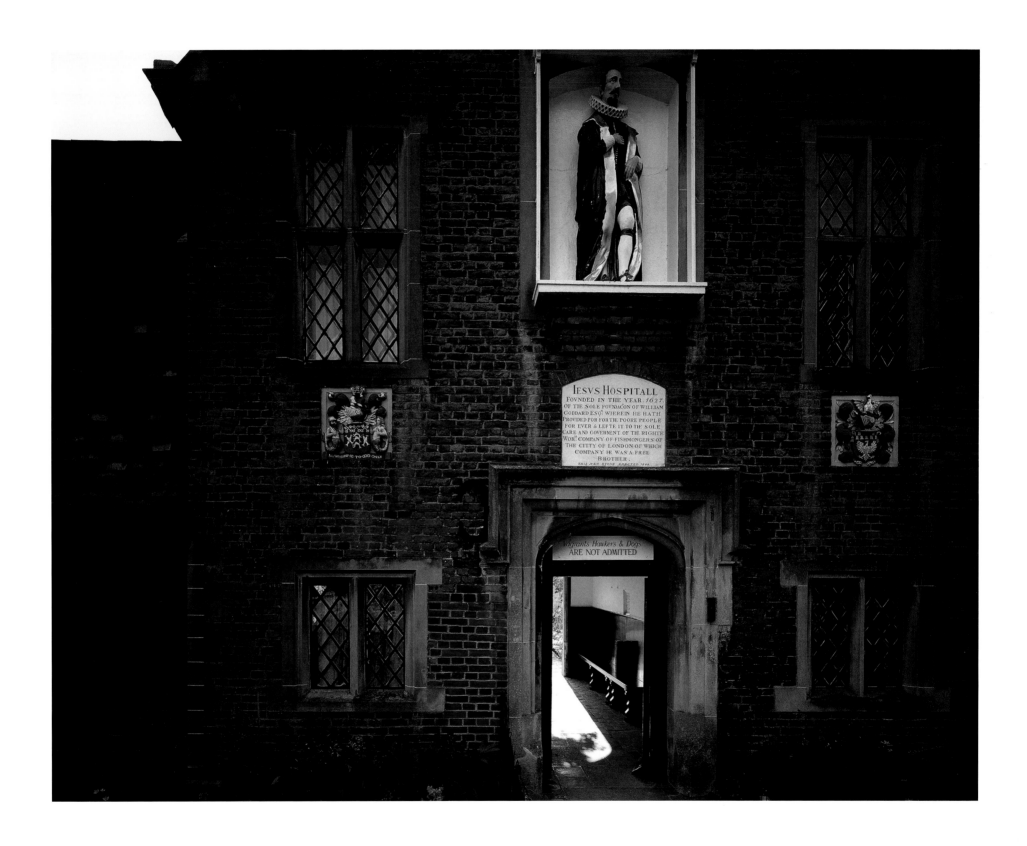

In Bray the Jesus Hospital of 1627 offers succour to worthy cases –
excluding the riff-raff, of course.

On the river bank between Boveney and Eton grows a mallow of truly celestial blue and once you stop to admire it there is no end to the wonders. Here is a convolvulus with delicate pink stripes, here are absolutely perfect teasels and here lacy dessicated umbellifera seemingly ten feet high. To the right is the massive construction of the new Eton boating lake and, as you turn off on the path to Dorney, you realize that the background squeaking that has been accompanying you for the past few miles is not to do with lack of cycle maintenance but a massively long conveyor belt removing the spoil from the dig.

Dorney means *the island of the bumble bees* and the manor of Dorney is detailed in the *Domesday Book*, the then owner, Milo de Crispin, having come over with the Conqueror. Who he displaced is not known, but there was a Saxon owner because there still survives the old Saxon winter larder: a pond stocked with carp and four islands where fowls were kept safe from hungry predators.

Dorney's kitchen garden is now run by Bressingham, with a pick-your-own orchard and honey from the Dorney hives and if you could buy seeds from that blue mallow you could ask for no more. Gardening is a tradition here, ever since a Dorney gardener, the horticulturist aptly named John Rose, was the first person in England to raise a pineapple successfully, the end product being presented to King Charles II who had set the challenge.

The current house dates from 1420, with the usual updates since then – or at least, not the usual updates: Dorney Court remains encapsulated as a jewel of the Tudor era, any renovations, additions and improvements having been undertaken with an extraordinary sensitivity and a visibly apparent love for the original concept.

Sir James Palmer of Dorney was Chancellor of the Garter to Charles I and acted as art advisor to him and to his father James I, and the Palmers remained loyal to the Stuarts throughout the turbulent years of civil war and religious persecution. So while the Dorney Church of St James the Less just across the way toed the official line throughout, embracing Protestantism as required, the recusant Palmers sheltered a priest and in the front parlour is a proper priest's hole.

The bedrooms still have the original curved twig ceilings and green oak panelling which has mellowed over the years by stretching here and shrinking there into a proper Tudor shape. The reason Tudor woodwork looks so curvaceous, our guide explains, is because the oak had to be carved when green, seasoned oak being too hard to work. She also mentions the ghost of the little grey lady who sits on the end of the bed in the small bedroom and weeps. 'The staff from the village refuse to enter the room,' she says, 'But I have no feeling for ghosts.' Nevertheless, I notice that she stays outside.

The Palmer family have lived here for four hundred years and four hundred years' worth of family portraits hang in the hall, including one of Barbara, Lady Castlemaine, beloved of Charles II.

On 13th July, 1660, just weeks after the king's restoration Samuel Pepys recorded in his diary: '*great Doings of Musique… the King and Dukes there with Madam Palmer, a pretty woman that they have a fancy to make her husband a cuckold…*'

It was not difficult. Shortly afterwards Roger Palmer was created Earl of Castlemaine (Barbara required a title) and despatched to the Levant as ambassador to look after the interests of British merchants. He was not unduly put out, having few illusions as to his wife's fidelity: Barbara Villiers had been married to him at an early age because her mother simply didn't know what else to do with her.

Barbara herself was to confess to the king: '*You know as to love one is not mistress of oneself,*' which Charles knew very well, having a notoriously wandering eye himself, so he forgave her several times. Only the last of her children did the king refuse to acknowledge as his own; and no, the Palmers are not descendants of Charles II. But you'll have to go to Dorney for the whole story.

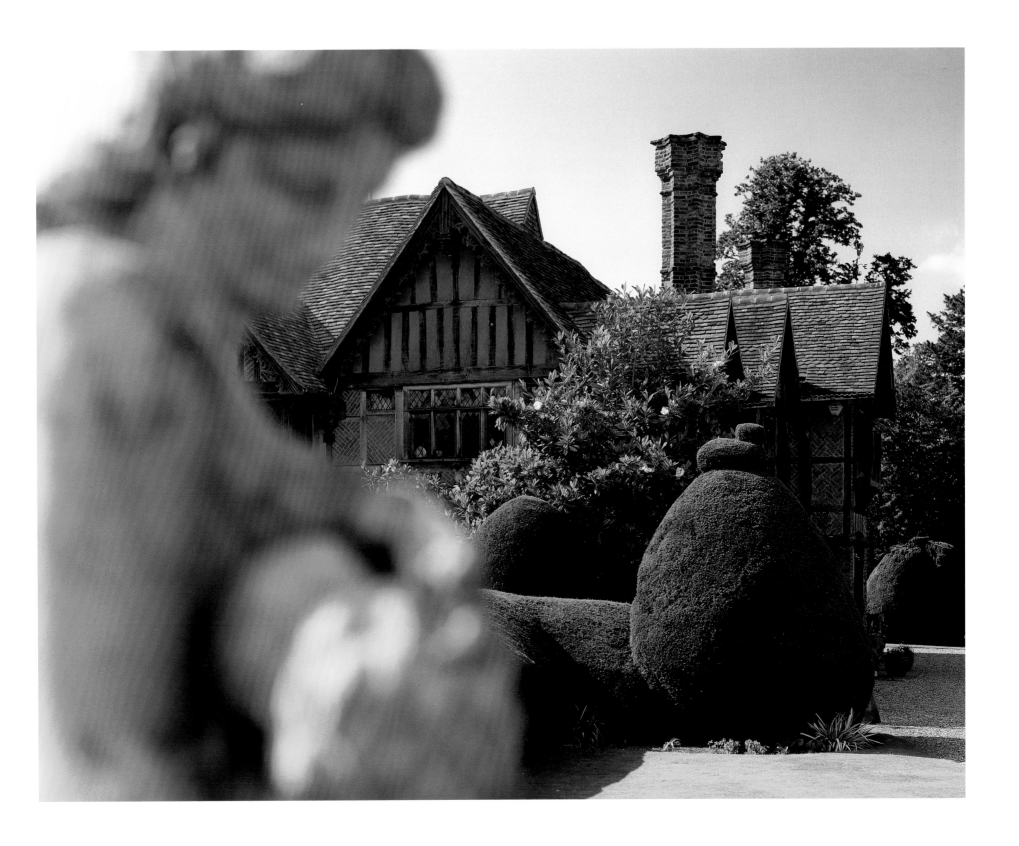

Dorney Court, dating from 1420, is still a family home to which
visitors are warmly welcomed.

A paddle steamer party passes me *en route* from Boveney to Eton. Men in suits with glass raised are saying earnestly to each other: 'Uurr urr uuurh' and the peacocks on the lawns of the Queen's Eyot Hotel on the far bank are mocking: 'Eaurgh! Eauurgh!' To my left are desirable residences with inscrutably smooth lawns and across on the further bank a ruined threepenny-bit boathouse, overgrown with a tangle of vegetation which I find appeals more to my sense of the romantic. Apart from the midges, of course.

'That! You must be Jyeeooowking!' shriek the peacocks from Queen's Eyot. Eyot means island. Ey generally means island. Thus Dorney, Boveney, Thorney… all were islands at some time, which means that the Thames at one time was a great, genial, sprawling giant of a river – covering a great deal of what is now lush pasture land. And it may be simply that Eton is reclaiming a part of the river it feels it has lost by excavating a new boating lake just here where I thought the path to Dorney Court should be. 'No! NO! NGEE-AA-O!' shrieks a peacock. But I ignore it. My map says the path exists. And it does – sort of; but it diverges apparently away from Dorney Court which is where I want to get. I give up and the peacocks give me three hearty 'AAGGHHs'.

The river this evening is awash with Eton skiffs – I have passed their boathouse and think it's a shame they are deserting the river for their own lake. They seem so much a part of the English summer, somehow. Yet the language of the coach is a foreign one: 'Three quarters, three quarters, three quarters… and *rake!* Right hand next, right hand… OK Light. Don't rush, don't rush…' The crew is being bossed unmercifully by a trunkless head in the bow. 'ONE! TWO! THREE! FOUR!' he yells. Then, kindly, 'Easy up.'

The tiny church of St Mary Magdalen at Boveney dates from the twelfth century. It is low, with doors at a height to suggest that the original floor must be some way below the current level of the grass outside. Which could, in turn, suggest that there is a graveyard here, a fact about which there has been some dispute.

The church has been disused for a number of years but the key is available from the local churchwarden. The interior is cool, quiet, austere. No decoration but for a hanging coronet of four metal candle holders reminiscent of the coronet of a Plantaganet king.

Outside, the sun comes out and the field of the unspeakable rape is blindingly yellow and ebulliently, hopelessly, ridiculously cheerful. You could almost like it. The path to Eton is pleasant, the fifteenth-century chapel of the famous school rising above a distant bank. From the M4 the quiet roar of incessant traffic, from the path here the quiet and the sweetness of the smell of rape.

This is the end of the day and I cross the bridge from Eton to Windsor, past a shop that proclaims ETON HAMPERS with all its connotations of public school boys and jolly japes and – hang on, my step-grandfather went to Eton. He was bullied remorselessly. 'But it wasn't so bad,' he reminisced fondly, 'You survive and after a while it's your turn to do the bullying.' Which is no doubt why the sons of Empire were such warm and understanding human beings. Gladstone called Eton 'The queen of public schools'. I rest my case.

The humble bumbles buzz and the sun shines approvingly on Henry VI's chapel of Eton College and here is a board displaying a copy of the Eton School rules from 1921: '…*boys who are undressed must either get at once into the water or get behind screens when boats containing ladies come in sight.…*' And quite right too. Having had a quick look to ascertain that none of the hunky lads from the boat shed are skulking, I am proceeding in a decorous manner when, with all of the mighty Thames to choose from, a midge decides to put an end to it all. It happened to James I and VI as well. 'Have I four kingdoms?' he remonstrated. 'And must you fly into my eye?'

Eton's new boating lake is being excavated near the
ancient church of St Mary Magdalen at Boveney.

From the surrounding area it is clear that Windsor Castle is one of the great sights of England and so it has been for nearly a thousand years. The prime reason for its selection by the Conqueror was that it was the most defensible site in the area, and the fact that the locality abounded in wild game for hunting probably came a very close second. Today's Windsor Great Park has been carved from William's hunting ground.

The on-duty policeman suggests that I leave my bike at the railway station. He cannot be serious. But I turn back from the car park and as his attention is deflected, tether it to the railings outside the Earl's Sandwich Bar. The Earl's Sandwich Bar is not run by an earl. It is run by Earl from Los Angeles. He has a royal line in patter: 'Just get your coffee from my granny over there,' gesturing to the young woman at the far counter. 'Where you from? London? You mean you came all the way from London for one of our sandwiches?'

You cannot visit all of the castle – it covers over 13 acres – just St George's Chapel and the State Apartments, and it is more than a little frustrating to be turned back from Henry III's thirteenth-century tower and the glimpse of an appealing jumble of medieval houses through a stone archway. But it is understandable when you consider that within the castle precincts lives an entire town-within-a-town: the Constable and Governor of the castle, the Military Knights of Windsor, the Dean, canons and choristers of St George's Chapel and the Household Regiments – all with families who have a right to privacy easily overlooked in a national monument.

But it is still worth the entrance fee. The state apartments are fabulous. Amongst all the gilt and the carvings by Grinling Gibbons, the fireplaces by Adam and the beautiful antique furniture and armour you just wander past paintings by Rembrandt, Van Dyck, Canaletto, Rubens, Reynolds, Lely, Holbein, Van der Velde, del Sarto, Zoffany, Hogarth… the whole thing is unbelievable. Ridiculous. And there is St George's Chapel. For a mere pittance you may even get a guide to yourself, and just soak it all up. It is beautiful and your guide will love it to bits, which makes all the difference. The chapel was first built by Henry VI as a place of pilgrimage, but after his deposition his cousin, as Edward IV, began it anew. Very sound PR, considering he had usurped the throne of a perceived saint.

The castle has been refined and improved by pretty well every monarch since William I and loved by most: King John 'loved Windsor above all others' and when in 1216 the town and castle were besieged by the barons intent on their Great Charter it was back here that he licked the royal wounds and shrugged the royal shoulders.

John's son, Henry III, built a wooden bridge over the Thames to Eton and in his time the town developed between the castle and the bridge. Henry's son, Edward I, spent much of his childhood here and here in 1254 he married his beloved queen, Eleanor of Castile. Their grandson, Edward of Windsor (later Edward III), was born here and it was he who on St George's Day 1350 established a chantry of twelve priests and set up a hostel for impoverished knights no longer able to support themselves: the Knights of the Garter.

Windsor was Queen Victoria's preferred residence in the early years of her reign and she entertained much of European royalty here, including Louis Philippe, Tsar Nicholas I and Napoleon III. These were Victoria's happiest years, when she had her adored husband Albert at her side and her nine children were dispersing in marriage about the royal houses of Europe.

Windsor as a family name has been in use only since 1917, when George V dispensed with Saxe-Coburg (Albert's name) as a proclamation of his Britishness and independence from his German relatives. Which would have been sad for Queen Victoria.

I unshackle my bike as Earl is slapping together another sandwich for a punter: 'You mean you came all the way from Wallington for one of our sandwiches?' I don't think so.

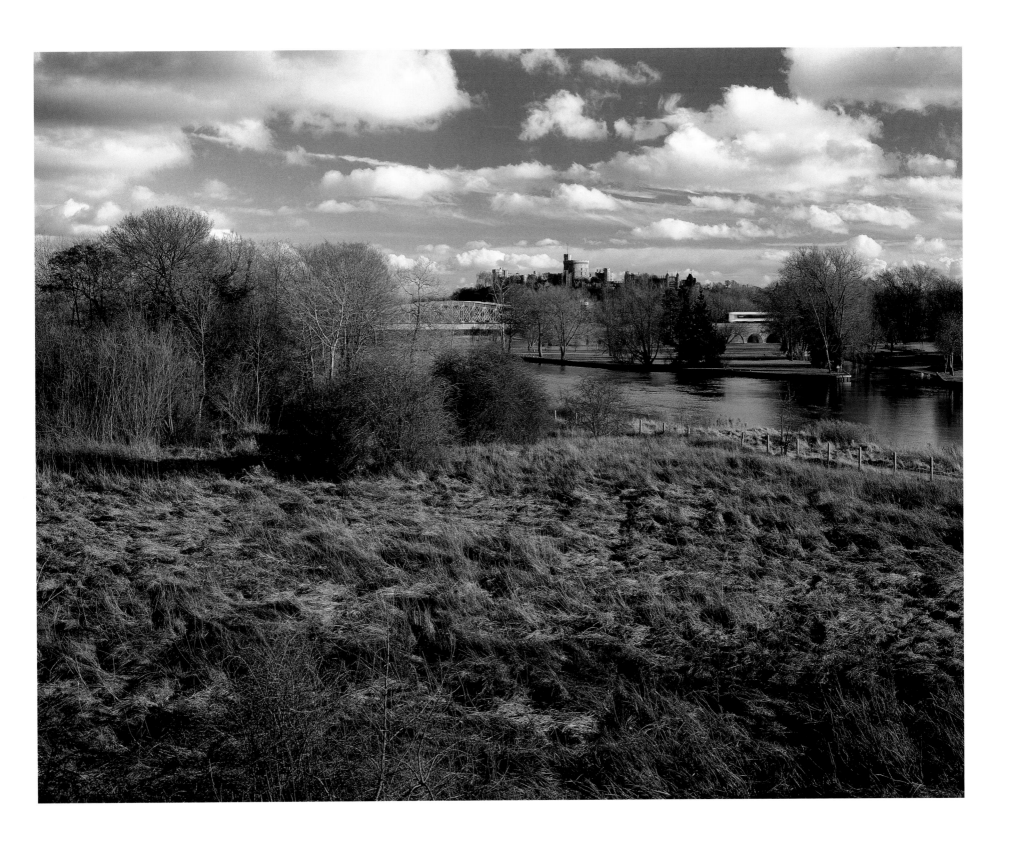

William the Conqueror built Windsor Castle where it would command the best view of the surrounding countryside.

King John has had a particularly bad press over the years, gaining a reputation for evil that is not entirely justified. True, he was cruel and oppressive, but no more so than his admired Norman predecessors.

The fourth son of Henry II and Eleanor of Aquitaine, Prince John was nicknamed 'Lackland' because there was, quite simply, no land left for him to inherit. After his birth Henry and Eleanor went their separate ways and the future family history was to be one of jealousy and intrigue between parents and siblings in all directions.

After the death of his brother Richard the Lionheart, John had to deal with thugs of barons who were unused to having their monarch domiciled in England. They had done very nicely under Richard, despite their continual grumbles, because he had spent most of his time on crusade. True, a continual replenishing of the royal coffers had been required, but on the whole they were quite happy to be left alone quarrelling amongst themselves.

John was a better manager than Richard. He had an innate distrust of people, which may account for his punctiliousness, but under him the royal administration was vastly improved, not always to the barons' advantage. They did have legitimate grievances. Scutage – a tax levied in lieu of military service – was imposed eleven times between 1199 and 1215. Not only that, but a tax of one thirteenth was imposed on goods and chattels. And not only *that*, but the king's young nephew, Arthur of Brittany, the rightful inheritor of large tracts of France, was mysteriously murdered, supposedly by his uncle.

Small wonder that the odious barons wanted to bring John to heel and lucky them to have (temporarily) on their side the decent Archbishop Stephen Langton who drew up the Great Charter, inserting the clauses that were to benefit the whole country rather than just the participating barons and who organized the signing party. John signed the charter because it was expedient to do so but he didn't take it seriously, any more than did the barons, who saw it as an excuse to thumb their noses at the king and lay waste the royal manors. The Pope, to whom John had surrendered England as fief in 1213, annulled the Great Charter which he saw as being *'as unlawful and unjust as it was base and shameful'* and by which the *'Apostolic See (is) brought into contempt, the royal prerogative diminished, the English nation outraged…'* and the last year of John's reign was spent in turmoil with Louis of France waiting in the wings.

At Runnymede today a sign illustrates wonders of nature to be seen here: the skylark, the cinnabar moth, the common blue butterfly and the yellow rattle (named for noise of ripe seed pods when shaken) which is indicative of ancient neutral grassland. And so it is still: farmed on the ancient principles of grazing by cattle in winter and leaving for hay in summer.

Which is very interesting, but I am preoccupied with the question of why Magna Carta has become such a powerful symbol. It doesn't say a lot that had not been largely accepted before, because England has always had great law-makers: Ine, Alfred, Edward the Confessor, William I, Henry Beauclerc… why does it matter so?

I am just coming through the gate from the Magna Carta Memorial, thoughtfully provided by the people of the United States and thinking it is all a bit ho-hum, really, when a great *wham!* hits me right in the chest and just for an instant I can feel the presence of John and those awful barons. I can hear clanking of armour, shouting, bugles, smell sweat and horses. Suddenly I understand the significance of it – not for what it changed for John but for what it made possible to happen all over the world. It brought the Stuarts to heel in the seventeenth century, it is the basis of Tom Paine's *Rights of Man* and is the reason that America has a constitution (which we, incidentally, do not). Then the sun comes out. A skylark rises from the grass disturbing a cinnabar moth and a common blue butterfly. It's one of those days when you seem to have it all.

Magna Carta, the basis of western democracy, was signed at Runnymede,
viewed here from Cooper's Hill.

William the Conqueror reckoned the distance between the Tower of London and his castle at Windsor to be a day's march, and after my experience at Runnymede I can see no problem. My calculation has disregarded the lateness of the hour, the contours of the river and the approaching rain, but would St Paul have been so easily daunted? Would John Wesley's heart have faltered? Would my mother have hesitated? 'I can't be bothered with poor-spirited people!' she would have said, and got on with it in the great British tradition. So do I.

There is a point near Weybridge where five streams unite: the River Wey, the Wey Navigation Canal, the Thames mainstream and the Thames sidestream with its weir, and the Shepperton Lock Cut. Near here, a gaunt and crumbling mansion looms across the Thames path from D'Oyly Carte Island, once owned by Richard D'Oyly Carte, the impresario of Gilbert and Sullivan. It's not all so picturesque.

All Middlesex is ugly, notwithstanding the millions upon millions which it is continually sucking up from the rest of the kingdom; and, though the Thames and its meadows now-and-then are seen from the road, the country is not less ugly from Richmond to Chertsey-bridge... the buildings consist generally of tax-eaters' showy, tea-garden-like boxes, and of shabby dwellings of labouring people, who, in this part of the country, look to be about half St Giles's: dirty, and have every appearance of drinking gin.

Cobbett travelled by horse, along nineteenth-century country roads, so his view of Middlesex is rather more jaundiced than is mine, as I encounter probably the best cycle track in the world. But is it Cobbett guiding the pen across my rain-splattered notebook?

Oh, Canaletto! You would weep to see Walton Bridge today! Gone is the gracious curve, gone the white latticework and gone Sir Thomas Hollis in his bright yellow coat! Here instead, laid alongside the 'new' nineteenth-century brick crossing a monstrosity of rusted metal, sporting along its side a great sewage pipe!

When Canaletto painted Walton Bridge it was a famous 'mathematical' or 'perpetual' bridge built for a local land-owner on the principle of every timber being arranged as a tangent to a circle, removable and replaceable without disturbing any other. You can see why Cobbett and I are so upset.

Apart from the Canaletto painting (now in the Dulwich Picture Gallery) Walton is remembered as the home of the experiment in communal living and ownership of land conducted by the Diggers in 1649–1650. They were a radical English Puritan group, led by Gerrard Winstanley, who saw themselves as *'the True Levellers'*. They planted and mowed the wasteland on Walton's St George's Hill in an attempt to revive what they believed to be the spirit of Magna Carta.

I arrive at Hampton Court tired and soaked from the heavy rain and happy to accept that the Conqueror's troops were strapping young men. The station attendant accepts my ticket because it is a return from Sunnymead which is a few stations further out and because he agrees I deserve something extra for effort.

Changing at Wimbledon, a man looking vaguely familiar asks if this train goes to Kings Cross? I confirm that it will do and we fall into conversation about the concept of public service. The way one does. He wonders if there ever was such a thing and that perhaps Government has always been led by business. But there have, I suggest, always been individuals within Government who have espoused the concept and none of them have been all that popular. We both agree that it is possible to effect change. Small, local, but the sort that makes a difference. And that life, on the whole, is pretty amazing.

It is not until I see a photo of him in the paper next day that I realize my fellow passenger was a Very Important Person. It's nice to feel one has been able to put a great man on the right track. Even if it was only to King's Cross.

Anthriscus sylvestris, the humble cow-parsley, achieves star status along
probably the best cycle track in the world, between Shepperton
and Walton-on-Thames.

The building of the palace of Hampton Court, just 14 miles from Westminster, was begun in 1515 by Cardinal Wolsey. Wolsey had bought the site from the Order of St John of Jerusalem the year before he became Cardinal and Lord Chancellor of England. With 280 rooms for guests and a staff of over five hundred, the hospitality offered by Wolsey was the wonder of Europe and Henry VIII so envied its splendid architecture and fittings that Wolsey made it over to him in 1526. But the gift was not enough to save him from execution in 1530.

Henry was a keen gardener and a huntsman and he took a personal interest in laying out the gardens and stocking the park with game. Hampton Court was where his beloved third wife, Jane Seymour, died, having given birth to Edward VI, and where Edward spent most of his short existence, the clean air and the pure water perhaps extending his life a little. His sister Mary received her proposal of marriage here from the awful Philip II of Spain and after her marriage returned through these gates to spend most of her honeymoon and the four lonely years of her reign here, waiting in vain through false pregnancies and bitter recriminations for the baby that never came.

Elizabeth came to live here the year after her accession to the throne in 1559. She, too, was a keen gardener, enjoying the nitty-gritty of digging and planting – but only when unobserved. In company, *'She, who was the very image of majesty and magnificence, went slowly and marched with leisure.'* One is reminded of a description by a contemporary at Windsor Castle who remarked on the Queen's perambulations on the battlements – but only in calm weather. She had a detestation of wind; probably as well as ruffling the royal composure it unsettled the royal wig.

Charles I dug the wide channel, 11 miles long, for bringing water to the ornamental lakes and fountains he designed in the gardens, and brought some four hundred fine paintings (including nine Mantegnas) as well as sculptures, ivories, crystal and porcelain to adorn the living quarters.

Here is some of finest Tudor architecture in Britain and, sadly, for its preservation we have to thank the untimely death of Queen Mary of smallpox in 1694. Mary's marriage to William, Prince of Orange, was a political one: Charles II having no legitimate children meant that her father, James Duke of York was the heir to the throne, and after him came Mary, the eldest of his two daughters. The religion of James was suspect, however: although he was not overtly Catholic, it was widely known that it was with Rome that his heart belonged. So, with the paranoia and terrorism associated with the so-called Popish Plot, it was expedient that the pretty fifteen-year-old Princess Mary should be allied with the House of Orange, perceived as a brave anchor of Protestantism in Europe. Never mind that her cousin, her appointed bridegroom, was ten years older, physically weak with a tendency to a hunchback and taciturn to a degree – not unlike his great-grandfather, William the Silent. Yet William and Mary were happy together and in 1688, a bloodless coup was executed when they landed in England and, James II having fled abroad for his life, were jointly offered the throne.

William and Mary reigned in tandem for only six years, and during their tenure of Hampton Court Henry VIII's state departments were demolished, it being the intention of their chosen architect, Sir Christopher Wren to built a new Versailles. Between 1696 and 1704 Wren was busy rebuilding and extending the palace, with constant advice and encouragement from Mary, whose judgement and taste Wren termed 'exquisite'. Well, it would be, with her Stuart ancestry. But the point is that after her death William lost heart and the plans for the great new palace were somewhat curtailed.

Which is nice for us, because from different façades we have two very different palaces, both of which, for their type, are quite simply unsurpassably splendid.

Hampton Court Palace comprises the very best in Tudor and
Palladian architecture. Queen Mary I would have driven past this
proud beast after her wedding to Philip II of Spain.

Kingston's earliest name was Moreford: the Great Ford. Until 1750 its bridge was the first to cross the Thames above London Bridge and rather than risk damaging London Bridge, Henry VIII had his artillery brought over the river here. Not on this bridge, of course, but a twelfth-century one, whose remains have apparently been incorporated into the John Lewis store. A little way up the Hogsmill River that lets into the Thames near King's Passage is the oldest bridge in Surrey, the triple-arched Clattern. The earliest known reference to the Clattern Bridge is in 1293, when it is described as the 'Clateryngbrugge', supposedly because of the sound of horses' hooves crossing it.

Kingston is the oldest of only three Royal Boroughs in England, a status it has enjoyed since medieval times. Its charter was granted by King John in 1200, but Kingston is much older than that. Across the High Road a little fence surrounds the Anglo-Saxon Coronation Stone, on which was crowned King Edward the Elder, son of King Alfred, in 902. Seven Anglo-Saxon kings were crowned here, the last being Ethelred the Unready.

By the time of his old age, Edward the Elder had a kingdom about twice the size of his father's to rule and it is small wonder that the somewhat arbitrary boundaries drawn by the Vikings about the country were less and less often challenged by him. It had finally to be accepted that the Vikings were here to stay, just as Edward's ancestors from Saxony had come to stay.

On the riverbank north of Kingston are boat houses and summer houses of various designs and states of repair. Old man's beard, strung out over the winter vegetation, shines in the winter sunlight, although for scruffiness it has nothing on an elderly heron outside the Thames Young Mariner's lagoon. The lagoon was made in the 1920s for loading gravel and sand from the flood meadow of the Ham Lands. Most of the land was refilled in the 1960s with rubble from London bombsites. Along with the landfill came a plethora of seeds: golden rod, rose bay willow herb ('fire weed'), everlasting pea, meadowsweet and tansy. It is rich in bird life, too, with tits, treecreepers, chiffchaffs, kestrels, goldfinches and, recently, parakeets.

A winter's picnic on the banks of the Thames is idyllic. No wasps, no flies, just a black labrador-cross leading his little spaniel friend into nefarious doggy doings among the dry brush and then leaping joyfully into the river. The spaniel doesn't mind where they go – just as long as they are together. 'I'm with him!' his blissful smile proclaims proudly.

Across the river, just near the end of Eel Pie island, Alexander Pope lived from 1719 until his death in 1744. When he bought the lease of the house, where St Mary's College now stands, it was not just because the open fields of Twickenham offered such a pleasant prospect. Rather it was because his father's house in Binfield, in his beloved Forest of Windsor, had been confiscated and because, as a Catholic, he was forbidden to live within ten miles of the City of London. He was to spend the rest of his life here. The remains of the grotto he built in his garden still exist and in the Church of St Mary the Virgin are memorials to him, his parents and his nurse.

Pope rebuilt the house in Palladian villa mode: *'High enough to attract the eye and curiosity of the passenger from the river, when, upon beholding a mixture of beauty and ruin, he inquires what house is falling, or what church is rising'.* But it was on the garden that he lavished most of his love and attention. With temple, wilderness and the famous grotto it attracted admiration from all quarters. Horace Walpole, living in Strawberry Hill nearby, considered Pope one of the greatest influences on English landscape gardening.

After his death in 1744 Pope's villa went through several owners until it was finally purchased in 1807 by a lady called Sophia Howe who totally demolished the house and the garden because she couldn't stand the constant stream of visitors. True.

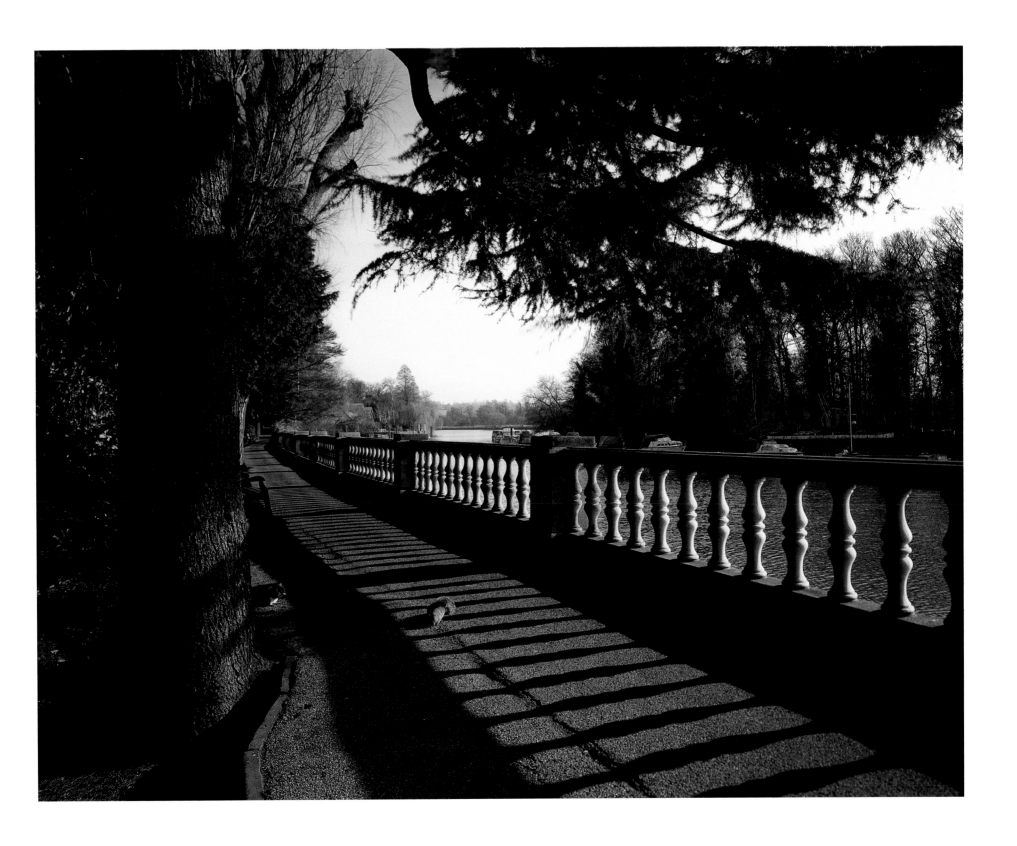

Twickenham was one of the most elegant addresses in the eighteenth century, but Alexander Pope built here because, as a Catholic, he had to live ten miles from London.

The ferryman from Ham House to the opposite bank dislikes bikes. 'Just think how it would be if everyone rode them instead of driving!' I pause from considering this not unpleasing concept in front of Marble Hill House, where a family of bright green parakeets has taken up residence in the old black walnut tree on the front lawn.

The house has two fine and almost identical façades: one to the river and one to the road, to welcome visitors however they arrive. Henrietta Howard, the lovely Countess of Suffolk, was helped in 1721 with the architectural plans for her house by her friend Henry Herbert. Mrs Howard was lady of the bedchamber to George II's queen, Caroline of Anspach, and for twenty years she was also the unenthusiastic mistress of Caroline's husband.

The Howards' attachment to the Hanoverian court began in Queen Anne's reign, when Howard, a renowned rake and debauchee, had run up enough debts to make life in England impossible. Forced abroad, the court at Hanover seemed a sensible option for the couple. All of Anne's seventeen children had died and despite the ailing queen's prevarications it was known that George Augustus, Elector of Hanover, with excellent Protestant credentials, was tipped as favourite to inherit the English throne. He was finally called to England from his beloved Hanover in 1714 and his court, along with his two famously ugly mistresses, included the Prince and Princess of Wales and their household, not least the Howards.

It did not include the Elector's wife, the beautiful Sophia Dorothea, who was to remain incarcerated in the gloomy castle of Ahlden for 33 years until her death. And it was perhaps because of his early separation from his mother that this Prince of Wales was to have such problematic relationships with women.

Because, despite her husband's insane jealousy, Henrietta's 'love affair' with Caroline's husband left much to be desired. Both as Prince of Wales and as King, George II was utterly devoted to his wife, seeing a mistress as the kind of accessory expected of a monarch. It is doubtful, anyway, if George had the intelligence to appreciate her culture and wit. Henrietta and the king, in their habitual three or four hours together of an evening, played cards. The traditional way to a sovereign's ear was via his mistress, but when Prime Minister Walpole boasted, in his inimitably crude manner, that he had *'taken the right sow by the ear'* he referred to Caroline. For twenty years Walpole ignored Mrs Howard.

The guide books may tell you that George II built this house for his mistress, but although he certainly stumped up a few thousand pounds, meeting the expenses for the building was a continual struggle for Mrs Howard and plans for the fine Palladian house and its garden were continually being adjusted to fit her purse. She kept an excellent cellar, though, which was greatly appreciated by her discerning friends Jonathan Swift and John Gay. Also Alexander Pope, although he, they teased, could not hold his liquor. Which, because of his health, was true enough.

The subtle terraces of lawn here double as flood barriers. The gardens were originally landscaped with Pope's help, and although there is little trace now of his work apart from the grotto, currently undergoing restoration, the original design was on the Pope pattern, with wildernesses, alleys, sweet-smelling walks, 'Gothick' barn and icehouse. The black walnut is a relic of that time.

As she grew older Henrietta's deafness became more apparent which irritated the short tempered monarch beyond his endurance and they finally parted company. Her final years were spent in enjoyment of her villa, her lovely garden and her friends of the 'Twickenham Club', one of whom was the loyal Pope, who wrote of Henrietta:

Not warp'd by Passion, aw'd by Rumour,
Not grave thro' Pride or Gay thro' Folly,
An equal Mixture of good Humour,
And sensible soft melancholy.

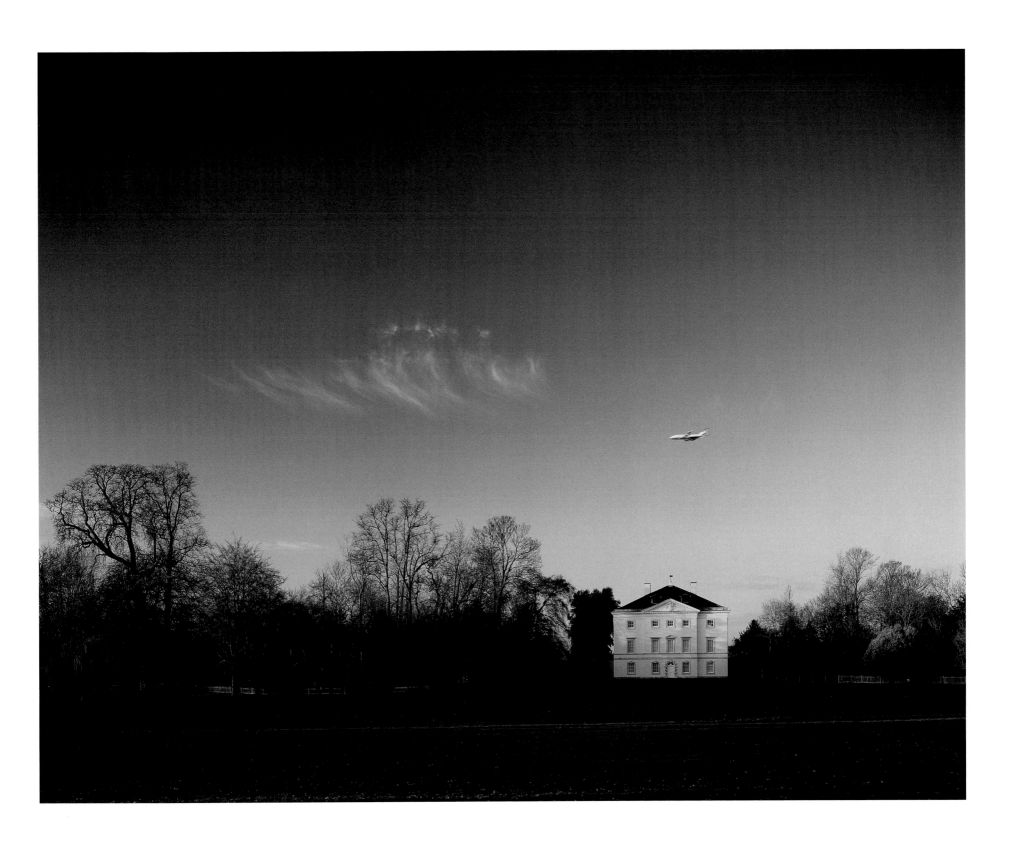

The elegant little Palladian mansion of Marble Hill House was built for
Henrietta Howard, mistress of George II.

'Heavens! What a goodly prospect spreads around, of hills and dales, and woods and lawn and spires and glittering towns and gilded streams,' enthused the poet James Thomson in 1727. He was something of an expert, being the author of the first major nature poem ('The Seasons', published in 1730) as well as that infamously jingoistic ditty beloved of Promenaders, 'Rule, Britannia!'

Since the sixteenth century wealthy gentlemen have built their houses here high on the hill overlooking the Thames valley. But most of these are from the elegant eighteenth century, including Lancaster House, the Wick and Wick House, built by William Chambers for Sir Joshua Reynolds in 1771. Reynolds lived here until his death in 1792, and this fine view was lovingly painted by him on his days off from portraying society women. Then there is No. 3 The Terrace, built in about 1769 by Sir Robert Taylor for Christopher Blanchard, George III's cardmaker, and although the *'Sweet Lass of Richmond Hill'* was probably a Yorkshire lass, to George, Prince of Wales it was undoubtedly Mrs Fitzherbert who lived here when they first met. A number of their early assignations took place on the riverbank opposite, just outside Kew Palace where the prince and the older of his brothers lived their riotous bachelor existence.

Close by and visible from afar, is the monster 'Star and Garter' Home for disabled servicemen, a twentieth-century building on the site of the old Star and Garter Inn. Clem from the front desk is a tireless guide, speeding up and down the numerous staircases to show off the salient points of the building. He came on a two-month trial thirty years ago and is still waiting to hear if he is going to be taken on permanently.

Opposite, a fountain and arbour commemorate Mary Adelaide, Duchess of Teck, who lived for many years in White Lodge in Richmond Park. Mary Adelaide was a hugely popular figure in Victorian times: ample in size and in personality, she continually lived beyond her means and was something of an embarrassment to her cousin the Queen. Mary Adelaide, her husband the Duke of Teck and their family were despatched to Italy to economize, but Mary Adelaide had a gift for unearthing royal cousins adrift in Europe, all of whom had to be properly entertained and eventually the family was recalled by Queen Victoria and allowed to settle back into the Duchess's beloved White Lodge.

Strangely, Mary Adelaide's only daughter, Victoria Mary (or Princess May), was a model of good sense and good housekeeping. May was selected by Queen Victoria as a suitable bride for her grandson Eddy, properly known as Prince Albert Victor, heir-presumptive to the throne. Eddy, meanwhile, was in love with his cousin Princess Alix of Hesse, who refused him. (Alix married instead Tsar Nicholas II of Russia in 1894 and was to perish with him and their children in 1918, in a cellar in Ekaterinberg.)

But Prince Albert Victor was an amiable fellow and easily persuaded to transfer his affections to Princess May. He fell in love readily, a trait understood well by his father the Prince of Wales, eventually Edward VII. Edward had been the prime mover behind a plan to despatch his eldest son and heir on an extended tour of the colonies rather than to Europe because the voyages would be longer. Sadly, though, six weeks after their engagement Eddy, never of robust health, died of influenza.

Queen Victoria was a practical woman who was still determined to see Princess May as Queen Consort. May was duly married to Eddy's younger brother George and as King George V and Queen Mary they were a devoted couple and a highly successful team. They saw the United Kingdom through the dark days of World War I and after the King's death it was largely due to Queen Mary that the monarchy survived the twin shocks of Wallis Simpson and the abdication of King Edward VIII.

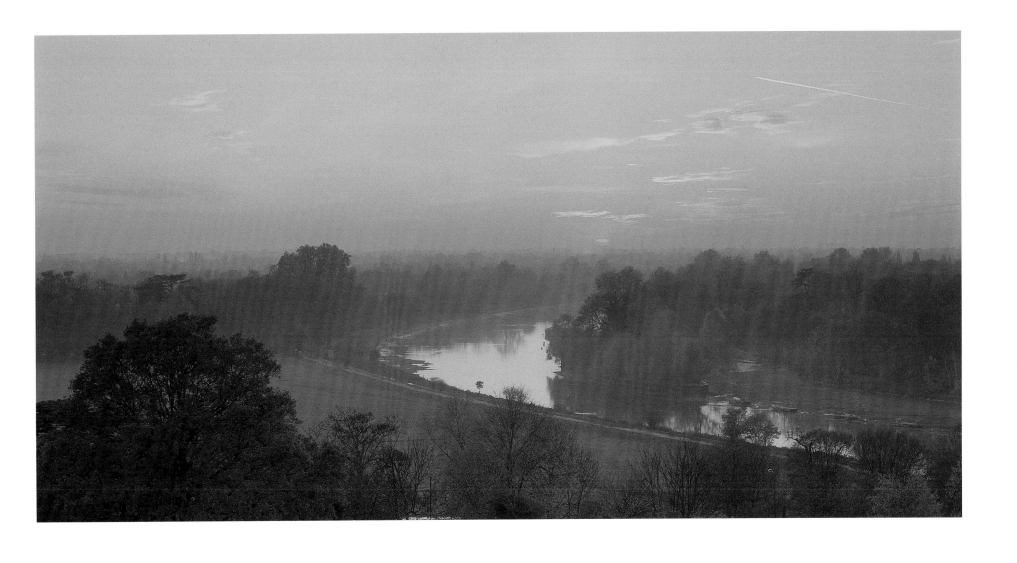

The view from Richmond Hill has been captured by some of
the greatest artists, including Turner and Reynolds.

Richmond is an interesting mixture of the majestic and the bijou; of the ancient and the new. Or newish. It has a fine little museum on the second floor of the old town hall where, as I peruse the model of Richmond Palace, as rebuilt in 1509 by Henry VII, I am suddenly blasted by 'Roll Over Beethoven'. There is a temporary exhibition at present of the Rock 'n' Roll Years. It makes it hard to concentrate, and as I leave and the voluntary custodian hopes I enjoyed my visit, I am torn between honesty and politeness. Honesty wins.

'I wish you had said,' she tells me, 'I could have turned it down.' But what was there to say? It would be unreasonable for me to expect everyone to share my taste for silence and it's not that I'm not a bit of an old rocker myself. 'Do tell your friends when they visit to ask to have it turned down,' she says. So I'm telling you now.

The model is a good one, though. It shows the palace built by Henry VII to replace the manor of Shene destroyed by fire at Christmas, 1497. And even that was not the original Shene Manor. Before that stood the manor where Edward III died, deserted even by his servants who, led by his mistress Alice Perrers, had snatched the rings off his fingers. Edward's grandson, Richard II and his wife, Anne of Bohemia, used Shene as their favourite summer residence and it is recorded that each day they fed ten thousand guests, which makes one suspect that history has been a little profligate with the noughts. But she was an extraordinary woman and much beloved of Richard, which is conveniently forgotten when people talk about his sexuality. He destroyed Shene after she died of the plague here in 1394. In the Undercroft Museum of Westminster Abbey there is a painted wooden funeral effigy of her, showing a very serious, perhaps sad-looking woman with a long face and a rather endearing double chin.

Before he set out for Harfleur and Agincourt, Henry V founded two religious communities near Sheen. One was a Carthusian monastery on the site of the Old Deer Park, and the other was Sion monastery for the Bridgettine order of monks, nuns and lay brothers. In the centuries following the Dissolution, Shene's priory buildings became dilapidated and in the eighteenth century George III demolished those remaining to use the area as pasturage. The hamlet of West Shene was also demolished and now Shene is remembered only in the names of North and East Sheen and Sheen Common.

But back to Henry VII. Having rebuilt it, the king was so enamoured of his brainchild that he renamed it his 'Manoyr of Richmount' or sometimes 'Rychemonde' after his earldom of Richmond in Yorkshire. In fact, though, it was now a royal palace. His sons, Princes Arthur and Henry (later Henry VIII), were brought up here, where the court was famed for its culture and the surrounding country (Richmond Park) for hunting. Henry VII preferred this to all other royal residences and when he died here in 1509 it was rumoured that he left hoards of gold hidden all over the palace. Quite possibly – he was a notorious miser. You can still see parts of the palace: the gate survives in Old Palace Yard as does the wardrobe, now used as private housing.

There are numerous attractive buildings in Richmond. Also on the green of Old Palace Yard with an imposing facade towards the river is Trumpeter's House, built in the early seventeenth century, probably by John Yemans, successor to Christopher Wren as Surveyor of Works. Metternich lived there in 1849 when Disraeli described it to his sister as *'the most charming house in the world'*. Also admired (though not by me) is Asgill House, in 'honey-coloured stone', also facing the river and also on the site of the old palace. It was built in 1758 by Sir Robert Taylor for the banker Sir Charles Asgill.

Architectural purists describe Quinlan Terry's Richmond Riverside complex of offices, shops, restaurants and flats as pastiche whereas Prince Charles reckons it *'an expression of harmony and proportion'* and I would have to agree with both. That is pure Richmond.

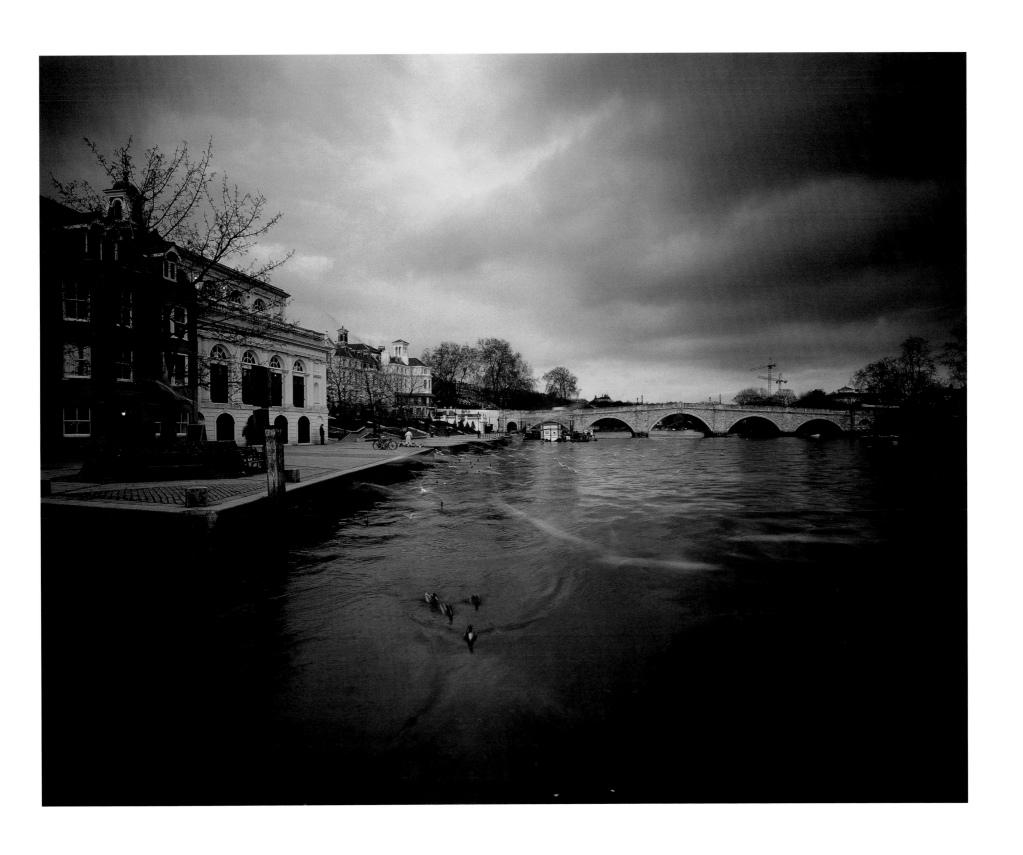

Richmond-on-Thames was named by Henry VII after his *'Manoyr of Richmount'* in Yorkshire. His son, Henry VIII, hunted in Richmond Park.

At Brentford is the beginning of the Grand Union Canal, leading eventually to Manchester, but there is no longer a ford. Or a ferry. If you proceed hopefully down Ferry Lane you may, however, see a 'limoboat' run by Virgin and if you were an Upper Class Virgin passenger you could be transported in one of these rather sleek little craft right down to St Katharine's Dock by the Tower of London.

Here in 1016 Edmund Ironside crossed in pursuit of Cnut (Canute) the Dane, both convinced they were King. Cnut was the son of Sweyn Forkbeard, King of Denmark and Norway, and Edmund was the son of Ethelred the Unready. He had been proclaimed king by the Londoners on Ethelred's death whereas Cnut had been offered the crown by the Witan, the assemblage who advised the monarch. Cnut defeated Edmund at Assundon (probably Ashdon in North Essex) and they agreed to partition the country between them, but Edmund died unexpectedly the next year and Cnut had the whole shebang. He then married Edmund's stepmother, Queen Emma, widow of Ethelred and mother of Edward the Confessor and thus became stepfather to the logical next king. Somehow things all work out in the end.

But Brentford's pride and joy must be Syon House, the London home of the Duke of Northumberland, which is grandly viewed from Kew Gardens and the Thames Path on the south bank. It is topped with the great Percy lion, brought from Northumberland House at Charing Cross on its demolition in 1874.

This was once the Abbey of Sion, built by Henry VII and beloved of his daughter-in-law, Catherine of Aragon. She came here regularly by boat from Richmond to pray and gained solace here during the years of Henry's disenchantment. The nuns forbade entry to Anne Boleyn with her English prayer book so it is probably not surprising that Sion was one of the first houses to be dissolved by Henry when he broke with Rome.

There was a time, in the autumn of 1535, when it would have been possible for Catherine to take up arms on her daughter Mary's behalf and to change history. No one in Christendom was on the side of Henry; her nephew the Holy Roman Emperor was at the height of his popularity and there was a new Pope (Paul III) with more pluck than the slow-moving Clement. But she didn't.

When Catherine finally came around to the idea the balance of power in Europe was changed and then, in January 1536, she died.

In 1552 Syon came into the hands of John Dudley, recently created Duke of Northumberland. His daughter-in-law, Lady Jane Grey reluctantly accepted the crown here at Syon and was taken by river to the Tower to be first proclaimed queen and then beheaded.

There is something heroic about the Percys. They seemed to be always on the wrong side, yet always on the side of right. The Percys supported Catherine of Aragon against Henry and a century later the tenth Earl, between 1646 and 1649, was deputed to look after the children of Charles I when he was imprisoned at Hampton Court.

It was a perfect place for children, with vast grounds and for wet days the long gallery to run in. And there was the site of the 1642 Battle of Brentford in full view of the house. Charles rode over to visit them and they visited him. The Earl commissioned Lely to paint portraits of the King and his children which you can see today in Syon House as well as a stunning Van Dyck portrait of the Queen, Henrietta Maria. Percy took the younger children up to Whitehall to say good-bye to their father before he was beheaded, by which time the Queen had left for France with her eldest son Charles – now king in exile.

The house has changed since then. In 1761 Robert Adam, recently returned from studies of antiquity in Italy, was commissioned to effect a complete redecoration and at Syon, the staff are pleased to inform one, the Adam style was actually initiated. Capability Brown redesigned the garden and it is simply perfect. Or it would be if the ferry between Syon and Kew was still in operation.

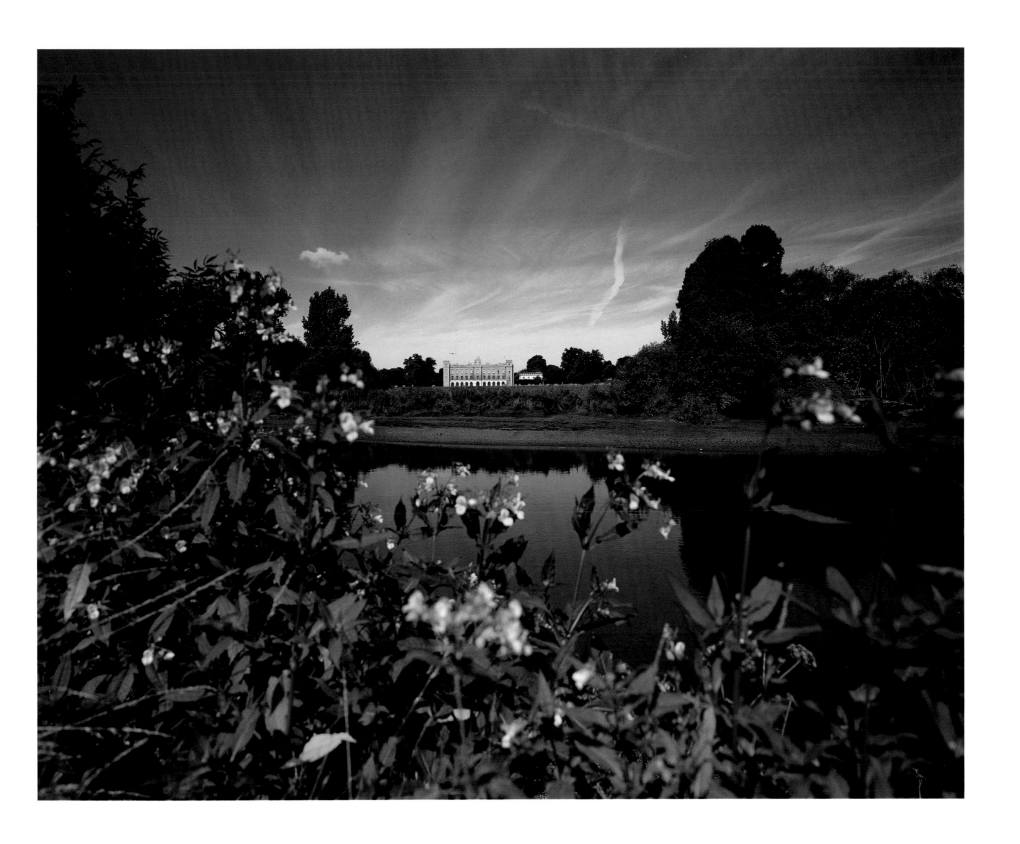

Syon House, the home of the Dukes of Northumberland, hosted the
children of Charles I while he was imprisoned at Hampton Court.

Modern day Kew seems synonymous with exotic plants and Virginia Woolf's *Mrs Dalloway* walking along neat paths. But behind this world of tidy borders, unparalleled scientific research and sedately cycling staff (I, though, had to leave my bike outside) is a history of passions and intrigues that is unmistakably Hanoverian.

The neat little Jacobean mansion of Kew Palace, originally called the Dutch House, was used as an annexe to the White House opposite, demolished in 1802. Frederick, Prince of Wales and his wife Princess Augusta moved here in 1737 following the final row between Fred and his parents, George II and Queen Caroline.

It is hard to know quite why his parents despised 'Poor Fred' so heartily. Smollett's obituary described him as

> *Liberal, generous, candid and humane; a munificent patron of the arts, an unwearied friend to merit, well disposed to assert the rights of mankind in general and warmly attached to the interests of Great Britain.*

But then, those were not attributes greatly admired by George II.

Princess Augusta first planned these now famous gardens at Kew, and it was whilst working on her plans, out in all weathers, that Frederick caught the chill that was to despatch him in March 1751.

> *Here lies poor Fred, who was alive and is dead.*
> *We had rather it had been his Father,*
> *Had it been his brother, better'n any other,*
> *Had it been his sister, no one would have missed her,*
> *Had it been the whole generation, all the better for the nation,*
> *But as it's just poor Fred, who was alive and is dead,*
> *There's no more to be said.*

Except by the king, who commented: *'This has been a fatal year in our family. I have lost my eldest son, but I was glad of it.'*

Frederick and Augusta had nine children, among them the genial 'Farmer' George III, who inherited his parents' love of gardening, and it was at Kew that he and Queen Charlotte brought up their family of fifteen. In the garden of the Dutch House the older children were instructed in agriculture and practical gardening and as the family grew George, Prince of Wales, and his younger brothers: Frederick, Duke of York ('the Grand old Duke of York'), William ('Silly Billy'), Duke of Clarence, and Edward, Duke of Kent, moved across to the Dutch House where they lived a gay bachelor existence. The river bank just outside the garden gate was the scene of many an assignation between George and ladies of the stage, for whom he had a special and notorious weakness.

Of an evening, the princes drank quantities of wine and discussed military matters. Against Napoleon the Duke of Kent was doing brilliantly with the army and William longed to do the same with the navy, but his overtures were spurned. In his Kew 'temple' are engraved his memories of the conflict and William, a simple naval man, would probably mind not a jot that Ken, Zak, Ahmed, Jason and Sunny have also, less formally, added their names for posterity.

Kew Palace today is shuttered, awaiting funds to complete its restoration, but it has a herb garden to die for — especially if you are a dog. Of *Periploca graeca* (climbing dog's bane) the sixteenth-century herbalist John Gerard writes *'the leaves heere of being mixed with bread and given, killeth dogs, woolves, foxes and leopards, the use of their legs and huckle bones being presently taken from them.'*

Behind these red-washed brick walls, after much politicking and truly appalling treatment by the charlatan Willis 'doctors', the sad remains of good Farmer George lived out his final years of madness, the Prince of Wales having finally gained his longed-for regency. When he, as George IV, finally died without legitimate issue the erstwhile Duke of Clarence, now King William IV, wore a broad grin to the funeral. Neither could he contain his glee when the privy council lined up to kneel before him.

'Aha!' he cried, 'and who's Silly Billy now?'

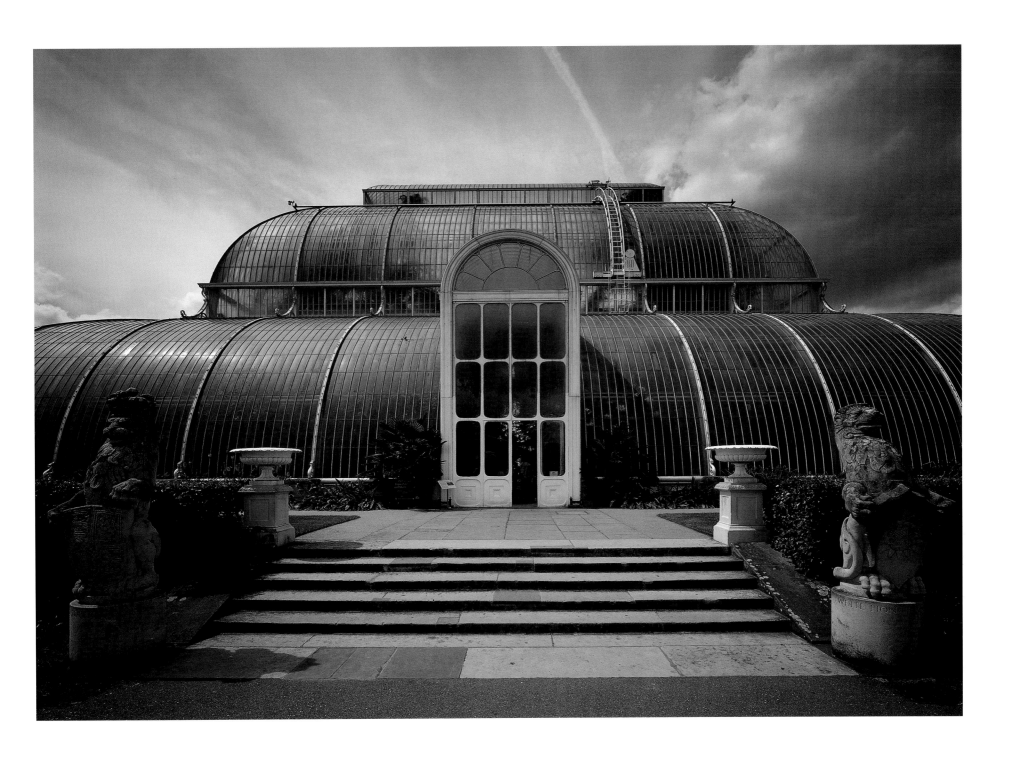

The magnificent glass Palm House of Kew Gardens was designed by
Decimus Burton. Some of the most important botanical research
in the world is carried on at Kew.

William Morris was unimpressed by the new Hammersmith Bridge, opened in 1887 and, to modern eyes, a model of well-engineered harmony. The design was by Sir Joseph Bazalgette, the hero of London's embankment and sewage system. Morris may, of course, have been simply fed up with the noise of four years' worth of drilling and building, although Bazalgette re-used the piers and abutments of Tierney Clarke's earlier suspension bridge, which must have cut down the building time considerably. But Morris would have preferred the traditional material of stone.

William Morris took the lease on Kelmscott House, now 26 Upper Mall, in 1877 from the poet and novelist George MacDonald. It was previously the home of Sir Francis Ronalds, who invented the electric telegraph in 1816 and in the course of his experiments had buried eight miles of glass-insulated cable in the garden. When Ronalds offered his invention to the Admiralty they replied that *Telegraphs are now totally unnecessary, and no other than the [signalling system] in use will be adopted.'* The system in use was semaphore.

Writing to his wife, Morris described the house as in bad repair – I don't know what he thought of the garden – but he thought that it might be made beautiful and that people would be more likely to visit them here. Kelmscott Manor in Oxfordshire was a long way for visitors to travel.

Of course they did make it beautiful. George Bernard Shaw wrote of it that nothing in *'this magical house'* was there for its curiosity or pecuniary value. *'Everything that was necessary was clean and handsome: everything else was beautiful and beautifully presented.'* And visitors flocked to see them. Not just fellow artists and writers, but also fellow socialists, and the coach house was turned into a meeting house for Hammersmith Socialist League, which is presumably how Shaw first came to visit. H.G. Wells and W.B. Yeats also attended lectures here.

When William Morris died here in 1896 at only sixty-two, his doctor was unsurprised. *'The disease is simply being William Morris, and having done more work than most ten men,'* he said.

Almost as soon as he moved into Kelmscott House Morris had set up a tapestry loom in his bedroom and carpet looms in the coach house and employed local women as weavers. In 1881 he moved the looms to his new factory across the river at Merton Abbey, a little way up the River Wandle.

The Kelmscott Press was Morris's last venture. He himself was responsible for typography, border design and binding and the press's publications included Morris's own works, English classics, including Chaucer's *Canterbury Tales*, and political leaflets. The coach house is now the museum of the William Morris Society and as well as examples of his work it houses one of Morris's Albion presses, which the Society still uses for occasional printing.

Down a picturesque little alleyway here, in a house now marked by a blue plaque, lived Thomas James Cobden-Sanderson (1840–1922), who founded the Dove's Bindery and Dove's Press in 1900. Dove's employees were among the first in the country to work a 48-hour week and to have fourteen days' paid holiday a year as well as Christmas and bank holidays. Morris and Cobden-Sanderson, working together on the enhancement of book production, were ideologically close, believing in the sanctity of work and that industrialization stifled creativity and the human spirit. But they disagreed about the nature of the 'Book Beautiful'. Cobden-Sanderson disliked the heavy type, narrow margins and disjointed text of Kelmscott. In 1903 he produced his masterpiece, *Doves Bible* in five volumes, hand printed with hand-made tools on vellum. A labour of love. But in 1916, the press had ceased operation and he threw the type into the Thames.

In the British Library I search for the reason. Yes, there were disagreements with his colleague Emery Walker. Yes, there was ill health. But perhaps the real reason lies in *Ecclesiasticus*:

I looked for the succour of men, but there was none.

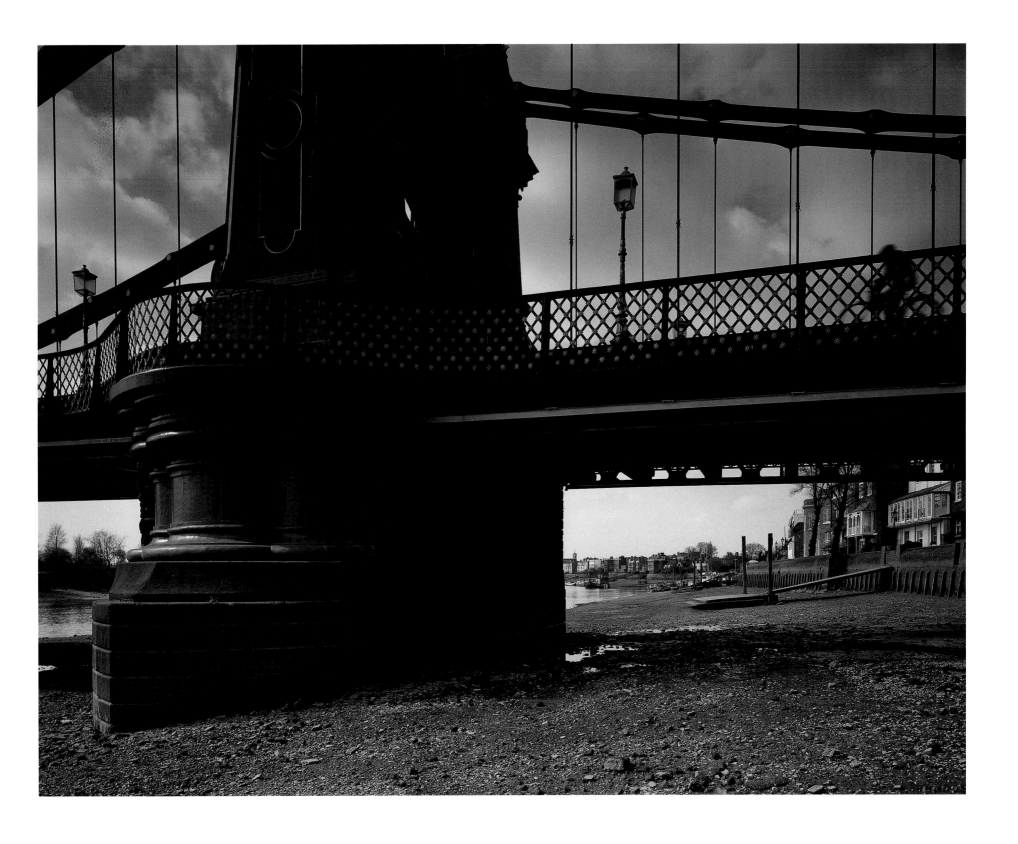

Hammersmith has been the home or the subject of many artists:
the composer Gustav Holst wrote his *Hammersmith Suite*
whilst living at Barnes, opposite.

On the north side of Putney Bridge the Kentish ragstone tower is the only medieval fragment remaining of All Saints Church. But I am looking for something even earlier. In 879, according to Asser, *'A great Viking army came up the river Thames and spent the winter at a place called Fulham.'* And on this winter's day some eleven hundred years later I am in search of the remains of this Viking camp, which could well be the moat surrounding Fulham Palace.

Once the official approach to Fulham Palace was by river, the last episcopal barge for conveyance of bishops and their guests lasting into the nineteenth century, but today approaching from the river is not easy. Wandering the meandering path where holly and yew meet overhead through the outskirts of the graveyard a black cat, clearly up to no good, pads across in front of me to the wilderness of brambles and ancient iron paling which is frustrating my exploration.

Instead, I am diverted past the charming almshouses in warm golden stone founded in 1680 by local worthy Sir W. Powell and past several enticing antique shops into Bishops Park to be mugged by a squirrel intent on seeing what I've brought by way of provisions.

Fulham Palace was the home of the Bishops of London from at least the eleventh century, and probably before – perhaps since Bishop Waldhere of London obtained the land from the Bishop of Hereford in the eighth century – until 1973, when the palace was leased to the local council. The present brick house dates from the beginning of the sixteenth century and the oldest part, this Tudor courtyard entered through the archway, is known as the Fitzjames Quadrangle, having been built by one Bishop Fitzjames. Through a window I am delighted to see a monk seated at a computer, but when he comes out for a quiet smoke his cowl turns out to be a hooded tracksuit. Oh, well.

Fulham Palace has always, somehow, attracted gardening bishops. One of the first was Edmund Grindal, exiled to Switzerland under Queen Mary. He returned on her death, bringing with him a tamarisk tree. Grindal was a farmer's son, one of the working bishops appointed by Elizabeth to carry out her policies rather than to act as courtiers. At Fulham, he cultivated vines and sent an annual gift of grapes to the Queen for some years, but Elizabeth fell out with him. As Archbishop of Canterbury, he wrote to her: *'Remember, Madam, that you are a mortal creature…'* So, just to prove she was a little more than that, Elizabeth had Grindal confined under house arrest in Lambeth Palace until his death in 1583.

Mindful of its horticultural history, I am disappointed in the walled garden where I peer through a hedge at a watercolour artist, protected from the January chill by the tartan rug over his knees, pausing to pour tea from the thermos flask at his feet. In fact, though, this glorious, haphazardly seedy, urban wilderness belongs to the local allotment society and the real Tudor walled garden is across the path, through a real Tudor gateway in a real Tudor brick wall.

It was enclosed in 1760 to form a kitchen garden, but happily also contains numerous aged specimens planted by Bishop Compton (1675–1713) who sent Dr John Banister, an Oxford trained botanist, as a missionary to Virginia with instructions to send back rare plants to him at Fulham. Bishop Compton produced the first magnolia ever to be grown in Europe and quite possibly this truly venerable holm oak still heroically sprouting just a few tufts of greenish bristles.

Bishop Compton seems to have had a way with plants which lingers. Here, on 28 January, in bitter cold, is a camellia studded with beautiful single pink blooms. This, surely, is Christian-like fortitude.

In front of the Tudor wall, two elderly gents have brought food for an indecently portly and enormously smug feral cat. They scrape out a pretty fine-looking dinner on to an opened newspaper by their bench and the cat, with studied condescension, decides what he fancies. Then, dispensing with his *hauteur*, he scoffs the rest as well.

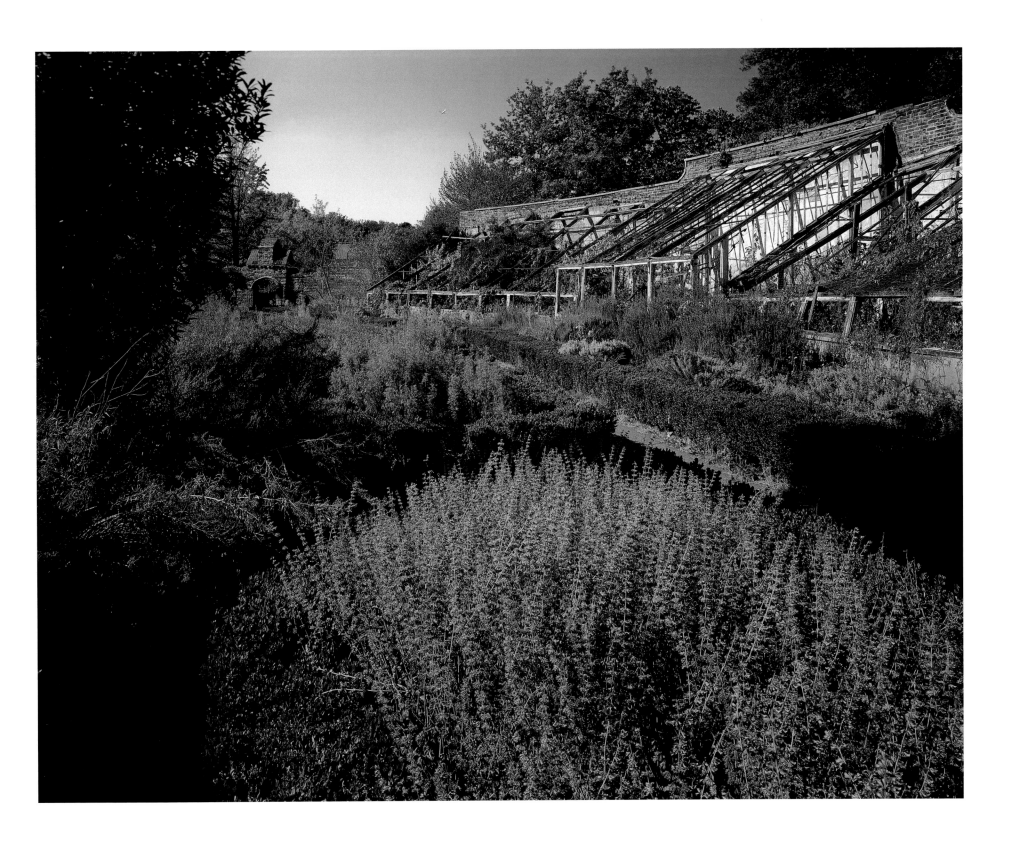

The ancient herb garden of Fulham Palace was enclosed in 1760
to form a kitchen garden for the Bishops of London.

Fishing is once again becoming a popular pastime at Putney Bridge as the river becomes cleaner. Roach, dace, bream and eels thrive and surely the seal of good housekeeping is close when an apparently healthy (although perhaps not very bright) seal is sighted.

Putney's history goes back at least to Roman times. Traces of a Roman settlement to the west of the high Street have been uncovered, as well as remains of Roman pottery on the riverbank. In the eighteenth century it was notorious for its heath, the haunt of highwaymen and vagabonds and a venue for duels. Nowadays, it is more renowned as the starting point of the Boat Race. Extraordinarily, although countless boat races take place throughout the country every year, many of them historic annual events and many on the Thames, 'The Boat Race' is immediately recognizable as the yearly contest between the rowing eights of England's two oldest universities.

But turn your attention for a moment to the twin churches at either end of the bridge, rebuilt, alas, in 1836. In particular to St Mary's of Putney, which in 1647 hosted the Putney Debates. Following Charles I's defeat by the parliamentary forces at Oxford it might have seemed that the Civil War was over. The army slowly marched on London with the intention of imposing its will. But in the autumn of 1647 it was very uncertain exactly what that was. Cromwell at first did not want to bring down the monarchy: '*No men could enjoy their rights and estates quietly without the king had his rights,*' he stated unequivocably. But the rank and file of the army had had a taste of power and were not about to back down. The King was defeated and they declared that there was now '*no visible authority in the kingdom but the power and force of the sword*'.

This was Cromwell's army. Discussing with his cousin John Hampden the difficulties of pitting his '*base and mean fellows*' against Prince Rupert's cavaliers, '*Gentlemen that have honour and courage and resolution in them,*' he had received sound advice: '*You must get men of spirit,*' said Hampden, meaning the puritan spirit.

'*A man who prays fiercely fights fiercely*' agreed Cromwell, which is why his New Model Army was invincible. Here were men of total conviction, and Putney's parish church saw the

unprecedented process of soldiers, all seeking divine guidance and quoting rival texts of scripture, taking the first stumbling steps towards '*An agreement of the People*'.

The agreement was drawn up by the Levellers, a puritan political group whose name was rather derisively applied to them because of their belief in social equality. But they, too, were divided. Some wanted no more than the sovereignty of a Parliament elected by all adult males who were not servants, alms-takers or royalists; others wanted one man, one vote (excluding supporters of the King) and a radical redistribution of wealth, with communes to take over agriculture from the feudal manors and the privately owned farms.

Cromwell sat on the fence. He tended to back his fellow soldiers against his fellow MPs but was horrified at the suggestion that men who had '*no interest but the interest of breathing*' might have votes.

In the end Cromwell came off his fence, persuading the debaters that the agitators ought to return to their regiments, supposedly to prepare their fellows for further discussion. But he had seen the writing on the wall and the passion of the Levellers worried him. '*Break them,*' he told his fellow officers, '*or they will break you.*'

It was possible to break them. With war raging in Ireland there was always room for fresh fighting men and lots were cast for regiments to go to Ireland, then cast again until the desired results were achieved: the regiments in which Levellers were strongest. John Lilburne, the Levellers' leader, distributed pamphlets discrediting the army leaders, but was arrested in 1649 and accused of treason.

The mantle of the Levellers fell on Gerrard Winstanley and his 'Diggers' and perhaps eventually on those eco-warriors of our time fighting against the odds for their belief in '*Land and Freedom*'.

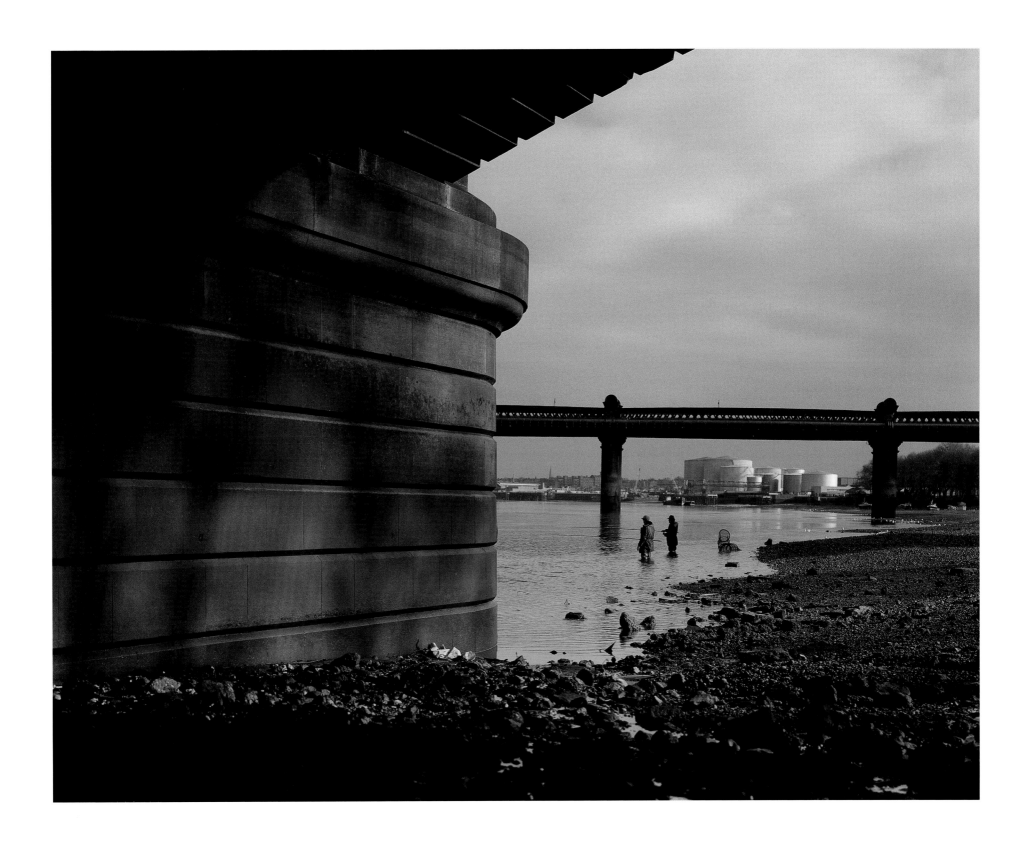

Between bridges, two early morning Putney fishermen try their luck.
As the river becomes cleaner, numbers of fish reappear. Could
salmon return?

In World's End, on a small island across the river, just near the outlet of warm water from Lots Road Power Station, are no fewer than ten herons. It's probably a kind of heron spa. The youngsters engaged in learning kayak skills in the rapids will probably not be too concerned if they are tipped out, either.

The present Battersea Bridge was designed by Sir Joseph Bazalgette and completed by 1890 and I pause for thought on my way across. In the 1890s the new craze was bicycling. The first bike might be said to be the *célérifère*, built by the Comte de Sivrac in 1791. It consisted of two wheels joined by a bar with a wooden seat, astride which you sat and 'walked' the bike along. But it was a start. The hobby horse, velocipede and penny farthing followed in quick succession until 1874 when H.J. Lawson produced the first chain-driven machine. The design has hardly changed since and I can state categorically that there has never – *ever* – been a more logical, efficient and affordable form of transport.

By 1896 bicycles were banned from Hyde Park, and Battersea Park, within easy reach, was well used by cyclists. In fact it was packed with them. Those who were too nervous to participate were *almost* content just to watch. They probably felt a bit like I do when watching people surfing… but then I put the thought firmly back in the Too Difficult Box and get back on my bike.

Once upon a time – about twenty years ago – the ugliest pub in Christendom was on the Battersea waterfront, not far from where the once again highly fashionable Battersea Village has rematerialized. There was also, I seem to remember, a harmless eccentric living on a ramshackle barge. There were Plans for the area though, and mysteriously, one night, the barge was burned out and the inhabitant disappeared. Now, from the terrace of smart houses comes the clink of glasses and snatches of sophisticated conversation.

The area is very desirable now. No hermits, no eccentrics. The up-market flats on the riverfront are in buildings named to reflect the river's trading history: Molasses House, Calico House, Ivory House, Plantation Wharf… and yes, it is very attractive.

For a little while in the 1990s there was an eco-village here, named Land and Freedom. It housed a group of young squatters proclaiming their right to trespass. They were not freeloaders, but idealists. Leo, recycling bits of old bikes to make new ones, told me: 'Anyone can come here as long as they contribute. If you just want to sit around and drink beer you're not welcome.' Tiny gardens were scratched out of land and surrounded with stones with irrigation systems made from old drainpipes and plastic bottles. Notices abounded: *Homes for Heroes… People not Profit… Make the Wasteland Grow…* They planted vegetables to grow on a rotation system, but of course they never really had time for a rotation system to get going.

Battersea has always had particularly fertile soil. At the time of the Norman Conquest 'Badric's Island' was a thriving Saxon settlement and St Mary's of Battersea was here, even then; the ancient building, however, was replaced in 1777 by the present simple village church, in time for William Blake to marry the daughter of a local market gardener in 1782. Catherine Boucher was talented but illiterate – she signed the marriage register with an 'x' – and she worshipped Blake. Their domestic cleansing arrangements were not a priority. Catherine insisted: *'But Mr Blake don't dirt!'*

Nearby is where the River Wandle meets the Thames. The creek at present is a feeding and over-wintering ground for a variety of birds: kingfishers, pintail ducks, sandpipers, redshanks, wagtails – but their arrangements may have to change if the gleam in the developers' eye for an upmarket marina is to come about.

Sainsbury and Safeway, twin monuments to our culture, confront each other across the water and I wonder what the author of 'Jerusalem' would have made of it all.

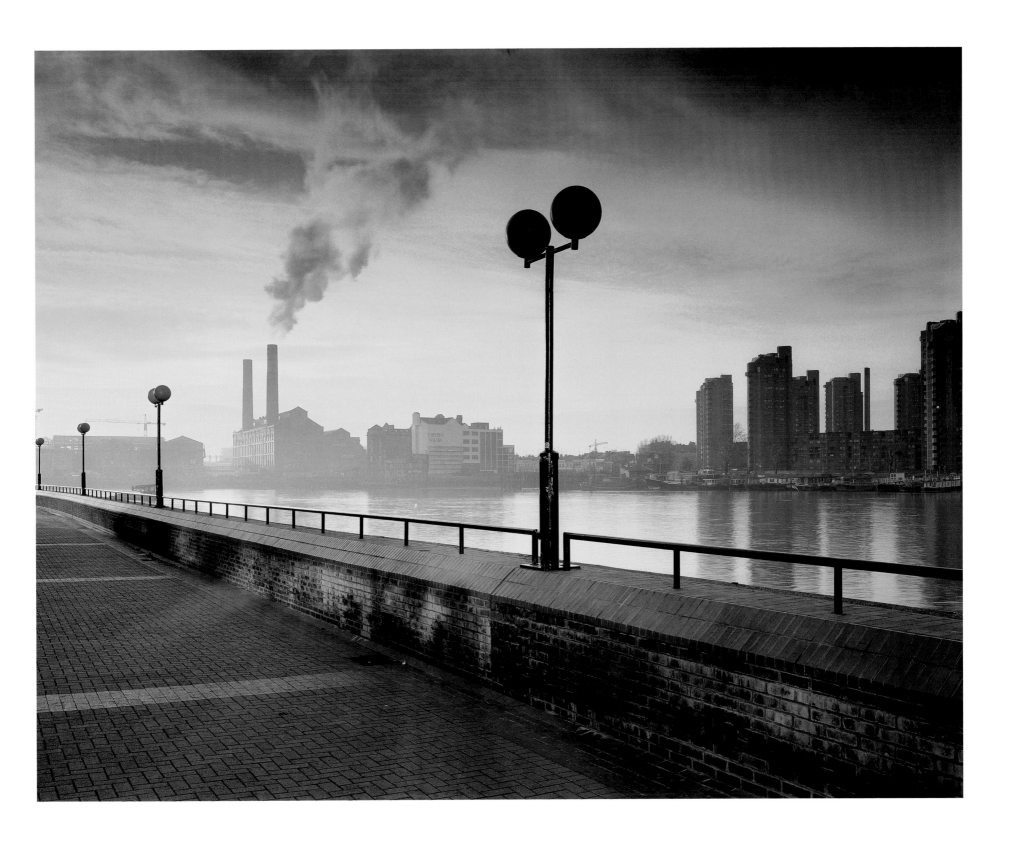

From Battersea's riverside, Lots Road Power Station, in Chelsea's World's End,
is still working after almost a hundred years.

Chelsea's embankment boasts among its statues two close friends, Sir Thomas More and Erasmus, who often stayed with More in his Chelsea home. More expected to be buried in Chelsea's Old Church but history is comprised of twists and turns and continually sends people in unexpected directions. Who would have expected Henry VIII's clever lawyer to slip – or jump – from the royal stage?

Since 1517, More had been Henry's friend and intellectual sparring partner, discussing with the king subjects ranging from astronomy and the classics to politics and theology. But from this spot in 1535 More was rowed by his son in law, the faithful William Roper, to Lambeth Palace for examination regarding his attitude to the royal supremacy. At Westminster Hall he told his successor as Chancellor, Thomas Audley, that his conscience was clear regarding his disagreement with his fellow bishops because,

> *Of the aforesaid holy bishops I have, for every bishop of yours, above one hundred; and for one council or Parliament of yours… I have all the councils made these thousand years. And for this one kingdom, I have all other Christian realms.*

More was imprisoned in the tower and when he died it was, famously, as *'The king's good servant but God's first'.*

The painter Joseph Mallord William Turner lived in More's orchard, albeit some time after it had ceased to be an orchard. His house, 119 Cheyne Walk, was one of a small group of houses in Cremorne Gardens when Turner moved here in 1846 with his landlady from Margate, Mrs Sophia Booth. He lived here incognito – or that was his intention – as 'Admiral' or 'Puggy' Booth.

Sylvia Pankhurst (1882–1960) lived in the blue villa next door, but fortunately her house was not built until after the great man's death, or his view would have been severely curtailed. Turner had a small terrace built behind the roof parapet from which, before sunrise, wrapped in a blanket, he would assess each morning sky. He thought of his view upriver as his 'English' view and that downriver as his 'Dutch' view but he wouldn't think so now. I don't know what he'd think of the latter now, but I suspect he'd love it and be painting at every available moment this cornucopia of houseboats, pot plants and flags.

In 1848 Chelsea was badly affected by a cholera epidemic. Turner succumbed, but regained his health in time to submit *The Wreck Buoy* to the Royal Academy's Summer Exhibition. No doubt Munro of Novar, who had bought it ten years earlier, was delighted to oblige, but less happy, perhaps, when he learned that Turner had then spent six days repainting it. But for a man who had such certainty of the value of his work Turner's actions were often curious. He refused to sell a painting to Sir George Beaumont, who had once criticized his work. Later, the ultimate put-down, he used the painting as a cat flap.

Artists seem to have a knack of finding people to look after them, but it seldom works in reverse. Turner's mother, admitted to Bethlem Hospital, was rarely, if ever, visited by either her husband or her son, and it was the painter's father and Hannah Danby, who kept house for them, who supported him in the venture of opening his first gallery in Queen Anne Street. William Turner was finally worn out by his son's demands, and as Hannah grew older, with a face disfigured by skin disease, Turner simply turned his back on her. For years he kept two establishments going independently and it is unlikely that Hannah, still 'keeping house' in Queen Anne Street for her absentee master, even knew of Sophia Booth's existence until the weeks preceding his death. Queen Anne Street had been consigned to the 'maybe later' file and she and her cats had been left to rot in the encroaching rain.

Yet there is a lovable side to the crusty old painter. Emerging, reeling, from the Academy along with a fellow drunk who complained of seeing two cabs, Turner advised him sagely: *'That's all right, old fellow, do as I do – get into the first one.'*

'The sun is God,' declared Turner during his final weeks. And he died overlooking the Thames on 18 December 1851, as a sudden shaft of brilliant winter sunlight flooded his Chelsea bedroom.

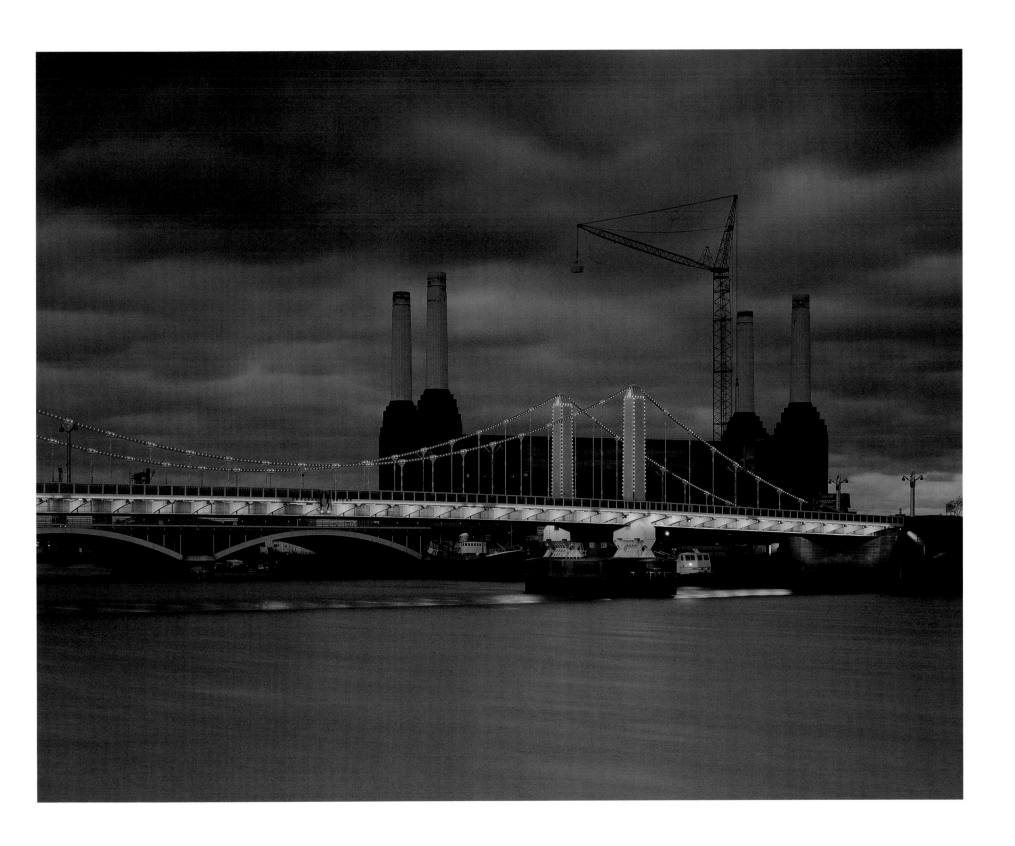

The decaying Battersea Power Station, seen through Chelsea Bridge,
is a monument to the great industrial architecture of the 1930s.

It is hard to imagine today's contained, urban Thames as the sprawling giant it once was, but it was possible, some thousand years ago, to ford the Thames at this point and in 1088 Lambeth was called Lamhytha, the 'landing place for lambs'.

Within the Church of St Mary at Lambeth is a fine modern (Francis Stevens, 1950s) stained-glass window depicting five saints with special relevance to the church. One is St Christopher who is shown carrying a traveller on his back across a river. Perhaps even this one, because another of the saints is Edward the Confessor, and his connection with St Mary's is a personal one. While Edward was building his great abbey across the way on the Isle of Thorney, his younger sister Goda, Countess of Boulogne, was building a church here. I like to imagine them rowing across to compare building notes. Well, it was possible.

St Mary at Lambeth is now home to the Tradescant Museum of Garden History, the churchyard containing a delightful walled 'knot' garden where many of the plants collected by John Tradescant, father and son, thrive. The museum is one of the most rewarding in the capital – small and friendly with attractive shop and cafe. Mozart's first 'Susannah', Nancy Storace was buried here, as were Captain and Mrs Bligh and the Tradescants. Nancy has a plaque inside, funded by her mother, and the Blighs and Tradescants have impressive tombs in the garden.

It was largely thanks to the two Tradescants that English gardens became more than the traditional repositories for herbs with medicinal and culinary uses, or for cosmetics and dyes. When the Wars of the Roses came to an end with the death of Richard III on Bosworth Field, the era of the Tudor peace began, when gracious living became the norm and the traditional castles gave way to country houses. It was then that gardeners like the Tradescants came into their own, bringing in from France and the Netherlands, and later from Constantinople, exotic plants such as tulips, anemones, lilies, cyclamen and hyacinths. They also experimented with cross-breeding from seeds, giving rise to new species such as carnations.

John Tradescant the elder, employed by Robert Cecil, was sent abroad by his employer to buy plants for his house, Hatfield. From the low countries he sent back such exotic varieties as vines, cherries, quinces, medlars, mulberries, pears and currants – sensibly keeping aside duplicate specimens for his own use. He then travelled on to Russia, from whence he *almost* brought back such novelties as hellebores, muscovy rose and dwarf dogwood, but on such a long journey his luck ran out. The plants were watered by the crew with salt water and the berries, a natural remedy for scurvy, were eaten. He did, however, keep a detailed diary of his journey and discoveries, held now in the Bodleian Library in Oxford. From Virginia the younger John brought back numerous varieties of plants, including the now hugely popular Virginia creeper.

The Tradescants were men of many parts. The elder John undertook a voyage to Algiers to confront the notorious Barbary pirates and he was part of the Duke of Buckingham's entourage which travelled to fetch the French princess Henrietta Maria as a bride for Charles I. Perhaps it was John Tradescant who first named her *'the Rose and Lilly Queen'*, amalgamating the English rose with the Fleur de Lys.

The Tradescants had their own museum in Lambeth, which they called the 'Ark of Novelties', but by fair means or foul (the latter is the most popular theory) their collection was commandeered by Elias Ashmole after the death of John Tradescant the younger, to form the basis of the Ashmolean Museum in Oxford.

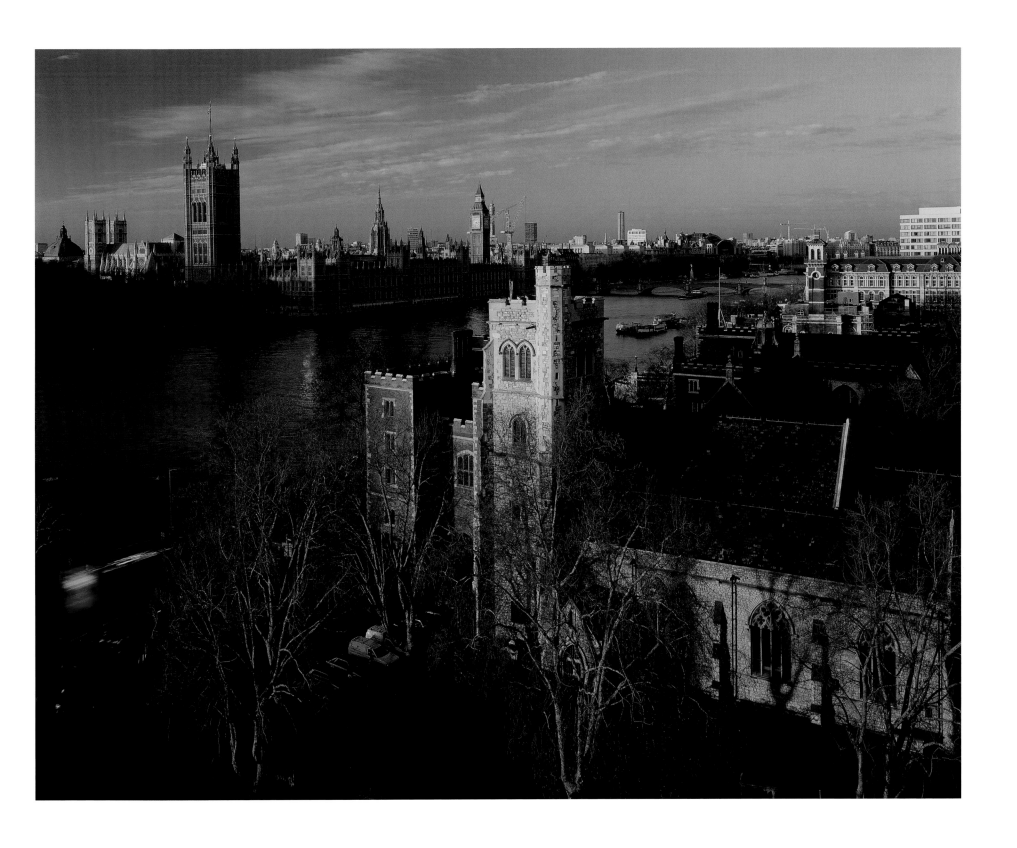

St Mary at Lambeth, now the Tradescant Museum of Garden History,
was built right at the gate of Lambeth Palace, London home of the
Archbishop of Canterbury.

It is hard to imagine this tight-knit community of ecclesiastical and governmental buildings as an island, but deep underneath today's turmoil of traffic and tourism flows the River Tyburn. It divides into two round about Green Park Station and its resultant twin streams flow into the Thames forming Thorney, an island of shingle amidst the London clay. Here Edward the Confessor built his great abbey.

Between the abbey and the river he built a palace which was to be the principal royal residence until 1512 when Henry VIII split his time between Greenwich and a splendid palace at Whitehall next door, having thoughtfully relieved Cardinal Wolsey of this encumbrance to his spiritual well-being. Over time, Westminster Palace became a great, sprawling town-within-a-town, frequented by thieves and prostitutes as well as the king and court.

Parliament met here until fire in 1834 destroyed most of the palace, sparing only the moated fourteenth-century jewel tower, the chapel crypt and the magnificent Westminster Hall. The Hall survives largely as built by William Rufus in 1097 and rebuilt for Richard II between 1394 and 1402. It was used as England's primary law court until 1882 and numerous trials have taken place here, including those of Sir Thomas More in 1535 and Charles I in 1649. The need for a meeting place for Parliament following the fire was the reason for the building of the present splendid Victorian Gothic buildings by Sir Charles Barry and A.W. Pugin.

When the old buildings were ablaze the public looked on admiringly. *'A judgement on the Poor Law Bill'*, was the general consensus, and the Duke of Wellington, for whom the French revolution was a recent memory, insisted that the new building should face directly on to the river so that it could never be surrounded.

Before long, though, members of the House began to wonder if they had done the right thing in building right next to the Thames. The exponential population explosion was causing serious pollution problems and Thomas Crapper's flushing lavatories, available from 1810 (compulsory from 1848), actually made the problem worse: the sewage that had gone into cesspools now went straight into the river and flowed past the windows.

Sessions of Parliament tended to be short in the summer months until the engineer Sir Joseph Bazalgette took on the problem. He initiated 82 miles of sewers running from west to east into which flowed the effluent hitherto bound for the Thames, and the whole lot was carried downriver to Barking and Deptford.

The tallest tower in Westminster is the Victoria Tower, from which the gardens below take their name, and here in its shadow is Rodin's sculpture of the Six Burghers of Calais whose massive hands and feet lend an extraordinary pathos. The burghers offered themselves as hostages during the year-long siege of Calais (1346–47). Edward III knew his claim to the French throne (finally surrendered only in 1802) was a bit spurious, but was intent on guarding his wine supply and the wool trade. The lives of the burghers were saved thanks to the intercession of Edward's wife, Philippa of Hainault, who threw herself on her knees in front of the king to beg for the lives of her countrymen and he, with great magnanimity, spared them. It was a great set-piece and was to be used on several occasions.

Across from Westminster is the fine building of County Hall, opened in 1922. By 1800, nine-tenths of Londoners lived outside the City with no local government, but neither Westminster nor the City were keen to see an elected London council. The London County Council was not created until 1889 when the population of London – some four million – started demanding measures to deal with disease, starvation and slum housing. There was always the fear at Westminster that the LCC (later the Greater London Council) would get too big for its boots and they were right. The solution was simple. In 1979, less than a hundred years after its inception, with matchless aplomb Prime Minister Margaret Thatcher simply abolished it.

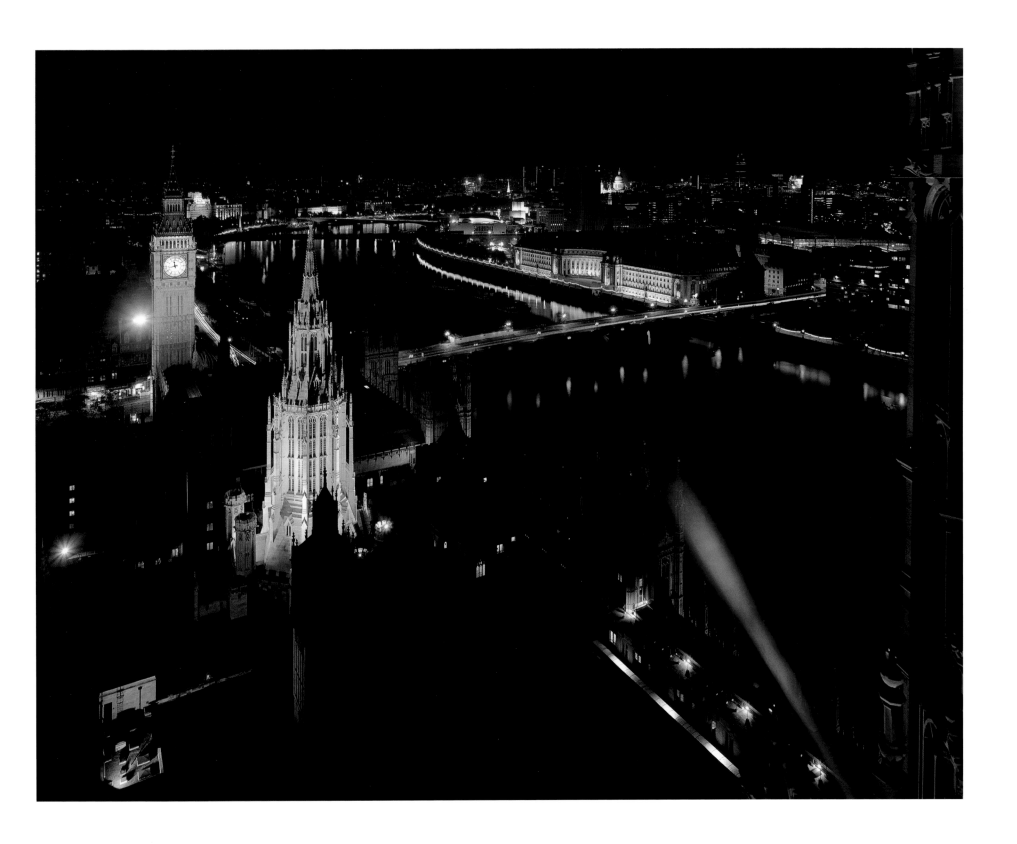

From the Victoria Tower, Westminster at midnight. Across the river from
the seat of Government is County Hall, seat of London's short-lived local
authority.

Inside Westminster Abbey, memorials of the country's great and good and largely forgotten jostle with each other for space amongst a community of three thousand souls and growing. Even in 1637 there was so little space for Ben Jonson that he had to be buried standing up. And who, one wonders, had to be elbowed aside to make room for the huge floor plaque for Sir Winston Churchill?

Three centuries before Edward the Confessor realized his dream of an abbey here, and five centuries before the present structure was begun by Henry III, the great King Offa of Mercia founded a monastery here, on *'that terrible place'* the Island of Thorney. Legend also attributes a Christian church to a second century king, Lucius, and another, consecrated by Saint Peter himself, to King Sebert, a seventh-century East Saxon. St Dunstan, Bishop of London in 957, founded a Benedictine monastery here.

Westminster's great abbey is a glorious mix of periods and traditions, of English and French, Gothic and Perpendicular. Edward began in 1040 in the Norman tradition and Henry III, a devotee of Edward, began rebuilding in 1245, surprisingly demolishing much of Edward's work as he went, regardless of the fact that his intention was to build a shrine for the Confessor, canonised in 1161. Much of the work in his time was financed by taxes and appallingly heavy fines on the Jewish community, anti-Semitism having conveniently been rendered practically a Christian duty by the crusades.

Henry III built the beautiful chapterhouse between 1240 and 1250. It was used for meetings, debates and for early sessions of parliament. But despite the huge amount of money spent on the abbey project, it was left to Henry VII (1485–1509) to build the great nave.

Hard as it is to imagine this famous building without them, it is interesting to try viewing it without the two great western towers, added only in the eighteenth century by Sir Nicholas Hawksmoor.

Edward's vision nearly a thousand years ago was for both a coronation and a final resting place for England's kings, and a few days after the consecration of the chancel in December 1065, it was used for both. His greatest achievement complete, he was laid to rest here on 6 January 1066. On the same day, with what could seem indecent haste, his successor, the charismatic Harold Godwinson, was crowned in order to send a clear message to William (the Bastard) of Normandy that the throne long promised him was no longer available. But just eleven months later there was a second coronation: that of William I, no longer styled Bastard, but rather Conqueror. Since then, with only two exceptions, Edwards V and VIII, every British monarch has been anointed here.

But it has not always been treated with respect. During the Civil War in 1643 soldiers were quartered here. They used Henry VII's altar as a table, destroyed medieval stained glass and paintings, used the altar rails for firewood and smashed the organ. The screen beside the Confessor's tomb shows signs of the damage inflicted.

And even today the fanned vaulting of Henry's soaring nave resounds less to the chant of plainsong and the murmur of prayer than to the clatter and shuffle of millions of tired and often reluctant feet obliterating all trace of those buried under its memorials, the ringing tones of tour guides in multifarious languages giving out their frequently repeated spiels and tired jokes: *'Henry the Eighth is not here… King James the First… Not by Henry but another king, it doesn't matter who… If you've ever heard the expression perpendicular… It was the Queen who… Never in the field of human conflict… Shoot the buggers down as they crossed the channel…'* Bombers, you may argue, but I know what I heard.

Then something quite extraordinary happens. Over a loudspeaker a gentle voice reminds us that Westminster Abbey is a place of pilgrimage and of prayer and we are invited to join in a minute's meditation. For just a moment, it is almost quiet.

The stone of Henry VII's chapel of Westminster Abbey
has been recently cleaned to reveal its full glory.

Today's Adelphi is a proud building celebrating the style of the 1930s. On the outside towered corners are hefty clean-lined stone sculptures and, inside, the foyer is resplendent with chiaroscuro etched-glass personifications of the arts. *Adelphoi* is Greek for brothers and it was the Adam brothers, Robert and James, albeit from Scotland, who in the mid-eighteenth century were granted permission to build Adelphi Terrace, an imposing riverside development of twenty-four houses on a series of terraces featuring arches and subterranean streets. Cheap Scottish labour was brought in to work on the site, cheered every morning by a piper.

The whole Adelphi complex occupies the 3-acre site that was once Durham House, built in the thirteenth century as a town house for the Bishops of Durham. Simon de Montfort lived here in 1258 when he offered his estranged brother-in-law, Henry III, shelter from a storm. Their quarrel was not just a family one. England was growing as a nation, with English, the language of the wet nurses, replacing French as the spoken language. Henry tried to emphasize his Englishness by naming his son for Edward the Confessor and requiring the sons of great Normans to decide whether they were French or English. But Henry himself was still suspect and there was great resentment over a court filled with his French family and favourites. Simon de Montfort had come down on the side of England and to his invitation Henry answered decisively: *'Thunder and lightning I fear much, but by the head of God I fear thee more.'*

Catherine of Aragon lived here after the death of her young husband Arthur, Prince of Wales in 1502 while her father-in-law, Henry VII, prevaricated over whether she should or should not marry his next son, Henry. Rumour had it that the king, widowed in 1503, wanted to marry her himself. *'A thing not to be endured!'* shuddered Catherine's father, Ferdinand of Spain, with exquisite delicacy. Widowed by the death of Isabella of Castile the following year, though, Ferdinand himself proceeded to marry his eighteen-year-old half-great-niece.

The gardens of Durham House went down to the river, and it was no doubt a pleasant enough place for the Dowager Princess of Wales (aged sixteen) to reside, but she could not be happy here. The years following Arthur's death were a wretched time for her: she had no function that she could see and she had not even had a chance to learn English properly. She was not returned home, because Henry VII, whatever other plans he might have along the way, was still greedy for her dowry, which had not been paid in full.

Catherine lived here in poverty. Her father-in-law told her that the food she was eating was given to her as alms. She was unable to provide dowries for her ladies-in-waiting, which shamed her even more than the fact that in six years of widowhood she had been able to buy only two new gowns for herself, both of black velvet. Increasingly isolated, even her confessor being taken from her, Catherine found solace in religion, which to her included rigorous fasting, prayer and pilgrimage; which may have had something to do with her later inability to bear healthy children.

When Henry VIII acceded in 1509, he married Catherine almost immediately and they were to remain fairly happily united, contrary to popular belief, for some twenty years.

Catherine had had a careful upbringing, there having never been any doubt that she was destined to be consort to one of Europe's great kings. She was an extraordinarily accomplished girl – not only in academic pursuits, but also practical ones. She continued to make King Henry's shirts even after he had cast her aside, because she always considered herself *'his true and loyal wife'*. Catherine died in 1536 in the conviction that she was still Queen. And so she should have been, after twenty years loyal and steadfast service. To mark her death, Henry dressed from head to foot in yellow and danced.

Reflections in the cut-glass wall mirrors in the foyer of the Adelphi:
an extraordinary example of 1930s architecture.

Richard D'Oyly Carte built the Savoy Hotel on land adjoining his Savoy Theatre. It opened in 1889, as even the drainpipes and hoppers proclaim as you wander Savoy Way which leads below the building, past the innards of kitchen and laundry and all that goes on in great houses behind the façade of grandeur. César Ritz was the first manager and Auguste Escoffier the first chef, which will give some indication of its class. It is a site which has always hosted the best.

In 1264, six years after turning down his brother-in-law's offer of shelter next door, Henry III gave the land to his wife's uncle Peter, Count of Savoy, but it was Henry, first Duke of Lancaster who almost a century later built here the greatest house in England.

In 1357, Edward III's eldest son, Edward the Black Prince, was away in France fighting in what was to become known as the Hundred Years War. On 24 May he returned with a trophy: King John of France, captured at Poitiers. John was to be presented as his prisoner in a special ceremony at Westminster Hall . It was officially a celebration of thanksgiving, but in fact turned out to be a victory parade. Amidst clamour and confusion the procession wended its way between heaps of arms – bows and arrows, hauberks, spears and battleaxes, breastplates and gauntlets – and, at the end of it all, John joined King David of the Scots in captivity, lodged in considerable comfort, first at Windsor and then at the great Savoy Palace, recently completed by Henry of Lancaster with his profits from France.

King John of France as hostage at the Savoy had a household of about a hundred and a thoroughly enjoyable time. In fact, he so enjoyed his English imprisonment that when, back in Calais in 1363 his son Louis broke his parole, John announced very firmly and honourably that the action had so impugned his honour that he was duty bound to return to England as Edward's prisoner. The whole charade had to be gone through again; but, fortunately for Edward's purse, John died unexpectedly the next year. Edward very fairly bequeathed his body to St-Denis in Paris, his heart to Canterbury and his bowels to St Paul's and I'm sure he meant well.

Henry of Lancaster died in 1362 in a new outbreak of plague. So did his eldest daughter Maud, which was a tragedy for the younger daughter Blanche, but less so for her husband, John of Gaunt, the fourth son of Edward III, who thus became probably the richest man in England. Blanche herself was to die in 1369. Her only surviving son was to become Henry IV, the subject of Shakespeare's greatest play, I think. And then, in 1371, John of Gaunt married Constanza, daughter of Pedro the Cruel of Castile and thus, by his reckoning, the rightful king of Castile. The job was actually taken at the time, by Pedro's son Henry, but the quest for the crown kept Gaunt busy for a long time.

With hindsight, it is hard to know why people hated John of Gaunt so much unless it is because he was so terribly rich. When his brother the Black Prince died, John of Gaunt was loyal to his nephew, Richard II (*'Time honoured Lancaster'*, Shakespeare's Richard calls him) and ashamed of his son's ambitions for the throne. But the people did hate him. When his great Savoy Palace was destroyed by fire during Wat Tyler's Peasants' Revolt of 1381 there was no looting and pillaging of John of Gaunt's belongings and the one thief with no such qualms – or the only one observed – was thrown on to the bonfire along with timbers, hangings and furniture.

The Savoy Palace was rebuilt by Henry VII as a hospital for *'pouer, nedie people'* and one of the three chapels he built still survives. It was largely destroyed by two different fires in the nineteenth century, but the walls are still those of Henry VII's day. The ceiling was reinstated as per the Tudor original by order of Queen Victoria, bless her. The Queen is still the Duke of Lancaster and in today's Savoy Chapel services the national anthem is sung as *'Long live our noble Duke'.*

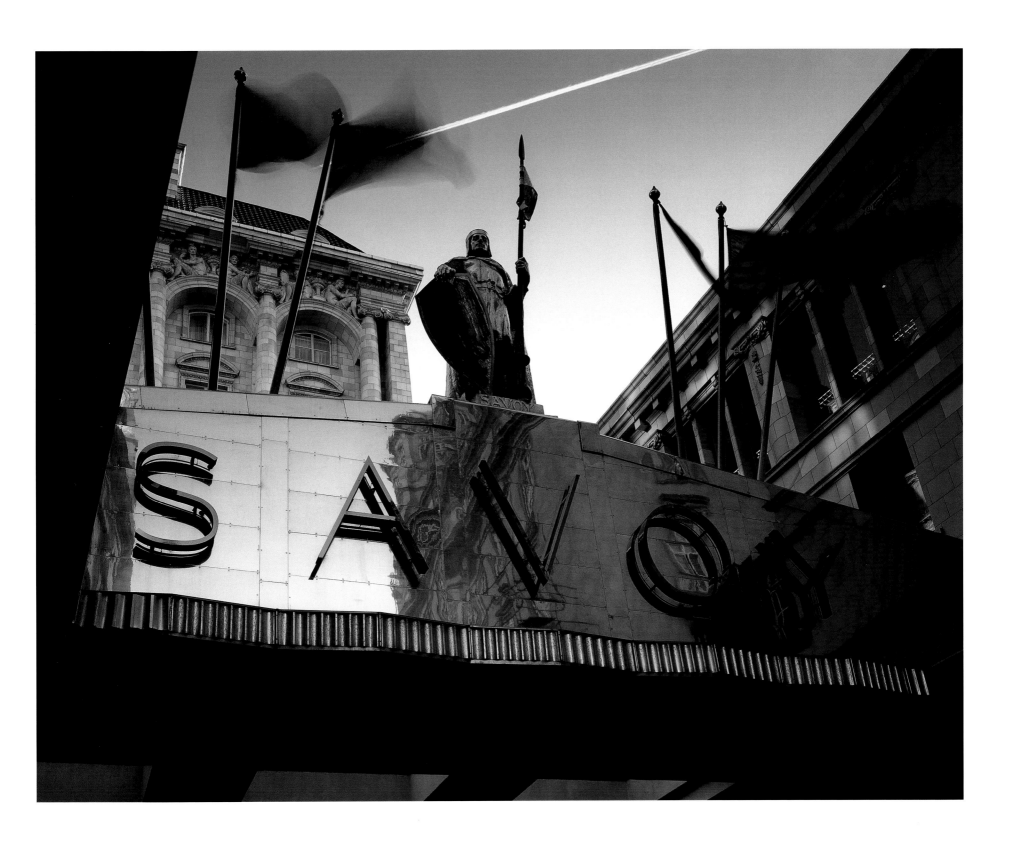

The Savoy has been associated with the very best in hospitality since
Peter, Count of Savoy, was granted the land by King Henry III.

The chunky red pillars stoutly crossing the river, seemingly without purpose are the remnants of the London, Chatham and Dover Railway Bridge of 1864. It was replaced in 1884 by the new railway bridge, further east, built by Wolfe-Barry and H.M. Brunel (son of the more famous Isambard Kingdom Brunel). A short life.

And look at the simple and imposing brick slab with its single tall chimney facing St Peter's Steps and St Paul's Cathedral on the north bank. This is now the Tate Gallery's Museum of Modern Art, but it was originally designed by Sir Giles Gilbert Scott and opened only in 1963 as the Bankside Power Station. Coming some thirty years after Scott's power station at Battersea, this must surely be one of the finest industrial buildings ever. But another short life.

Yet, belying the solemnity of Scott's building, the site itself simply throbs with history. Bear-baiting and brothels abounded in medieval times and prior to its somewhat raunchy days as a Shakespearean theatreland (the Rose, Swan and Hope theatres were all hereabouts, and actors, stage managers and writers like William Kemp, Edward Alleyn and Philip Henslowe lived here) it was the Great Pike Gardens, supplying fish to nearby religious houses.

Southwark was the northernmost limit of the Diocese of Winchester (it stretched from the Thames to the Solent) and Winchester House, or Palace, housing the Bishop of Winchester, was one of the many such institutions. You can still see the rose window from the palace in Clink Street. It is stunningly floodlit at night. Winchester House was situated in 70 acres of parkland entitled the 'Liberty of the Clink' – 'Liberty' because it lay outside the jurisdiction of the City of London and 'Clink' after the bishops' small prison which hosted small-time troublemakers from the brothels in the 'stews' hereabouts, frequented by Shakespeare's Falstaff.

But not only small-time troublemakers. Bishop Hooper and John Bradford were both imprisoned here before their deaths for the Protestant cause in 1555. Bradford's death was an inspiration for the future martyrs. *'Be of good comfort, brother, for we shall have a merry supper with the Lord this night!'* he cried encouragingly to his

fellow in flame, the young apprentice candlemaker, John Leaf. Hooper's departure was less gladsome. You can read a very graphic account of it in John Foxe's *History of the Protestant Martyrs*, but I couldn't recommend it to anyone of a sensitive nature.

And here is a bit of an anomaly. On Bankside, known for some time as Stews Bank because of its bear-baiting, brothels and general seediness, were buried in a communal unconsecrated grave the bodies of women who worked in the brothels. The anomaly is not so much the proximity of the working girls to the bishops' palace, but the fact that their grave was treated with such disrespect, even though the bishops, far from condemning them, regulated their opening hours and the rules under which they operated. Henry VIII closed the brothels down in a fit of piety, but they were soon operating again.

Inland from Bankside is Hopton Street, named after Sir Charles Hopton, a fishmonger whose will in 1752 provided for the charming Hopton's Almshouses, still in use. Amidst the wholesale redevelopment of the area the little house at No. 61 still survives, reputedly the home of Nell Gwynn. Nell, among the many women beloved of Charles II, lived from 1650 to 1687 and Charles, dying in 1685, begged of his brother James II according to John Evelyn that he should *'not let poor Nelly starve'*.

A small Victorian paper business also survives. Paper mills have been part of Thames life for centuries. But not for much longer. 'The paper man will have to go,' says the young man from the architect's office, 'Because he's blocking the view from the first-floor flats. Anyway, he's not included in the landscaping plans.'

But it's been a long life in Bankside terms.

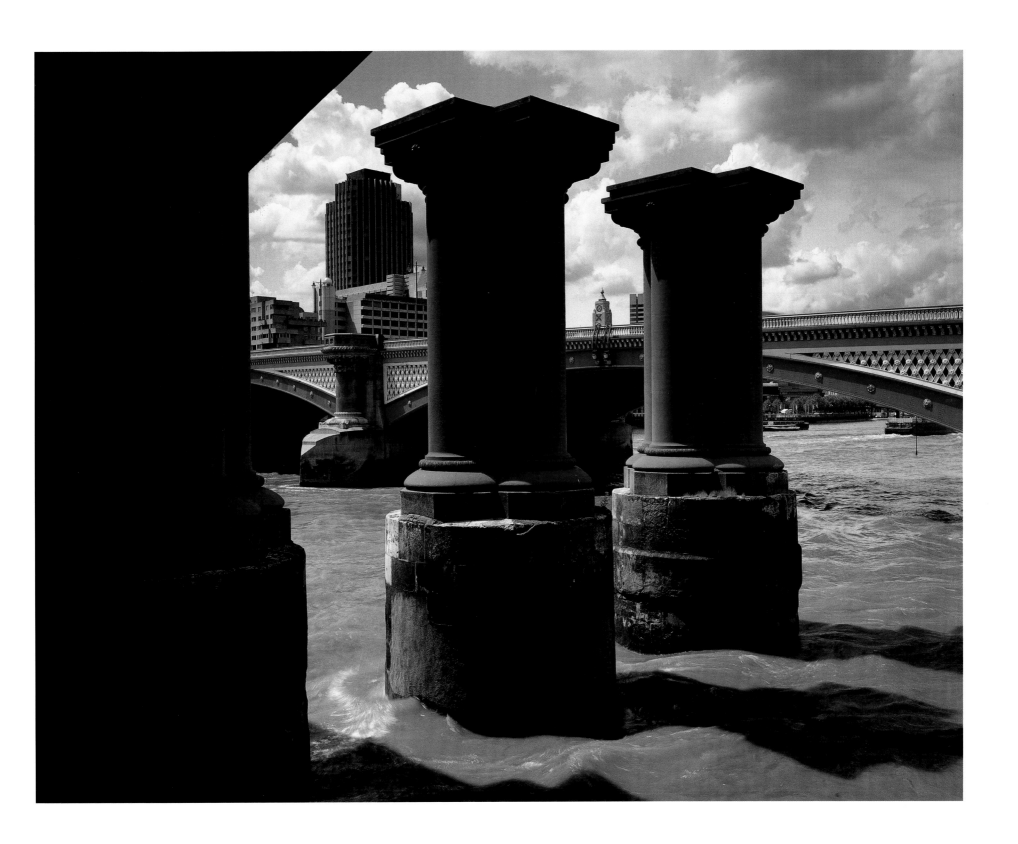

Passengers on the London, Chatham and Dover Railway crossed the
Thames here in Victorian times: the golden age of rail transport.

Directly across the river from the Bankside Tate annexe is a broad flight of steps, Peter's Hill, leading up to Sir Christopher Wren's masterpiece, St Paul's Cathedral. Sung Eucharist 1700 at St Paul's does not mean 1700 AD, it means 17.00 hours, but if I had realized that I would have missed it. The Choir of Christ Church Cathedral, Indianapolis, is practising as I arrive.

Looking up at Wren's great dome you realize that you are actually looking through it – or them. You are looking through a dome to a further dome – from sphere to sphere. We nearly didn't have this dome. After the Great Fire of London in 1666 rebuilding was forbidden until landowners had cleared the roadway in front of their properties and established a legal claim to the land. Which was very sensible when you come to think about it. It also meant that there was time for a committee to be set up to consider a rebuilding strategy.

St Paul's was in the process of rebuilding before the fire, originally under the direction of Inigo Jones, but work had ceased during the Civil War and by the time Wren's plans for completing the restoration work were accepted, just six days before fire broke out, the nave was a thoroughfare and the porch was a market-place where pedlars and seamstresses traded and so did prostitutes. Pepys regularly picked up women here.

But the plague was extinguished along with the fire, the slums had been razed and here was a heaven-sent opportunity to plan a truly beautiful city. John Evelyn submitted a plan on Italianate lines with trees, wide streets, piazzas and a riverside quay reminiscent, perhaps, of Venice. Christopher Wren envisaged turning the River Fleet into a canal and building a scheme of streets radiating from the central point of a new St Paul's Cathedral. Both wanted the city to be gracious, elegant and timeless with noisy and smelly trades relocated on the outskirts. It was a nice thought, but the consensus was that London was a commercial city and that it should be business as usual.

The rebuilding of the cathedral, though, offered a clean slate for Wren, with the opportunity for an entirely new design: English Baroque. His first plan was rejected because – well, because churches had to be cruciform and they had to have a steeple – but when his third design was accepted Wren showed incredible acuity. Aware that, as building progressed, economies would be insisted upon, he began building not in the usual way from east to west, (which is why cathedrals take centuries to reach completion), but to build upwards, stage by stage, from the ground. It was a sensible precaution and building proceeded uninterrupted. It took over thirty years, but it didn't stop. Of course the authorities did insist on economies – in fact, after twenty years they halved his salary – but Wren was content.

He did not stick to the agreed plan. As work progressed he shortened the nave and modified into circular form the meeting between nave and transepts. Then, of course, a dome rather than a steeple was the only way to crown it. And if any doubt remained in those fervent traditionalist bosoms it was surely dispelled when he asked for a stone from the rubble to mark the centre point of the dome. The stone he was handed read *'Resurgam'*: I will rise again.

During the building of St Paul's, although he was engaged on the building of probably fifty other churches, Wren visited the site at least once a week to check on the progress. He lived across the Thames, at Cardinal's Wharf, next to the reconstructed version of Shakespeare's Globe. He was an old man by the time St Paul's was finished and his was one of the first burials in the crypt. On the pavement under the dome is his epitaph: *'Beneath lies buried the founder of this church and city Christopher Wren… if you seek his monument, look around you.'*

I had been expecting to hear William Byrd, and the *Sanctus*, by William Albright, feels less like music than a – well, a sound. But what a glorious sound! Rather like a great celestial rabble. The hymn they had been practising when I arrived turns out to be called *'Tis good, Lord, to be here!'* And I'm glad I came, too.

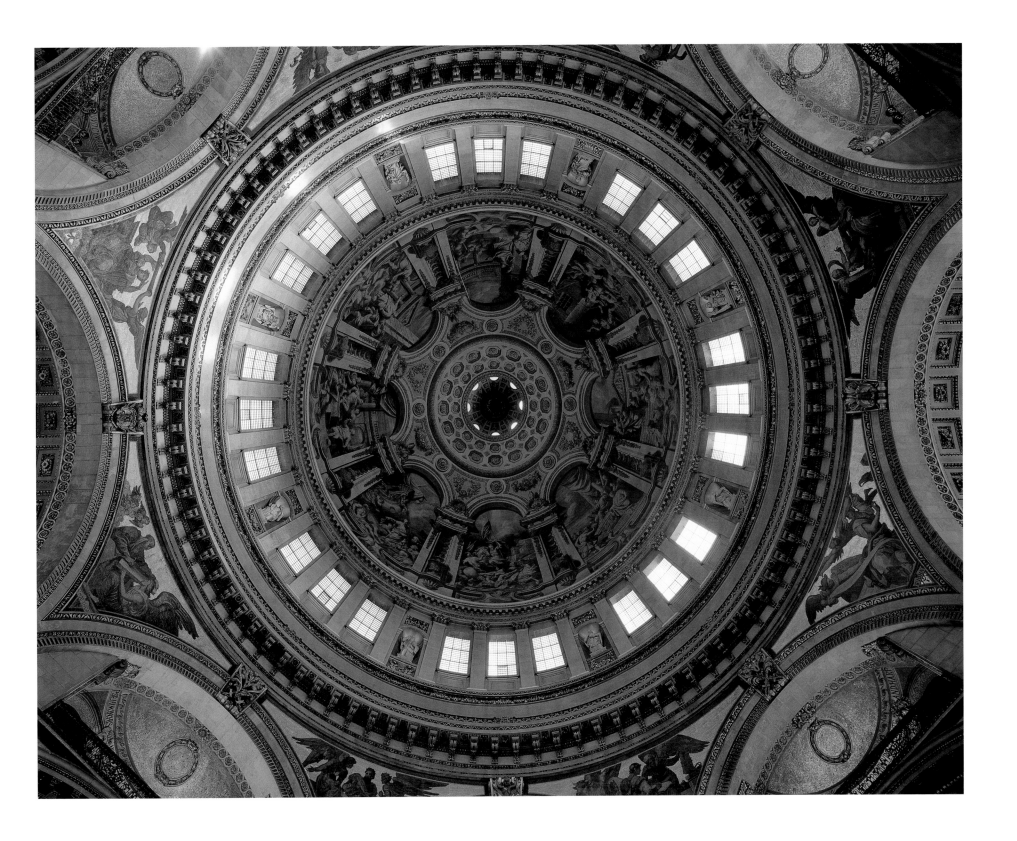

Looking up into the cupola of St Paul's Cathedral, Sir Christopher Wren's
crowning achievement. Below is his epitaph: *'If you seek his monument,
look around you.'*

The original Globe Theatre, built by Cuthbert and Richard Burbage in 1598–9, was named not so much for its shape – which was usual – but for its sign, which showed Hercules carrying the world on his shoulders. Shakespeare was both a shareholder and a player, but his talents as a playwright seem to have been taken for granted.

The theatre burned down in 1613, when a cannon fired during a performance of *Henry VIII* set the thatch on fire. There were no injuries but one playgoer *'had his breeches on fire that would perhaps have broyled him if he had not with the benefit of a provident wit put it out with bottle ale'*. It was rebuilt, only to be closed and then demolished by the Puritans during the Commonwealth.

It is thanks to the American film-maker Sam Wanamaker and his persistence in the face of prolonged apathy and animosity (*But he's an American! But he makes pictures!*) that this new Globe exists and he died, sadly, before it was completed.

The first ever performance at the new Globe is *Two Gentlemen of Verona*, and the Globe's Artistic Director, my young hero Mark Rylance, appears as Proteus. Of course all the tickets were sold months ago, so my journey is purely in the interests of research. I shall be content to sit on the river wall opposite, happy if I get the occasional glimpse of the 'groundlings' in the open courtyard, delighted if I hear occasionally a burst of applause, laughter, or heckling, which is what the company hopes for. Tomorrow there will inevitably be carping in the press about the lack of toilets, catering facilities and parking, and the planes passing overhead. But none of this will dull the pleasure I am unselfishly taking in the excitement of those happy few with admission tickets. Then a shy young man in a suit comes by, asking if anyone would like a £5 ticket?

Within moments I am among the groundlings, surely the best place to be, looking up all around at the people who have not yet got sore bottoms from the wooden benches and buying a pastry from a vendor. I am at the beginning of three hours of magic.

Not, as the critics say, a great play. But a perfect play for the opening because it is a simple, unpretentious piece by the supreme master and if we do not hang on every word, well, what matter? We will be able to wander about, to gaze overhead at the clear blue night sky, knowing it would be in keeping to shout: 'SPEAK UP!' when we cannot hear Sylvia and not doing so, because – well, what the hell. Enough of the play will rub off on us all to make it a night of nights. The crowd will heckle and boo and hiss and give a collective intake of breath at the rare hard-won stage kiss, and roar its disapproval of Proteus' attempted ravishment of Sylvia; and Rylance will raise his eyebrow at us when we taunt him as a knave and we will be completely and utterly won over by him and his company.

And the biggest cheer of the evening will go to Dennis, a ragged mongrel with extraordinary star quality playing Crab, who takes everything in his stride apart from the audience's wild appreciation at the end, when his tail goes between his legs and he looks unsure as to why, when he has just done his job, this tumult is happening around him. Are we *cross* with him? But no doubt every other night for the rest of the run, he will, as tonight, be petted by some female groundling who cannot resist his bedraggled, hang-dog charm. Ah, a dog's life.

So this is the opening of Shakespeare's new Globe, rebuilt after four hundred years. What makes it work? The concept? The building? The setting? The ghost of so many hundreds of Elizabethans among whom perhaps Will himself (in whom Rylance does not believe, which matters not a jot)? The sheer bloody-mindedness of Sam Wanamaker and the sheer bloody professionalism of Rylance, director Jack Shepherd and their crew?

What makes it work is sheer bloody magic.

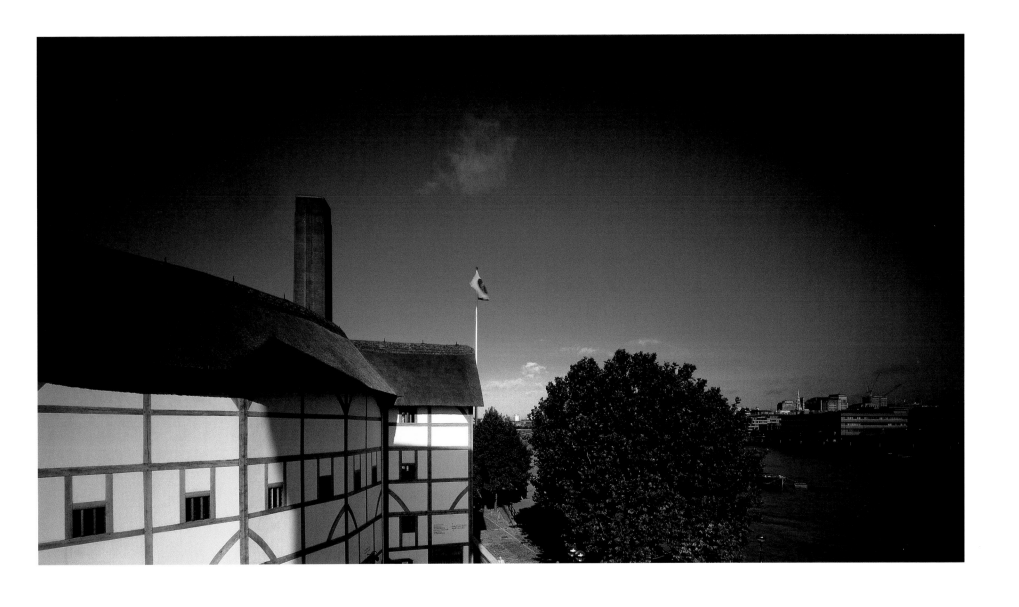

The chimney of the old Bankside Power Station – now the Tate Gallery's
Museum of Modern Art – appears to pierce the thatch of the reconstructed
Globe Theatre.

When Dr Johnson decided on a course of action he leaped in feet first, shambling around with face working and hands gesticulating. It is that kind of innocence which makes him so lovable.

When his friend Henry Thrale died in 1781, Johnson was one of his executors. He is described at the sale of Thrale's brewery, the Anchor, as *'bustling about like an exciseman'* with pen and ink-horn. His gifts of imagination and prose were employed to the full in looking after the interests of the widow, Hester Thrale. Asked for an opinion as to the true value of the property he launched into oratory: *We are not here to sell a parcel of boilers and vats, but the potentiality of growing rich beyond the dreams of avarice!'*

I can picture Sam throwing himself into the part with a minimum of grace and boundless goodwill. But he was right. Henry Thrale had built the brewery into the fourth largest in London, covering the site of Shakespeare's long-gone Globe Theatre. Barclay, Perkins & Co bought it and they were eventually swallowed up by Courage.

After her husband's death Hester Thrale married a musician, Gabriel Piozzi, which, regardless of her great happiness, hurt Johnson deeply. For the past sixteen years he had had a second home in Streatham at the Thrale household and had nurtured a deep love for Hester which he had perhaps never analysed. After Johnson's death Hester published two memoirs of him: *Anecdotes of Dr Johnson* and *Letters to and from Dr Johnson*, but the two had not been on speaking terms since her second marriage.

Johnson and Henry Thrale shared a love for good food. But its enjoyment did not diminish his wit at the table. Here is a fragment of conversation at the Thrales regarding the roasting of meat:

'Desmoulins has the chief management of our kitchen, but our roasting is not magnificent, for we have no jack.'
'No jack! Why, how do they manage without?'
'Small joints, I believe, they manage with string, and larger are done at the tavern. I have some thoughts of buying a jack, because I think a jack is some credit to a house.'

'Well, but you'll have a spit, too?'
'No, Sir, no. That would be superfluous, for we shall never use it; and if a jack is seen a spit will be presumed.'

The Anchor pub here had both a spit and a jack and a room is named for Johnson, who was a frequent patron along with his biographer Boswell as well as the dissolute poet Richard Savage, the subject of Johnson's *Life of Richard Savage*.

In penury, Savage and Johnson wandered London throughout long nights, declaring their patriotism with Savage bemoaning the hand fate had dealt him. His professed desire to retire to the country and live the simple life was exposed as a sham when Pope took up a collection from literary colleagues, making a pension possible. Savage went to Richmond to sponge on a friend, but returned. He couldn't stand the boredom.

Johnson was as kind as he was innocent. His marriage to the widow Elizabeth Porter, twenty-five years his senior, cannot have been entirely fulfilling for a man with Johnson's capacity for enjoyment, but he was steadfastly loyal and, one hopes, never knew of his friend Garrick's party piece: an hilarious impression of the near-blind and amorous Johnson blundering in hot pursuit of his kittenish 'Tetty'. Even the affectionate nickname was enough to reduce fellow members of Johnson's literary club to helpless tears.

In recognition of his services as the compiler of the great dictionary Johnson was awarded a pension by King George III. In his dictionary he had defined a pension as *'pay given to a state hireling for treason to his country'*. The pension was set up by Thomas Sheridan, a teacher of oratory, for whom Johnson held affection but not respect, and on learning that Sheridan, too, was in receipt of a pension Johnson was seriously minded to give his up, but he didn't. To his credit, he didn't change the definition of 'pension' in his dictionary, either.

Dr Johnson and his biographer Boswell frequented the Anchor
public house on Bankside, near Henry Thrale's brewery.

In 1066 the manor of Southwark belonged to Earl Godwin, father of King Harold, and after Harold's death at the Battle of Hastings it fell to his friend Ansgar, who had been badly wounded at Hastings and had to be carried in a litter as he organized resistance, to prevent William of Normandy from crossing London Bridge. So William burned Southwark and proceeded south-eastwards on his great circle of destruction, crossing the Thames at Wallingford and returning eventually to London.

Southwark recovered and, as the main entry from the south to London via the only river crossing, London Bridge, it became well known as a place of hospitality to travellers. Chaucer's pilgrims met at the Tabard inn, which was in Talbot Yard, Borough High Street. It no longer survives, but a little further along Borough High Street is the George, dating from 1677 and worth a visit for its architecture and ambiance if nothing else. Southwark's inns became largely redundant with the advent of the railways.

The first Southwark Bridge was not built until 1819 by the architects John Rennie & Son and was the iron bridge that features in Charles Dickens' *Little Dorrit*. Today's bridge was built in 1912–21 by Mott and Hay to the design of architect Sir Ernest George.

Southwark became a centre for entertainment mainly because the earliest theatres had to be established beyond the City's jurisdiction. In 1580 the puritan Lord Mayor of London pronounced players *'a very superfluous sort of men'* so when the Rose, the Swan and the Globe opened in the late sixteenth century they were all on the south bank, securely out of harm's way. When the Puritans gained power in the City in 1640 they closed them all, but with the restoration of Charles II in 1660 they all opened again apart from the Globe.

Closed, also, was the Davies amphitheatre of 1662–82, the last bear-baiting ring of Bankside, visited with great pleasure by the hedonistic Samuel Pepys and, perhaps with less pleasure, by his more fastidious friend John Evelyn. Bear-baiting was not a new phenomenon. Queen Elizabeth I had visited the Bear Gardens, but the amphitheatre was later replaced by the Hope Playhouse, intended for both bear-baiting and plays. Ben Jonson's *Bartholomew Fair* was first performed there in 1614. There are no gardens now, just a derelict Victorian warehouse, home to the ubiquitous buddleia where a pigeon roosts peacefully in a tree awaiting the developers – who are at least preferable to bear-baiting.

Behind Anchor Terrace on Southwark Bridge Road today a once-proud sign proclaims with a large arrow: THE GLOBE THEATRE. Archaeological Excavation. But alas, the excavation now taking place is not a gentle uncovering of our heritage. Rather a development of new luxury flats. Mark Rylance and Zoë Wanamaker, who knew how much we had still to learn, were brought to tears by the decision of the then Heritage Minister Virginia Bottomley. Will the new inhabitants appreciate what they are living above? Will they hear ghostly feet in the night – will ribald jokes and alarums and excursions disturb their slumbers?

Above the excavation a flock of birds shimmers overhead backwards and forwards. Changing and ever changing direction like dispossessed souls. As the late summer sun catches them, these humble London feral pigeons become shades of grey, black, and purest, purest white. A flock of doves, no less. Below, excavators in their employers' red shirts and hard hats dig on.

At Southwark Bridge the Thames appears to be a bustling highway, but in fact commercial river traffic is just a fraction of what it has been in the past.

Here in Southwark is a cathedral of human rather than heroic proportion with a flint exterior harmonizing with the humble London pigeon. The bosses in the thirteenth-century ceiling of the nave are low and the people walking around below them, to the accompaniment of trains rumbling overhead and an organ lesson in progress, look comfortable.

Southwark has not long been a cathedral. Originally it was the priory church of St Mary Overie (St Mary over the river) and after 1539, when its Prior, Bartholomew Linsted, surrendered to Henry VIII at the dissolution, it served as the parish church of St Saviour until 1897. Then until 1905 it was the Collegiate Church of St Saviour and then the Cathedral Church of the new Diocese of Southwark. In 1937 it became the Cathedral and Collegiate Church of St Saviour and St Mary Overie, Southwark. It might have been simpler starting out as a cathedral.

But hidden within this rather lacklustre summary is fascinating history. Among Southwark's memorials is the tomb of John Gower, who died in 1408. Gower was a friend of Chaucer and Poet Laureate to both Richard II and Henry IV. Now that must have required some diplomacy, but as he was a well-known figure at court during his last years diplomacy must have been one of his talents. 'Moral Gower' as Chaucer referred to him, wrote *Vox clamantis*, an account of the rising of Wat Tyler and *Cronica Tripertita*, an account of the deposition and the last years of Richard II. He wrote the first in Latin elegiacs and the second in leonine hexameters and I think you should look those up. I had to.

If you walk around behind the high altar to the retro-choir you might sit quietly and think about John Rogers who, in 1553, the first year of Mary's reign, was tried here for heresy by Stephen Gardiner, Lord Chancellor of England and Bishop of Winchester. *'Thou canst prove nothing by scripture. The scripture is dead,'* Gardiner assured Rogers, and Rogers, unconvinced, became the first of three hundred Protestants to be burned during Mary's five-year reign.

As the daughter of the ill-used Catharine of Aragon, Mary's anti-Protestantism is perhaps understandable. During the previous six-year reign of her half-brother, Edward VI, the king's maternal uncles, the Seymours, had done very well out of the dissolution of the monasteries and were not at all keen on the prospect of a return to Catholicism. In 1548, under the approving gaze of the self-proclaimed 'Protector' Edward Seymour, Duke of Somerset, the young king ordered the removal of all images from churches and chapels, the whitewashing over of all wall paintings of saints, the dismantling of all roods and the smashing of all crucifixes.

But Edward's reign was brief and his Seymour relatives over-ambitious. When it became clear that he was not going to live long, an unseemly jostling for useful marriages took place. The king's younger uncle, Thomas Seymour, attempted to gain the hand of the Princess Elizabeth. His ambitions were seriously curtailed when Somerset ordered his execution. Somerset, in turn, was deposed by the Duke of Northumberland, who persuaded Edward to divert the succession to Lady Jane Grey, granddaughter of Henry VIII's younger sister Mary. Then he married her to his son. It all came to nothing – except the sacrifice of the gentle Lady Jane, executed by Mary's triumphant supporters after a reign of just nine days.

Mary reigned for five years and on her death her half-sister Elizabeth, Anne Boleyn's daughter, succeeded. Under her three hundred died as Catholic martyrs and eight hundred young men left England for Europe in order to train secretly as Catholic priests. Among many spies recruited to confound their plots was Christopher Marlowe and it could be partly due to him that on their return a hundred of these young men were executed.

The twentieth century is a kinder one. Now, services in the cathedral are often interdenominational, and the only rumbling audible right now is the 12.47 to Charing Cross.

Southwark Cathedral takes one by surprise – a secluded haven
amidst the tumult of road, rail, river and market activity.

When William I conquered England he conquered a sophisticated people. They were not, though, a people as experienced in warfare as his own army, which is surprising in the light of their long struggle during the years of Viking aggression. But Alfred's people were simply defenders of their island home and had no military caste like that of the Norman invaders. Their defences were wood and earthen fortifications and their buildings were of wattle and daub.

Yet the Normans who came with William were not so much an army as a collection of military adventurers intent on gaining property. Land was the reward promised William's invasion force by their Duke, and nobles and humble small landowners alike were keen to offer their sons as knights. Knighthood was a job rather than an honour conferred, and William's knights were largely younger sons whose elder brothers had inherited their family estates. Their clever brothers could look for a career in the church, but for young men without hopes of inheritance and with little aptitude for learning, the army was a sensible choice of occupation.

So William and his knights, leaving a trail of devastation, completed their circuitous route from Southwark via Wallingford and, on entering the City, William issued the Charter to London:

> *William the King sends greetings to William the*
> *Bishop and Gosfrith the Portreeve, and all the citizens in*
> *London, French and English in friendship. And I give you to*
> *know that I grant that you be worthy of all the rights of which*
> *you were worthy in King Edward's day. And I grant that*
> *every child be his father's heir after his father's day, and*
> *I will not allow any man to do you wrong. God keep you.*

Then he built Baynard's Castle to the west of the City, near St Paul's and to the east he built the formidable fortress of the White Tower. Stone for the tower was brought by barge from Kent and from Caen in Normandy. The mortar, mixed with Roman bricks, was of a red colour. The rumour was that it was mixed with blood, and William did not deny it.

William's Tower served London well. The first time its guns were ever turned on the City was during the civil war in 1460, when the Garrison Commander, Lord Scales, was besieged by heavy cannon firing from the south bank, bringing down part of the curtain wall. Scales tried to escape down the Thames in a wherry but he was recognized and lynched by a mob of boatmen, enraged that Londoners had been fired upon. His naked body, covered in stab wounds, was thrown into the churchyard of St Mary Overie.

The Tower was the perfect medieval fortress and it has been augmented and refined by a succession of monarchs since the Conqueror. The second largest tower, the Wakefield, was built by Henry III, between 1220–40. When, in 1464, the childlike Henry VI was captured by Edward IV and paraded through London tied astride a sickly horse, straw hat on his head and placard on his back, he was confined here for six years before he was murdered. He was allowed his Bible and breviary, a pet dog and a pet sparrow for company.

The Tower of London. How many people have taken their last glimpse of freedom entering here? Religious martyrs like John Fisher and Thomas More, discarded queens like Anne Boleyn and Catherine Howard, helpless pawns like Lady Jane Grey and her champion, Archbishop Cranmer, and even in the twentieth century, men like Roger Casement in 1916 and the alleged German spy Joseph Jacobs in 1941.

Not all were to die. Princess Elizabeth survived, walking her sentence away on the wall between Bell and Beauchamp Towers and emerging to become *Gloriana*, probably the greatest sovereign of all.

The Tower of London is one of the capital's unmistakeable landmarks:
once a royal palace, then a prison, now a tourist attraction.

If, in the year 1255, you had been surveying this scene of Tower Wharf from where I pause on Tower Bridge, you might have seen a polar bear disporting its great shaggy bulk in the Thames. It would have been tethered by a rope or a chain to the curtain wall of the Tower.

The Tower has served variously as castle, royal residence, prison, royal mint, repository for jewels and, well, menagerie.

Richard I brought back a crocodile from one of his crusades in the 1190s but it escaped into the Thames and was never seen again. The first animals to take up permanent residence were three leopards, presented to Henry III by the Holy Roman Emperor. A whimsical enough gift, representing the three leopards on the Plantagenet coat of arms, they probably gave Henry the idea of a royal zoo; certainly before long he is on record as having two leopards, an elephant presented by King Louis of France, and two bears. One of the bears was a polar bear, presented as a gift by the King of Norway. The Sheriffs of London were ordered to provide fourpence a day for food for him and a chain so that he could go fishing in the river.

The royal menagerie was relocated from its then home in the Lion Tower to Regents Park in 1834 to form the nucleus of London Zoo and now the only creatures the Tower is famous for are the ravens. Charles II was told that if they left the monarchy would fall. And *that* would be a shame, they seem to say as they thoughtfully eye your sandwiches.

But of course you could not have stood here, because the bridge, the great symbol of London, resplendent on a million postcards and tea towels, has been here barely a hundred years.

Tower Bridge straddles the Pool of London. Roughly speaking, the stretch between Tower Bridge and London Bridge, upriver, is the Upper Pool, and that downriver between the bridge and Limehouse is the Lower Pool. The Pool of London was for centuries the busiest port in the world and the source of London's prosperity. In the seventh century The Venerable Bede described it as the reason for London's existence and a thousand years later,

when Charles I, in a fit of pique, threatened to move his court to Oxford the City fathers said it was all one to them as long as he did not remove the Pool.

London Bridge was until 1749 the only bridge to span the river in London. The other eleven central London crossings came a lot later, beginning with Westminster in 1750. But they were all to the west of London Bridge and as much of London's eighteenth- and nineteenth-century workforce lived to the east, they were poorly served. By this time, London Bridge was appallingly crowded with horse-drawn traffic as well as pedestrians and cyclists, and it took just one fallen horse, overturned cart or dislodged load to wreak havoc and a traffic jam of several hours.

There were ferries – in fact one, the Horsleydown, plied from the base of Tower Bridge itself until it opened in 1894 and, later, there were tunnels: Brunel's double pedestrian tunnel from Rotherhithe to Wapping (now converted to a railway tunnel) opened in 1843 and in 1871 came the Tower Subway, from Tower Hill to Pickled Herring Lane (behind HMS *Belfast*), which is now used to carry telephone cable.

It was obvious that another bridge was needed, but the Pool posed a seemingly insurmountable obstacle. To cut off the Upper Pool to tall ships would spell disaster for trade and any bridge high enough to allow for tall ships to pass underneath would require a gradient too steep for horses.

Invitations for a design were invited but in fact the solution came from the City Architect, Sir Horace Jones. He designed a bridge on the 'bascule' or see-saw principle, which had been used by Dutch engineers for some time. The system involved using hydraulic power to activate pistons, crankshafts, gear wheels and toothed quadrants and I wish the excitable tourist in the worthwhile audio-visual *London Bridge Experience* was less insistent on explaining it all in such a loud voice. I know. My brother had a Meccano set.

The ghostly image of a warship passes silently under
Tower Bridge out of the Pool of London.

Much of Bermondsey is naturally below water level in an exceptionally high tide: the name comes from the Saxon: 'Beormund's Ey', or Beormund's Island. Bermondsey Wall, running parallel with the now tidily encased London waterway was originally just that: a wall to keep the encroaching tide of the then spreading river at bay.

The flooding made for exceptionally rich pasture land and Bermondsey Abbey, founded as Bermondsey Priory in 1082, was a rich abbey with grain, bees, meadowland for cows and woods where pigs might forage for nuts and acorns. It remained a wealthy foundation until it was dissolved under Henry VIII and bought by Sir Thomas Pope. Sir Thomas demolished the abbey buildings and used the stone to build himself a mansion, now lost. All that remains of the abbey are two iron hinges emerging from the plaster of an old house in Grange Walk. Near it is a council estate building named Woodville House, whereby hangs a tale.

Henry VII, having defeated Richard III at the Battle of Bosworth, consolidated his rather spurious right to the throne by marrying Elizabeth, sister of the two princes murdered in the Tower. He granted his mother-in-law, the unpopular Elizabeth Woodville, several privileges, among which were the right to feed pigs in Savernake Forest and the right to dredge for mussels in Tilbury Hope. Clearly, Elizabeth was not particularly given to donning a smock to tend pigs or hitching up the royal skirts to collect mussels and in 1487 she exchanged her estates, including the pigs and mussels, for an annuity, and retired here into Bermondsey Abbey which was a relief to Henry.

It was the monks from the abbey who embanked the river, building in the process St Saviour's Dock. They had their own mill – hence Mill Street. There were a number of mills hereabouts: the Knights of St John at Jerusalem had several and the street name Shad Thames is a corruption of the 'Street of St John at Thames'.

In medieval times the river hereabouts was lined with mansions – many of them the London residences of powerful churchmen. Further east along the river bank, near the Angel public house, are the remains of that built by Edward III. The Angel itself dates from 1850, but there has long been an inn on this site – in the fifteenth century the monks of Bermondsey sold their beer here and it may have been here that, in June 1664, Pepys repaired having visited nearby Cherry Gardens to buy cherries for his wife, because he reports *'singing finely'* as he returned by boat to London Bridge.

Yet Bermondsey was also home to one of London's smelliest trades, as Tanner Street, Morocco Street and Leathermarket Street still testify. A City proclamation was issued in 1392 ordering that butchers should have a place in Southwark for dumping such 'garbage' as offal and animal skins. The locals of Bermondsey rose to the occasion, as has always been their habit, and turned the disadvantage into a highly profitable industry. The numerous creeks filling and emptying with the tide offered ideal washing and soaking facilities, and the abbey's oak forest provided the bark that was an integral part of the leather-making process. Neither did they have far to look for a market: just across the river were those rich City fathers. And an unlikely tourist boom developed in the plague years, when people flocked here in the belief that the smell would ward off sickness.

In 1900, Dr Alfred Salter (of vaccine fame) set up a local practice in Bermondsey, charging his poor patients a nominal fee or nothing at all and yet treating them, as the women said, *'as though you were a duchess'.* Dr Salter and his wife Ada had a vision of turning Bermondsey into a 'garden city' with low-density housing and trees planted in every street. They formed the Socialist Movement of Bermondsey and lived by their principles: their daughter Joyce was born here and educated in a local school, dying, along with many schoolmates, of scarlet fever. Cherry Walk, with its bronze sculptures comprising 'Dr Salter's Dream' is a tribute to Bermondsey's finest.

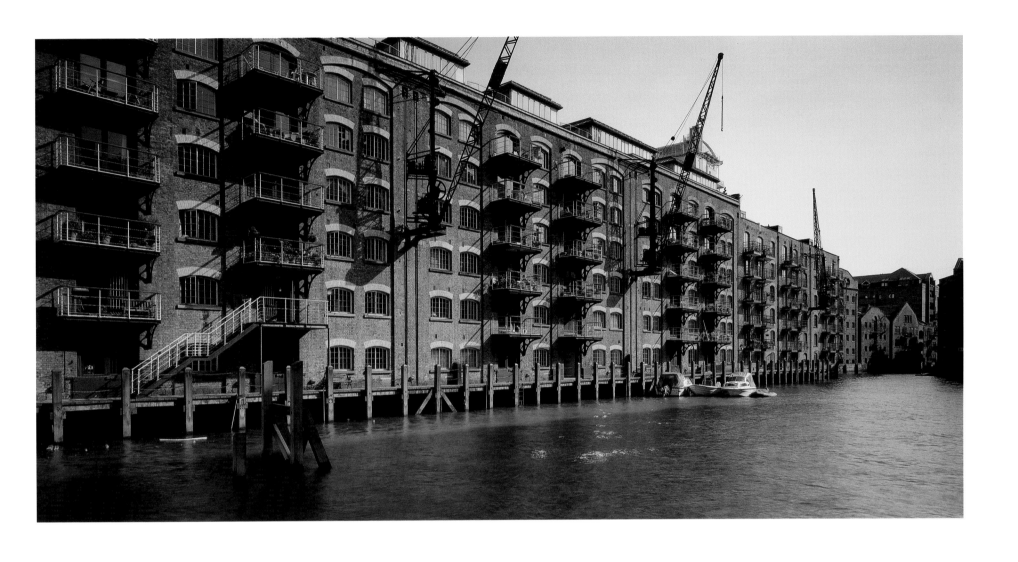

Bermondsey's riverside warehouses beside St Saviour's Dock
are now desirable residences.

In the National Maritime Museum at Greenwich is a painting from 1704 showing the great naval dockyard at Deptford. All that remains today is the Master Shipwright's house. Deptford Creek is still here, though, with juggernauts pounding across, and it is still in use. Today a barge from Lowestoft is beached here, laden with scrap metal, and another enters just as I leave.

The riverfront at Deptford is going through a renaissance at present. The attractive Victorian storehouses on the Pepys Estate have been well recycled into homes and the view across to the huge tower of Canary Wharf is clean and pleasant enough, if lacking in the bustle of past ages. And it certainly did bustle. This was Henry VIII's victualling yard and here is the spot where his daughter Queen Elizabeth I knighted her hero Sir Francis Drake after his voyage around the world on the *Golden Hind*.

But it is Samuel Pepys for whom the area is named. Pepys is known to us mainly for his extraordinarily indiscreet diaries – albeit written in his private shorthand – but his fame nearer his own time was as the saviour of the navy. He was in charge of victualling for Charles II's navy at the time of the wars with the Dutch and he was an excellent choice. He wrote that:

> *Englishmen, and more especially seamen, love their bellies above anything else, and therefore it must always be remembered in the management of the Navy that to make any abatement from them in the quantity or agreeableness of the victuals is to discourage and provoke them in the tenderest point, and will sooner render them disgusted with the King's service than any other hardship that can be put upon them.*

The fact that he tended to make free with their wives has obscured the fact, to our somewhat cynical minds, that Pepys did his best for his crews. Men were reluctant to serve in the navy, despite unemployment and widespread starvation, because they believed, with good reason, that they were likely to be left unpaid. 'Tickets' issued when cash was short were supposedly redeemable at the Navy Office, but both Charles II and, later, his brother James kept the navy desperately short and brokers made tidy profits from starving seamen.

Pepys' diary entry for 7 October 1665:

> *Did business, though not much, at the office, because of the horrible Crowd and lamentable moan of the poor seamen that lie starving in the streets for lack of money – which doth trouble and perplex me to the heart. And more at noon, when we were to go through them; for then a whole hundred of them fallowed us – some cursing, some swearing…*

The men were also dying of plague, which many regarded as part of a Dutch plot. The Dutch certainly made the most of it, pushing on with the war and the Royal Navy, desperate for recruits, patrolled the channel, pressing into service merchant sailors, who had already been away from their families for two or three years, before they could escape ashore.

It was Pepys who made the navy modern and professional. It was he who insisted on ships' masters being literate and numerate, the knowledge of the unlettered, as he explained, *'lying in their hands confusedly'*. It was Pepys who dispensed with the old 'gentleman' captains and insisted on certification for would-be masters from Trinity House and it was he who founded a mathematics school at Christs' Hospital, seeing it as a training school for navigators. It was Pepys who tried to end the corruption of pursers and captains and the numerous frauds perpetuated against poor seamen; he who tried to deal with the arrears of their wages. This was the professional Pepys.

There was also the Pepys who continuously cheated on his wife and beat his servants. But the Pepys I love above all is the Pepys who is interested in everything, but whose passion is for music above all else, who plays his lute and sings *'on the leads'* and whose conversation was, as a friend said, *'more nearly akin to what we are taught to hope for in heaven, than that of anybody else I know'*.

River barges at Deptford await the incoming tide before the day's
work, just as they have done for hundreds of years.

'Welcome to Sayes Court Park' says Lewisham's cheery notice. Here is one sandpit, derelict; one paddling pool, derelict; one climbing frame, derelict. Slide and swings, ditto. You get the picture. What a charming playground this must have been until very recently. But modern Lewisham is a thriving, thrusting London borough. It has a public library that must have other councils grinding their municipal teeth. And children's playing habits change along with everything else, so there is little point in ruminating on what the Salters would have thought of it. They would have just got on with what needed doing.

The diarist John Evelyn did. Here, where barley and buddleia thrust their way through modern asphalt, Evelyn planted his garden.

January 17, 1653. I began to set out the Ovall Garden at Says Court, which was before a rude Ortchard, & all the rest one intire fild of 100 Ackers, without any hedge: excepting the hither holly-hedge joyning to the bank of the mount walk: & this was the beginning of all the succeeding Gardens, Walkes, Enclosures & Plantations there…

By 1665 Evelyn's house and garden were the delight of his family and friends. His diary of February 9, 1671, reads: *'This day dined with me Mr. Surveyor Dr. Chr: Wren, Mr Pepys Cleark of the Acts, two extraordinary ingenious, and knowing persons and other friends. I carried them to see the piece of Carving which I had recomended to the King…'* which was by the Dutch sculptor and woodcarver Grinling Gibbons living and working nearby. Charles II was to employ Gibbons at Windsor and on the new St Paul's and it would be good to know what riches the extraordinary craftsman created at Sayes Court, but nothing of the house or the garden remains. Except – just possibly – this gnarled and ancient mulberry? Well, it's nice to dream.

Pepys visited Sayes Court often. On 5 May 1665 he recorded:

After dinner to M. Evelings; he being abroad, we walked in his garden, and a lovely noble ground he hath endeed. And among other rarities, a hive of Bees; so, as being hived in glass, you may see the Bees making their honey and Combs mighty pleasantly…

Pepys and Evelyn had a great admiration for each other. Pepys wrote on 29 April 1666: *'he and I walked together in the garden with mighty pleasure, he being a very ingenious man, and the more I know him the more I love him'.* They were both important and influential men of their day and it is interesting to compare their portraits, both in the National Portrait Gallery. Pepys is shown by John Hayles as an alert, ambitious man and Evelyn, by Robert Walker, cultivated but languid with one long hand supporting his head, the other resting on a skull.

When the court painter visited Sayes Court Evelyn presented him with home-grown oranges *'as good as were ever eaten I think, to Signor Verrios no small admiration'.*

But not all his visitors were so appreciative. After forty years at Deptford, Evelyn, in advancing age and failing health, moved back to the family home, Wotton. On 6 February 1698, he wrote: *'The Czar Emp: of Moscovy, having a mind to see the Building of Ships, hired my house at Says Court & made it his Court & palace, lying & remaining in it, new furnish'd for him by the King…'*

Peter the Great was a nightmare tenant. His retainers trashed the house and the garden. They broke windows, burned furniture and carpets, damaged the pictures and, on discovering a wheelbarrow, the Tsar insisted on being pushed through the hedges, Evelyn's pride and joy. It took Evelyn years to get compensation from the government. It would not have taken Pepys as long.

Evelyn would have been at a loss in modern-day Deptford but Pepys would have relished it, and I would love to read his diary entry relating his first glimpse of Canary Wharf. I cycle from Sayes Court down to the river and look across to the Isle of Dogs just to refresh my memory. Now there's thrusting for you.

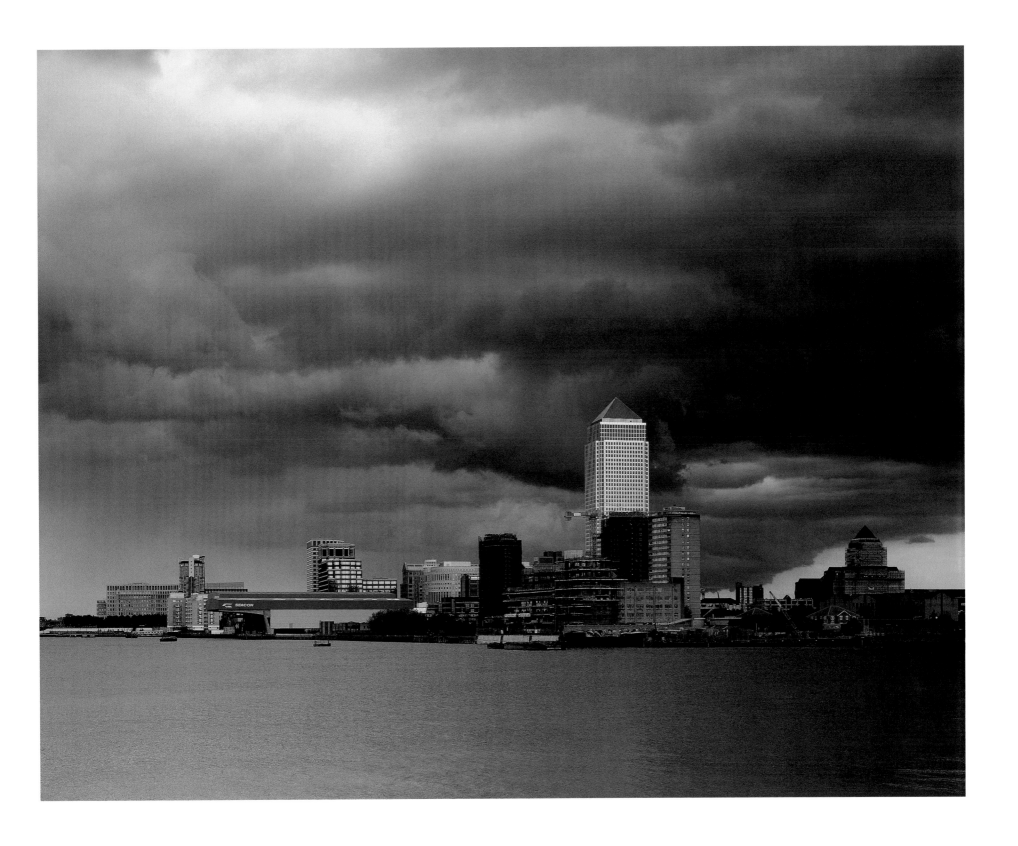

The Isle of Dogs as John Evelyn never saw it: Canary Wharf
is a landmark for most Londoners. From here in Deptford,
Evelyn would have looked across to windmills.

Greenwich was a royal residence probably since the time of Edward I in 1300. Certainly, there was a Tudor palace here: 'Placentia', or the 'Pleasant Place' built by Henry VII. Placentia was a conglomeration of domestic and administrative buildings spreading out haphazardly along this stretch of the Thames where the elegant arrangement of Wren buildings now stands and it features in the background of numerous seventeenth-century-paintings in the National Maritime Museum.

Henry VIII was born in Placentia, as were his daughters Mary and Elizabeth, and the ancient hollow oak tree where Henry courted Anne Boleyn and where little Elizabeth played finally blew down only during the gales of the early 1990s. Henry ruled from here for twenty years and his tournament ground lies below the handsome building housing the administration wing of the museum.

At a window of Placentia Henry's son, the sickly and sad young king, Edward VI was displayed, rouged and coroneted, by his 'protectors' the Duke of Somerset and the ambitious John Dudley, Duke of Northumberland. The charade was to persuade the local populace that the king ruled and all was well. But all was not well because Edward was dying of consumption, although there are rumours that it was not consumption that finally killed him.

Having diverted the succession away from his Catholic sister Mary, Edward was allowed (or quite possibly helped) to die at the age of sixteen. It is rumoured that a local boy bearing a physical resemblance to him was murdered to provide a more attractive corpse – and also to allay suspicions as to the cause of his death, which were, not without foundation, pretty grim. If this is the case, then Edward's body is perhaps buried somewhere under these tidy lawns.

After the Restoration it was Charles II's intention to construct a new palace at Greenwich, but building on the palace was halted in 1669 when funds ran out with only one wing completed. It was not until 1694 that the other was built, on the orders of Queen Mary, who envisaged a naval hospital to match Charles II's hospital in Chelsea for soldiers. Mary recalled Sir Christopher Wren to the project, who offered his services free and appointed Nicholas Hawksmoor his assistant.

The compact, Palladian-style house in the midst of Wren's elegant rectangle is the Queen's House, begun in 1616 by Inigo Jones for Anne of Denmark, James I's consort. Anne died in 1619 and when the house was finally completed in 1635 her daughter-in-law, Henrietta Maria, moved in. When Mary made her plans for the hospital in 1694 she was reluctant to have the house obscured from the river, which is why Wren's building encloses it so protectively.

But Mary, sadly, died that very year. It *was* sad. Mary was thrust centre stage as a revolutionary, landing with her husband and first cousin, William of Orange, when leading clerics and landowners asked him to invade. Her father, James II and his second wife the Catholic Mary of Modena were forced to flee to France with their baby, James Stuart (the 'Old Pretender'). But Mary loved her father and everyone loved Mary. During her short reign she did a lot to atone for the previous excess of the Stuart courts and when she died Purcell wrote his *Ode on the Death of Queen Mary* for her.

Mary's brother-in-law, Prince George of Denmark, bought the Queen's House in 1708, intending to give it to the Naval Hospital, but George, too, died before his plans were realized. Not a lot went right for George. He didn't have a sparkling personality and Charles II said of him: *'I've tried him drunk and I've tried him sober and there's nothing to the man.'* But Queen Anne, Mary's younger sister, loved him and bore him seventeen children, all of whom died in infancy.

Which is why the succession went to the Protestant Elector of Hanover, George I, who landed in Greenwich in 1714 and why the first ever Hanoverian reception was held here in the Queen's House.

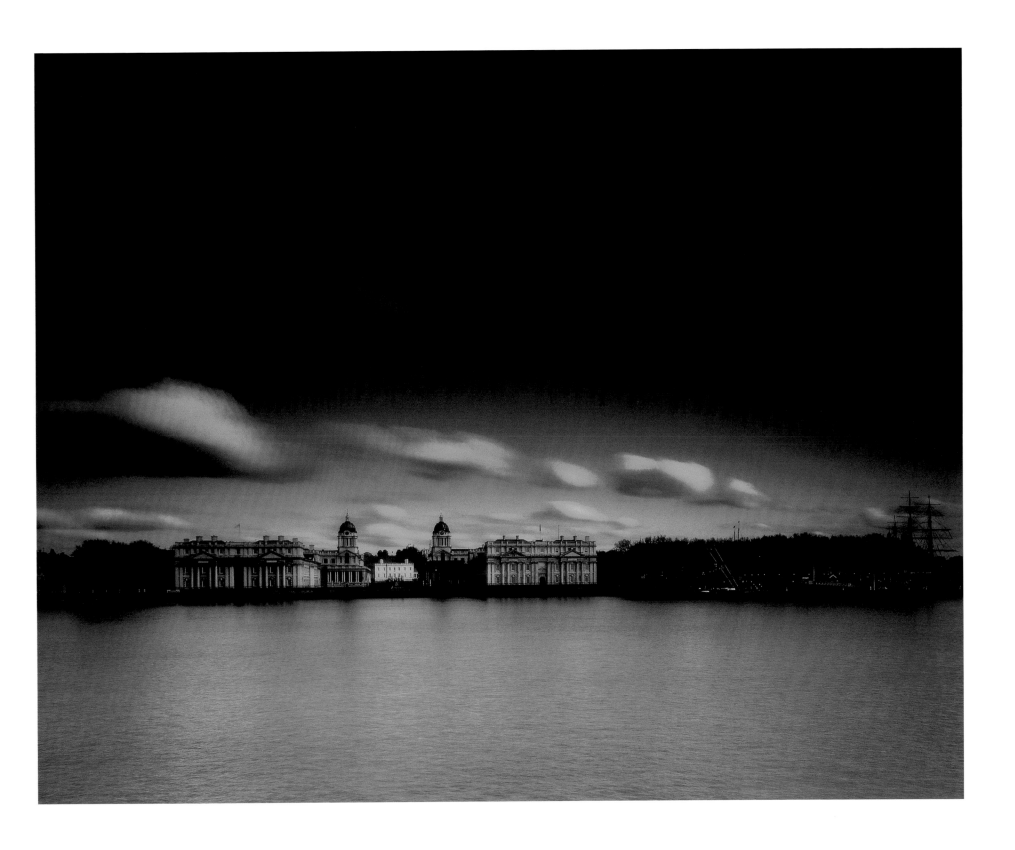

The Cutty Sark, far right of the Royal Naval College, was one of the tea
clippers which made a fortune for her owners, transporting tea and opium.

Greenwich. Now there's a name to conjure with. On top of the hill, across this great expanse of well-kept parkland where kites soar, frisbees zoom, dogs gambol, families take the air and cyclists mount only *at their peril,* the source of the allure stands in tree-shrouded dignity: the Flamsteed Observatory. A tourist standing astride the meridian line is awed by an extraordinary coincidence. 'That there should have been room at this very spot to draw this line!' she breathes, overwhelmed with the wonder of it.

We are now so used to Greenwich being the centre of the world that we forget the reason for the siting of the royal observatory. Because it was the King's pet project, it was sited, quite literally, in the King's back garden.

Charles II commissioned the observatory building from Christopher Wren. Charles, despite his flamboyant lifestyle, was not only the arbiter of fashion, but also educated, intelligent and keenly interested in the arts and science. He designated the young John Flamsteed his first personal 'astronomical observator', entrusting him with the task of updating and perfecting the astronomical charts and tables used for navigation at sea. Because Charles, whose navy was largely funded by privateering and whose merchantmen were constantly harried and plundered in turn by marauding Dutchmen, wanted to be the one who solved the age-old problem of determining longitude at sea. Not only would it mean fewer lost ships, it would give him enhanced status in the eyes of his glorious cousin Louis XIV of France, the Sun King.

That is how the observatory came to be sited here, but the term Greenwich Mean Time has existed only since 1884, when the Reverend Nevil Maskelyne, the fifth Astronomer Royal, brought the prime meridian here during his term of office between 1765–1811. The prime meridian (or line of longitude) as I could have told the awestruck tourist at the time (if only I had understood it then), is not fixed by nature, as is the line of zero latitude along the equator; it can be – indeed has been – drawn anywhere. The Greek astronomer Ptolemy, in AD 150, drew it through the Canary Islands. It has been drawn through Rome and Jerusalem and until the very last moment French astronomers insisted that it should run through Paris.

The longitude problem was not solved during Charles's reign but neither, of course, did it go away. During the reign of his niece, Queen Anne, in 1714, the Longitude Act offered a prize of £20,000 for a method of accurately determining longitude at sea.

Longitude equals time. If you had a clock that would keep regular, accurate time at sea for weeks or months on end, you could establish your position whenever you wanted to. It was John Harrison, a self-educated inventor and horologist from Yorkshire who built the revolutionary timepieces that finally put an end to the problem: a clock with apparatus to compensate for the irregularities caused by variations in temperature and climate.

But Harrison had an uphill battle with Maskelyne proving his invention. Maskelyne was a Cambridge man and an astronomer. He was, furthermore, a member of the prestigious Royal Society and he found it incredible that a humble mechanic should imagine he could understand the mysteries of the heavens. At every opportunity he put Harrison down, disregarding even the endorsement of Harrison's invention by the great navigator Captain James Cook.

Harrison was finally awarded the prize by the excited King George III *('By God, Harrison, I will see you righted!')* and his clocks finally found a home here at the Flamsteed Observatory where they were disgracefully neglected by Maskelyne and his successors. Then in 1920 Lieutenant Commander Rupert T. Gould of the Royal Navy rediscovered them and over a period of twelve years lovingly restored them. They are now meticulously wound every morning by the curator of the Maritime Museum.

It's all a bit like a *Just So* Story, I think. 'And that, O best beloved, is how the prime meridian came to Greenwich…'

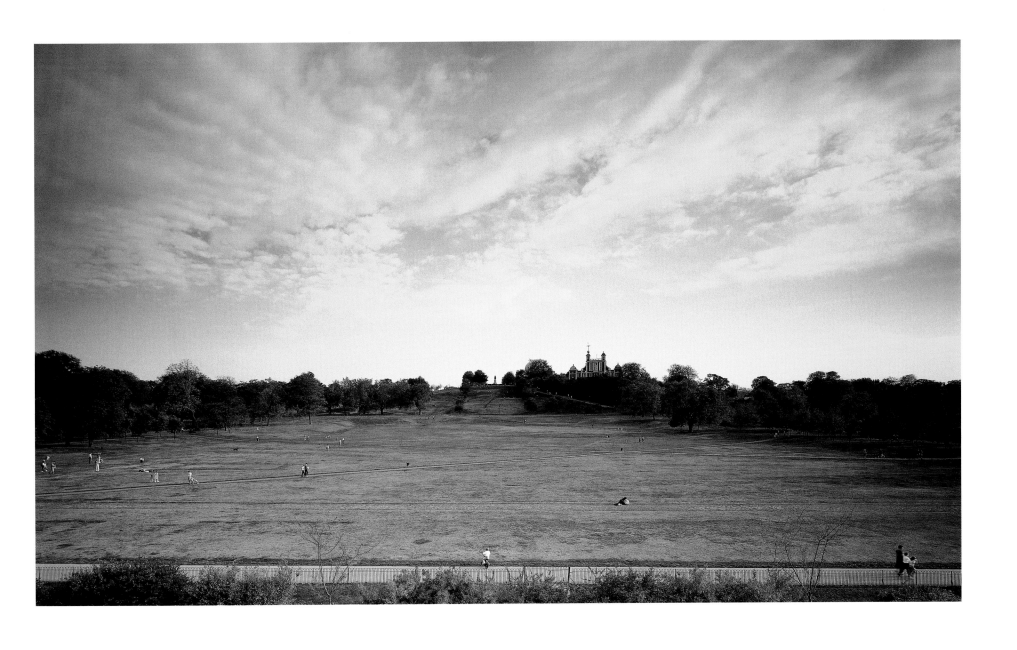

The Old Royal Observatory, viewed here from the balcony of the
Queen's House, straddles the prime meridian of zero degrees longitude.

East of the great Millennium Dome, between Wapping New Stairs and King Henry's Stairs and near the entrance to the Blackwall Tunnel is Execution Dock. Here, at low water, the hanging of pirates was carried out, the bodies being left until three tides had washed over them. This stretch of the river is called Bugsby's Reach and comparatively recent (nineteenth-century) eyewitness accounts describe the sight of bodies hanging in chains at 'Bugsby's Hole', crows pecking at the flesh through the metal netting in which they were encased. What kind of a mind does it take to treat a fellow being like that?

Look ahead, though, at those stainless steel sails straight from the Sydney Opera House. Look at the elegant way they cowl the piers that step out across the river. What kind of a mind did it take to envisage this? Each of these piers houses an electro-hydraulic machine for turning the gates of the titanic Thames Barrier and each gate has a counterbalance weighing in at 3,700 tons.

Once a month this monument to British engineering closes its gates just to make sure all is in working order and once a year Londoners of all ages converge in holiday mood when the barrier closes to confound an exceptionally high autumn tide. Announcements of the procedure are made over a loudspeaker system and those ashore of a mechanical inclination nod sagely whilst pointing out the salient points to children and sweethearts keen to be impressed. Engineering staff in hard hats gather in random gangs atop the gantry and periodically disappear into a doorway and descend to the depths of the river, there to be whisked secretly along its silty bed. And up they come again at another towering island further across the river. It is a great show; but it's not just a show, it is in deadly earnest.

London has been prone to flooding from its very beginning. In 1099 the *Anglo-Saxon Chronicle* relates that *'On the festival of St Martin, the sea flood sprung up to such a height and did so much harm as no man remembered that it ever did before.'*

Here at Woolwich in 1237 the marshes were described as *'a sea wherein many were drowned'* and in the Great Hall at Westminster Palace that year the lawyers rowed around in wherries. In 1242 the river overflowed at Lambeth to a width of six miles, which would have included all the land up to and past Elephant and Castle, including, perhaps ironically, Waterloo.

Flood water receding from the Great Hall of Westminster Palace in 1579 left fishes gasping on its floor. As recently as 1928 fourteen people were drowned in the basements of Westminster, and only in 1953 a flood on the east coast and the Thames Estuary claimed three hundred lives.

But it was not until the full realization of what would happen if London's underground were flooded that a decision was taken to augment the traditional river walls with a barrier at Woolwich. (Such a fortification had been envisaged in the 1850s by the philosopher and sociologist Herbert Spencer, rather ironically, perhaps, considering that he was a great believer in the doctrine of *laissez-faire*.)

Yet even this mighty Thames Barrier is a stop-gap measure. Britain continues to tilt towards the south-east at a rate of one foot every hundred years and the polar ice caps continue to melt. The tides, therefore, continue to rise: presently at about the rate of two feet every century. As we gather to admire the spectacle of these 65-foot-high, 3,000-ton gates holding back the vast wall of water on the east side while, on the west, canoeists frolic in the extemporized rapids of that fraction that is allowed underneath, we might pause to wonder what the next step might be in the continual battle against the encroaching sea.

But that there will be a next step we have no doubt. We have modern science and technology at our beck and call and we just have to set our minds to work.

What kind of a mind does it take? The human mind.

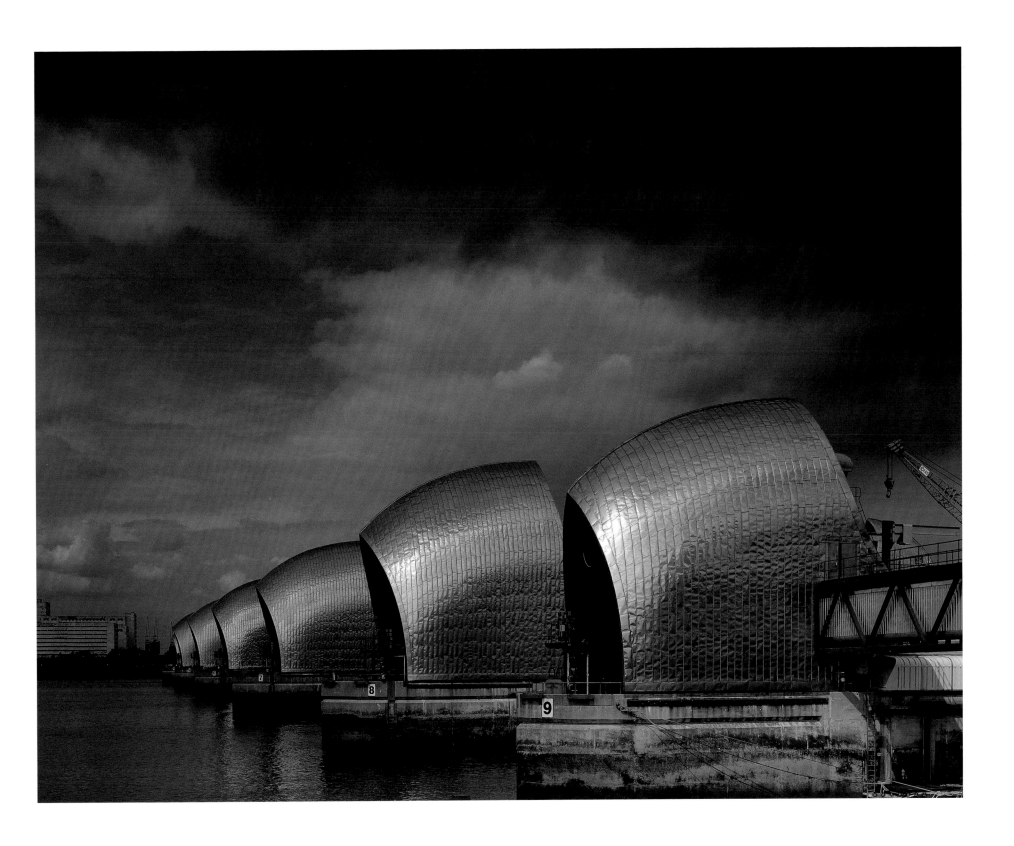

The seemingly invincible Thames Barrier at Woolwich
will not protect London for ever from the encroaching sea.

From Mariner's Haven on the river at Greenhithe, you can gain a superb view of the Queen Elizabeth II Bridge. To the right, well camouflaged by the usual industrial waterside debris, you can also see one of the original 'stone' barges: flat, cement-hulled vessels which were towed over to France, then sunk to provide a ramp for army trucks to disembark during the Normandy landings in World War II. A kind of thumbing the nose, after nine hundred years, at William.

Behind you, old Greenhithe is a conservation village where interesting eighteenth- and nineteenth-century buildings jostle their way down the narrow streets to the green on the Thames. There are two pubs on the riverfront: the White Hart at 64 High Street now backs on to the river, whereas originally, some four hundred years ago, it fronted on to the Thames, which was much more convenient for smugglers. And smugglers there were aplenty: the White Hart has hidden passages, secret tunnels and all the proper attributes of a smugglers' pub.

The Pier Hotel at No. 6 High Street is similarly endowed. Although this was reputedly the more respectable of the two public houses, the lease offered for sale (£84 per annum) in 1850 described it as *'This well known and respectable premises'*. Well, possibly it was. It sports a suitably jingoistic recruiting poster from the time of George III:

> *Let us, who are Englifhmen, protect and defend our good KING and COUNTRY againft the Attempt of all Republicans and Levellers and againft the Designs of our NATURAL ENEMIES who intend this year to invade OLD ENGLAND our happy country to murder our gracious KING as they have done their own, to make WHORES of our Wifves and Daughters to rob us of our Property and teach us nothing but the Damn'd Art of murdering one another. ROYAL TARS are urged to report to Lieut. W.J. Stephens at his rendezvous at Shoreham.*

And such was the people's affection for their good KING, Farmer George, despite his little peculiarities (and his German ancestry) that no doubt they did.

A fire on a train at Stone Crossing means that our journey will be continued by bus but my bike and I are welcomed with a certain dubiety by the bus driver who has no experience of dealing with cyclists. Perhaps under the relevant legislation we should treat it as a dog and carry it upstairs? I look at him in disbelief. Dogs have a certain flexibility which my sturdy Hercules lacks. Or, he suggests hopefully, the A226 is just down the ramp and through two roundabouts. He doesn't mention the hills, so when a path appears leading downhill towards the river I take it thankfully. At the end is an ancient church, St-Mary-at-Stone, 'The Lantern of Kent'.

This 'Lantern' has long been part of Thames life. Placed high on the hill at Horns Cross, the tower of St Mary traditionally had a beacon in its tower to tell ships rounding St Clement's or Fiddler's Reach that they were approaching the Port of London. St-Mary-at-Stone – more attractive inside than out – was built at about the same time as Henry III's reconstruction of Westminster Abbey, and it seems likely that it was built by a friend of Henry, Bishop Lawrence de St Martin, who shared Henry's admiration for the new Sainte Chapelle in Paris. It still has the original exquisitely carved arcading.

It also has, reputedly, a secret passage to the river, but I take the outside path down to a tiny footbridge crossing the straight-as-a-die railway line that I would have been traversing but for the hand of fate.

An ancient horse is seeing out the end of his days in a gentle meadow crossed by a rivulet. He raises his head momentarily at my greeting, but he has more serious things to ponder than a cyclist crossing his patch. There is the glorious sunshine on this crisp spring day, the endless stream of vehicles of unquantifiable horsepower making stately progress from the north bank of the Thames over the impressive Queen Elizabeth Bridge, and perhaps the endlessly puzzling question in this mechanical age of the meaning of equine life.

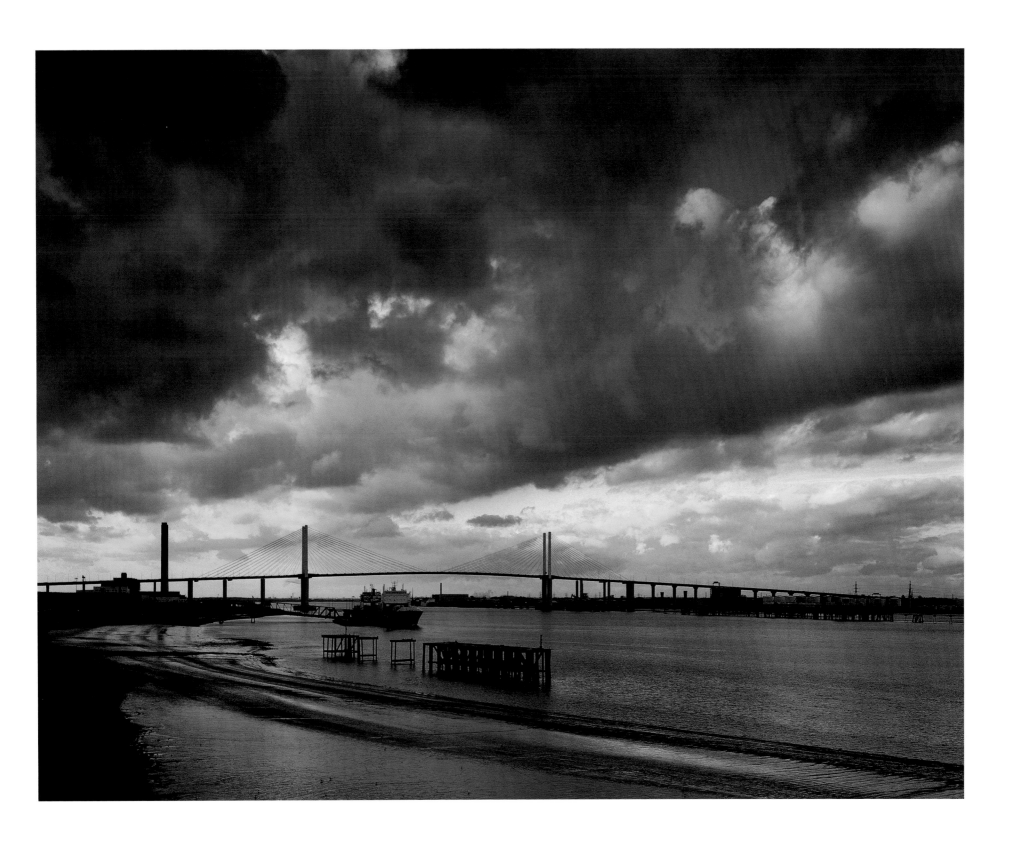

The graceful Q.E.II Bridge takes traffic from north to south;
the northbound traffic uses the Dartford Tunnel.

The perimeter fence of Ingress Abbey (never an abbey, just a house, built with grand ideas but little expertise) is plastered with a plethora of notices from a long defunct authority about who patrols it, how forbidden and dangerous it is and how trespassers will be shot on sight. Well, I made the last bit up, but you get the picture. Nobody has dared enter for some time, I suspect from the attitude of a particularly louche dog fox sauntering across an overgrown tennis court.

Tony Vaughan is a Freeman of the River and a true Viking if ever I saw one: six feet tall, broad-shouldered, with reddish fair hair, greying; and piercing blue eyes set evenly on a weatherbeaten face. He has a theory about the name of Ingress. At this point, just past Broadness, the river often gives rise to a fog that is, in riverman's parlance, 'thick as guts'. In Tony's days on the river someone would stand on the pier when he was bringing in a boat and he would hear a voice calling from the grey blanket: 'Tony! Toneee!'

'I can imagine,' he says, 'A Roman standing in the same position and calling: *'Ingressio!'* Just a theory, but I like it.

The tiny road leading towards the river from the abbey will lead, says my map, to a mill. A lone gatekeeper agrees that it might be possible to pass this way to the river. Perhaps. 'But there may,' he suggests vaguely, 'be things going on down there.' The path leads down through an accidental forest, past the crumbling and disused structure of what was once the huge Empire Paper Mill, slowly and silently returning to nature, with a buddleia growing from a wall here, a door quietly subsiding from its useless hinges there. But clearly nothing has been anything 'going on' here for years. Over what was the gateman keeping watch? For over an hour I have not seen a living soul. Was there a gateman? And how long ago?

Then a brown-and-white cannonball hurtles through the forest brambles towards me with an ear-shattering shriek and halts at my feet. A round, short-legged terrier wants *To Know What I Think I Am Doing On His Path. NOW!* Fellow canines of the larger, more sensible variety apologize for him as does his owner, all reassuringly solid, and I proceed in the present to Swanscombe

Marshes where piebald ponies roam, seemingly wild; and a tiny community of boat dwellers on Broadness Creek are polite but happy in their solitude.

The Blue Circle cement works seems to own a lot of the Thameside but it is a mistake to dismiss the industry too quickly as a twentieth-century horror. The industry has always played a large part in the wealth of the area. This is chalk country and chalk is a major constituent of cement. What could be a more profitable enterprise? You start with what the land provides, free, and you sell it. You transport it with what is provided, free – the river – and a huge trade is guaranteed. You are on to a – forgive me, please – concrete certainty.

William Aspdin patented his 'Portland Cement' process and moved to Northfleet in 1845, but the Romans knew about cement long ago. The core of Hadrian's Wall is bonded with concrete, and Salisbury Cathedral still stands on its original concrete foundation. It has, in fact, probably been in use from about 6500 BC. Concrete is OK.

So is shipbuilding, in which Northfleet excelled. Pitcher's Shipyard, founded here in 1788, built merchant ships for the East India Company and warships for the British navy, for use against Napoleon and in the Crimea. But serious shipbuilding on the Thames ended with the advent of the great iron ships for which the facilities were never as ideal as in Southampton – or, of course, as in the north, where they could be allied with the ordnance industry. And there was the problem of launching huge modern ships: Scott Russell's yard at Millwall was practically bankrupted by the *Great Eastern*, built broadside-on to the river, which immobilized the yard for years.

At Ingress we had talked about the training ship *Worcester*, anchored for years in the Thames before being towed off to Scapa Flow to be broken up. It must have made a huge hole in the landscape, I suggested. 'It made a huge hole,' said Tony, thumping his great Viking chest, 'in my heart!'

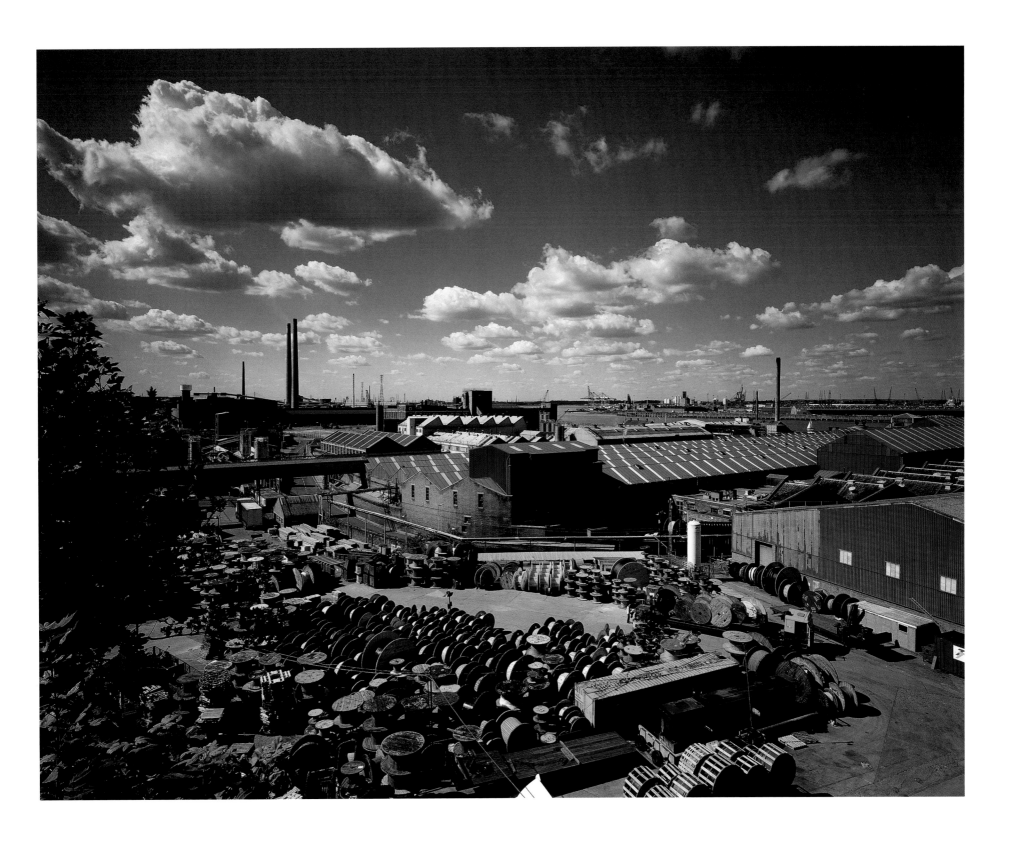

Cement production, shipbuilding, papermilling and the electrical
and engineering industries are just a few of the trades that have
been carried on at Northfleet.

At Gravesend, the Thames narrows to become 'London River' and coastal pilots give over control of their vessels to river pilots, because Gravesend is still considered the point of entry for the Port of London and it remains the headquarters of the Port of London Authority.

Since 1401, when Gravesend was granted the sole right to ferry passengers to London and back in 'tiltboats', Gravesend residents have transported goods and people for business and pleasure between here and London, and various piers and landing places have come and gone. Progress has not been smooth. The Town Quay Pier, now derelict, was completed by the town council in 1834 only after the Watermen's Riot on the night of 22 June 1833. The protest was at the loss of part of their livelihood, rowing passengers ashore, a service the piers rendered redundant. Before long, in fact, the new, privately owned Royal Terrace Pier (still in fine condition) bankrupted the corporation anyway. Small comfort to the watermen, but even smaller to the council.

But the traffic has by no means been confined to that London-bound. Next to the Town Pier is the Three Daws Inn, probably the oldest public house in Kent, and reputedly the stopping place of pilgrims from Essex *en route* to Canterbury. No one knows the original name of the 'Daws', because the old inn sign was simply a picture of three birds, but the landlord likes to think they could be those embroidered on the cope of Thomas à Becket, and so do I.

The Three Daws was a natural haunt for smugglers, too, complete with tunnels leading to the river, hidden stairways and the secret passage leading to the church. Press gangs were forbidden to recruit here unless there were two of them working in concert – with the myriad opportunities for escape, one crew was needed to head off less than willing subjects and guard against the possibility that His Majesty's recruitment officers would be left looking foolish.

An extraordinary variety of people have lived in this town. There was Pocahontas, the American Indian princess who saved the life of Virginian planter Captain John Smith. Christened Rebecca,

she was brought to England and fêted at the court of King James; but was desperately homesick and died here of suspected plague – and perhaps, indirectly, of a broken heart.

There were those like the Governor, Sir John Griffith, an out-and-out thug, who, in 1669, demanded money from ships before letting them pass; there was the floating population of army and navy personnel, the highly respected river pilots and watermen; the smugglers and the resultant customs men or 'searchers'; and there were the 'Mudlarks', members of the eighteenth-century society 'working poor' whose poverty was of a depth hitherto unknown in Britain. They worked – and often lived – in the mud of tidal rivers, scavenging for objects to sell: lumps of coal, firewood, or food; and, most lucrative of all, sub-standard or illicitly imported tea, dumped overboard to escape the attentions of HM Customs. When Prime Minister Pitt, devoted to the Adam Smith principles of Free Trade, reduced customs duties on luxury goods – especially tea – to discourage smuggling, it hit these small-time entrepeneurs probably more than anyone.

In Victorian Gravesend, where a huge population explosion meant overcrowding, dirty water, lack of drainage, and the resultant cholera epidemics, the workhouse was a fact of life. It accommodated the orphans, the old, the poor, the disabled and the insane. General (Chinese) Gordon, who lived here between 1865 and 1871, while he reconstructed Gravesend's New Tavern Fort, found work at sea for many of the local street urchins; which could be interpreted as a sensible bit of recruitment, but the General also taught at the Ragged School, and he turned his gardens at Fort House into allotments for poor families to grow their own food. And meanwhile Charles Dickens, living at nearby Gads Hill Place, in Higham, was writing *Our Mutual Friend* – probably the most evocative picture of riverside life ever. Amongst Gravesend's urban decay lived truly eminent Victorians.

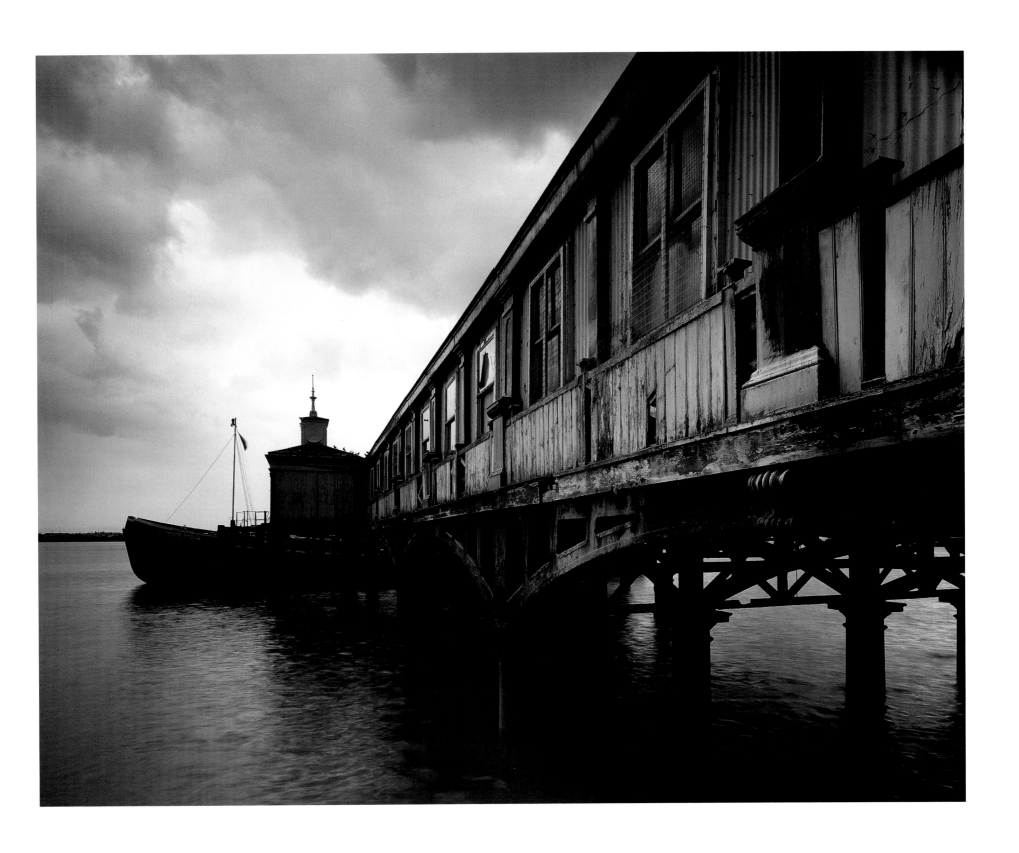

The homesick Pocahontas, on board a ship bound at last for her native
America, was returned to Gravesend to die — perhaps of plague.

The Gravesend-to-Tilbury ferry service has a new craft and our fellow traveller is not impressed with the state-of-the-art trimaran *Martin Chuzzlewit*. 'What's this, then?' she asks, tapping the shiny bench disparagingly. 'Plastic?'

'Nah,' says the mate comfortably. 'Tupperware.'

There was a 'blockhouse' or an old wooden fort at Tilbury from the time of Henry VIII, but it was not until his daughter, Elizabeth I, signed the death warrant for Mary, Queen of Scots, that war with Spain became inevitable and Philip II's mighty Armada threatened the English navy. By then, England's land forces were weak and the Thames forts in a state of decay. But on 8 August, 1588, while Sir Francis Drake and the Lords Howard and Seymour harried the Spanish fleet in the Channel, the Queen addressed her troops at Tilbury: *'I know I have the body of a weak and feeble woman but I have the heart and stomach of a King, and a King of England too…'*

Today at Tilbury Fort, two young men in yellow earmuffs strim emerald-green grass to within an inch of its life. English Heritage cares for this historic fort, and it is cared for immaculately, in the true English military tradition. Except that had you walked through this gateway in the seventeenth century when this beautifully gabled archway in the 'Artisan Mannerism' style was built for Charles II, you would have been knocked sideways by the smell of a couple of dozen unwashed soldiers in the confined space of the gatehouse, smoking, drinking and lacking proper sanitary facilities.

Most of the current structure dates from 1670–84. As you walk around, it is obvious from the abundant water that this is naturally a very marshy area and it took an expert, in this case Charles's Dutch Engineer-General, Sir Bernard de Gomme, to devise the fortifications. In fact, despite intermittent war with the Dutch, engineers from the Netherlands were in great demand in Essex because of their experience of 'inning', or the drainage and reclamation of swampland.

Yet Tilbury Fort never really saw active service as far as we know. For the most part it was used as a transit camp for regiments on the move or on standby, and it was not a popular domicile.

Tilbury was damp, marshy, lacking a reliable supply of clean water and consequently prone to outbreaks of malaria.

Of course, it was the ideal place for a prison. After the Jacobite rebellion in 1745 over 3,000 prisoners from the Battle of Culloden were shipped here. Some three hundred men were accommodated in the cramped magazine quarters across the parade ground, whilst the rest – men, women and children – mouldered on hulks in the river. They were starving, stinking and, thanks to the terrible overcrowding, they were suffering from typhus. They were sad, frightened and homesick but they created quite a diversion for Londoners tripping out on river excursions, suitably equipped with their handkerchiefs, herb posies and smelling salts.

One in twenty of the Bonny Prince's alleged followers was brought to trial, following the drawing of lots to select the most appropriate one in twenty. Many were transported to Antigua or Barbados, of whom about one in three survived the eight-month journey and the rest, like many of those left anchored on the Thames, saved the government any further trouble by dying.

Martin Chuzzlewit takes about five minutes to cross the Thames and land us at Tilbury International Maritime Port, at the very spot that we landed in England on the P&O liner *Orcades* thirty years ago.

Yes, gentle reader. Your guides on this Thames journey arrived here from New Zealand over a quarter of a century ago and, like other foreigners from the past thousands of years, are still here. English? No, but perhaps our children feel English and perhaps their children will be English, but it takes time. Some, in the decade before us, were invited to keep the capital's transport system and the health service manned. They found, when looking for homes, notices prominently displayed in windows: NO DOGS. NO BLACKS. It takes time. History is continuous, each and every bit of it personal to someone. But it comes and hits you when you least expect it.

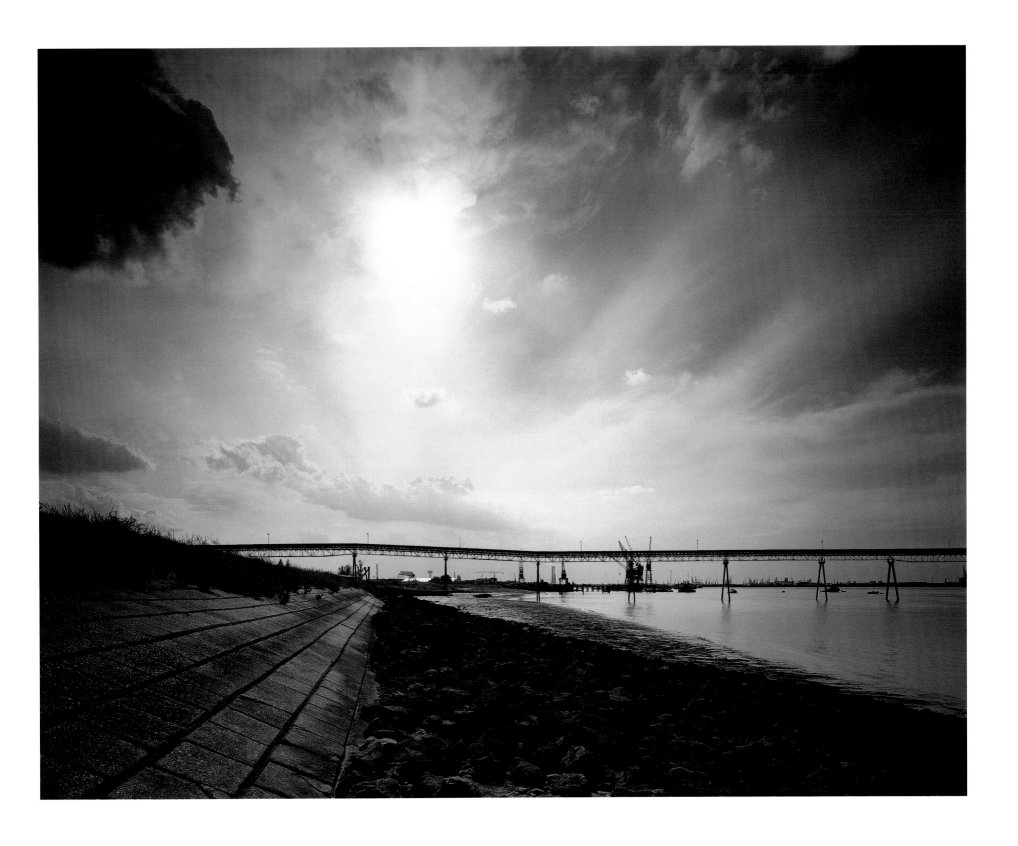

The bleak industrial landscape of the riverside east of Gravesend, between
New Tavern and Shornemead Forts. Tilbury Fort is across the Thames,
on the Essex Coast.

On 10 June, 1667 the Dutch, having seemingly not imposed their will on England by means of either the Plague or the Great Fire, resorted to more traditional forms of warfare. Dutch warships had sailed up the Thames as far as the Hope and thumbed their noses at Gravesend. The strategic importance of Henry VIII's blockhouses was at last appreciated and Pepys wrote from Gravesend:

> we do plainly at this time hear the guns play. Yet I do not find the Duke of Albemarle entends to go thither, but stays here tonight and hath (though the Dutch are gone) ordered our frigates to be brought in a line between the two blockhouses – which I took then to be a ridiculous thing

One of the endearing things about Pepys is that, regardless of national emergency and his private concerns about the safety of his gold, it is business as usual. In the midst of this catastrophe when there are, apparently, 'not twelve men to be got in the town to defend it', he repairs to a tavern to eat and drink. He continues:

> I homeward, as long as it was light reading Mr. Boyles book of Hydrostatickes, which is a most excellent book as ever I read; and I will take much pains to understand him through if I can, the doctrine being very useful. When it grew too dark to read, I lay down and took a nap, it being a most excellent fine evening

On the 13th June, in the absence of further news of the Medway invasion from Chatham, ships were sunk in Barking Creek near the Tower and in other strategic places to hinder the Dutch from making progress towards London. The City Militia was at the ready on Tower Hill, the King assuring them 'that they should venture themselfs no further then he would himself.' And finally, late at night, came the news from Chatham that the best of England's fleet had gone up in smoke or, in the case of her pride and joy the *Royal Charles*, been captured and fitted out by the enemy.

It was an insult which devastated the navy. Especially as there was rumour, too, that English voices had been heard on the Dutch ships: *'We did heretofore fight for tickets, now we fight for dollers… 'Thus the king is repaid for letting his seamen starve!'* If only they had listened to Samuel Pepys.

Cycling eastwards along the river from Gravesend toward Shornemead Fort and Henry VIII's old blockhouse at Higham Saltings a band of youngsters in anoraks is trudging towards me, hot and tired. 'Are you pilgrims?' 'No! We're just twelve-year old boys and we want to go home!' They rather fancy my bike, but I need it to catch up with the lighthouse keeper, cycling to the lighthouse near Shornemead. But he is gone, on a route across the marshes that escapes me.

Large quantities of Roman pottery have been found in Higham Marshes and, hard though it is to believe, because the various villages of Higham are seemingly far inland, Higham was then probably a thriving port – as it was, indeed, well into the middle ages.

After the invasion of Britain by Julius Caesar in 55 BC, almost a century was to elapse before it was followed in AD 43 by the decisive conquest by the Emperor Claudius. The Roman general Plautius in that year is said to have pursued *'the flying Britons, who being acquainted with the firm and fordable places of the river, passed it easily'* across the estuary here. We may well look askance. Firm and fordable places? But there are certainly traces of roads on both sides, leading down to the water's edge.

The remains of Higham Priory, founded by King Stephen for his daughter, Mary, in 1151 are buried hereabouts. A causeway (though it seems more likely that it was a ferry) reputedly ran from the priory across to Essex, where the priory also had land, and the nuns of Higham Priory had charge of it. They kept watch, also, for the dreaded Matilda arriving from France. And they might have been more use against the Dutch than Charles II's under-funded navy.

At Coalhouse Point, a now illegible sign warns of quicksand.
In Roman times, the river was probably passable by causeway
between here and Higham at low tide – if you knew the route!

In 851, when Alfred the Great was about three years old, 350 Viking ships sailed up the Thames to invade London. In 855 they set up camp on the Isle of Sheppey and in 865 the Kentish peninsular was overrun and the promise of Danegeld extracted from the men of Kent. Alfred never really got the hang of treating the Vikings as the hooligans they were rather than fellow Christians. He thought he had been proved right when his enemy Guthrum was baptized in 878, after the Battle of Edington, but he wasn't. After Alfred's death the raids continued as ever, which is why Edward the Elder (Alfred's son) paid 40 pounds of gold by way of ransom for a bishop in 914.

The delicate stone tracery aound the tower of Cooling Castle dates from 1381, at a time when raids from Europe were the threat. Just in 1380 a combined Spanish and French fleet had entered the Thames and burned and looted both Tilbury and Gravesend. Cooling Castle belonged to Sir John Oldcastle, Shakespeare's Falstaff. In the earliest version of *Henry IV* Falstaff is actually called Sir John Oldcastle, but the Cobham family objected; perhaps not surprisingly when you consider how far Shakespeare's greatest comic character strays from his original. Sir John Oldcastle (Lord Cobham thanks to his marriage) was certainly the one-time friend of King Henry V, but fell out of favour in 1413, shortly after his accession, by leading an ill-fated Lollard uprising. Rather than meeting the peaceful death Falstaff comes to after a life of drunken debauchery, Sir John was declared a heretic in 1414 and confined to the Tower, from which he escaped only to be captured near Welshpool and *'hung and burnt hanging'* for his religious zeal. Not much like Falstaff at all when you come to think of it.

In the churchyard of St James on Cooling Marshes are the

little stone lozenges, each about a foot and a half long, which were arranged in a neat row … and were sacred to the memory of five little brothers of mine – who gave up trying to get a living exceedingly early in that universal struggle

and to which Pip was

indebted for a belief I religiously entertained that they had all been born on their backs with their hands in their trouser pockets, and had never taken them out in this state of existence.

This is the churchyard where Pip pondered on life and death and these marshes *'intersected with dykes and mounds and gates, with scattered cattle feeding on it … the low leaden line beyond [that] was the river…'* were where our small, terrified hero from *Great Expectations* first encountered the escaped convict. This is pure Dickens country. But it is more than that.

If you head north from the church of St Mary at Higham and wander amongst the disused and flooded chalk quarries you may, with a little luck or an excellent map, come to Cliffe Fort, one of a ring of five built in the nineteenth century to frustrate Frankish ambitions. You may equally well, as I do, get lost and spend a good hour or so following lines of bullrushes, looking for the way across a network of drainage ditches and heaving your bike across ten-foot high gates. But pause a moment and reflect.

Have you ever before seen ships sailing apparently through marshlands with such ease? Have you ever seen a sky so vast, so evocative, so perfectly Dutch? This is pure Cuyp, pure Wouwerman. And when, finally, you mount the earthen seawall and find Cliffe Fort crumbling back to the earth, have you ever seen such perfection of colour and lack of colour? Have you ever seen such a silver as this, shafting the cloud to light the estuary? Have you ever seen such blacks as in this seaweed, as in these seeds of sea-hog fennel, as in those elderberries swooping through wine-red rosehips? And here in the mud is the blackening wreck of an old Finnish schooner which, *en route* from Sheerness in the 1960s, got this far and simply gave up the ghost; an atonement, perhaps, for the years of pillage? And see where those five jet-black cormorants stand in line, motionless, on the ruined jetty. They could almost be the shades of Mary's nuns, watching for Matilda's army.

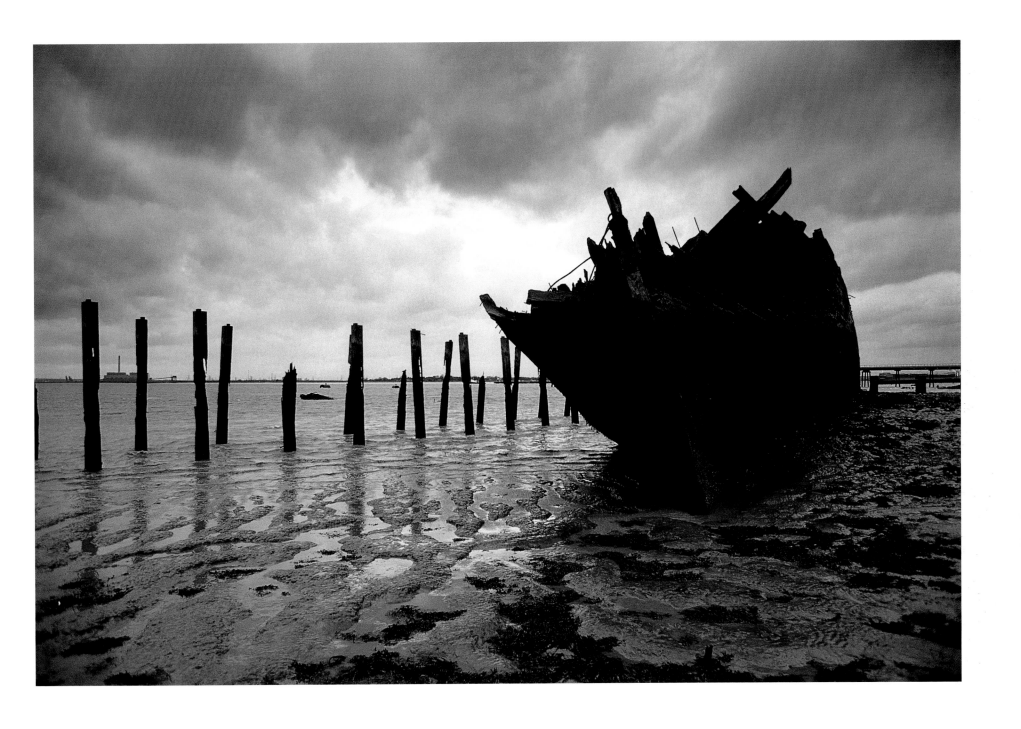

At Cliffe, a Finnish schooner wreck lies on the marshes outside an
important Saxon village with a fort from the Napoleon Wars and the
remains of the Brennan Torpedo Station.

How to decide where the search ends? Looking for the Thames Estuary, one can keep going east seemingly forever and be tempted to include more and more. Over there, on the northern bank, past Southend, are Maplin Sands and Foulness Island. Out here to our right is the Isle of Grain and Sheerness and the Medway, and – enough. Here on the south we are at Allhallows, noted mainly for a caravan park, inexpensive seaside holidays for young London families and a pub selling average beer and inordinately good sandwiches. And this is the lowest reach of the Thames. Official.

But is it the end of the journey? After your average beer and extraordinary sandwich, walk out over the two stiles and past the frisky young bullocks. Be nice to them – life is not going to offer them much, despite their sweet faces and friendly dispositions. Today they seem to have a game under way. First, they all form a queue and follow any random group of walkers until they reach the stile near the pub. Then they all turn around and like cheeky children run hell-for-leather (although the expression is an unfortunate one, given their future) towards the opposite gate. Nothing seems to be driving them and nothing is happening there. They stop, turn and tear off to the right. It is as if a rumour has gone round that one of the gates is open, but no one is going to tell them which one it is.

Far across the mudflats to the right, towards the Isle of Grain, a tiny lighthouse denotes the beginning of the shipping channel. Further inland, on the marshes, is a warning beacon. Across the dykes, rich Kentish pasture land supports healthy looking cattle, sheep and horses and here, on the marsh, numerous wooden piles in divers locations signify that the tiny channel negotiable by *ad hoc* stepping stones has been at one – or various – times used by boats.

Allhallows. Whilst Essex, across the Thames was obdurately pagan, surely there has never been so Christian a county as Kent. *'Not Angles but angels,'* murmured Pope Gregory, seeing fair-haired children for sale in the Roman marketplace, and he despatched the reluctant St Augustine here to the farthest outreach of the Roman church, where the influence of the Roman occupation was fast disappearing, to gather the Anglo-Saxons into the flock.

From Gaul, Augustine sent a last plea to Gregory to reconsider. He was a Benedictine, not a missionary, and he didn't want to go to the edge of the world. But Gregory stood firm, and the justification was the baptism on Christmas Day 598 of ten thousand Kentish souls.

Now it is a haven for birds. Sandpipers, plover, redshanks and a variety of other waders take off in high dudgeon as you walk over the shelly sand. The marshes are worth a visit for their own sake. Take a day out here, to walk and watch the oystercatcher and the dunlin going about their daily work.

How many have walked here or sailed past this spot? Kings, emperors and refugees; slaves, soldiers and princes; royal brides, Christian missionaries and Vikings. An extraordinary variety of races and beliefs, each making its unique contribution to what we fondly like to imagine the 'pure' English race.

Just stop for a while and listen: to the birds and to the past. Can you hear the faint chanting of plainsong? The plash of galley oars? Can you sense the presence of St Augustine? Of Hengist and Horsa, leading the first Anglo Saxons? Of Harold Godwinson? William the Bastard? Pip and Magwich? Little of a concrete nature remains here to tell us of the people who journeyed through the centuries where we journey today, but just listen.

And what has it all been about, the search? In the silence of the marshes you could be tempted to think, just for an instant, that you *almost* understand… and then, in another instant, it is gone. But surely it is still there. Just listen.

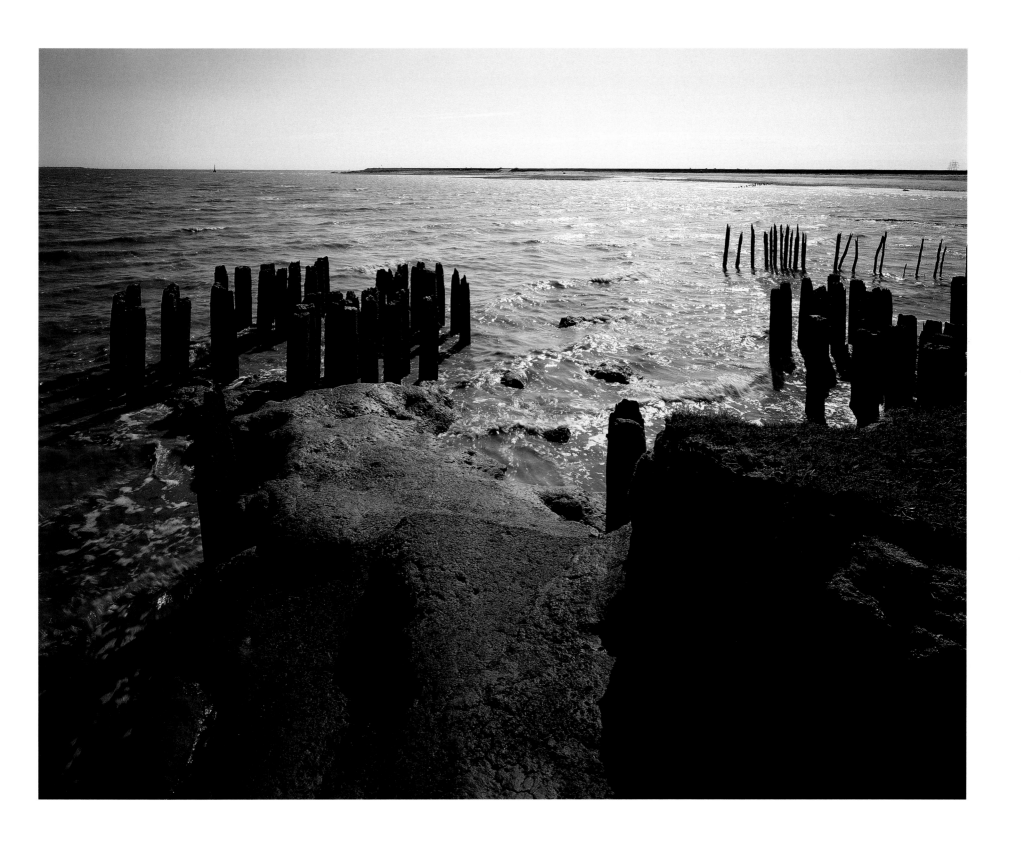

Romans, Vikings, missionaries, merchants and slavers have sailed
past Allhallows where the Thames meets the English Channel,
the North Sea and the rest of the world.

BIBLIOGRAPHY

Asser, *Alfred the Great*, Harmondsworth, Penguin Classics, 1983.

Astbury, A.K., *Estuary*, London, The Carnforth Press, 1980.

Banbury, Philip, *Shipbuilders of the Thames and Medway*, Newton Abbot, David and Charles, 1971.

Boswell, James, *The Life of Samuel Johnson*, London, Guild Publishing, 1991.

Brooke, Christopher, *The Saxon and Norman Kings*, Glasgow, Fontana, 1978.

Cassady, Robert, *The Norman Achievement*, London, Sidgwick & Jackson, 1986.

Cavendish, Richard (ed.), *AA Road Book of Britain*, Basingstoke, AA, 1995.

Clanchy, M.T., *England & its Rulers 1066–1272*, London, Fontana, 1989.

Clive, Mary, *This Sun of York*, London, Cardinal, 1975.

Cobbett, William, *Rural Rides*, London, Penguin, 1985.

Defoe, Daniel, *A Tour through the Whole Island of Great Britain*, London, Penguin, 1971.

Dixon, Peter (ed.), *Alexander Pope*, London, G. Bell & Sons, 1972.

Douglas, Keith, *The Complete Poems*, ed. Desmond Graham, Oxford, Oxford University Press, 1995

Edwards, David L., *Christian England*, London, Fount, 1989.

Evelyn, John, *Diary*, ed. Guy de la Bédoyère, Woodbridge, Boydell, 1997.

Fraser, Antonia (ed.), *The Lives of the Kings and Queens of England*, London, Weidenfeld, 1993.

Fraser, Antonia, *The Six Wives of Henry VIII*, London, Weidenfeld & Nicholson, 1992.

Gibbings, Robert, *Sweet Thames Run Softly*, London, Dent, 1944.

Grahame, Kenneth, *The Wind in the Willows*, London, Magnet, 1980.

Gray, Robert, *A History of London*, London, Hutchinson, 1978.

Guy, John, *Tudor England*, Oxford, Oxford University Press, 1988.

Hardy, Alan, *The Kings' Mistresses*, London, Evans, 1980.

Holmes, Richard, *Dr Johnson and Mr Savage*, London, Flamingo, 1994.

Holmes, Richard, *Shelley, The Pursuit*, London, Weidenfield & Nicholson, 1974.

H.M.S.O., *Thames Strategy*, London, H.M.S.O., 1995.

Jebb, Miles, *A Guide to the Thames Path*, London, Constable, 1988.

Jerome K. Jerome, *Three Men in a Boat*, London, Penguin, 1957

Kemp, Peter, *The History of Ships*, London, Orbis, 1983.

Knightley, Philip & Kennedy, Caroline, *An Affair of State: The Profumo Case & the Framing of Stephen Ward*, London, Cape, 1987.

Lane, Margaret, *Samuel Johnson and His World*, London, Hamish Hamilton, 1975.

Lee, Sidney (ed.), *Dictionary of National Biography*, Smith, Elder & Co., 1899.

Loyn, H.R. (ed.), *The Middle Ages*, London, Thames & Hudson, 1991.

MacCulloch, Diarmaid, *Thomas Cranmer*, London, Yale University Press, 1996.

Mabey, Richard, *Flora Britannica*, London, Sinclair-Stevenson, 1988.

Mack, Maynard, *Alexander Pope: A Life*, New Haven, Yale University Press, 1985.

Martin, W. Keble, *The Concise British Flora*, London, Book Club Associates, 1974.

Masters, Anthony, *Nancy Astor: A Life*, London, Weidenfeld & Nicholson, 1981.

Morris, William, *News from Nowhere*, London, Penguin, 1993.

Nicholson, *Ordnance Survey Guide to the River Thames*, London, Nicholson, 1994.

Ollard, Richard, *Samuel Pepys – A Biography*, London, Hodder and Stoughton, 1974.

Packe, Michael, *King Edward III*, London, Routledge & Kegan Paul, 1983.

Peacock, Thomas Love, *Nightmare Abbey/Crotchet Castle*, London, Penguin, 1986.

Plumb, J.H., *England in the Eighteenth Century*, London, Penguin, 1983.

Poole, A.L., *Domesday Book to Magna Carta*, Oxford, Oxford University Press, 1955.

Pope-Hennessey, James, *Queen Mary*, London, George Allen and Unwin, 1959.

Prince, Alison, *Kenneth Grahame: An Innocent in the Wild Wood*, London, Allison & Busby, 1996.

Richmond. I.A., *Roman Britain*, London, Penguin, 1981.

Robinson, Duncan, *Stanley Spencer: Visions from a Berkshire Village*, Oxford, Phaidon, 1979.

Rogers, Pat, *An Introduction to Pope*, London, Methuen, 1975.

Seward, Desmond, *The Wars of the Roses*, London, Constable, 1995.

Sharpe, David, *The Thames Path*, London, Aurum Press, 1997.

Sinclair-Stevenson, Christopher, *Blood Royal: The Illustrious House of Hanover*, London, Book Club Associates, 1979.

Smith, V.T.C., *Defending London's River*, Rochester, North Kent Books, 1985.

Smyth, Alfred P., *King Alfred the Great*, Oxford, Oxford University Press, 1995.

Sobel, Dava, *Longitude*, London, 4th Estate, 1996.

Spark, Muriel, *Mary Shelley*, London, Constable, 1988.

Spencer, Gilbert, *Stanley Spencer*, Bristol, Redcliffe, 1991.

Stenton, Sir Frank, *Anglo-Saxon England*, Oxford, Oxford University Press, 1989.

Swanton, Michael (ed.), *The Anglo-Saxon Chronicles*, London, Dent, 1996.

Tate Gallery, *Stanley Spencer, a Sort of Heaven*, Liverpool, Tate Gallery, 1992.

Thompson, E.P., *The Making of the English Working Class*, London, Penguin, 1991.

Tomalin, Claire, *Jane Austen: A Life*, London, Viking, 1997.

Tomalin, Claire, *Shelley and His World*, London, Penguin, 1992.

Wedgwood, C.V., *The King's Peace*, London, Book Club Associates, 1974.

Wilkinson, Bertie, *The Later Middle Ages in England, 1216 – 1485*, London, Longman, 1977.

Wilson, David G., *The Making of the Middle Thames*, Spur, 1977.

Wilson, David G., *The Thames: Record of a Working Waterway*, Batsford, 1987.

Wilson, David G., *The Victorian Thames*, Stroud, Allan Sutton, 1993.

Wilson, David G., *A Short History and Description of Godstow, Oxford and the Local River Thames*, private publication: Wilson, 1987.

Ordnance Survey Landranger 1:50,000 Maps: Nos. 163, 164, 174, 175, 176, 177, 178.

TECHNICAL DATA

CAMERAS:
Ebony 5″ × 4″ – ebony & titanium field camera, (sometimes with 6×12cm roll film back)
Deardorff 5″ × 4″ – mahogany and steel field camera
Gandolfi 5″ × 4″ – mahogany and brass field camera
Mamiya 645 Pro – medium format camera
Leica M6 – 35mm camera

FRONT COVER
The Thames at sunset:
CAMERA: Gandolfi 5″×4″
LENS: 90mm Schneider Super-Angulon f5.6
FILM: Kodak Ektachrome 100 Plus (EPP) 5″×4″
EXPOSURE: 1/15 @ f11½
FILTRATION: 85B+Cokin E1 & E2 graduated

BACK COVER
From 'The Wasteland' by T. S. Eliot:
CAMERA: Ebony 5″×4″
LENS: 90mm Schneider Super-Angulon f5.6
FILM: Kodak Ektachrome E100SW 5″×4″
EXPOSURE: 1/15 @ f16⅔
FILTRATION: 81C

FRONTISPIECE
Swans at Mapledurham:
CAMERA: Mamiya 645 Pro
LENS: 35mm Mamiya-Sekor C f3.5
FILM: Kodak Ektachrome E100SW 120
EXPOSURE: 1/60 @ f4
FILTRATION: 81C

9. *The Source*
CAMERA: Ebony 5″×4″
LENS: 150mm Schneider Symmar-S f5.6
FILM: Kodak Ektachrome 100 Plus (EPP) 5″×4″
EXPOSURE: 1/4 @ f 11⅓
FILTRATION: 81D+5R

11. *Cricklade*
CAMERA: Ebony 5″×4″
LENS: 90mm Schneider Super-Angulon f5.6
FILM: Kodak Ektachrome E100SW 5″×4″
EXPOSURE: 1/4 @ f16⅓
FILTRATION: 85C+Lee 0.3 & 0.6 graduated

13. *Castle Eaton & Kempsford*
CAMERA: Ebony 5″×4″
LENS: 90mm Schneider Super-Angulon f5.6
FILM: Kodak Ektachrome 100 Plus (EPP) 5″×4″
EXPOSURE: 1/4 @ f11
FILTRATION: none

15. *Inglesham*
CAMERA: Ebony 5″×4″ with 6×12cm back
LENS: 75mm Schneider Super-Angulon f5.6
FILM: Kodak Ektachrome E100SW 120
EXPOSURE: 10 sec @ f22
FILTRATION: 85C+Lee 0.6 graduated

17. *Lechlade*
CAMERA: Ebony 5″×4″
LENS: 75mm Schneider Super-Angulon f5.6
FILM: Kodak Ektachrome E100SW 5″×4″
EXPOSURE: 5 sec @ f32
FILTRATION: 85C+Lee 0.3 & 0.6 graduated

19. *St John's Bridge*
CAMERA: Ebony 5″×4″
LENS: 210mm Schneider Symmar-S f5.6
FILM: Kodak Ektachrome E100SW 5″×4″
EXPOSURE: 1/8 @ f11⅓
FILTRATION: 81D+5R+Cokin E1 graduated

21. *Cheese Wharf*
CAMERA: Ebony 5″×4″
LENS: 90mm Schneider Super-Angulon f5.6
FILM: Kodak Ektachrome E100SW 5″×4″
EXPOSURE: 1/2 @ f22
FILTRATION: 81C+polarising+Cokin E1 graduated

23. *Buscot*
CAMERA: Mamiya 645 Pro
LENS: 80mm Mamiya-Sekor C f2.8
FILM: Kodak Ektachrome E100SW 120
EXPOSURE: 1/60 @ f2.8
FILTRATION: none

25. *Kelmscott*
CAMERA: Ebony 5″×4″
LENS: 58mm Schneider Super-Angulon XL f5.6
FILM: Kodak Ektachrome 100 Plus (EPP) 5″×4″
EXPOSURE: 1/2 @ f16½
FILTRATION: 81C+Lee 0.3 graduated

27. *Radcot*
CAMERA: Ebony 5″×4″
LENS: 90mm Schneider Super-Angulon f5.6
FILM: Kodak Ektachrome 100 Plus (EPP) 5″×4″
EXPOSURE: 1/4 @ f45
FILTRATION: 85C+Lee 0.3 & 0.45 graduated

29. *Tadpole Bridge*
CAMERA: Ebony 5″×4″
LENS: 90mm Schneider Super-Angulon f5.6
FILM: Kodak Ektachrome E100SW 5″×4″
EXPOSURE: 1 sec @ f11½
FILTRATION: 85C+81D+Cokin E1 graduated

31. *Stanton Harcourt*
CAMERA: Gandolfi 5″×4″
LENS: 120mm Schneider Super-Angulon f5.6
FILM: Kodak Ektachrome E100SW 5″×4″
EXPOSURE: 1/2 @ 32⅔
FILTRATION: 85C+polarising

32, 34, 35. *Swinford Bridge*
CAMERA: Deardorff 5″×4″
LENS: 75mm Schneider Super-Angulon f5.6
FILM: Ektachrome 100 Plus (EPP) 5″×4″
EXPOSURE: 1/4 @ f11½
FILTRATION: 81D+5R + Cokin E1 graduated

37. *Godstow*
CAMERA: Gandolfi 5″×4″
LENS: 90mm Schneider Super-Angulon f5.6
FILM: Kodak Ektachrome 100 Plus (EPP) 5″×4″
EXPOSURE: 1/8 @ f 22⅔
FILTRATION: 81D+5R

39. *Binsey*
CAMERA: Ebony 5″×4″
LENS: 75mm Schneider Super-Angulon f5.6
FILM: Kodak Ektachrome E100SW 5″×4″
EXPOSURE: 15sec @ f32
FILTRATION: none

41. *Oxford*
CAMERA: Deardorff 5″×4″
LENS: front half 150mm Schneider Symmar-S f5.6 + back half 90mm Schneider Super-Angulon f5.6
FILM: Kodak Ektachrome 100 Plus (EPP) 5″×4″
EXPOSURE: 1/4 @ f5.6
FILTRATION: 85B

43. *Christ Church Meadow*
CAMERA: Deardorff 5″×4″
LENS: 90mm Schneider Super-Angulon f5.6
FILM: Kodak Ektachrome 100 Plus (EPP) 5″×4″
EXPOSURE: 1/15 @ f16⅔
FILTRATION: 85C+Cokin E1 graduated

45. *Ifley*
CAMERA: Ebony 5″×4″
LENS: 75mm Schneider Super-Angulon f5.6
FILM: Kodak Ektachrome E100SW 5″×4″
EXPOSURE: multiple – 1/125 @ f22 (× 8)
FILTRATION: 81C+polarising

47. *Radley & Nuneham*
CAMERA: Ebony 5″×4″
LENS: 75mm Schneider Super-Angulon f5.6
FILM: Agfa RSX100 5″×4″ (cross-processed C41)
EXPOSURE: 1/15 @ f16⅔
FILTRATION: 85C+Lee 0.3 & 0.45 graduated

49. *Abingdon*
CAMERA: Ebony 5″×4″
LENS: 90mm Schneider Super-Angulon f5.6
FILM: Ektachrome 100 Plus (EPP) 5″×4″
EXPOSURE: 1/15 @ f8⅓
FILTRATION: 85C+Lee 0.3 & 0.45 graduated

51. *Culham*
CAMERA: Deardorff 5″×4″
LENS: 90mm Schneider Super-Angulon f5.6
FILM: Kodak Ektachrome 100 Plus (EPP) 5″×4″
EXPOSURE: 1/15 @ f16½
FILTRATION: 81D+Cokin E1 graduated

53. *Clifton Hampden*
CAMERA: Mamiya 645 Pro
LENS: 35mm Mamiya-Sekor C f3.5
FILM: Kodak Ektachrome E100SW 120
EXPOSURE: 1/4 @ f8
FILTRATION: 85C

55. *Dorchester Abbey*
CAMERA: Mamiya 645 Pro
LENS: 50mm Mamiya-Sekor Shift C f4
FILM: Kodak Ektachrome E100SW 120
EXPOSURE: 1/4 @ f16½
FILTRATION: 81C

57. *Sinodun Hills*
CAMERA: Mamiya 645 Pro
LENS: 35mm Mamiya-Sekor C f3.5
FILM: Kodak Ektachrome E100SW 120
EXPOSURE: 1/2 @ f8½
FILTRATION: 85B

59. *Wallingford*
CAMERA: Ebony 5″×4″
LENS: 120mm Schneider Super-Angulon f5.6
FILM: Kodak Ektachrome E100SW 5″×4″
EXPOSURE: 1/4 @ f22⅓
FILTRATION: 85B+Cokin E1 graduated

61. *Streatley & Goring*
CAMERA: Deardorff 5″×4″
LENS: 90mm Schneider Super-Angulon f5.6
FILM: Kodak Ektachrome 100 Plus (EPP) 5″×4″
EXPOSURE: 1/15 @ f11½
FILTRATION: 85B+81D+Cokin G1 graduated

63. *Whitchurch & Pangbourne*
CAMERA: Ebony 5″×4″
LENS: 90mm Schneider Super-Angulon f5.6
FILM: Kodak Ektachrome E100SW 5″×4″
EXPOSURE: 1/2 @ f11⅓
FILTRATION: 85C

65. *Mapledurham*
CAMERA: Deardorff 5″×4″
LENS: 120mm Schneider Super-Angulon f5.6
FILM: Kodak Ektachrome 100 Plus (EPP) 5″×4″
EXPOSURE: 1/8 @ f16⅔
FILTRATION: 81D+5R

67. *Reading*
CAMERA: Ebony 5″×4″
LENS: 210mm Schneider Symmar-S f5.6
FILM: Agfa RSX100 5″×4″ (cross-processed C41)
EXPOSURE: 1/2 @ f11
FILTRATION: 85B

69. *Shiplake*
CAMERA: Gandolfi 5″×4″
LENS: 90mm Schneider Super-Angulon f5.6
FILM: Kodak Ektachrome 100 Plus (EPP) 5″×4
EXPOSURE: 1/15 @ f11½
FILTRATION: 85C+Cokin E1 graduated

71. *Henley*
CAMERA: Gandolfi 5″×4″
LENS: 120mm Schneider Super-Angulon f5.6
FILM: Kodak Ektachrome 100 Plus (EPP) 5″×4
EXPOSURE: 1/15 @ f8⅔
FILTRATION: 85D+5R

73. *Hambleden & Medmenham*
CAMERA: Deardorff 5″×4″
LENS: 75mm Schneider Super-Angulon f5.6
FILM: Kodak Ektachrome 100 Plus (EPP) 5″×4
EXPOSURE: 1/8 @ f11⅔
FILTRATION: 85C+Cokin E1 & E2 graduated

75. *Bisham*
CAMERA: Ebony 5″×4″
LENS: 90mm Schneider Super-Angulon f5.6
FILM: Kodak Ektachrome E100SW 5″×4″
EXPOSURE: 1 sec @ f32
FILTRATION: 85C+Cokin E1 graduated

77. *Quarry Wood & Bisham Wood*
CAMERA: Ebony 5″×4″
LENS: front half 150mm Schneider Symmar-S f5.6 + back half 120mm Schneider Super-Angulon f5.6
FILM: Agfa RSX100 5″×4″ (cross-processed C41)
EXPOSURE: 12 sec @ f5.6
FILTRATION: none

79. *Marlow*
CAMERA: Ebony 5″×4″
LENS: 75mm Schneider Super-Angulon f5.6
FILM: Kodak Ektachrome E100SW 5″×4″
EXPOSURE: 1/15 @ 22
FILTRATION: 81C+Lee 0.3 & 0.6 graduated

81. *Cookham*
CAMERA: Ebony 5″×4″
LENS: front half 150mm Schneider Symmar-S f5.6 + back half 120mm Schneider Super-Angulon f5.6
FILM: Agfa RSX100 5″×4″ (cross-processed C41)
EXPOSURE: 1/2 @ f22
FILTRATION: 85C

83. *Cliveden*
CAMERA: Ebony 5″×4″
LENS: 75mm Schneider Super-Angulon f5.6
FILM: Kodak Ektachrome E100SW 5″×4″
EXPOSURE: 1/4 @ f32
FILTRATION: 85C+Lee 0.3 & 0.45 graduated

85. *Maidenhead*
CAMERA: Ebony 5″×4″
LENS: 210mm Schneider Symmar-S f5.6
FILM: Kodak Ektachrome E100SW 5″×4″
EXPOSURE: 1/8 @ f22
FILTRATION: 85C+Lee 0.6 graduated

87. *Bray*
CAMERA: Ebony 5″×4″
LENS: 75mm Schneider Super-Angulon f5.6
FILM: Kodak Ektachrome E100SW 5″×4″
EXPOSURE: 1/2 @ f22½
FILTRATION: 85C

89. *Dorney Court*
CAMERA: Ebony 5″×4″
LENS: 210mm Schneider Symmar-S f5.6
FILM: Kodak Ektachrome E100SW 5″×4″
EXPOSURE: 1/8 @ f11
FILTRATION: 85C

91. *Boveney and Eton*
CAMERA: Ebony 5″×4″
LENS: 75mm Schneider Super-Angulon f5.6
FILM: Kodak Ektachrome E100SW 5″×4″
EXPOSURE: 1/2 @ f45½
FILTRATION: 81D+Lee 0.3 & 0.45 graduated

93. *Windsor*
CAMERA: Ebony 5″×4″
LENS: 90mm Schneider Super-Angulon f5.6
FILM: Kodak Ektachrome E100SW 5″×4″
EXPOSURE: 1/8 @ f22⅓
FILTRATION: 85C+polarising

95. *Runnymede*
CAMERA: Deardorff 5″×4″
LENS: 90mm Schneider Super-Angulon f5.6
FILM: Kodak Ektachrome 100 Plus (EPP) 5″×4″
EXPOSURE: 1/4 @ f11
FILTRATION: 85B+Cokin E1 & E2 graduated

97. *Shepperton & Walton-on-Thames*
CAMERA: Leica M6
LENS: 90mm Leitz Tele-Elmarit f2.8
FILM: Kodak Ektachrome E100SW 35mm
EXPOSURE: 1/250 @ f11
FILTRATION: 81C

99. *Hampton Court*
CAMERA: Ebony 5″×4″
LENS: 210mm Schneider Symmar-S f5.6
FILM: Kodak Ektachrome E100SW 5″×4″
EXPOSURE: 1/15 @ f11½
FILTRATION: 81C+polarising

101. *Kingston to Twickenham*
CAMERA: Ebony 5″×4″
LENS: 90mm Schneider Super-Angulon f5.6
FILM: Kodak Ektachrome E100SW 5″×4″
EXPOSURE: 1/4 @ f22
FILTRATION: 81C+Lee 0.3 graduated

103. *Marble Hill House*
CAMERA: Ebony 5″×4″
LENS: 150mm Schneider Symmar-S f5.6
FILM: Kodak Ektachrome E100SW 5″×4″
EXPOSURE: 1/8 @ f5.6⅓
FILTRATION: 85C+polariser

105. *Richmond Hill*
CAMERA: Ebony 5″×4″ with 6×12cm back
LENS: 90mm Schneider Super-Angulon f5.6
FILM: Kodak Ektachrome E100SW 120
EXPOSURE: 1/8 @ f16⅔
FILTRATION: 85B+Cokin G1 & G2 graduated

107. *Richmond*
CAMERA: Ebony 5″×4″
LENS: 90mm Schneider Super-Angulon f5.6
FILM: Kodak Ektachrome E100SW 5″×4″
EXPOSURE: 1/8 @ f8
FILTRATION: 85C+Cokin E1 graduated

109. *Syon*
CAMERA: Ebony 5″×4″
LENS: 120mm Schneider Super-Angulon f5.6
FILM: Kodak Ektachrome E100SW 5″×4″
EXPOSURE: 1/30 @ f11
FILTRATION: 85C+Lee 0.45 graduated

111. *Kew*
CAMERA: Ebony 5″×4″
LENS: 58mm Schneider Super-Angulon XL f5.6
FILM: Kodak Ektachrome E100SW 5″×4″
EXPOSURE: 1/15 @ f22
FILTRATION: 81C+Lee 0.3 & 0.6 graduated

113. *Hammersmith*
CAMERA: Ebony 5″×4″
LENS: 210mm Schneider Symmar-S f5.6
FILM: Kodak Ektachrome 100 Plus (EPP) 5″×4
EXPOSURE: 1/15 @ f11
FILTRATION: 85C+Lee 0.3 & 0.6 graduated

115. *Fulham Palace*
CAMERA: Ebony 5″×4″
LENS: 75mm Schneider Super-Angulon f5.6
FILM: Kodak Ektachrome E100SW 5″×4″
EXPOSURE: 1/8 @ f22
FILTRATION: 85C+Lee 0.3 graduated

117. *Putney*
CAMERA: Gandolfi 5″×4″
LENS: 150mm Schneider Symmar-S f5.6
FILM: Kodak Ektachrome 100 Plus (EPP) 5″×4″
EXPOSURE: 1/8 @ f11⅓
FILTRATION: 81D+5R

119. *Battersea*
CAMERA: Gandolfi 5″×4″
LENS: 90mm Schneider Super-Angulon f5.6
FILM: Kodak Ektachrome 100 Plus (EPP) 5″×4
EXPOSURE: 1/4 @ f16⅓
FILTRATION: 85B+Cokin E1 & E2 graduated

121. *Chelsea*
CAMERA: Ebony 5″×4″
LENS: 210mm Schneider Symmar-S f5.6
FILM: Kodak Ektachrome 100 Plus (EPP) 5″×4
EXPOSURE: 6 sec @ f16
FILTRATION: 85C+pair of Lee 0.6 graduated

123. *St Mary at Lambeth*
CAMERA: Ebony 5″×4″
LENS: 120mm Schneider Super-Angulon f5.6
FILM: Kodak Ektachrome E100SW 5″×4″
EXPOSURE: 1/2 @ f11
FILTRATION: 81C+polariser

125. *Westminster*
CAMERA: Ebony 5″×4″
LENS: 75mm Schneider Super-Angulon f5.6
FILM: Kodak Ektachrome 100 Plus (EPP) 5″×4″
EXPOSURE: 60 sec @ f11
FILTRATION: none

127. *Westminster Abbey*
CAMERA: Ebony 5″×4″
LENS: 210mm Schneider Symmar-S f5.6
FILM: Kodak Ektachrome 100 Plus (EPP) 5″×4
EXPOSURE: 1/15 @ f22½
FILTRATION: 81D+5R

129. *The Adelphi*
CAMERA: Ebony 5″×4″
LENS: front half 150mm Schneider Symmar-S f5.6
 + back half 90mm Schneider Super-Angulon f5.6
FILM: Kodak Ektachrome E100SW 5″×4″
EXPOSURE: 1/2 sec @ f5.6
FILTRATION: none

131. *The Savoy*
CAMERA: Ebony 5″×4″
LENS: 120mm Schneider Super-Angulon f5.6
FILM: Kodak Ektachrome E100SW 5″×4″
EXPOSURE: 1 sec @ f16⅔
FILTRATION: 85C+Lee 0.45 & 0.6 graduated

133. *Blackfriars*
CAMERA: Ebony 5″×4″
LENS: 150mm Schneider Symmar-S f5.6
FILM: Kodak Ektachrome 100 Plus (EPP) 5″×4
EXPOSURE: 1/8 @ f22½
FILTRATION: 81C

135. *St Paul's Cathedral*
CAMERA: Deardorff 5″×4″
LENS: 75mm Schneider Super-Angulon f5.6
FILM: Kodak Ektachrome 100 Plus (EPP) 5″×4
EXPOSURE: 10 sec @ f11
FILTRATION: 81C

137. *Shakespeare's Globe*
CAMERA: Ebony 5″×4″
LENS: 58mm Schneider Super-Angulon XL f5.6
FILM: Kodak Ektachrome E100SW 5″×4″
EXPOSURE: 1/8 @ f32
FILTRATION: 85C+Lee 0.3 & 0.45 graduated

139. *The Anchor*
CAMERA: Ebony 5″×4″
LENS: 90mm Schneider Super-Angulon f8
FILM: Kodak Ektachrome E100SW 5″×4″
EXPOSURE: 1/2 @ f5.6½ + flash fill
FILTRATION: 81C

141. *Southwark Bridge*
CAMERA: Leica M6
LENS: 90mm Leitz Tele-Elmarit-M
FILM: Kodak Ektachrome E100SW 35mm
EXPOSURE: 1/250 @ f8½
FILTRATION: 81C

143. *Southwark Cathedral*
CAMERA: Ebony 5″×4″
LENS: 90mm Schneider Super-Angulon f5.6
FILM: Kodak Ektachrome E100SW 5″×4″
EXPOSURE: 1/2 @ f8
FILTRATION: 85B

145. *The Tower of London*
CAMERA: Ebony 5″×4″
LENS: 90mm Schneider Super-Angulon f5.6
FILM: Kodak Ektachrome E100SW 5″×4
EXPOSURE: 1/8 @ f16
FILTRATION: 85C+Lee 0.3 & 0.6 graduated

147. *Tower Bridge*
CAMERA: Ebony 5″×4″
LENS: 75mm Schneider Super-Angulon f5.6
FILM: Kodak Ektachrome E100SW 5″×4″
EXPOSURE: 5sec @ f11
FILTRATION: none

149. *Bermondsey*
CAMERA: Ebony 5″×4″ with 6×12cm back
LENS: 75mm Schneider Super-Angulon f5.6
FILM: Kodak Ektachrome E100SW 120
EXPOSURE: 1/15 @ f22½
FILTRATION: 85B

151. *Deptford*
CAMERA: Gandolfi 5″×4″
LENS: 210mm Schneider Symmar-S f5.6
FILM: Kodak Ektachrome 100 Plus (EPP) 5″×4″
EXPOSURE: 1/4 @ f11
FILTRATION: 85C

153. *Sayes Court, Deptford*
CAMERA: Ebony 5″×4″
LENS: 120mm Schneider Super-Angulon f5.6
FILM: Kodak Ektachrome E100SW 5″×4″
EXPOSURE: 1/8 @ f11
FILTRATION: 85C+Lee 0.3 & 0.6 graduated

155. *Greenwich*
CAMERA: Ebony 5″×4″
LENS: 90mm Schneider Super-Angulon f5.6
FILM: Kodak Ektachrome 100 Plus (EPP) 5″×4″
EXPOSURE: multiple – 1/125 @ f16 (× 8)
FILTRATION: 85B+Cokin E1 & E2 graduated

157. *Greenwich Observatory*
CAMERA: Ebony 5″×4″
LENS: 75mm Schneider Super-Angulon f5.6
FILM: Kodak Ektachrome 100 Plus (EPP) 5″×4″
EXPOSURE: 1/15 @ f16
FILTRATION: 85C+frost

159. *Thames Barrier*
CAMERA: Ebony 5″×4″
LENS: 210mm Schneider Symmar-S f5.6
FILM: Kodak Ektachrome 100 Plus (EPP) 5″×4″
EXPOSURE: 1/4 @ f32
FILTRATION: 85B+Cokin E1 & E2 graduated

161. *Greenhithe & Stone*
CAMERA: Ebony 5″×4″
LENS: 75mm Schneider Super-Angulon f5.6
FILM: Kodak Ektachrome E100SW 5″×4″
EXPOSURE: 1/4 @ f11⅔
FILTRATION: 85B+Lee 0.3 & 0.6 graduated

163. *Ingress, Broadness & Northfleet*
CAMERA: Ebony 5″×4″
LENS: 75mm Schneider Super-Angulon f5.6
FILM: Kodak Ektachrome E100SW 5″×4″
EXPOSURE: 1//30 @ f32
FILTRATION: 85C+Lee 0.45 graduated

165. *Gravesend*
CAMERA: Ebony 5″×4″
LENS: 75mm Schneider Super-Angulon f5.6
FILM: Kodak Ektachrome E100SW 5″×4″
EXPOSURE: 1 sec @ f32
FILTRATION: 85C+Lee 0.3 & 0.6 graduated

167. *Gravesend – Tilbury Ferry*
CAMERA: Ebony 5″×4″
LENS: 75mm Schneider Super-Angulon f5.6
FILM: Kodak Ektachrome E100SW 5″×4″
EXPOSURE: 1/8 @ f45
FILTRATION: 85C+Lee 0.6 & 0.6 graduated

169. *Higham to Coalhouse*
CAMERA: Ebony 5″×4″
LENS: 75mm Schneider Super-Angulon f5.6
FILM: Kodak Ektachrome E100SW 5″×4″
EXPOSURE: 1/8 @ f22⅔
FILTRATION: 85C+polariser

171. *Cliffe & Cooling*
CAMERA: Leica M6
LENS: 35mm Leica Summicron-M f2
FILM: Kodak Ektachrome E100SW 35mm
EXPOSURE: 1/60 @ f2
FILTRATION: 81C

173. *Allhallows*
CAMERA: Ebony 5″×4″
LENS: 90mm Schneider Super-Angulon f5.6
FILM: Kodak Ektachrome E100SW 5″×4″
EXPOSURE: 1/15 @ f16½
FILTRATION: 81C+Lee 0.6 graduated